READING BOYISHLY

READING
BOYISHLY

ROLAND BARTHES,

J. M. BARRIE,

JACQUES HENRI LARTIGUE,

MARCEL PROUST,

and

D. W. WINNICOTT

CAROL MAVOR

DUKE
UNIVERSITY
PRESS
Durham
and
London
2007

Duke University Press gratefully acknowledges
the support of the University of North Carolina,
Chapel Hill, which provided funds toward the
production of this book.

For my boys

OLIVER,

AMBROSE,

and

AUGUSTINE

CONTENTS

ACKNOWLEDGMENTS

ROUND, ROUND, AND ROUND AGAIN, this book makes three. For the third time my Ariadne string leads me back home again to Helene Moglen. Not only did she show me the way to becoming a writer, with as much criticism as praise, as much forewarning as optimism, she also showed me the way to becoming what I hope is a "good enough mother:" a being (according to Winnicott) who keeps a little something for herself, as gift to *both* herself and to her child. What's more, Helene, a mother of three boys, encouraged me to have my own children: I ended up with three boys of my own. (Life is filled with these little surprises.) Likewise, through Winnicott, through Helene, I unwrapped the gift of teaching my boys to find (I hope) a little something just for themselves: their own "transitional objects."

Speaking of boys times three: clearly every page of this book feels the birdliness of Augie in the nest, of Ambie waiting to be pushed out, and of Ollie in flight. I thank them and their father, Kevin, who has not only lovingly spent his own time sitting on eggs and padding our nest with all sorts of interesting things and bringing back delicious food for all of us to eat, he has also opened up my eyes to the beauty of flight (by closing them and setting them to dreaming). I enjoy soaring with Kevin.

Grandma's blue eyes are still keeping me forever happy in the ocean that she never left. (And Grandma, thanks for the all the messages in the New Zealand clouds. It really was the next best thing to eating lamb chops and mint sauce with the boys.)

Hayden White is still a wheel of smiles nodding approvingly at my devotion to Barthes. I will never cut the strings to Hayden (or Barthes): in my mind, they are a couple.

On the topic of couples, while writing this book, I benefited enormously from my two-person writing group: Ranji Khanna and myself. She helped me to find all the right strings and ribbons to wrap this book up. As Winnicott has remarked, "string can be looked upon as an extension of all techniques of communication . . . [it] helps in the wrapping." Ranji gave me miles of it.

elin o'Hara slavick planted daisies in my mouth.

A number of graduate students enthusiastically went on this boyish pilgrimage with me: Teri Devoe (Teri Devoted), Mara West, Allison Fox, Betsy Towns, Elizabeth Howie, Pam Whedon, and Sarah Miller.

I refuse to be weaned from publishing with Duke University Press. Ken Wissoker, my wise, tender, brilliant forever-editor is so generous with himself that I need no "transitional object" to carry me between the writing at the tips of my fingers and the book that ends up resting in your hands. How lovely to never have to think of another press, another editor. Indeed, it has become a most beautiful habit. And, even if you do not read past these acknowledgments, or even if you do not like what the chapters that follow have to say, I can bank on your loving of the gorgeous, sensitive design of this *Reading Boyishly*. You can thank, and I will thank, Amy Ruth Buchanan for that. Last, but not least, Courtney Berger, assistant editor at Duke Press, is nothing short of ideal to work with. She's made this plump book possible.

Oh, can I thank Kevin again? Once is never enough.

One more time? That makes *three* thanks to Kevin, bringing this page of gratitude round full circle. For as Bachelard insists: life is round; it just is; that is its essence. "Like a walnut that becomes rounds in its shell" (La Fontaine), I shall always be enveloped in the roundness of Kevin's mouth.

ANORECTIC

HEDONISM:

A READER'S

GUIDE TO

READING BOYISHLY;

NOVEL OR A

PHILOSOPHICAL

STUDY?

AM I

A NOVELIST?

When your words came, I ate them.

⌐ Jeremiah 15: 16

To press on from the half-measure
of kissing to biting, it will go down
cleaving to mouth and throat
like an icy aromatic jelly . . .
lightly veined with the smell
of cherries and apricots.

⌐ Marcel Proust, *Contre Sainte-Beuve*

MARINA WARNER ONCE REFERRED to my voice, my writing voice that is, as being in partnership with the "new hedonists."[1] Just who those new hedonists are, I am not sure, but I do know who the original hedonist to whom she refers is: Roland Barthes. (As Barthes once said in an interview: "In my case, I have taken on the responsibility of *a certain hedonism*, the return of a philosophy discredited and repressed for centuries: first of all by Christian morality, then again by positivistic, rationalistic morality.")[2] And it is most certainly true that I eat him up. I have an appetite for Barthes who had an appetite for Proust.

As both hedonist *and* structuralist, Barthes's full language crumbles and whips between "egoism and terrorism, actor and policeman."[3] Puffed, glazed, and fluted by the "hopelessly irresolvable choice he faced as writer and teacher," [4] monster and critic, Barthes suffered and took pleasure in a game of two languages. Such play makes Barthes a promising gourmand, a sweet and savory character. As Barthes writes at the beginning of *Roland Barthes by Roland Barthes*: "It must all be considered as if spoken by a character in a novel."[5] Likewise, but in an inversion, Marcel Proust's *In Search of Lost Time* began, not as a novel, but as a hybrid form of literary criticism against the author Sainte-Beuve, entitled *Contre Sainte-Beuve*. (*Contre Sainte-Beuve* was never finished.) Confused as to whether he was or should be working on a novel or a critical study of Sainte-Beuve, Proust writes in one of his working notebooks: "Should I make it a novel, or a philosophical study — am I a novelist?"[6] Like some of Barthes's writing (*Roland Barthes by Roland Barthes, Camera Lucida, A Lover's Discourse, Empire of Signs*), *Contre Sainte-Beuve* is as much autobiographical as it is critical as it is "novel."

When reading *Contre Sainte-Beuve*, I am delighted by parts that I recognize from *Swann's Way* (the first book of the many-volumed *Search*). Amid the heated attacks on its so-called subject (Sainte-Beuve), I find elements of the *Search*: the memories of the bedrooms that the Narrator had slept in; the water closet that smells of orrisroot (but with a more focused masturbation scene in *Sainte-Beuve*); and a taste of magic madeleine (served up as dry toast with tea in *Sainte-Beuve*).

"When reading *Contre Sainte-Beuve*, I am delighted
by parts that I recognize from *Swann's Way*."

In the spirit of Proust, we also know that Barthes had a novel gestating inside him. Between the years 1978 and 1980, he taught two course at the Collège de France, both entitled *The Preparation of the Novel*. The second *Preparation* was the final course that he would ever teach, for which he would give his very last lecture on 2 November 1979.[7] Barthes began this last lecture with these words: "I say: to finish and not to conclude. Indeed, what should the conclusion to this course be? — The Work itself."[8] But the course did not produce The Work: there was no novel. Barthes admitted that he could not pull any work out of his hat.[9] But there is evidence, beyond the teaching of the courses, that he had been trying. After his death, Barthes left behind a small collection of eight sheets of scribbled paper, neatly stored in a red cardboard shirt box. On the outside of the box he had written in capital letters: VITA NOVA. Inside the darkness of this box was Barthes's novel in gestation. The pages — one on a sheet of graph paper, the others on typing paper, written first in ink, with later additions in black and red pencil — are bare evidence of the start of the novel. In Barthes's tender script, in the spirit of Dante and Proust, he describes a desire for rebirth through writing, with the Mother as the guide.[10]

Although Barthes coined his own academic approach as "novelesque" and wrote of wanting to write a novel, he never did write his "fiction," due to his tragic premature death at age sixty-five. Yet, if we understand the "novelesque" as the novel minus traditional plots, then *A Lover's Discourse, Camera Lucida, Roland Barthes, The Pleasure of the Text, Michelet* — in sum, Barthes's most "hedonistic" books — are nearly there as novels. They "float" — they "do not destroy anything" but are "content" to "simply . . . disorientate the Law."[11] Likewise, the *Search*, which began as a rubbing away against Sainte-Beuve but settled more narcissistically on Proust himself, is a memoir turned literary criticism (with a dash of art criticism to enhance the flavor), served as a novel meal. And the meal's novelty turns on language of, in the words of the *Search*'s beloved grandmother, a "sumptuousness to make you die of hunger."[12]

Indulging in an appetite for Barthes who had an appetite for Proust, "Anorectic Hedonism" is an appetizer to *Reading Boyishly*, at once too filling and

too tiny. In keeping with the vim of my anorectic-hedonistic starter, the stars of my jam-packed meal to follow — Barrie, Barthes, Lartigue, Proust, Winnicott — are betwixt and between. They are neither man nor boy, neither little nor big: they are boyish. The "ish" keeps them swishy: some more, some less, some very. The hybrids of this book's boydom grew in France, England, and Scotland, in the real and fictional settings of Kensington Gardens, Thrums, the Bois de Boulogne, a grandmother's garden in the southwest of France ("roses, hydrangeas . . . carpet grass, rhubarb, kitchen herbs in old crates, a big magnolia"[13]) along the river Vivonne (on Easter morning "still black and bare, its only companions a clump of premature daffodils and early primroses, while here and there burned the blue flame of a violet, its stem drooping beneath the weight of the drop of perfume stored in its tiny horn" [I, 235; I, 165]), at Black Lake Island ("it was a coral island glistening in the sun"[14]). Embodying categories like the greatest novelist ever, or the author of the most popular children's play ever, or the popular therapist for "good-enough" mothers, or the Professor of Desire, or The Photographer of the Century, the ingredients are everyday and highbrow. Ancient boys, aged children, adolescent gentlemen: I dish them up as boyish cuisine. Salted and peppered, spiced and buttered, sugared and glazed, fired and chilled, they taste of pastimes with mother, goodnight kisses, apron strings, play, play, play, albumen, *paperoles*, boy-love, mother-love, ink, (don't forget the swishiness), swallow's nests, glass negatives, paper negatives, magnifying glasses, magic lanterns, flight, asparagus-scented urine, whippings, bitter growing-up fears, fermented memory, untied shoestrings, crumpled shadows, shadowy fathers, blue muslin dresses, Fortuny folds, golden dust, the sea, race cars ready to run, rabbit fur, pink hawthorns, coffee, coffee, coffee, speed, cigars, and too-cold beer. My book is *puerile*, a depreciative term meaning *merely boyish*. But, for me, the *merely* blossoms as full, fulfilling, full-mouthed, full-hearted, fulgurant, and fulgent, without shame. Brought to its fullcome, my book *boyishly* strives to be betwixt and between not only boy and man, gay and straight, Mama's boy and father's spitting image (well, you know the list), but most decidedly novel and philosophy.

The writing appetite of Barthes is a conflicted, but extremely beautiful gastronomy of withholding and hedonism (anorectic or ascetic and hedonistic). Although a self-proclaimed hedonist, Barthes's love of pleasure was always fraught by a kind of intellectual asceticism, as is made evident in his contradictory fame: "To many, he is above all a structuralist, perhaps *the* structuralist, advocate of a systematic, scientific approach to cultural phenomena [*Image, Music, Text, Writing Degree Zero, The Fashion System*]. . . . To others, Barthes stands not for science but for pleasure [*Camera Lucida, The Pleasure of the Text, A Lover's Discourse*]."[15] One might ascertain this split to be analogous to Barthes's own notion of his body split in two: his childhood body (thin, assuredly so by his childhood tuberculosis, resulting in confinement in a sanatorium) and his adult body (plump). In *Roland Barthes*, Barthes longs for the boyish body of his youth. Above a photograph of himself as a young man in long socks with a jacket draped foppishly over his shoulders, Barthes writes:

> Sudden mutation of the body (after leaving the sanatorium): changing (or appearing to change) from slender to plump. Ever since, perpetual struggle with this body to return it to its essential slenderness (part of the intellectual's mythology: to become thin is the naïve act of the will-to-intelligence).[16]

In order to return to this essential slenderness, Barthes must withhold. Barthes's structuralist texts are his dry toast without butter, jam, or tea; they withhold fat, sugar, and alcohol as in the scientific semiotics of his surprisingly dull book *The Fashion System*. When he writes as structuralist, as semiotician, Barthes withholds the hedonistic pleasures of a hyperglycemic diet: the "potbellies of Louis-Philippe" in favor of "fops of Louis Bonaparte . . . the dry lively man, the coffee drinker of the eighteenth century (a century [so claims Barthes] favored above all others)."[17] Yet, coffee is both hedonistic and ascetic. Coffee keeps the outrageous artist awake all night. But coffee also keeps the studious ascetic academic awake all night. Coffee

*Mutation brusque du corps
(à la sortie du sanatorium) : il
passe (ou croit passer) de la maigreur
à l'embonpoint. Depuis, débat
perpétuel avec ce corps pour lui rendre
sa maigreur essentielle (imaginaire
d'intellectuel : maigrir est l'acte naïf
du vouloir-être-intelligent).*

" 'perpetual struggle with this body to return it
to its essential slenderness' "

makes you wild with energy. Yet, coffee has no calories; it keeps you thin. Coffee makes sperm swim faster. Is it no wonder that Stewart Lee Allen calls it "the devil's cup" and sees it as "the driving force in history"?[18]

In his series of lectures at the Collège de France on *The Neutral* (1978), Barthes addressed the anorexic as both an intellectual, writerly response (through the work of André Gide) and as a bodily reaction to the maternal. Quoting in his lecture a letter from his student and friend, the psychoanalyst Jean-Michel Ribettes, Barthes notes "that the anorexic finds in nothing the object of his desire—which is to say that he finds enough to fulfill desire's requirements . . . in the refusal of what the other gives him."[19]

In the *Search*, food is even a more direct recipe for writing. The Narrator of the *Search*, as mirrored "character" of Proust himself, is trying to find the voice and structure required for the novel that he (the Narrator/Proust) so desperately wants to write; eventually he comes to understand that it is his family's fabulous cook who will provide him with the model of how to write his novel. Françoise is, as the Narrator tells us, "the Michelangelo of our kitchen" (II, 39; I, 449): just as the great Italian master took such care in choosing the most exquisite marble for the monument to Julius II, Françoise would search for the best cuts of meat.[20] Françoise, like a great artist, knew how to put all the right ingredients together:

> And—for at every moment the metaphor uppermost in my mind changed as I began to represent myself [as a writer] more clearly and in a more material shape the task upon which I was about to embark—I thought that . . . under the eyes of Françoise, who like all unpretentious people who live at close quarters with us, would have a certain insight into the nature of my labours. . . . I should work beside her and in a way almost as she worked herself . . . and, pinning here and there an extra page, I should construct my book, I dare not say ambitiously like a cathedral, but quite simply like a dress. Whenever I had not all my "paperies" near me as Françoise called them, and just the one that I needed was missing, Françoise would understand how this upset me, she would always say that she could not sew if she had not the right size

of thread and the proper buttons. And then through sharing my life had she not acquired a sort of comprehension of literary work? (VI, 509; IV, 610–11)

The Narrator's memory of his first meeting with Françoise, *the one* who would critically provide his approach to writing, indeed his "comprehension of literary work" (ultimately to cut it up and restructure it as if one were sewing the perfect dress, mirroring how this talented woman picked the best pieces of meat and enriched it with the perfect juices when she was slowly and carefully making her exquisite *bœuf à la gelée*), took place at the home of the Narrator's Aunt Léonie, during a New Year's visit to Combray.

✌﹅

"'I should construct my book . . . quite simply
like a dress.'"

It is a memory of "*spun* sugar" (*sucre filé*): an image of madeleine (sweet memory) and sewing (spinning one's novel) in one.

> No sooner had we arrived in my aunt's dark hall than we saw in the gloom, beneath the frills of snowy bonnet as stiff and fragile as if it had been made of spun sugar, the concentric ripples of a smile of anticipatory gratitude. It was Françoise, motionless and erect, framed in the small doorway of the corridor like the statue of a saint in its niche. (I, 71; I, 52)

Just as Françoise is presented as food that is not really meant for serious eating (spun sugar), the *Search* is chock-full of lists of food that have the effect, like Françoise's Sunday luncheon, of being more visual than gastronomical. In Proust's sinuous hands-turned-words, Françoise's Sunday lunch is musically "poured," Jackson Pollock–like, as if there were no table-canvas edges, as if no place were ever full. Françoise wallpapered the family table with food with the all-over sensibility of an Abstract Expressionist, only much more refined with her measured culinary gestures. Allow me to quote the passage in full:

> Upon the permanent foundation of eggs, cutlets, potatoes, preserves, and biscuits, which she no longer even bothered to announce, Françoise would add — as the labour of fields and orchards, the harvest of tides, the luck of the markets, the kindness of neighbours, and her own genius might provide, so that our bill of fare, like the quatrefoils that were carved on the porches of cathedrals in the thirteenth century, reflected to some extent the rhythm of the seasons and the incidents of daily life — a brill because the fish-woman had guaranteed its freshness, a turkey because she had seen a beauty in the market at Roussainville-le-Pin, cardoons with marrow because she had never done them for us in that way before, a roast leg of mutton because the fresh air made one hungry and there would be plenty of time for it to "settle down" in the seven hours before dinner, spinach by way of a change, apricots because they were still hard to get, gooseberries because in another fortnight

there would be none left, raspberries which M. Swann had bought specially, cherries, the first to come from the cherry-tree which had yielded none for the last two years, a cream cheese, of which in those days I was extremely fond, an almond cake because she had ordered one the evening before, a brioche because it was our turn to make them for the church. And when all this was finished, a work composed expressly for ourselves, but dedicated more particularly to my father who had a fondness for such things, a chocolate cream, Françoise's personal inspiration and specialty would be laid before us, light and fleeting as an "occasional" piece of music into which she had poured the whole of her talent. (I, 96–97; I, 70)

In the above passage, we find Françoise (the Michelangelo of the kitchen) as a great artist, though here extremely and comically modern as she appears to prefigure the dripped and poured painting of postwar American art. The list of foods is as gluttonous as a huge tabletop *Number 1* by Pollock (who is famous for painting on horizontally laid, rather than vertically hung, easel-type canvases), and like the artist who danced around his canvases, gracefully tossing paint off sticks and paintbrushes, crossing one foot over the other, Françoise's art maintains its own kind of rhythm, a kind of musicality. Although heavy, Françoise's meal is as "light and fleeting as an 'occasional' piece of music."

In the *Search*, Proust emphasizes food, but rarely does he physically savor it. Even when tasting the madeleine cake from which grew all the volumes of the *Search* (given by Mamma on a winter's day during a return to home), the protagonist takes only a "morsel of the cake" in a mere "spoonful of the tea" (I, 60; I, 44). The madeleine is like Mamma's kiss, "frail and precious" (I, 29; I, 23), and that is it. The Narrator does not stuff a cake, or even several, in his mouth. He takes a spoonful of tea with a tiny morsel of cake, has a few more sips of tea and then stops eating, in order to begin desiring and remembering and telling and writing. As the Narrator writes: "No sooner had the warm liquid mixed with the crumbs touched my palate than a shiver ran through me and I stopped, intent upon the extraordinary thing that was

happening to me" (I, 60; I, 44). The scallop-shell-shaped cake, described as being "so richly sensual under its severe, religious folds" (I, 63; I, 46) is perfectly hedonistic (rich, sensual, the trigger for the longest novel in history) *and* anorectic and ascetic (severe, religious, hailing the scallop-shell badges worn by the pilgrims of Saint-Jacques who passed through Proust's boyhood hometown of Illiers).[21]

Hardly food, eating the madeleine cake is closer to sharing a kiss. As Adam Phillips has noted, kissing "involves some of the pleasures of eating in the absence of nourishment."[22] Proust writes of his maternal cake as if it was a kiss: "It had the effect, which love has, of filling me with a precious essence . . . not in me, it *was* me" (I, 60; I, 44). To eat the madeleine cake is to eat the mother, to return to home, to mother. To kiss her is to eat her up. In the novel, Mamma's offering up of goodnight kisses is cast under the shadow of Christianity, as if the Mother and Son were partaking in communion. Under this metaphor of eating the body (hedonistic), yet partaking of it in the form of an anorectic wafer, kissing becomes an eating of the host, the Word: "She had bent her loving face down over my bed, and held it out to me like a *host* for an act of *peace-giving communion* in which my lips might imbibe her real presence and with it the power to sleep" (I, 15; I, 13; emphasis is mine).[23] The kiss as host is further underscored by the suggestion that Mamma's bestowing hails the "kiss of peace": a ceremonial gesture, used as a sign of love and union in some Christian churches during celebration of the Eucharist.

On my Proustian pilgrimage, rooting for the breast, the lips, the word, I stop at the first line of Julia Kristeva's long book on Proust (*Time and Sense*) and find the madeleine cake claimed as "incestuous."[24] Perhaps this incestuousness lies behind the fact that *the cake* first appears in the novel as *Petites Madeleines*,[25] a capitalization (which is not retained in the English translation), which suggests a proper name, a complex character who grows out of (Mother) Mary.[26] As Kristeva notes:

> The . . . reference to "madeleine" recalls three characters from the Gospels . . . [including] Mary Magdalene . . . [Furthermore] Marie-

Madeleine [is] the patron saint of perfumers, glovers and penitent girls. . . . In the seventeenth century, the common noun *madeleine* was applied to the fruits found in Saint Mary Magdalene's season—peaches, plums, apples, and pears. This alimentary bent continued well into the nineteenth century, from which point *madeleine* has denoted a cake. (According to the Bescherelle dictionary, this was a tribute to a cook named Madeleine Paulmier).[27]

The madeleine is a "woman-cake."[28] Madeleine holds and releases, like a Barthesian punctum (always tiny) or a Lacanian *objet petit a*.

There is a strong biographical connection between Proust's dwindling appetite, when writing the *Search*, and a taste for words that grew and grew, nearly replacing food altogether. Before the serious years of writing the *Search*, Proust was known for bouts of gluttony. Even when suffering from the severe asthma attacks that began when he was nine, Proust still managed a hearty diet. In a letter to his mother (August 31, 1901), he brags that a series of asthma attacks "didn't stop me from eating at about half-past two a meal consisting of two tournedos steaks—I ate every scrap—a *dish*—of chips (about twenty times as much as Félicie used to make), some cream cheese, some gruyère, two croissants, a bottle of Pousset beer."[29] A manipulative tease, such "passionate self-absorption is founded on the luxury of knowing" that his mother "devoured every detail."[30] He got extra attention from her for his illness and eating was part of the play. In another letter, he further joked to her: "Lunch is my favourite moment."[31] In a letter to Mme Daudet[32] he wrote that Lucien[33] had complained of being repelled by this gluttony.[34] As a result, Proust's "stomach sometimes became so distended the elastic around his underpants wasn't strong enough, and he resorted prematurely to a corset, but this, combined with overeating, hurt his stomach so much he was soon forced to abandon both."[35]

Gradually, as he became more and more committed to writing, writing in his bed, Proust would eat less and less and his asthma became more and more severe. Retreating to his cork-lined nest of a room to complete

his *Search* (free of dust, free of sound, yet full of the thick fumes of the Legras powders that he burned for his asthma, a ritual that he referred to as "smoking"[36]), nourishment was squeezed thin. By the end of his life, his book, there was no first, and certainly no second, croissant to be delivered by his trusted servant Céleste Albaret. When Albaret was initially hired by Proust, it had been her primary job to have Proust's "morning" coffee ready with hot milk and a croissant (sometimes even a second croissant) to be delivered when he awoke in the afternoon (after writing all night and sleeping in the day). In the words of Albaret, "The most extraordinary thing of all was that he could survive and work, ill as he was, without taking any but the most meager nourishment. Or rather, by living on the shadows of foods he'd known and loved in the past."[37]

As Proust grew smaller and his book grew larger, his staples of silence and coffee were amplified. Because he was lying still all of the time and because he was not eating much, he grew cold. "People who shook hands with him were slightly surprised by the coldness of the hand he held out."[38] Without enough food, the body has no choice but to slow down its metabolic activity to survive the deficit in calories. In response to what is no less than starvation, Proust's body temperature was decreasing. Proust in his isolated, surprisingly dimly lit room (how could he write with so little light, so little food?) was splitting away from the world. By the end (the end of his life, the end of writing the *Search*), there was not even a bit of milk for his coffee: no *café au lait*.

But, of course, Proust would and always did have a taste for reading, a taste for words over food, which comes out so clearly in one of his earliest writings. In Proust's introduction to his translation of Ruskin's *Sesame and Lilies*, 1906, entitled "On Reading," Proust hardly says a word about Ruskin. Instead, Proust chews over how one reads, as he savors his own childhood memories of reading. In this *mise-en-scène* of boyish reading, we finding reading at its best: at his aunt's house in Illiers, which will become known as Combray in the *Search*.[39] To read boyishly is to covet the mother's body as a home both lost and never lost, as Barthes also does, especially in *Camera Lucida*, as Proust does in the *Search*—to desire her as only a son

can—as only a body that longs for her, but will never become Mother, can.[40] In "On Reading" (as in the *Search*), we learn from Proust that he would sneak reading, like other children steal sweets. Reading, "which one would go and do in secret," where he would "slip into the dining room," not to eat, but to read.[41] "Lunch . . . alas!, [and to Proust's dismay] would put an end to reading."[42] And while reading in the dining room, the others (after walks and taking care of their correspondences) would begin to arrive early, would sit down too soon, pronouncing that "lunch would not be unwelcome."[43] How little Marcel dreaded these early birds, fearing his parents' soon-to-be-pronounced "*fatal words: 'Come, shut your book, we're going to have lunch.'*"[44] After the lunch that put an end to his reading, Proust tells us, "my reading resumed immediately."[45] And, according to "On Reading," what makes books dangerous to eat is they serve as an escape from our own personal lives, "*honey ready-made* by others . . . which we have only to take the trouble of reaching for on the shelves of libraries and then *savoring passively* in perfect repose of body and mind."[46] Nectar for the mind to drowsily suckle: what could be more delicious?

Reading can be good or bad food. (At least according to mothers and grandmothers.) In Proust's early, unfinished, posthumously published *Jean Santeuil* (worked on between the years 1895 and 1899), "The mother initiates Jean into the love of poetry by reading to him from Lamartine's *Méditations*, Corneille's *Horace* and Hugo's *Contemplations*. Jean's mother believes that good books, even if poorly understood at first, provide the child's mind with healthy *nourishment*."[47] The scene is repeated, when in the *Search*, the Narrator tells us how his grandmother viewed anything that was not well written as bad, unnourishing food: "My grandmother . . . considered light reading as unwholesome as sweets and cakes" (I, 52; I, 39). This good taste in words leads the grandmother to buy the four pastoral novels of George Sand for the young Narrator's upcoming birthday: his first "real" novels. After the famous scene of the goodnight kiss, in an effort to comfort and uplift the melancholic Narrator, Mamma brings out the Sand books that were to be given to him on his birthday. She chooses to read Sand's *François le champi*, first:

Mamma sat down by my bed; she had chosen *François le Champi*, whose reddish cover and incomprehensible title gave it, for me, a distinct personality and a mysterious attraction. I had not then read any real novels. I had heard it said that George Sand was a typical novelist. This predisposed me to imagine that *François le Champi* contained something *inexpressibly delicious*. (I, 55; I, 41; emphasis is mine)

As Kristeva has noted, *François le champi* has many ingredients that eventually fold into the final *Search*, even if they are infinitely small, even if they come as a mere dash or a quick pinch. Most distinct is the incestuous fact that Sand's François becomes the lover and eventually the husband of his adoptive mother after her widowhood. (Champi means waif in the Berry dialect).[48] Sand's scandalous widow-mother-wife[49] is reminiscent not only of Proust's illustrious love for his own mother, but also of Barthes's deep relationship with his mother Henriette,[50] as is replayed in *Camera Lucida*'s undecided captioning of Félix Nadar's photograph of his wife Ernestine as "The Artist's Mother (or Wife)."[51] *And* Sand's widow, who becomes both mother and wife to François, *just happens* to be named Madeleine: Madeleine Blanchet. This Madeleine Blanche(t), this little white sponge cake, this wife of the village miller, folds a bit of her incestuous self into the pages of the *Search* (the last step of making madeleines is to fold the egg whites into the flour), and she leaves a bit of her dusty white flour on the face of the Narrator's Mamma. (In *Camera Lucida*, Barthes may have been awakened by "the rumpled softness of [his mother's] crêpe de Chine and the perfume of her rice powder," triggered by an old photograph is which she is hugging him, "a child, against her"[52]—but in the *Search*, Proust is awakened by the taste of sugar, flour, and whipped egg whites given to him by his mother.) For our young Narrator in the *Search*, hearing about Madeleine Blanchet, although he did not yet understand, suggested something *"inexpressibly delicious"*—something more adult, like a real novel, like real food. The childish sugar cake is supplanted by dreams of grown-up foods enhanced with a little champi-gnon,[53] long stemmed and not so squat, not so plump as the madeleine, and certainly not dipped

" 'The Artist's Mother (or Wife)' "

in tea. Covered in moist dirt, mushrooms are closer to death (like the faded
lime blossoms of Aunt Léonie's tisane). Mushrooms add a bit of distinct,
mature flavor. Mushrooms are often quite decorative. Mushrooms add a
chewy texture. And though they might feed the mind, they will not fatten
up the asthmatic-bachelor-Proust-turned-Narrator, widowed by his own
mother. The cake of the afternoon tea meets the *champignon* of a midnight
snack.

By the end of the *Search*, the Narrator will stumble across a copy of *François le champi* in the library of the Prince de Guermantes. The title will
awaken (much like the madeleine that holds in its folds all of Combray)
memories of his mother and his child-self "who spelt out its title in the little
bedroom of Combray" (VI, 289; IV, 466). The book in his hands: "Now a

thousand trifling details of Combray which for years had not entered my mind came lightly and spontaneously leaping, in follow-my-leader fashion" (VI, 283; IV, 463). Cake, mushroom, and book are mere trifles, yet they are also, in fact, each a *"morceau idéal."* Speaking of the experience of reading his favorite author Bergotte, the Narrator describes the seductive qualities of Bergotte as if the Narrator were describing Proust's own strategy of turning a crumb into a universe:

> I now had the impression of being confronted not by a particular in one of Bergotte's works . . . but rather by the "ideal passage" [*morceau idéal*] of Bergotte, common to every one of his books, to which all the earlier, similar passages, now becoming merged in it, had added a kind of density and volume by which my own understanding seemed to be enlarged. (I, 130; I, 93)

Yet, to withhold is *also* to keep desire in check. To withhold is to defer or postpone, to detain (as in bondage), to retain. Withholding is driven by the relationship of desire. So then, even in his novelesque, hedonistic books, Barthes must withhold (plot, direct narrative) amid his excesses in order to keep desire burning in author and reader alike. Like the anorexic who presents a beautiful meal, but prefers not to eat, Barthes would prefer not to tell a story.[54] He does not want to fill his readers up; to do so would cut off desire and appetite. (He gives them a little coffee instead. "Coffee," Barthes writes, "is an ambiguous substance . . . its advent in the eighteenth century has brought with it critical lucidity. . . . And yet coffee, 'the alibi of sex,' is itself . . . a part of the infernal trilogy [the dozing off of love] of which tobacco and alcohol are the other two members.")[55]

Just as Barthes claims that the photograph force feeds sight, fills up space and the viewer — to make his reader full on sweets, so it seems, would be nothing less than violent. As Barthes writes in *Camera Lucida*:

> The Photograph is violent: not because it shows violent things, but because on each occasion *it fills the sight by force*, and because in it nothing can be refused or transformed (that we can sometimes call it mild does

not contradict its violence: many say that sugar is mild, but to me sugar is violent, and I call it so).[56]

Like Proust, Barthes is a boyish man who carefully loves "people and places with his mouth."[57] Barthes's punctum, that tiny bit of light carried to us by the photograph that triggers memory (that wounds us with our past) is a tiny detail that seems to have grown out of Proust's crumb of madeleine cake. Like a kiss, both punctum and madeleine are "a story in miniature, a subplot."[58] They suck up their texts in one smack.

In a kiss, "there is the return of the primary sensuous experience of tasting another person."[59] Proust, like Barthes, is hungry for mother. Proust, so nostalgic, suffers from eating the home, from homesickness: the very etymology of nostalgia itself. This longing love for home, for mother, produces not only the seventeenth-century disorder of nostalgia (a subject taken up in this book's first chapter, "My Book Has a Disease"), but also a love for appetite itself. Proust was in love with his hunger, not only his own, but his mother's hunger for him. As the Lacanian analyst Juan David Nasio has written (in the voice of the anorexic): "No I do not want to eat because I do not want to be satisfied, and I do not want to be satisfied because I want my desire to remain intact — and *not only my desire but that, as well, of my mother.*"[60]

An eating disorder is actually the ultimate ordering of eating. It is the clean empty room; it is purified appetite. "A world is created in which nothing can be eaten, nothing must be taken in,"[61] a state akin to the densely packed, tightly woven, make-use-of-everything nest (beaten with his own body) world of the *Search*: at once anorectic and hedonistic. Proust casually seems to *almost* say: "'I would prefer not to' tell a story" (a line that Barthes would ventriloquize in his own day). Just as the anorexic passively and aggressively and usually very politely claims, "I would prefer not to" (eat) — resulting in powerful control of environment, Proust is also a withholder that sucks us into his folds of tremendous text.

Eating interferes with hunger and one might argue that plot or traditional narrative (at least in the eyes of Proust) interferes with writing. In the

Search, we experience what is now famously called the Proustian sentence: a peculiar winding, revising, rethinking, destabilizing, breathtaking, delicious, exhausting, ribbon of perfection — minus story, minus linear time. In the words of Kristeva:

> Unlike linear time, the [Proustian] sentence reproduces a giant breath through explanatory detours or backwards leaps that develop traces that had already been constructed, erased, and not absorbed. The chronological progression, broken up and superimposed onto itself, can thus stretch out a space — the architectures, the always already anterior texture of a sort of timelessness.[62]

Food becomes Proust's writing, and Mamma eats his words:

> That forbidden and unfriendly dining-room, where but a moment ago the ice itself — with burned nuts in it — and the finger-bowls seemed to me to be concealing pleasures that were baleful and of a mortal sadness because Mamma was tasting of them while I was far away, had opened its doors to me and, *like a ripe fruit which bursts through its skin, was going to pour out into my intoxicated heart* the sweetness of Mamma's attention while she was reading what I had written. Now I was no longer separated from her. (I, 39; I, 30; emphasis is mine)

The Narrator's heart becomes full, full like a ripe fruit at a bursting point. The moment is sexual, as she turns from her flavored ice with burned nuts, as she ceases to clean her sticky fingers in the dressed table's tiny basins of water. When Mamma partakes of his boyish words, it feeds his desire. Mamma's lips are moving as she silently reads, as if in a series of kisses, as if in practice for the reading of *François le champi* yet to come. Lips barely parted, her mouth is not wide open. Her hunger for the boy is restrained, but it is palpable nevertheless. Mamma's hunger feeds the Narrator and it turns out that madeleine is never just sponge cake, nor mother, nor seashell turned pilgrim's badge, nor every kind of Mary-Magdalene-Madeleine you can think of — it is also, of course, a morsel of Marcel (inflated like a soufflé) ready to read (eat). But Mamma will never be full; she will never get enough

"'My life has now lost its only goal, its only sweetness,
its only love, its only consolation. . . . In dying, Maman
took with her little Marcel.'"

of him. Just as his words are too much, they are also never enough. Just as
Marcel would (not) have it.

THE STEREOGRAPHIC APPETITE of Proust and Barthes, anorectic
and hedonist, is tethered to the image of umbilicus: a cord that both brings
in food and takes away excess. Scarring, after birth, it leaves its mark, its
longing. A "longing" (as Susan Stewart so eloquently writes) is maternity's
"craving" for its child and, in turn (I would add) the child's craving for
the maternal.[63] Craving becomes a carving. It is a queer "longing mark."[64]
"Trace or scar, this impression finds its synonym in the generative meta-
phor of writing."[65] Barthes's deep relationship with his mother comes out
in his final writing ("I dream only about her"[66]). Shortly before his own
death, the death of Barthes's mother (October 25, 1977), the final cutting

of umbilical ribbon, made him want to write about her (*Camera Lucida*). Likewise, Proust would not really become a writer until after his mother's death on September 26, 1905. In Proust's own words: "'My life has now lost its only goal, its only sweetness, its only love, its only consolation.' Later he would add, 'In dying, Maman took with her her little Marcel.'"[67] As Edmund White astutely observes, this sentence can be interpreted, if the emphasis is placed on "little," to mean that "the ineffectual, dandified, immature Marcel [the hedonist] died at her death to be reborn as the determined, wise ascetic [anorectic] Proust."[68] For Barthes, his mother's death may have usurped him of what remained of his former ascetic semiotic self, in favor of full fat. (Barthes writes: "The language (of others) [including, one would assume, the complications of the (m)other tongue] transforms me into an image, as the raw slice of potato is transformed into a *pomme frite*.")[69] But we shall never know. In any case, Proust's asceticism produced the hedonism of the *Search*, just as Barthes will always be the author of two voices, the actor and the policeman.

The maternal is the magical-whipped-egg-white air of the *novelesque* approach of both Proust and Barthes. Proust wrote the critical novel (a monster of fiction, memoir, and criticism) and Barthes the novelesque criticism (also a monster of fiction, memoir, and criticism). Their queer maternality has, here and there, salted and peppered and sugared and spiced my earlier sweet and savory books (*Pleasures Taken* and *Becoming*),[70] but it has truly inflated this gravid soufflé: a monster that I call *Reading Boyishly*.

⁓

Should I make it a novel, or a philosophical study—

am I a novelist?

—Proust, *Le Carnet de 1908*

MY

BOOK

HAS

A

DISEASE

Our gaze can fall,
not without perversity, upon
certain old and lovely things,
whose signified is abstract,
out of date. It is a moment
of gentle apocalypse, a historical
moment of the greatest pleasure [jouissance].

 Roland Barthes, "Inaugural Lecture"

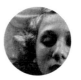

The subject of nostalgia comes into
the picture: it belongs to the precarious
hold that a person may have on the inner
representation of a lost object.

 D. W. Winnicott, "Transitional Objects
and Transitional Phenomena"

READING BOYISHLY is a labor of love for four boyish men and one boy. The men are J. M. Barrie (1860–1937), Roland Barthes (1915–1980), Marcel Proust (1871–1922), and D. W. Winnicott (1896–1971). The boy is the boy photographer Jacques Henri Lartigue (1894–1986), who did grow up and continued to snap pictures for his entire life (but I will focus on the keepsakes that he made when still in knee pants and during his adolescence). Between the covers of their books, journals, and photograph albums, childhood is a place prolonged through (what some have anxiously labeled as) an overattachment to the mother.

All five of "my boys" are privileged to read boyishly, largely as a result of class privilege. Lartigue was the son of wealth French banker; he lived long and fully with a lifetime of toys, cameras, dogs, kites, homemade flying machines, go-carts, paints, and sunshine, without any serious financial worries. Proust's bourgeois days, always with servants, spent reading in the garden as a child ("under the chestnut tree, in a hooded chair of wicker and canvas in the depths of which I used to sit and feel that I was hidden from the eyes of anyone who might be coming to call upon the family" [I, 115; I, 82–83]) and later reading in his brass bed as an adult, sounding his bell for the prompt delivery of his whims-turned-needs, are stories of infamous cushiness, despite being plagued by lifelong asthma. Winnicott's father was a British businessman, specializing in corsetry, an occupation that provided his son with a thorough upper middle-class life, including boarding school. However, Barthes and, especially, Barrie were weighed down as boys with the heft of monetary uncertainties. Barrie waxes it nostalgically. Barthes gives it a bitter taste.

For Barrie, growing up as a son of a weaver in his tiny house in the even tinier town of Kirriemuir, Scotland, was the fairy-tale, rags-to-riches story. But it seems that it was the reading that pampered him. And he caught the reading bug from his mum, a great reader. In Barrie's own words:

> We read many books together when I was a boy, *Robinson Crusoe*, being the first (and the second), and the *Arabian Nights* should have been the

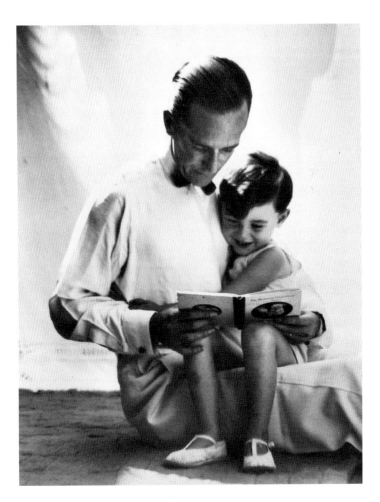

"reading boyishly"

next, for we got it out of the library (a penny for three days), but on discovering that they were nights when we had paid for knights we sent that volume packing, and I have curled my lips at it ever since. . . . Besides reading every book we could hire or borrow, I also bought one now and again, and while buying (it was the occupation of weeks) I read standing at the counter, most of the other books in the shop, which is perhaps the most exquisite way of reading.[1]

Barthes's background is "bourgeois," although his maternal grandmother was a "wealthy" member of the "constellation."[2] Barthes was not even a year old when his father died in combat in the North Sea, and there seems to be no mourning for him. After his father's death, Barthes and his warwidow mother, Henriette, moved to Bayonne, in the southwest of France, to live with his father's family. (Apparently Henriette was never close to her own mother.) Barthes describes his grandmother's home in Bayonne, with its lovely gardens, as an "ecological wonder."[3] The house is the stuff of fairy tales: "With the modesty of a chalet, yet there was one door after another, and French windows, and outside staircases, like a castle in a story."[4] "His mother, his aunt, and his grandmother all kept a careful watch on the young Roland, and he was surrounded by female affection."[5] However, a "transgression" brought the happy times to a halt. When Roland was eleven, his mother gave birth to his half-brother Michel, out of wedlock. This "transgression," Barthes claims, cost his mother financially and emotionally. Barthes has memories of financial misery:

Simply this, that my childhood and adolescence were spent in poverty. That there was often no food in the home. That we had to go and buy a bit of paté or a few potatoes at a little grocery store on the rue de Seine, and this would be all we'd have to eat. Life was actually lived to the rhythm of the first of the month, when the rent was due. And I had before me the daily spectacle of my mother working hard at bookbinding, a job for which she was absolutely unsuited. . . . I remember for example, the small crisis at the start of each school year. I didn't have

the proper clothes. No money for school supplies. No money to pay for schoolbooks. It's the small things, you see, that mark you for a long time, that make you extravagant later on.[6]

Barrie, Barthes, Lartigue, Proust, and Winnicott all were able to be extravagant enough later on, if not in their knickerbockers or school pants, then in their grown-up, if always boyish, trousers.

⌐ ACCORDING TO THE *Oxford English Dictionary*, "boyishly" is a real word, an adverb related to "boyish": "1. Of pertaining to boys or boyhood. 2. Boy-like; puerile."[7] It is the "boy-like" and the "puerile" that interest me. The *OED* gives three examples of "boyish": the first two are colored by shame, the third is couched in feminine vanity. From the Renaissance English poet Fulke Greville, we get the following bit of boyish shamefulness: "This is such a boyish sophisme as I am ashamed to aunswere it" (1579). From Abraham Cowley, who began writing at age ten, the boy poet of *Poeticall blossomes*, who was inspired by *The Faerie Queene*, we get a response to his own early verse, touched by shame: "The beginning of it is Boyish, but of this part . . . I should hardly now be ashamed" (1663). And last, from Britain's Thomas Macaulay (not that other eternally boyish Macaulay Culkin, mind you), who began his poems at age eight (a precociousness that beats Cowley), but turned away from such boyishness, in favor of the law and his *History of England*, we reach ultimate clarity: "Boyish vanities, and no part of the real business of life." In sum: "boyishly" holds shame and vanity with a stroke of the puerile.

"Puerile" according to the *OED* is boyish not girlish: its Latin root *puerilis* means boyish, childish. In its feminine form *puer* is also a boy, a child. Most commonly, according to the *OED*, "puerile" is a depreciative term meaning of "merely boyish or childish, juvenile; immature, trivial."

It is worth noting that the word "girlishly," as opposed to "boyishly," is not, or at least, not yet in the *Oxford English Dictionary* (although it has crept into other dictionaries, including *Merriam-Webster*). Not that I adhere to rules. I am a quick study of Alices (both the Wonderland and Look-

ing Glass varieties) and I learned from her what she learned from the White Queen, that there is "no day" for rules:

> "The rule is, jam to-morrow and jam yesterday—but never jam to-day."
> "It *must* come sometimes to 'jam to-day,'" Alice objected.
> "No, it can't," said the Queen. "It's jam every *other* day: to-day isn't any other day, you know."[8]

In fact, it was through Alice and Carroll's Alicious texts that I first found my own place to revel, not in "reading boyishly" but, in "reading girlishly." For me that was a place to begin. That was a place to play "out" those girl-things disavowed by the culture that I call home: from dress-up, to a love for girls, to motherhood itself. Indeed, a girlish read enabled me to write two books which took serious pleasure in girl-children, girls' teendom, and the mothers who bore them: *Pleasures Taken* and *Becoming*.

Pleasures Taken took blissful delight in the Victorian photographs I love: Carroll's girldom ("girldom" like "boydom" is a "real" word); Julia Margaret Cameron's loving pictures of her maid Mary Hillier as an erotically charged beautiful Madonna, often coupled by the wispy water-baby children that lived with the two of them on the utopian Isle of Wight;[9] and, Hannah Cullwick's Cindy Shermanesque masquerades, way before Cindy. And, of course, there were the *Alice* books: stories far more darling to girls, not boys, although Carroll is championed by philosophers and Surrealists alike.

Becoming "listened carefully" to Clementina Hawarden's homoerotic photographs of her gorgeous daughters. There, I was taken by what I imagined as beneath the surface of the photographs, beneath the whispering of petticoats, linen, water-marked silk, suppressed giggles, coiled hair, weary sighs: the unfamiliar sound (at least in my personal experience) of a mother's voice filled with passion for the adolescent, and very sexual, beauty of her daughters, often in pairs, often provocatively, if subtlety, touching one another. Hawarden speaking softly in paper, glass, collodion, and emulsion, whispers: "I adore you." I wondered how it felt to be her

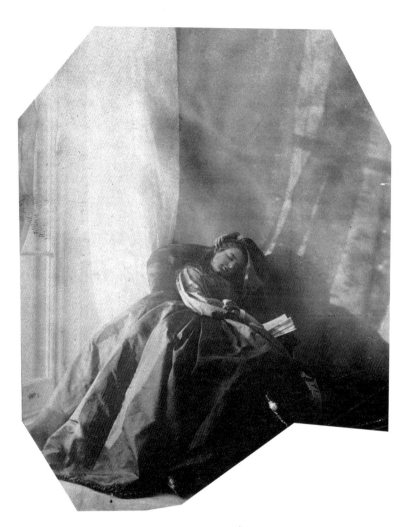

"reading girlishly"

most-photographed daughter (also named Clementina), to be kissed all over by the natural light streaming through the home's gauze-curtained giant windows (the very radiance which made her mother's pictures possible) and to be kissed all over by the cherishing gaze of her artful mother.

Let it suffice to say that the "string-tied" (one of this book's richest metaphors for speaking to that continually linked, if imaginatively so, umbilicus between my boyish men and their mothers) and "aesthetically productive" work of Barrie, Barthes, Lartigue, Proust, and Winnicott is not specific to boys: it is also the work, if differently so, of mothers and their daughters. *Becoming*, especially, attests to such related umbilical ribbons through its jump ropes, stitching, shutter cords, and other string-tied (re)productions. But this time around, to read boyishly is to embrace effeminophobia (when it comes to the bodies of the boy, the boy-man, and even the man) and to boldly, if quietly, articulate the effeminizing relation between a boy and his mother as a specific and beautiful production. But here I am sounding too steady, when I am laboring to shake things about.

⌐ *READING BOYISHLY* TRAVAILS:[10] it shakes things about, like mothers and sons and boys and men; it labors, with maternity and femininity; it travels, from the beginning of the twentieth century to its end, from home to the skies. Travail can mean many things, including the hard work of bodily or mental toil, the straining movement of a vessel in rough seas, a finished work of art or piece of literature, the work and pains of childbirth. Travail is journeying (to travel). And travel we will, "like paragraphs of wind"[11] in the breaths of then and now, of over there and over here, as momentarily held in a gust, a rising, a lift, a wave, a breath.

Barrie, Barthes, and Proust are notably queer in their affairs with Mother. Winnicott reveres Mother in his writing, but seems effeminophobic in his efforts to disassociate himself with the queerness of "the string boy" (whom we shall meet soon enough). While Lartigue was surely close to his mother (Maman snapped the famous picture of our impish boy in the bathtub) and his boyhood journals are filled with pleasant descriptions of days attached to Mami—running errands, paying visits, going to the Eiffel Tower, check-

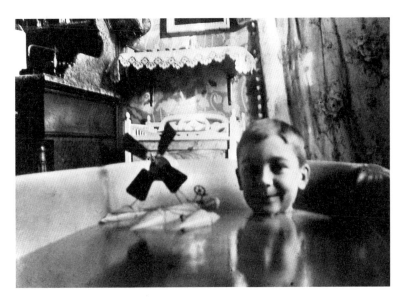

"'Maman snapped the famous picture of our impish boy in the bathtub.'"

ing out the fashionable of Paris—Lartigue's attachment to Mother is certainly without the obsession of Barrie, Proust, and Barthes. Nevertheless the maternal looms in his own refusal to never grow up. In sum, the body of Mother wrinkles the smooth childhood sheets of Barrie's *Peter Pan*, of Proust's *In Search of Lost Time*, of Barthes's *Camera Lucida*, of Winnicott's *Playing and Reality*, of Lartigue's childhood gaze. (In the technical jargon of sewing, as Peter Stallybrass has noted, wrinkles are called "memory.")[12] Each respective boyish call of "Mama" hails her large: as food for all thought, as having your cake and eating it too (Proust); or as cure for all that ails (Winnicott); or as the ultimate lover (Barthes); or as a mixture of intense sentimental devotion, resentment, and calloused distance (Barrie); or as childhood itself (Lartigue). For Barrie, Proust, Winnicott, Lartigue, and Barthes, the maternal is a cord (unsevered) to the night-light of boyish reading. To read boyishly, as stated in this book's introduction, is to covet

the mother's body as a home both lost and never lost, to desire her as only a son can, as only a body that longs for her, but will never become Mother, can.

Reading boyishly (as opposed to girlishly) is differentiated through its maintenance of a reproductiveness that never looks forward to the realm of motherhood that the girl may or may not choose, may or may not be able to attain (even if she so chooses), but that girls are nevertheless culturally subjected to. Boyish labor (which is always nostalgically centered) is exhausting: it never severs the umbilical cord through which travels the passionate blood between mother and son; rather, it refuels the long cord with hormones and food and oxygen; circulatory and never ending, it also carries away waste-laden blood. Long enough to allow boyish dancing within the watery environment (a tender and irreverent play of words tapping and probing and kicking and sailing and floating through the bellies of the fantastical mothers), the cord allows the boyish read to fly like a kite on a string, connected yet separate, but the cord can also become a noose, a crisis, a halting of life. Nevertheless, boyish labor never lets go of its labyrinthine thread. It lassoes Mother: not as Other, not exactly as the same, but certainly as united, at times indistinguishable. The French historian Jules Michelet (1798–1874), a favorite of Barthes's (little wonder, given the fact that his many-volumed *Histoire de France* is not only history but also a masterpiece of French literature due to its style and emotional strength), also had a passion for the mother. Michelet's love of Mother runs the gamut from *his* own mother to *our* earth as Mother, the latter manifesting itself in his predilection for mud baths, a *reunitation* of himself with *terra mater*: "I felt her very clearly, caressing and comforting, warming her wounded child. . . . I no longer distinguished myself from her."[13]

While Freud felt that girls could never successfully go through the Oedipal phase (how could they hate what they were destined to become: the giving, reproducing mother?) — he failed to acknowledge those boys who chose to stay behind with mother, making a couple, not unlike Michelet's merging of himself with Mother Earth (a "mud couple") cultivating another kind of reproductiveness: a transubstantiated twinning.

Nostalgia is at the heart of the labor of travailing boyishly, which is queer in its love affair with the mother. Reading boyishly swishes like Mamma's skirt as she comes up the stairs to kiss her Marcel-boy goodnight: "I heard her climb the stairs, and then caught the sound of her garden dress of blue muslin, from which hung little tassels of plaited straw" (I, 15; I, 13).

I am now old enough, and Roland Barthes is now dead enough—not only did he physically die in 1980, but his writing is considered old-fashioned and out of date—for his labor to have achieved the patina of nostalgia. When a colleague recently asked me what I was working on and I cheerfully and proudly said "Barthes," I received a dismissive reply, "O-o-o-h, how retro." Yet, my colleague's comment resonated with me in a helpful way. "Retro" is from the Latin adverb meaning backward and hails retrospection or meditation on the past. To look at the past—whether it be by my initiation as a student into French post-structuralist theory, or by childhood itself, or by Barthes's focus on "certain old and lovely things, whose signified is abstract, out of date"[14]—is nostalgic. Nostalgia, at the center of Barthes's discourse and my book is, I hope to show, an approach that is useful and not simply backward.

As a graduate student, I was initially drawn to Barthes (not only because he was then in fashion) but also because of his writerly emphasis on desire and pleasure. More recently I have become more literate in the nuances of his queer sensibility. And even more recently, I owned up to the fact that what drew me to Barthes and continues to draw me is not only his tender and beautiful writing, his hedonism, his brevity, his strangeness, coupled with my own nostalgia for "the good old days" of graduate school and critical theory and tiny houses and too much coffee and generous teachers and startlingly smart fellow graduate students, but the fact that Barthes himself is nostalgic. Barthes is claimed by what Susan Stewart refers to as "the social disease of nostalgia."[15]

While nostalgia is in the wings of Winnicott, Barrie, Proust, and Lartigue—for the purpose of this first chapter, nostalgia will flutter most readily, if delicately, out of Barthes, occasionally settling on the attractive boxes of Joseph Cornell (1903–1972), like a butterfly panting on clover.

With his intense love for childhood, a long life with mother, a fear of losing the past, Cornell, America's most nostalgic artist, boyish through and through (he eternally loved kid food such as Kool-Aid and jelly doughnuts), is easily boxed into this book, like a daguerreotype framed, like a treasured swallowtail butterfly behind glass, like a treasure kept in an oval Shaker box. Insurmountably, *the* shy American eccentric, Cornell remained (for most of his life) nestled on Long Island in a small house with Mother and Brother, bowered by their home's endlessly astonishing fairy-tale address of 3708 Utopia Parkway.

I believe that it is possible and useful to read Barthes's attachment to nostalgia as more than a "cloying sentimentality.'[16] Barthes's nostalgia is more than a commodified, if academic, "fond backward gaze."[17] I hold Barthes's nostalgia as "a [useful] strategy for coping with change, loss, or anomie."[18] While I will not deny that his preference for wooden toys over plastic toys (captured in *Mythologies*), his passion for his mother (confessed in *Camera Lucida*), and his love of *The Sorrows of Young Werther* (perpetuated in *A Lover's Discourse*) are overly romantic, maudlin, cloying, undeniably bourgeois, Barthes's nostalgia (unlike its less productive forms) is not in the service of foreclosing the future, of rejecting the possibility of productive change. Attempting to define nostalgia, while acknowledging the abuses of nostalgia (the ways in which it smoothes over, makes easy, difficult histories, both personal and public), I seek to rescue nostalgia, not as an innocent child but as a formidable critical tool (as more adolescent). My ambition for nostalgia is akin to Adam Gopnik's reading of Cornell. Cornell, the artist, stuffed parrots, owls, reproductions of Renaissance portraits of boys and girls, balls, jacks, and clock faces without hands into his finely (but primitively) carpentered wooden boxes sealed in glass, not unlike Snow White's coffin, or a shop window, or a medicine cabinet whose mirrored door has been replaced with one of clear glass, or like a faded butterfly collection. I, like Cornell, want "to make nostalgia into one of the big permanent emotions you could put in a box [or between the covers of a book], like lust or greed, instead of one of the smaller disreputable ones you kept in a drawer."[19]

"nestled on Long Island in a small house with Mother and
Brother, bowered by their home's endlessly astonishing
fairy-tale address of 3708 Utopia Parkway."

∾∾

Behind the six-paned window of *Butterfly Habitat* (c. 1940), Cornell has
pinned paper insects to the back of the box. The butterflies look like the
real materials of the entomologist, but they are really children's paper toys
for studying in elementary school, for pretending, for making things. The
child, of course, is never so far from the scientist. Cornell knew this when
he recorded in his diary the following statement by Isaac Newton: "I do
not know what I may appear to the world; but to myself I seem to have
been only like a boy playing on the seashore and diverting myself in now
(and) then finding a smoother pebble or a prettier shell than ordinary, whilst
the great ocean of truth lay all undiscovered before me."[20] Likewise, Cor-
nell the man played and travailed on the streets of Manhattan, traveling
into the city from his house on Utopia Parkway. It was possibly on one of
his missions to scout "the Fourth Avenue rare book and antique stores" in

search of those objects that might *find him* by suggesting "'rarefied realms,' or times past" that Cornell was greeted by his paper butterflies in a cellophane bag without a habitat.[21] (Cornell, our modern American *flâneur*, who also happened to be a member of the Christian Science Church, called his journeys "pilgrimages.")[22] Lustrous copper, old world swallowtail, eastern tailed-blue, falcate metalmark, zebra swallowtail, lupine blue: each of these butterflies with paper wings (*papillon de papier*) have since been housed by Cornell in their own glassy squares, splattered with white paint to give their small windows the "Christmas effect."[23] Cornell was very fond of Christmas, or at least of his memories of it. Born on Christmas day in 1903, Cornell recalled being "peculiarly prone to Christmas, from childhood, in the context of New York, snow, magical store windows, [Christmas] Eve, etc."[24] As Jodi Hauptman has noted in regards to *Butterfly Habitat*, the snow on these little windows has been partially cleared away in "a circular aperture like one a child might make using a mitten, allowing the viewer to see each butterfly."[25] Peering in like a child at winged memories turned frozen (what is more childish than the dream of flight?), like hummingbirds in a glass box ("A Resonance of Emerald — A Rush of Cochineal"[26]), we are frosted in by the daguerreotype of nostalgia.

In a journal entry from 1949, Cornell writes of nostalgia's contradictory state—as both pressing watery weight and fluttery butterfly escape:

> I am almost drowned in nostalgia; so much seems to "get away" — and yet the present with its invitation to adventure should rebuke all this. Perhaps this is not very well stated. The attempt to hold as much of the passing beauty as one is able to do needs no apology.[27]

Indeed, Proust's project with his own nostalgic love for the beauty of the secondhand, the used, the smell and taste of the past, has a Cornellian texture as he tries to stuff everything into his Search box. Proust and Cornell even shared a predilection for cork. Proust lined his room with it; Cornell used it to line boxes or to stop up his Petit Musées bottles containing "ephemera such as colored sand, coins, fragments of maps, pages of books, beads, mechanical springs" or nothing at all.[28] Even Cornell's studio was a

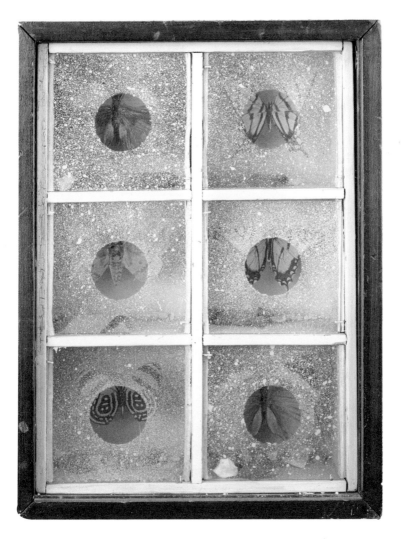

"Lustrous copper, old world swallowtail, eastern tailed-blue,
falcate metalmark, zebra swallowtail, lupine blue: each of these
butterflies with paper wings (*papillon de papier*) have since been housed
by Cornell in their own glassy squares, splattered with white paint
to give their small windows the 'Christmas effect.'"

kind of Petit Musée with boxes of glasses, balls, birds, plastic shells, and, of course, corking, within his box-like studio-room. As Proust writes: "We find a little of everything in our memory; it is a sort of pharmacy"(V, 526; III, 892).

As the most famous enchanted wanderer in the history of art, Cornell spent a lifetime in the basement of Utopia (Parkway) making nostalgic boxes in the service of childhood lost. Utilizing his tender sentiment for childhood's games and toys—"his sanctification of the small object—a marble or a block, which he treated as if it were a treasure"[29]—Cornell worked hard to become a child (without distance). But the pleasure that he felt while constructing, "a richness and poetry felt when working with the boxes," often became lost in the cracks or, as he put it, "completely extraneous to the final product."[30] Cornell wanted the impossible, as he himself wrote, he had an "intense longing to get into the box."[31] Unable to get into the box, Cornell's failure manifested itself in migraines, troubled sleep, vertigo, pressures in his spine, right leg.

Unable to get into the box, Cornell could only achieve childhood unsatisfactorily as nostalgia, as a game motivated not so much by memory as by the inevitability of forgetting. *Untitled (The Forgotten Game*, circa 1949) is one of Cornell's most enigmatic boxes. The face of the box, with carved-out holes, suggests the game that it once was. It is a game that I may have played as a child. Faintly familiar, it triggers memories of playing with my father's old toys in my grandmother's apartment. Behind the holes, songbirds peer through like long-lost friends: silently trilling and quivering, frozen joy in their happy-turned-melancholy throats. The box begins to suggest a nesting box, one that you might make for a bluebird or for the memory of your own childhood lost.

The Greek root of the word nostalgia, *nostos* means "the return home." But anyone who has been there knows that the return home is never without pain. That pain is the physicality of the disease of nostalgia. For "*nostos* might hold out that promise that, yes, you can return whence you came, but nostalgia happens because you can't go home again."[32] Nostalgia makes its dreamer melancholic. According to the *OED*, nostalgia is "a form of mel-

"like hummingbirds in a glass box ('A Resonance of Emerald—
A Rush of Cochineal . . .') we are frosted in by the daguerreotype
of nostalgia."

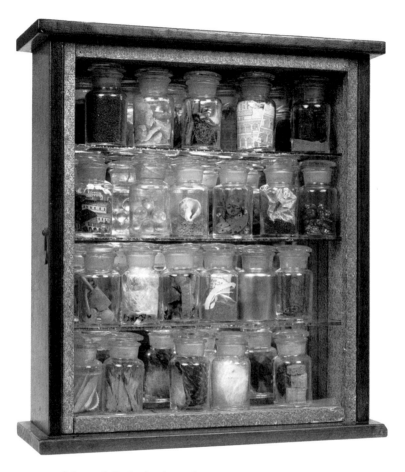

"glasses, balls, birds, plastic shells, and, of course, corking. . . .
As Proust writes: 'We find a little of everything in our memory;
it is a sort of pharmacy.'"

෴

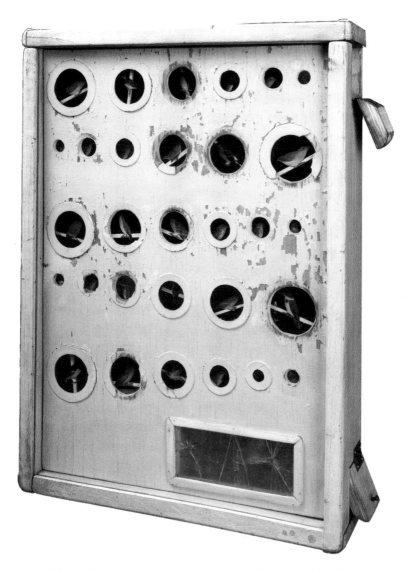

"The box begins to suggest a nesting box, one that you might make for a bluebird or for the memory of your own childhood lost."

ancholia caused by prolonged absence from one's home or country; severe homesickness."[33] Like nostalgia, melancholia is both a disease and a mood, for the meaning of melancholia can range from a sense of a functional mental disease characterized by gloomy thoughts and ill-grounded fears to its lighter sense of a tender or oppressive sadness. Nostalgia, then, is a form of melancholia that wells up as a yearning for home, that throbs as an ache, that becomes an intense "longing" — hence the title of Stewart's book *On Longing*.

Homesickness

Michelet describes the bird's nest, the bird's home, as follows:

> Less a weaving than a *condensation*; a felting of materials, blended, beaten, and welded together with much exertion and perseverance. . . . The tool really used is the bird's own body — his breast — with which he presses and kneads the materials . . .
>
> Thus, then, his house is his very person, his form, and his immediate effort — I would say, his suffering.[34]

Likewise, Barthes's texts often emphasize the body with the "texture of perfume,"[35] that make use of other authors like a bird makes use of string, sticks, leaves, feathers, pieces of paper, grass, flower petals, and mud to build his nest, with all of the voluptuousness that touches him. In his most poetic texts (as opposed to his more scientifically semiotic studies), Barthes famously seeks to eroticize the entire body with language: "Language is a skin: I rub my language against the other. It is as if I had words instead of fingers, or fingers at the tip of my words. My language trembles with desire."[36] Barthes's bodily writing, written with his body, is his house (whether it be the nest or its close cousin the shell, the latter a "dream of a house that grows in proportion to the growth of the body"[37]), it is his suffering: a house that makes him homesick. In Cornell's *Object* (*Soap Bubble Set*, 1941), Cornell collages a clay pipe, whose tobacco bowl is austerely held by the Victorian claws of a bird. Emitted from the pipe is neither smoke nor simple childish

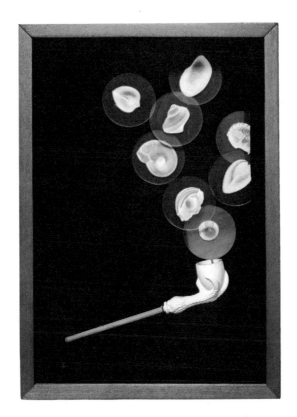

"Cornell's fleeting bubbles are homes of other days;
like childhood, they are delicate, stone nests
of lost intimacy."

soap bubbles, but rather breath that has bubbled sea shells (homes from the
bottom of the sea). These empty shells, like discovering "an empty nest,"
invite "day-dreams of refuge."[38] Peering through wise, yet kiddish, phe-
nomenological eyes, Cornell's fleeting bubbles are homes of other days;
like childhood, they are delicate, stone nests of lost intimacy.[39]

Originally, nostalgia was a medical term for homesickness. David
Lowenthal, in his book *The Past is a Foreign Country*, notes that:

Seventeenth-century nostalgia was a physical rather than a mental complaint, an illness with explicit symptoms and often lethal consequences. First medically diagnosed and coined (from the Greek *nostos* = return to native land, and *algos* = suffering or grief) in 1688 by Johannes Hofer, nostalgia was already common; once away from their native land, some people languished, wasted away, and even perished, Hofer saw the illness as a "continuous vibration of animal spirits through those fibers of the middle brain in which the impressed traces of the Fatherland still cling." The neurologist Philippe Pinel later traced nostalgia's course: "a sad, melancholy appearance, a bemused look, . . . an indifference towards everything; . . . the near impossibility of getting out of bed; an obstinate silence, the rejection of food and drink, emancipation, marasmus and death." A physician found the lungs of nostalgia victims tightly adhered to the pleura of the thorax, the tissue of the lobe thickened and purulent. They had in fact died of meningitis, gastroenteritis, tuberculosis; but everyone blamed nostalgia. To leave home was to risk death.[40]

Today nostalgia is a disease of longing, sociocultural and not medical. It grows out of a juxtaposition of "an idealized past with an unsatisfactory present."[41] We long for the past because we do not like the present. As Malcolm Chase and Christopher Shaw have remarked: "Our present usage of the word is therefore distinctly modern and metaphorical. The home we miss is no longer a geographically defined place but rather a state of mind."[42]

Barthes, Barrie, Winnicott, and Proust are birds of nostalgia. They are swallows. As Michelet writes:

She [the swallow] is the *bird of return*. And if I bestow this title upon her, it is not alone on account of her annual return, but on account of her general conduct, and the direction of her flight, so varied, yet nevertheless circular, and always returning upon itself.[43]

The Geography of Nostalgia as Childhood

However, nostalgia in the hands of Barthes, as sewn in "The Light of the Sud-Ouest" and *Empire of Signs*, is geographical—but Barthes's geography is utopian, fantastical in that it costumes Southwest France and Japan in the garments of a childhood lost. He begins the journal entry that is the text and style of "The Light of the Sud-Ouest" by hailing a childish squint, to see as children do:

> Today, July 17, the weather is splendid. Sitting on the garden bench and squinting so as to obliterate all perspective, the way children do, I see a daisy in the flowerbed, flattened against the meadow on the other side of the road.[44]

"So as to obliterate all perspective," to see "the way children do"—Barthes is not far from seeing with his eyes closed (the preferred method of looking at photographs in the most nostalgically driven of all of Barthes's texts, *Camera Lucida*). Barthes is choosing to forsake adult vision and perspective. Barthes chooses to claim "Sud-Ouest" as "My Sud-Ouest," a possession, a toy lost and refound. Barthes writes: "My Sud-Ouest is . . . extensible, like the daisy [that he saw through the eyes of a child, through a child-gaze] and like all images that change their meaning with the level of perception where I choose to locate them."[45] Unabashed by his nostalgia, he wears it "out" like a flower boutonniere on the lapel of his childhood jacket, remembered but not necessarily real. He claims that the accent of the Sud-Ouest "has formed the models of intonation that marked my earliest childhood."[46] When making the drive from Paris to Sud-Ouest, "there is a signal that tells me I have crossed the threshold and am entering the country of my childhood."[47] After describing the sensations of the Sud-Ouest in terms of its "odors, exhaustions, sounds of voices, errands, changing light"[48]—memories of lost time, of childhood lost—Barthes concludes his short essay by elevating childhood as "the royal road by which we know a country best. Ultimately, there is no Country but childhood's."[49] For Barthes, the past is foreign country (an other place) as experienced by the child.

Like the beautiful bodies of those who died before growing old,
sadly shut away in a sumptuous mausoleum,
roses by the head, jasmine at the feet —
so appear the longings that have passed
without being satisfied, not one of them granted
a single night of pleasure, or one of its radiant mornings. C.P. Cavafy

"seeing with his eyes closed"

The cordage between *Empire of Signs* to childhood is not as raw, as "out," as it is in Barthes's memories and reflection on Sud-Ouest. (Barthes never lived in Japan nor visited there until 1966.)[50] Nevertheless, the *Empire*'s tender, puerile indulgent fragments, its strong child-like naïveté, and its almost pious devotion to the maternal turn an imagined Japan into a fictive boyish recollection that is all his own, that is typically Barthesian: "intimate but not personal."[51]

Empire of Signs begins with a telling, opening chapter title: "Faraway." From its initial stamping, Barthes tries to send us like a letter to a place both real and fictive: to an empire of *empty* signs, where meaning is finally banished, to an *unthinkable* place, like the *unthinkability* of childhood itself. (One cannot think through childhood once one has outgrown it; that is its impossibility.) Japan and childhood are "paradise" for Barthes, "*the* great student of signs,"[52] because, for him, they are deliciously empty. And so he begins: "If I want to imagine a fictive nation, I can give it an invented name, treat it declaratively as a novelistic object, create a new Garabagne, so as to compromise no real country."[53] Like Henri Michaux's travel-inspired *Voyage en grande Garabagne* (1936), both imaginative books write an inner "artificial paradise," based on travel. By the final line of the *Empire of Signs*, the child-like traveler joyfully concludes, newborn, back at the beginning, an infant happily wrapped in swaddling: "There is nothing to *grasp*."[54]

Empire of Signs is a bold treatment of a real place as an imagined geography, a fictive nation. Barthes clings to what he sees as Tokyo's inherent emptiness— "The streets of this city have no names";[55] "[Its city] center is empty";[56] "Japanese, it is said, articulates impressions, not affidavits . . . is much more a way of diluting, of hemorrhaging the subject in a fragmented, particled language diffracted to emptiness";[57] Japanese gifts are more about the package than "the empty sign" inside ("a sweet, a bit of sugared bean paste, a vulgar 'souvenir'";[58] tempura is "the fragile, the transparent, the crisp, the trifling . . . whose real name would be *the interstice* without specific edges, or again: the empty sign"[59]—and he claims this empire of empty signs as affording "him a situation of writing."[60] Japan becomes *his* "empire of signs," and Barthes makes no apologies for wearing the emperor's

crown. (My Sud-Ouest. My Japan.) But Barthes knows, even celebrates, what Hans Christian Andersen's blind-to-his-own-preposterousness emperor does not: that his grand clothes and majestic cloak are provocatively, even productively, invisible. That is why Trinh T. Min-ha[61] can celebrate Barthes's *satori*[62]/*satorial* writing of Japan: for it is not the observed, nor the observer, but the "observing."[63] "He is concerned with the approach itself, with the discourse produced and with the confection of the envelope."[64] Barthes gives us a lesson, but it is not a lesson that one already knows. In Barthes's own words when accepting his position as chair in literary semiology at the Collège de France:

> Then comes another age at which we teach what we do not know; this is called *research*. Now perhaps comes the age of another experience: that of *unlearning* . . . "*Sapientia*": no power, a little knowledge, a little wisdom, and as much flavor as possible.[65]

The most persuasive evidence for Barthes's tether to childhood in *Empire of Signs* comes out of the fact that he willingly did not know the language. This willed ignorance *allowed* Barthes to live in a child-like state of a self-governed naïveté. ("In Japan, as elsewhere, Barthes showed absolutely no interest in the living language.")[66] Invoking the beauty of not knowing, the protection of a life swimming within an envelope of protective and maternal amniotic fluid, Barthes begins his segment "Without Words," with the following words:

> The murmuring mass of an unknown language constitutes a delicious protection, envelops the foreigner (provided the country is not hostile to him) in an auditory film which halts at his ears all the alienations of the mother tongue. . . . Here I am protected against stupidity, vulgarity, vanity, worldliness, nationality, normality.[67]

Likewise, chopsticks move food maternally: "For the foodstuff never undergoes a pressure greater than is precisely measured necessary to raise and carry it; in the gesture of chopsticks, further softened by their substance — wood or lacquer — there is something maternal, the same precisely

measured care taken in moving a child."[68] And Barthes does not relinquish his maternalized, Orientalized, alimentary tools there, for he ends "Without Words" as follows:

> By chopsticks, food becomes no longer a prey to which one does violence (meat, flesh over which one does battle), but a substance harmoniously transferred; they transform the previously divided substance into bird food and rice into a flow of milk; maternal, they tirelessly perform the gesture which creates the mouthful, leaving to our alimentary manners, armed with pikes and knives, that of predation.[69]

Japan, then (like the space of the maternal as blanketed by his nostalgia for Bayonne, his fictive to Proust's Combray) was a place of protection from predation, not unlike the sanatorium that Barthes would be sent to after the onset of tuberculosis in 1934. Like Proust's own disease of breath, Barthes, too, found himself to be "entering into the spirit of the illness and assuming his condition almost as if it were a religion."[70] (The coincidence of the shared names of Proust's beloved childhood church set in Combray, "Saint-Hilaire," and Barthes's equally beloved student sanatorium set in the mountain village of Touvet in the Isère, "Saint-Hilaire-du-Touvet" is the kind of fluke connoisseurs can smile over without exaggeration.) Barthes became ill at a time when tuberculosis was a disease which made the patient an object of taboo. He became both *taulard* (jailbird) and *tubard* (someone suffering from tuberculosis): the rhyming sound rhyming his experience.[71] Nevertheless, the sanatorium gave him two fundamental experiences that he would later wax nostalgic:

> For years you lived with people [boys] of the same age, often sharing a room with two or three others. What kept you going were the close bonds of affection which developed in this kind of environment. . . . The second thing, of course, was *reading*. What else did you have to do except read? I read a great deal during my time there, above all the classics, French and foreign. I also started to do a little writing, short pieces for the student magazine *Existences*. It was while I was at the sanato-

rium that I read the collected works of Michelet, whom I later worked on. So you see it was a very important experience for me.[72]

Although couched in a shared language of the little gentle man of the student sanatorium, and filled with the tragedy of young deaths, the place enveloped him in ways akin to Japan, to mother. All three, Saint-Hilaire, Henriette, and Japan, were fictive nations for housing Barthes's own disease of nostalgia; sometimes that is called art.

Carefully, if blindly, observing Japan through his satori writing, Barthes phenomenologically evokes his fictive nation as both altered by his hand and altering his body, as a place that writes him just as much as he writes it. In the segment "No Address," Barthes explains that "The streets of this city have no names. There is of course a written address, but it only has a postal value, it refers to a plan (by districts and by blocks, in no way geometric), knowledge of which is accessible to the postman, not the visitor."[73] As a result:

> This city can be known only by an activity of an ethnographic kind: you must orient yourself in it not by book, by address, but by walking, by sight, by habit, by experience; here every discovery is intense and fragile, it can be repeated or recovered only by memory of the trace it has left in you: to visit a place for the first time is thereby to begin to write it: the address not being written, it must establish its own writing.[74]

For Barthes, Japan was an envelope of nostalgia (no address, full of emptiness) that he brought back to France. Calvet writes:

> And it is easy to discern Tokyo behind that city of twelve million inhabitants where you do not understand either what is said or, above all, what is written. Between 1966 and 1967 he went there three times, bringing back with him from the few weeks he spent there not only the material for the book on Japan he would eventually write, *L'Empire des signes* (*Empire of Signs*), but also a huge sense of nostalgia, almost of homesickness for the country he had conceived an immediate passion for.[75]

Nostalgia as a Form of Bigotry: Empire of Signs, Incidents

The wild Orientalism of Barthes's *Empire of Signs* and the "primitivism" of "The Light of the Sud-Ouest" is then a longing for a state of mind, a nostalgia. Elizabeth Howie (in a seminar that I gave, devoted entirely to Barthes) commented that "growing out of colonization, nostalgia is a form of bigotry."[76] We see this bigotry most clearly in "Incidents," written in 1969, and controversially published after his death. To pry into the text is, perhaps, as loathsome as the bigotry that I am both searching for and seeking to smooth over. (Perhaps my smoothing out of these crumpled sheets of boyish reading has more to do with my always-at-the-ready "make-nice" way of "reading girlishly," a sometimes deplorable yet often valuable practice I learned when trying to put out all of the social "fires" my own mother was so fond of setting. Could a girlish read here, just as the blaze picks up, be productive alongside the sometimes, but not always, too-easy stick rubbings of "colonizer," "bourgeois," "exoticizer"?)

"Incidents" performs fragmented snatches of Morocco as hands, stains, hygiene. Color is everywhere as bodily description, as a painterly image, as heart-stopping delight, as oppressive burden, as entrance into intrigue, as confirmation of racial and cultural stereotype, as the taste of sensuality, and the erotic as taboo. In "Incidents," the nostalgia for childhood is all but lost: "The child—he can't be more than five—in shorts, and a hat: knocks on a door—spits—adjusts his crotch."[77] "A boy of fourteen is sitting there, a tray of old pastry in his lap."[78] As a sometimes prettified, sometimes raw, form of colonialist tendencies, "Incidents" is part of Barthes's more generalized project of wanting to "be a primitive, without culture":[79] wanting to see with his eyes closed. Thereby, is Barthes's own form of "childhood recovered at will" simply a veiled (or not so veiled) package of bigotry? Certainly, if bigotry is defined not only as an intolerance of difference, but also as a purposeful, constructed hypocrisy. The *OED* says that hypocrite is, at root, an actor on the stage, pretender, dissembler.[80] Barthes, as "actor," as "dissembler," as a lover of contradictions, perhaps, even, the lover of contradictions, manages to enfold hypocrisy as a textual skill. In *Roland*

Barthes, the professor of desire embraces the label of hypocrite as he turns it inside out, by *manipulating it*. Under the entry "Hypocrisy?" Barthes speaks of himself as follows:

> Speaking of a text, he credits its author with not manipulating the reader. But he found this compliment by discovering that he himself does all he can to manipulate the reader, and that in fact he will never renounce an art of *effects*. [81]

In "Incidents," Barthes imagines that he finds the eroticism that he desires, open, nonmoralistic (not unlike his "observing" in *Empire of Signs*); that is why he prefers his Moroccan lover's word for coming: burst. "I enjoy Amidou's vocabulary: *dream* and *burst* for *get an erection* and *have an orgasm*. *Burst* is vegetal, scattering, disseminating, not moralistic, narcissistic, closed off." [82] But where does this bursting, this adolescent word for sex, take us as readers? "Incidents" and *Empire of Signs* burst with an erotics for the other. As Malcolm Chase writes: "Of all the ways of using history, nostalgia is the most general, looks the most innocent, and is perhaps the most dangerous." [83]

Can a Child Be Nostalgic? Can Only a Grown-Up Long for the Past?

One might argue that children, at least very young children, cannot be nostalgic because they cannot *keep* time. Oskar in *The Tin Drum* is a confused creature of child and adult who cannot keep time but does manage to stop, or perhaps burst, time.

> On the morning of his third birthday, dressed in a striped pullover and patent leather shoes, and clutching his drumsticks and his new tin drum, young Oskar makes an irrevocable decision: "It was then that I declared, resolved, and determined that I would never under any circumstances be a politician, much less a grocer, that I would stop right there, remain as I was — and so I did; for many years I not only stayed the same size but clung to the same attire." [84]

As Shaw and Chase write:

> While adults experience both kinds of time [public time and the subjective experience of time, which Bergson called the *durée*] it is plausible to suggest that small children live in only one: it is a trivial truth that they are congratulated on learning to tell the time, that it is to mesh with [the] impersonality of public time: "Once upon a time and a very good time it was . . . His mother had a nicer smell than his father. She played on the piano the sailor's hornpipe for him to dance . . . Dante had two brushes in her press. The brush with the maroon velvet back was for Michael Davitt and the brush with the green velvet back was for Parnell" [James Joyce, *A Portrait of the Artist as a Young Man*]. Joyce's intention here is obviously to recreate the undivided consciousness of childhood. There is an irony, however. Inevitably we cannot know how successful he is, for both author and reader can remember the state only through the divided consciousness of adult sensibility and memory.[85]

Nostalgia, good or bad, is not possible without a divided or split consciousness. The split comes out of loss, not just one, but life's succession of losses. It begins in childhood. You learn about death and the fact that you (even you) cannot escape it. You learn that as you grow older, your childishness backfires and no longer secures love; it pushes others away. Your mother has another child; your princely place dissolves all around you. You discover your father is not who you thought he was; your mother had a past before you; a teacher disappoints you. Boredom sets in. Your playthings stop giving you the joy that they once did. You return to a favorite place from childhood, a charming place (at least it was so before that return): everything is small and worn and pathetic. You recognize your divided self. That it cannot be just like the last time. That nothing is the same.

Barthes had struggled with the meanings of photography earlier in his life (*Mythologies, Image, Music, Text*), but it was after his mother's death on that fateful day of October 25, 1977, that he dedicated himself entirely to how a photograph obliges "the loving and terrified consciousness to return to the very letter of Time."[86]

In her recent novel, *The Tiny One*, Eliza Minot confronts the loss of childhood through the death of a mother. (Although her novel is a work of fiction, Minot herself did lose her mother when she was a child.) Via Mahoney Revere is eight years old when she suddenly loses her mother. In an attempt to *un-lose* her mother, Via "holds a microscope up to her day" in hopes of holding onto every detail, in hopes of finding "the crack in the world through which her mother must have slipped."[87] The novel, told in the first person from the perspective of and in the voice of eight-year-old Via, is a child's gaze at that crack, that split, which separated her not only from her mother but from her child self. At the start of the book, the memory of that day, Via tells us: "How can something so big fit into such a little thing like a day? I can't get it. . . . The day was just another day and then something stopped. Something else began."[88] And what Via understands is that she not only lost her mother, she lost "that girl,"

> that girl in the pigtails walking to school, that girl in the T-shirt swinging down from a swing, that girl in the sneakers kicking at rocks, that girl in the towel running back from the pool, that girl in the raincoat headed over next door, that girl in the life jacket up front in the bow, that girl in the high-tops whittling the stick, that girl with her hair brushed who waited, who watched, who jumped in the water when no one else went, who came into the kitchen and no one was there . . . that girl with the fever and drink by her bed, who's building a fort out of branches and leaves, who's up in her room and won't come down . . . who's seeing her mother, then running back on outside. Who first finds her mother, then does all the rest.[89]

The loss of her mother triggered the loss of her child self and enabled the nostalgia of *The Tiny One*. Her name says it all: Via is the Latin word for road. A journey. A wandering, an enchanted wandering. Revere travels with the French word *reverer*, meaning to revere and is close to *revenir*, meaning to return. Via Revere signifies the reverie of her journey home, a return to mother.[90] The excursion is called nostalgia and what she finds is a

kernel of something that connects: a tiny one thing that works and makes her *sick*, makes her stomach jump.

At the beginning of the novel, Via exclaims: "I want to be able to find something in that day to hold on to like a rope swing, to swing with. Trying to hold on to all that I remember makes my stomach jump—there goes something; here comes another."[91] By the end of the novel, Via does find her rope to swing with, that connects her, to Mum:

> I feel, like, lit. I can't explain . . .
>
> That's what I feel like now. Like someone sprinkled special glittery dust all over me that went right through my skin. . . . It's the tiny one thing in me that's at the bottom of all the rest, that I know will never go. It's the tiny one thing in me that will, like, hold me forever to looking for Mum. It makes my eyes like watcher eyes. That's what's in there. It's like the dust of magnet or something that will pull me to her.[92]

Via's tiny one thing, like Proust's *mémoire involontaire*, like Barthes's punctum,[93] is like the kiss that is like a tiny box within a box within a box that Wendy could never get, but would nevertheless believe in:

> [Wendy's mother] was a lovely lady, with a romantic mind and such a sweet mocking mouth. Her romantic mind was like the tiny boxes, one within the other, that come from the puzzling East, however many you discover there is always one more; and her sweet mocking mouth had one kiss on it that Wendy could never get, though there it was, perfectly conspicuous in the right-hand corner.[94]

The tiny one, *mémoire involontaire*, punctum, and the conspicuous but unattainable kiss are also like the one secret thing that resides in Winnicott's envisioning of mother, as metaphorically played out by the middle-class handbag as a stand-in for that which "can't be got":

> Surely there is a little bit of herself that is sacrosanct, that can't be got at even by her own child? Shall she defend or surrender? The awful thing is that if the mother has something hidden away somewhere, that

is exactly what the small child wants. If there is no more than a secret, then it is the secret that must be found and turned inside out. Her handbag knows all about this."[95]

What follows are long and brief excursions home to mother, by the four boyish men and one real boy who have generated not only their own boyish productions but my own imagination of what it means to play their forgotten games.

A photograph is but a shadow of what once was there, but now is gone. Not unlike the mother, whom we all have to live without sooner or later,[96] save for Peter, whom Barrie claims as the only boy who never grew up; Proust, whose search of lost time was driven and sustained by a bite of madeleine and that famous last goodnight kiss; Winnicott, whose Mother inhabits every transitional object; Barthes, who always lived with his mother, so that she could, or because she did, "play" into his hedonism; and Lartigue, who through journals and photography obsessively recorded the details of his boyhood so much so that it seemed that he never had to leave her (his childhood). *Reading Boyishly*, too, evokes a whole area of play around the mother, yet the center is not always so peaceful. Proust, Winnicott, Barrie, Barthes, and Lartigue not only play with the mother's body but in order to glorify it, to embellish it, they also tear it apart. That is the nature of art, of representation. Critics (and friends) have also torn Proust, Winnicott, Barrie, Lartigue, and Barthes apart, like so many other boyish boys, for their eternal love of the mother. This book seeks to "repair" that critical stance, so that boys can love their mother, can repeat the maternal attitude, without fear of retribution, without fear of what Eve Kososfky Sedgwick has labeled as our culture's "effeminophobia," when it comes to the body of the boy.[97]

My book has a disease that I would call love.

WINNICOTT'S

ABCS

AND

STRING

BOY

> But then the memory—
> not yet of the place in which
> I was, but of various other
> places where I had lived and
> might now very possibly be—
> would come like a rope let down
> from heaven to draw me up out of
> the abyss of not-being . . .
>
> ❧ Proust, *In Search of Lost Time*

BEAUTY—DEBRIS OF ALL KINDS—acidic, sweet, and unpleasant scents in their well-washed sheets—cracker crumbs—miniature model racing cars arranged on the floor in apparent readiness—sticky chairs—sticky hands—ginger hair—dirty-blond hair, thick as straw—small, worn, smelly shoes—brown curls of soft mouse fur—tiny exquisite drawings of motorized things—jumps off furniture—trumpet playing—the sound of heavy feet running circles around the kitchen—diapers—dog tackling—rubber bands flying—shoe strings that have been stepped on, dragged across the earth, never tied, always damp—foil-wrapped chocolate kisses—Atomic Fire Balls—balsa-wood gliders in need of constant repair—Smarties—Bazooka Bubble Gum—Sour Runts—pats on my back from two tiny hands—mouths making the sounds of guns and bombs—an approach from behind—metal toys—rust—string . . .

Boys at play.

At the center of D. W. Winnicott's famous article on play, subjectivity, and the weaving of a relationship between mother and child ("Transitional Objects and Transitional Phenomena," the key essay to his most treasured book, *Playing and Reality*), a little boy has a tendency to string things together.[1] Although his objects are not specifically named, I can see the chairs, the bed, the wagon, the dollhouse, the toy car, the dining table, and so on, all linked, encircled, wrapped, bound, tightly and loosely connected by string. And he was not the only boy whom Winnicott saw with a preoccupation with string. Winnicott had another boy quite concerned with string who appears in his "Playing: A Theoretical Statement."[2] (However, Winnicott never makes a connection between the two string boys: the unnamed boy of "Transitional Objects" and the boy, named Edmund, of "Playing: A Theoretical Statement.") Apparently, "Edmund" revealed to Winnicott his preoccupation with string in his office by using one end of the string in a gesture that suggested that he had plugged it into "his mother's thigh" as an "electric flex" (a British term for the rubber cord attached to vacuums and the like).[3] At another time, Edmund used the string

"(which he seemed to be fond of) at the bottom of the bucket like bedding and began to put the toys in, so that they had a nice soft place to lie in, like a cradle or cot."[4] In Winnicott's words, "It was clear that the string was simultaneously a symbol of separateness and of union through communication."[5]

In 1942, Marcel Duchamp *played* on modern art's inability to communicate, its absolute obscurity to all those outside (and even some of those inside), when he wound miles of string throughout the exhibition entitled the *First Papers of Surrealism*, which he was asked to install at the Whitehall Reid Mansion at 451 Madison Avenue, New York. Duchamp bought sixteen miles of string from someone in the cordage business. As Calvin Tomkins writes in *Duchamp: A Biography*:

> With help from André and Jacqueline Breton, Max Ernst, Alexander Calder, and the young American sculptor David Hare, Duchamp proceeded to spin a vast spider's web throughout the rooms of the Reid mansion, winding the string from chandeliers and mantels and pillars in crisscrossing skeins that made it nearly impossible to see some of the works on display. . . . Duchamp also made a secret arrangement with Sidney Janis's eleven-year-old son, Carroll, to show up at the mansion on opening night with a bunch of his friends. When the invited guests arrived . . . in their evening clothes, they found the premises already inhabited by a dozen boys and girls in their athletic gear, kicking and passing balls and skipping rope and chasing each other around and through the barriers of string.[6]

I have seen my own boys do it: looping string inside and around a bureau drawer, up and over a bunk bed, down and through the axle of a toy truck, up and over and around the doorknob, through a box of toys and back on over to yet another handle on a bureau drawer. To open the bedroom door is to feel the tension of the domestic, the maternal tied up.

"I have seen my own boys do it: looping string inside and around a bureau drawer, up and over a bunk bed, down and through the axle of a toy truck, up and over and around the doorknob, through a box of toys and back on over to yet another handle on a bureau drawer. To open the bedroom door is to feel the tension of the domestic, the maternal tied up."

Play

> The writer is someone who plays with his mother's body . . . in order to
> glorify it, to embellish it, or in order to dismember it, to take it to the
> limit of what can be known about the body.
> —Barthes, *The Pleasure of the Text*

> [My mother's] kindness was specifically out-of-play.
> —Barthes, *Camera Lucida*

Winnicott focused his most important work on the mother. In fact, Winnicott founded his primary notion of the ethical and instructional role that the analyst *plays* with the patient on the "good-enough mother's" relationship to her infant and growing baby.[7] Winnicott's famous "good-enough mother" (who is "not necessarily the infant's own mother"[8]) secures the child's emotional well-being through active adaptations to the infant's needs. She is there for almost all of the caresses, snuggles, feedings, diaper changes, gentle baby bounces, soft washes behind the ears, cooing conversations that her baby desires. "*At the start,*" Winnicott tells us, the mother's "adaptation needs to be almost exact."[9] This is the space that Winnicott refers to as "illusion."[10] Under this *illusion* of omnipotence, the baby does not differentiate himself from his mother. Gradually, as the child begins to be able to tolerate any "failure"[11] of maternal adaptation, the mother lessens her constant presence and this role of nearly satisfying Baby's every need. Her necessary "failure" makes space for what Winnicott refers to as "disillusionment."[12] Here the infant fills in these first pangs of loss (the loss of mother and breast) with cooing songs (Baby's first music), rubbing his thumb and forefinger on the satin trim of a "blankie," clutching onto a soft toy: song or blanket or both, these transitional objects are the first inklings of creative life.

Likewise, Winnicott envisioned that it was the role of the analyst to hold, nurture, and ease the patient into a transitional space, which allows for this necessary letting go, just as the mother holds, nurtures, and eases her child

into the world by such an eventual letting go. As Adam Phillips points out in his brilliant book *Winnicott*, Winnicott (the pragmatic British analyst who was so unlikely Freud and Lacan) sought "to translate psychoanalysis from a theory of sexual desire into a theory of emotional nurture."[13] As Phillips emphasizes, British postwar psychoanalysis (as centered around the work of Winnicott) stressed "not so much a return to Freud, as there had been in France with the work of Lacan, as a return to Mother."[14] And for Winnicott, Mother was at the heart of care, which is never far from his particular vision of cure. In Winnicott's own words, "I believe cure at its root means care."[15] Winnicott saw the model for cure, like a gift tied with ribbon, as given to us at the start of our own lives by our own mothers. In a lecture given to doctors and nurses, Winnicott elaborates: "I suggest that we find in the care-cure aspect of our professional work a setting for the application of principles that we learned at the beginning of our lives, when as immature persons we were given good-enough care, and cure, so to speak, in advance (the best kind of preventive medicine) by our 'good-enough' mothers, and by our parents."[16] And, of course, it is Winnicott's famed and aforementioned "transitional" object (also referred to as the "not-me" object),[17] that allows the transition from a mother-centered world to the "real" world to be made. The Winnicott primer for the ABCs of the transitional object goes something like this:

A. In the beginning of an infant's life he understands himself to be one with the mother.[18] He is not separate from his mother. The attentive mother understands this and gives into it, with pleasure. No compromises. No other desire than this. This fantastic sweet pleasure of being elsewhere, walled off, *enceinte* (that French word of Julia Kristeva punning which means a protective wall around a town, but is also the *femme enceinte*, the pregnant woman),[19] keeps "the nursing couple" afloat in the sweet odor of a symbiosis that lives to be aired. ("Nursing couple"[20] is Winnicott's own erotically charged term for the walled-off, wedded mother and suckling baby. Winnicott's nursing couple is akin to Michelet's "mud couple."[21]) The days, even when cloudy, are sparkled in release from the overcast gloom of obliga-

tions, unpleasant work, conflict. Like Bellini's *Frizzoni Madonna and Child* (1460–64), the nursing couple presses close in inner experience. *Parapetted, high above the real world: theirs is a world of shared luminosity, of pastel pinks, velvet crimsons, sky blues, milky aquamarines, opalescent whites, ivory fleshes.* The light of these light days, like the two of them, is flirtatious: dancing in and out, it brushes, nestles, illuminates. Nearly everything is connected, because it is not so hard when it is just the two of them, walled off from the world. Her breast, Baby's first object, is his. Always appearing at just the right time, it is as if he is creating it. Baby omnipotence is the rule of the day (and night). The breast is, in Winnicott's own funny words, "under the baby's magic control."[22] And not just the breast, for her face is also his mirror: his emotions, his needs, his very being is held steadfast in her face, her eyes, her very being. As Winnicott writes, "The precursor of the mirror is the mother's face"[23]—the "mother's role [is] . . . giving back to the baby the baby's own self."[24]

Though created some 500 years before Winnicott's writing, the baby Christ with his mother Mary in Baldovinetti's *Madonna and Child* illustrates the Winnicottian illusionment of the infant's first days. The infant's body is bound by swaddle wrapped round and round, from his tender chest down to what must be chubby ankles. Curiously, the feet of this baby mummy are not bound; they are loosely encased, transparently hidden, by a soft chrysalis cloth. Baby Jesus's toes bloom into a flower fish tail. He is a boy mermaid. On the seas of his mother's billowing lap, he floats high. A bobbing b(u)oy. Behind his soft head (covered in skin softer than the baby curls yet to come, asking to be stroked, common baby craniology) is the halo which marks his sinlessness and mirrors his mother's own nimbus. (Afloat, Christ's halo is otherworldly, a reflective lily pad.) Mother and son: their haloes are circular mirrors, as are their faces, which reflect each other. Eye to eye, mirror to mirror, the two are bound together, immobilized by illusion (which is another name for love). Winnicott gives words to the picture: "There is no interchange between mother and infant [because there is no separateness there can be no exchanging, no following of one by another,

"*Parapetted*, high above the real world: theirs is a world of
shared luminosity, of pastel pinks, velvet crimsons, sky blues,
milky aquamarines, opalescent whites, ivory fleshes."

"the Winnicottian illusionment of the infant's first days . . .
He is a boy mermaid."

only oneness] . . . the infant takes from a breast that is part of the infant, and the mother gives milk to an infant that is part of herself."[25]

B. As the child begins to see and crawl and laugh and gurgle and cry for more than food, there begins an unraveling of that which is the "not-me" and that which is the "me." (Play is erupting.) He may suck on his thumb and begin to understand that which is the "me." His mother both gives and takes away the breast, which is the "not me."

Again I look to Baldovinetti, specifically his *Madonna in a Landscape*, to picture the workings of Winnicott's "transitional space." This time it is Baby proceeding from near total illusionment to a place where his good-enough mother (one must assume that the Virgin was good-enough) begins to, according to Winnicott, adapt "less and less completely, gradually, according to the infant's own growing ability to deal with her failure."[26] This beautiful Baldovinetti Madonna shows our mermaid boy unswaddled. Bracing himself with his fragile arm and plump, little hands, he is sitting up. Baby curls are erupting from his once merely downy, if exquisite, head. His ringlets are the illogical commas, dashes, periods, colons, and semicolons to what undulates from his lips, tongue, throat: a babble of gurgles, giggles, oohs and ahs. (Infant grew from *infans*, which means "without speech.") Indeed, language (but not traditional speech) is blossoming everywhere. Winnicott calls such language "play."

Play and language are there, but speech not, in the strange wooden jelly-roll-fronds that brace the Virgin's chair, as they peer over the parapet, like clucking geese over a garden wall. Like tongues of moths, these slim decorative wings to the Holy Seat are surreal anthropomorphic foliage. Silently they nearly mutter, they play. Like the "scrolls" at the top of a cello, a violin, a viola da gamba, these (wooden) fronds play music: Mother's lullaby; Baby's first song.

But what is most curious about this lovely painting is the gesture of the infant: unbound swaddle in left hand (his soft belly has been set free), his eyes seems to be pleading, questioning. Indeed, the child is playing with its swaddling bands. The swaddle turned ribbon turned umbilical, cascades

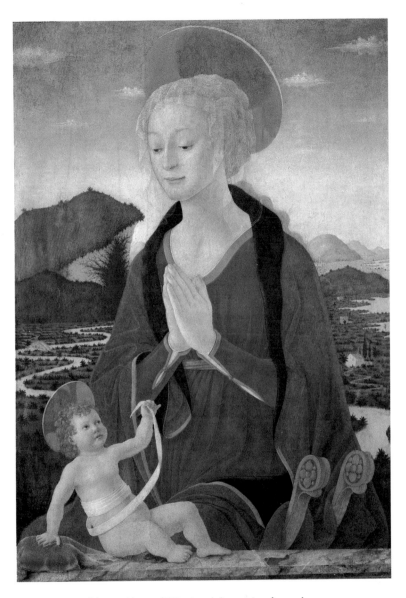

"the workings of Winnicott's 'transitional space' . . .
one must assume that the Virgin was good-enough."

down from her womb to his navel and around and round his odd little waist. Is he asking to be rewound, retied, reconnected? The baby's swaddle-ribbon-umbilicus is a banderole waiting for inscription. Baldovinetti's banderole is what the semiotician Mieczyslaw Wallis calls a "semantic enclave" (inscriptions in paintings, autonomous entities, whose "different semantic structure" speaks a "different 'language'"[27]); this semantic enclave is blank, but speaks of play becoming speech, of the not-yet unrolled from the tip of the tongue.

C. The mother, in sympathy with this enormous intellectual work of coming to terms with the world understands that "an attachment to a teddy, a doll or soft toy, or to a hard toy"[28] can ease the child's transition. Winnicott writes: "It is . . . well known that after a few months infants of either sex become fond of playing with dolls, and that most mothers allow their infants some special object and expect them to become, as it were, addicted to such objects."[29]

⌐ THE SUCCESS OF THE TRANSITIONAL OBJECT is the success of living a fulfilled life. For Winnicott emphasizes that a true "not-me" separation from the mother is never achieved, nor even desirable, and that we effectively and productively avoid such separation through "the filling in of the potential space [between 'me' and 'not-me'] with creative playing, with the use of symbols, and with all that eventually adds up to a cultural life [including the making of art]."[30]

Freud, in his strange tail-sucking text, *Leonardo da Vinci and a Memory of his Childhood*, also emphasizes the importance of play with special regard for artistic practice.[31] In the text, Freud establishes Leonardo's lifelong wish to fly like a bird as a covert symbol of the erotic, which was a tie to the mother, that lasted throughout adulthood as a childish wish that kept the great Italian Renaissance artist forever "boyish." As Freud states: "Indeed, the great Leonardo remained like a child for the whole of his life in more than one way."[32] Not only was Leonardo overly attached to the maternal and eternally "*bound up*" in a special and personal way with the

problem of flight,"[33] he also "continued to *play*"[34] well into adulthood. In order that we might see the honor and importance of play, Freud makes it clear that any disappointment that we might feel in Leonardo's puzzling attachment to making toys at a time when he might be finally finishing one of his great works of art is our own problem, our own blindness to the relationship between creativity and pleasure. In regard to our inability to appreciate Leonardo's "play-instinct,"[35] Freud writes: "It is only we who are unsatisfied that he [Leonardo] should have constructed the most elaborate mechanical toys for court festivities and ceremonial receptions, for we are reluctant to see the artist turning his power to such trifles."[36] Freud finished writing his text on Leonardo at a time (1910) when, to quote the Leonardo text, "aviation . . . is at last achieving its aim, its infantile erotic roots."[37] This was six years after *Peter Pan* had reached the stage; one year before the *Peter and Wendy* (the story) was published. The personage of flight as a play-instinct that allows eternal boyhood to soar with an attachment to mother, like a kite on a string, struck Leonardo (or at least Freud's interpretation of him), it seems, as hard as it did Barrie. Through Winnicott's play, we fly forward in this book to Barrie, flipping past pages fast, and glimpse flight as a boyish tug on Mom.

Although Winnicott emphasizes that the mother must give almost all of herself (far more than just her breast) over entirely to her infant, a small bit must be left of herself, must be kept intact for the child to begin making fulfillment from her failure. Gradually, the mother must pull back adequately in order for the child to make the transition from illusion to disillusion so necessary for the creation of transitional objects. Weaning encourages creative play, independence. In sum, the daunting task for the mother is to give of herself almost entirely and then be able to pull back, at the right time, with confidence and care. Her "failure" to be there must be carefully orchestrated so as not to fail her own child. Winnicott writes: "If illusion-disillusionment has gone astray the infant cannot get to so normal a thing as weaning, nor to a reaction to weaning, and it is then absurd to refer to weaning at all. The mere termination of breastfeeding is not weaning."[38]

String

I find my way back to the unnamed "boy with string," who ties up so much
space in Winnicott's "Transitional Objects and Transitional Phenomena."
Not only did this seven-year-old boy join together chairs and table with
string, or perhaps a cushion to the fireplace, it turns out that he was "ob-
sessed with everything to do with string."[39] Brought into Winnicott's office
through referral (the family doctor saw "character disorder"[40]), Winnicott,
as he often did, employed the child in a "squiggle game."[41] The squiggle
game was Winnicott's famed method for drawing the patient out: it was a
collaborative form of drawing between analyst and analysand; Surrealist
in form and tone, it was not so far from the Surrealist practice of making
Exquisite Corpses, which too was also a collaborative form of drawing. To
play the game, Winnicott would make some kind of impulsive line-drawing
and then he would invite the child to turn it into something, and then the
child would make a squiggle for Winnicott to turn into something during
his turn. An hour-long session might produce some ten drawings. In the
case of our boy with string, among his ten drawings Winnicott lists the
appearance of the following items, written out like a poem, a disturbing
fun poem:

> lasso
> whip
> crop
> a yo-yo string
> a string in a knot
> another crop
> another whip.[42]

If not explicitly, Winnicott implicitly presents the string boy as a develop-
mental outcome of his *mother's failure to properly fail her child* at the right
time, with just the right amount of pulling back. The mother, a "depres-
sive person," had "been hospitalized on account of depression,"[43] and even
when home, the boy often felt her lack of attention, her mental absence,

"The squiggle game was Winnicott's famed method
for drawing the patient out."

because of her "complete preoccupation with other matters."[44] The boy, it
seems, never had the proper chance to develop a "transitional object." Pa-
thologized by Winnicott as effeminate, as dangerously close to becoming a
"homosexual," as ripe for developing a "perverted"[45] preoccupation with
string, the final paragraph turns the sweet, maternal play of the boy into a
place of shame and anxiety:

> The following additional detail might be of value in the understand-
> ing of the case. Although this boy, who is now eleven, is developing
> along "tough-guy" lines, he is very self-conscious and easily goes red
> in the neck. He has a number of teddy bears which to him are children.
> No one dares to say that they are toys. He is loyal to them, expends a
> great deal of affection over them, and makes trousers for them, which
> involves careful sewing. His father says that he seems to get a sense of
> security from his family, which he mothers in this way. If visitors come
> he quickly puts them all into his sister's bed, because no one outside the
> family must know that he has this family. Along with this is a reluctance

to defaecate, or a tendency to save up his faeces. It is not difficult to guess, therefore, that he has a maternal identification based on his own insecurity in relation to his mother, and that this could develop into homosexuality. In the same way the preoccupation with string could develop into a perversion.[46]

The bears are his open secret. Needle and thread, he sews them into his other family, connecting them to himself, and in turn (through feminine play) the body of the mother. He has no desire to be weaned. His boyish ways keep him tied to his mother's apron strings. To be "tied to the apron-strings (of a mother . . .)," so says the *Oxford English Dictionary*, is to be "wholly under her influence."[47] Because he is encroaching upon adolescence (he is eleven), the string-boy's feminine play becomes a sign of queerness.

Our cultural imagination of the gay man, even in supposedly gay-affirmative revisionist psychoanalysis, is a boy who, like the "string boy," does not grow out of his boyishness. (Apparently Peter Pan was not the only boy who never grew up.) In the body of a growing or grown male, "boyishness" is always already feminine. As Eve Kosofsky Sedgwick points out in "How to Bring Up Your Kids Gay," phrases in contemporary psychology like "masculine competency" and "masculine self-regard" are synonyms for self-esteem, which in turn are synonyms for *good* sexuality (heterosexuality), even when they are used to describe homosexual bodies.[48] Winnicott is demonstrating (what Sedgwick has termed) effeminophobia: our culture's pervasive fear of effeminate boys.[49] (While we often encourage our girls to be tough, to play the man's game, we rarely encourage our boys, especially older adolescent boys, to be feminine, maternal, soft, caring.) Through a contemporary lens, Winnicott's final lines on the string-boy end up, ironically, pathologizing the doctor as homophobic. This is especially ironic given that the string boy was doing exactly what Winnicott was attempting to do in his own practice and revolutionary theory: holding, caring, mothering, playing the effeminate role.

I am inspired by Winnicott, yet troubled by his analysis of patients like

" 'He has a number of teddy bears
which to him are children.' "

⨳ ⟐

the string boy. Using him with caution, I have done some reparative work on Winnicott: I've loosened some knots, mended some strings, and broken a few others. While the term "reparative" is currently (and destructively) used in psychoanalytic *practice* to cure what some practitioners deem as pathological, perverted (the homosexual, the transsexual, et al.), my reparative work embraces the texts and textures of Sedgwick (who has already pulled the threads through the hettles), in order to usurp "reparative" to repair not the gay body so pathologized by psychoanalysis itself but the body of psychoanalysis, so responsible for this initial pathologization.

In a follow-up note on the string-boy (1969), Winnicott remarks on the boy's ultimate failure: he could never leave the mother. "The *tie-up* with the mother's depressive illness remained, so that he could not be kept from running back to his home."[50] Sent away to school, the "boy regularly escaped

"the yo-yo's string reaches all the way to Ma-ma."

and ran back home."[51] I picture myself as mother of the boy. Gone. I want him here.

By throwing a wooden spool on a string turned toy, back and forth, Freud's young grandson Ernst invented the fort/da game in order to cope with his mother's absence. (The story is famously told in *Beyond the Pleasure Principle*.[52]) When the spool was close to him, he said a happy *da* for *there*, and when the spool was away, he said a sorrowful *fort* for *gone*. He imagined that he could control his mother's comings and goings, like a spool on a string. Ernst's invention, as Rosalind Krauss has wittily pointed out (in her Surrealist-inspired dictionary, *Formless: A User's Guide*) might be read as an early prototype of the yo-yo.

Yo-Yo

We could see it as the relatively sophisticated, commercially produced equivalent of the little object Freud's infant grandson made famous, as he threw the spool onto his cot to make it disappear behind the bedclothes and then pulled on the string attached to it to draw it back into view, the first gesture accompanied by a mournful "fo-o-ort" and the second by a joyous "da!" And the yo-yo is serviceable in this connection to yet another dimension, since its very name cycles around the field of linguistic principles that the "fort/da" instrument articulates.

For yo-yo belongs to a whole series of childish terms—the very earliest being "mama."[53]

For Krauss the yo-yo's string reaches all the way to Ma-ma.

I have no desire to play fort/da with my child. I have no desire for my child to be, nor do I desire to be, yo-yo or doll. I play with string like Edmund, not Ernst. I plug my children into my thigh with metaphorical string, umbilicus, electric flex. (As Winnicott remarks, "string joins."[54]) "String can be looked upon as an extension of all techniques of communication . . . [it] helps in the wrapping."[55] My "da" is a (k)not; it is a never-fort; it is my own Neverland.

SPLITTING:

THE

UNMAKING

OF

CHILDHOOD

AND

HOME

I say Mother. And my thoughts are of you, oh, House.
House of the lovely dark summers of my childhood.
⌐ O. V. de Milosz, as quoted in Bachelard's
The Poetics of Space

*I am writing. My three-year old
son, Augustine, is frustrated
by my lack of attention.
He grabs my chin, pulling
my eyes into his gaze and exclaims
with clenched, small, first-teeth:
"I am going to make my very
own house and you cannot
come in."*

Walled Off and Frozen

Childhood as we now understand it, as innocent and pure, walled off from adult life (like a child's bedroom in the middle-class or bourgeois home, even the home itself), was perfected side by side with the development of photography. By the middle of the nineteenth century, "childhood" was elaborately *capitalized* through children's books, clothes, perambulators, a profusion of nannies, toys, photographic albums, and more. This modern conception of childhood and its material offspring grew as quickly as the child it was trying to suppress, contain, and stunt. As I argued in *Pleasures Taken*, it was as if the camera had to be invented in order to document what would soon be lost—childhood itself—and childhood had to be invented in order for the camera to purely document childhood (a fantasy of innocence) as real.[1]

Modern childhood and the photographic print were born of the nineteenth century. They are a couple. Lartigue's early pictures are childhood taken with the burst of the new twentieth century, secure in its fantasies of a childhood nostalgically rendered with the ease of photography developed as a near egalitarian hobby. Perhaps, then, it is not *so* surprising that these lovely pictures were snapped by the hands and eyes of a child. Nevertheless, they do have an amazing boy-ogle, and there is no body of work like his, no body of photography so tightly and beautifully held by a child-come-adolescent picture-maker.[2] Lartigue is our first child photographer.[3] As the director of the vast Donation Jacques Henri Lartigue, Martine d'Astier, who knew Lartigue as an "ancient boy" and who even appears in his late, late pictures tells us: "Lartigue was only seven in 1901 when he was given his first camera, a polished-wood 13 x 18 plate camera on a tripod; the ensemble was taller and heavier than he was."[4] By age eight, he officially began to be a photographer. As Lartigue writes in his published journal *Mémoires sans mémoire*: "Every lovely, strange bizarre or interesting thing gives me such pleasure I'm delirious with joy! So much so that I can remember much of it, thanks to photography! I've got a splendid collection! Begun at the age of eight!"[5] Over his long lifetime, Lartigue would produce hundreds of thou-

"snapped by the hands and eyes of a child."

sands of photographs (there are 280,000 in the Donation Lartigue[6], along with 158,968 negatives[7]).

Lartigue put his treasured pictures together in well over a hundred large albums *after* his boyhood. (The Donation houses 130 of these large albums.)[8] It was in the 1970s that Lartigue began constructing large albums, roughly an album for each year or so, as a way of reconstructing his life.[9] While Lartigue did record his *daily life* with snippets of writing and tiny, delightful sketches in a series of lovely desk diaries (the *agendas*) written from 1911 through 1918 (then subsequently in sheaths until 1986, totaling some 7,000 pages), the large photograph albums were not, as it might first appear, constructed on a daily basis, save for those album pages (although they were not bound at the same time) made in the twenties and the thirties. At one time, there were small albums that Lartigue made in concurrence with the taking of the early photographs, but they are long extant.[10] Lartigue destroyed these little vintage albums that were made contemporaneously with his life to make the new big albums. All of the big albums are the same size; our little photographer of the century desired to have each year of his life in the same dimensions. Stuck on the pages of these big albums are mixes of vintage prints (these are the little ones), with larger prints made later and much later. Photographs reappear in duplicate places. Like our own memories, which are always under revision, it is all dreadfully confusing. But perhaps that is the beauty of this work: the albums reflect the imperfections of memory. This constant rebuilding, rethinking, reorganizing of his life into a narrative of large albums was, as d'Astier has often remarked to me in conversation: "obsessive."

However, Lartigue's mother compiled contemporaneous albums of her son's pictures, and one such "mother book" from 1902 (or so) survives. The little scrapbook contains her son's first photographs, along with two drawings. It is sweet and uncomplicated. Maman simply pasted her son's precocious photographs into one of Lartigue's small, broadly lined schoolbooks filled with thin writing paper; she did not make much of a fuss. Many of the photographs that appear in this little schoolboy book are reprinted (even more than once) and are glued into the large albums. Maman's little

904: PARIS 40 RUE CORTAMBERT

MON HYDRO-GLISSEUR A HELICE AERIENNE -

PHOTOS AVEC MON
BLOC-NOTE GAUMONT
POSE SUR UNE PLANCHE
OBTURATEUR
DECLENCHE PAR
MAMAN

BLOC-NOTE 4½ X6
GAUMONT-

OBTURATEUR DECLENCHE PAR DUDU

"that is the beauty of this work: the albums reflect
the imperfections of memory."

10 MISE AU POINT DE TOUT MON JOURNAL AVEC FLO ETTE

"This constant rebuilding, rethinking, reorganizing of his life
into a narrative of large albums was, as d'Astier has often
remarked to me in conversation: 'obsessive.'"

"'mother book'"

photo-book features overexposures and underexposures of landscapes and family members and other images that are almost completely unreadable, in a range of deep black-browns, deep reddish-browns, with dreamy light patterns. The photographs are both poorly printed and have deteriorated over time — and that is their charm. The paper of this ancient schoolboy *cahier* is fragile, discolored, eaten by time. This little book made in the spirit of a mother's pride is what still remains after death. It embodies both the emotion and biological processes that make up and constitute death and eventual decay. Later, bequeathing this sweet book to his obsessive collection, Lartigue wrapped it in a sleeve, a shroud of white paper, and broadly titled it, with colored marking pens, in his familiar bold script, casually inscribing his precious, vintage object, as if he were still a child, with "VIEUX CAHIER MAMAN."

It is a disappointment to learn that most of the large photo albums did not come together until "he was already over fifty, at a time when his fear of death became unbearable. [For, in reality as d'Astier makes clear] the albums

were [less about the joy of his day to day life, than] a way of fighting against death, of constructing his happiness."[11] But let us turn our eyes away, full-swing like a springtime robin turns its head 180 degrees from seemingly-far-off-autumn, and take a backward gaze on Lartigue's head-tucked-back, red-breast-forward boyhood days.

IN 1905, WHEN LARTIGUE was a child of eleven ("but already an experienced photographer"[12]) he lined up all of his cars in his beautiful boyhood bedroom, ready to take off (*Collection of Racing Cars Ready to Run*). But it is not just the cars that are alive. Objects in the room speak "Mama" and "Papa." The dresser, like a mother, draped with its own shawl, as if it were wearing a skirt or an apron, animistically looms over the cars (which themselves are a stand-in for the boy). The clock ticks out time, not only play time and race time, but also all of the metaphors of father time, so as to suggest the inherent "stop-time" and the "eternal-time" qualities of photography itself. (As Barthes writes in *Camera Lucida*, the "first photographic implements were related to techniques of cabinetmaking and the machinery of precision: cameras . . . were clocks for seeing."[13]) With the mother as aproned bureau, the father as clock, and the child as the playful driver of the splendid cars, all are "invisible," but Lartigue is at the center of things. (The camera is "Daguerre's mirror,"[14] but we cannot see the charming face of the young French boy reflected in the mirror.) Family and home are there under Lartigue's magical control. Winnicott's imagination of the infant whose "illusion" allows him to feel omnipotent and as one with the mother (to use Winnicott's own funny words, the breast is "under the baby's magic control"[15]) — Lartigue magically invents his own secret world to snare with his camera. As material outcome of shutting childhood eyes, within the safe mechanical womb of the camera's own shutter, Lartigue's racing-car picture walls off the world. (As little children, many of us believed that if we shut our eyes, we could not be seen.)

In contrast to Lartigue's child-focused gaze of his room and mirror is Atget's 1905–6 photograph of the interior of the Austrian Embassy in Paris. Atget's chairs (like lovely whispering ladies in beautiful, if confin-

"he lined up all of his cars in his beautiful boyhood bedroom,
ready to take off."

ing, gowns), are stiffly reflected in the shiny mirror within the fireplace (the warmth of the hearth has been displaced with icy coolness). They are "in formal conversation."[16] The huge candelabra atop the fireplace mounts thin candle-men in butler-servitude to the fancy-dressed chairs that ignore their presence. A quiet, hefty chair-man observes the ladies before him. Who is the velvety couch (also reflected in the indifferent glass) who lounges behind the lady-chairs? Although they have an affected, grown-up life all their own, Atget's chairs are without the *childish* animism of Lartigue's race cars. This picture and its furnishings are heavy with adultness. Positioned from the heightened eyes of an adult, Atget's camera-eye does not crawl on the floor.

Lartigue's *Collection of Racing Cars Ready to Run* features the private

"heavy with adultness."

"motorized"

imagination of the child's home that has come alive. It is the animated
home so familiar to us in classic children's stories: from Alice's disturbing
confrontation with a soup tureen and a leg of mutton in *Through the Look-
ing Glass* to the *Velveteen Rabbit* who begins his life as a stuffed animal in
a boy's bedroom and eventually learns the hard lessons of how to become
"real." Lartigue's emphasis on the "liveness" and the animation of things,
whether they be motorized, propelled by wind, caught in flight or even the
inanimate turned animistic as in *Racing Cars Ready to Run*, comes at the
time when cinema was flickering its way through Parisian consciousness.
Lartigue was born on June 13, 1894; on December 28, 1895, at the Grand
Café on the boulevard des Capucines in Paris, the Lumière Brothers got the
image out of the box with their Cinématographe, which shot, developed,
and projected movie film. Children of the period, including the Narrator of
Swann's Way, lit up their rooms with toy magic lanterns, primitive cinema
in the heart of one's room.[17]

By placing his body on the ground (like a toy, like a boy), Lartigue evokes in us the lowliness of his child-body that moves (runs, crawls, squeezes, stares, touches) through space differently. We remember our own secret walled-off places of childhood, where adults were changed by our play, our imagination, and were therefore prohibited entry. We covered tables with blankets, so as to make instant private rooms. We dreamt of escaping parental control, of becoming orphans with secret hideaways, of living on the simplest and most meager foods, of living on the most outrageous and indulgent foods, of living behind the curtains, of living in the bathroom and never coming out, of being as tiny as a Borrower, as small as Stuart Little. We hid in the closet and read about magic wardrobes.

Like the bite of tea-soaked madeleine cake that prompted so many memories of home in *Swann's Way*, "so richly sensual under its severe, religious folds" (I, 63; I, 46), there are many crevices in Proust's novel which covet

"propelled by wind"

"caught in flight"

places of private childhood solitude: from his bed to his grandmother's garden to the kitchen to the stairwell to the pages of a book. But the one place that is especially significant to Proust's childhood as fantasy was the only place that he was allowed to lock himself into: his precious bathroom, "which smelt of orris-root" (a musty, woody, earthy scent.) Upset by his family's teasing of his beloved grandmother, the Narrator is prompted to lock himself up in the only room where he can partake in privacy: that special room necessary for dreams, reading, and sensuality. As Proust writes:

> I ran to the top of the house to cry by myself in a little room beside the schoolroom and beneath the roof, which smelt of orris-root and was scented also by the wild currant-bush which had climbed up between

"Children of the period, including the Narrator of
Swann's Way, lit up their rooms with toy magic lanterns,
primitive cinema in the heart of one's room."

the stones of the outer wall and thrust a flowering branch in through
the half-opened window. Intended for a more special and a baser use,
this room, from which, in the daytime, I could see as far as the keep of
Roussainville-le-Pin, was for a long time my place of refuge, doubtless
because it was the only room whose door I was allowed to lock, when-
ever my occupation was such as required an inviolable solitude: reading
or day-dreaming, tears or sensual pleasure. (I, 14; I, 12)[18]

It is from the half-opened window of this same locked room, this water
closet, this closet of desire, smelling of orrisroot that Proust will speak of
his awakened desire in viewing "the castle-keep of Roussainville," begging
the tower, "appealing to it as to the sole confidant" of his "earliest desires"

that a daughter from the village might be sent from the village, so that they might wander among the woods together (I, 222; I, 156).

Ingmar Bergman magically transformed his "spacious wardrobe in the nursery" into a *mise-en-scène* of childhood discoveries, cinematic and, like Proust's locked water closet, sexual. As Bergman writes in his autobiography, *The Magic Lantern*:

> I retreated into the spacious wardrobe in the nursery, placed the cinematograph [a form of the magic lantern] on a sugar crate, lit the paraffin lamp and directed the beam of light on to the whitewashed wall . . .
>
> A picture of a meadow appeared on the wall. Asleep in the meadow was a young woman apparently wearing national costume [nothing at all; she was a Goddess of Love]. *Then I turned the handle!* It is impossible to describe this. I can't find words to express my excitement. But at any time I can recall the smell of the hot metal, the scent of mothballs and dust in the wardrobe, the feel of the crank against my hand. I can see the trembling rectangle on the wall.
>
> I turned the handle and the girl woke up, sat up, slowly got up, stretched her arms out, swung round and disappeared to the right. If I went on turning, she would lie there, then make exactly the same movements all over again.
>
> She was moving.[19]

As a tiny child, even before his father's gift of a camera, Lartigue believed that he could freeze what he saw in an endless series of engraved memories upon his brain: stilled images of movement, of life, like his own photographs, like magic lantern slides. (It was as if this childhood genius was reading Freud's "Screen Memories" [1899] and sensed the future germination of "A Note upon the 'Mystic Writing Pad'" [1924]; it was as if Lartigue knew Freud without knowing Freud.) In Lartigue's journal that he reconstructed from childhood memories, he refers to his human form of photogravure as his "eye-trap": a process marked by the closing and reopening of his eyes in order to first capture and then to retain the image of what he

" 'My stories are a way of shutting my eyes.' "

saw. (Barthes's lovely line from *Camera Lucida* surfaces: "My stories are a way of shutting my eyes."[20]) But when his "eye-trap" began to fade, at the tender of age of six, he fell ill. (The doctor diagnosed growing pains.) "It was dating from this convalescence that I would try, with human means, to revive my beautiful ever-vanished 'angel snare.' . . . I tried to photograph everything and paint everything."[21] Like a victim of nostalgia with throat and lung tissues thickened and purulent—like Michelet whose "eating" of history was troubled and propelled by his migraines[22]—like Barthes whose time in the sanatorium allowed his tubercular body to record hundreds of passages from Michelet's writings on index cards, which he then rearranged like playing cards to compose fragmented texts that rather magically projected the books that he was yet to write—like the asthmatic Proust writing and rewriting in his cork-lined room—a real illness or an imagined illness enabled Lartigue with the *chronic* time of disease (specifically, it seems, the disease of nostalgia, here a rarity in that it has already infected, affected, the body of a young child) that afforded him (along with his class) his gigantic creativity. Using photography's predilection for collectomania and his own for the miniature, the child-like, Lartigue snared his bourgeois *Belle Époque*, including the boyish self-portrait in which he plays with a self-made miniature hydroglider, complete with propeller (he sports his famous impish grin; to take the picture he placed his camera on a floating board in the tub, set the exposure and focus, and had Maman snap the picture); *real* racing cars that look as if they drove out from his bedroom floor and grew once they hit the road outside, like the Delage (which could travel at the fantastic speed of thirty-five miles an hour); ladies that look like dolls, promenading in fine feathery, featuring hats that are just as much of an engineering invention as fashion innovation, with unbelievably stylish small dogs at their side who look more like their velveteen cousins than the real thing; the family's pet rabbit as animistic plush toy riding in the miniature roller coaster built by his brother Zissou. As Lartigue wrote in a small black book whose earliest entries were written around 1911, the time he began keeping a record of all of his daily tricks, errands, weather, fashions, illnesses: "'All the pretty or curious things give me so much pleasure. Thanks to photography I can hold

"as if they drove out from his bedroom floor"

them.'"[23] By miniaturizing the world through his passion for photography, Lartigue could hold everything, even himself, like a toy.

In 1903, a photograph of Jacques and his brother Zissou was taken at the base of the Eiffel Tower by their father. Jacques, under the shade of his straw hat, no more than eight steps up the tower, gazes down, while holding his camera in his left hand. Ready to climb up this strange structure, which Eiffel meant as a "serious object," but which has grown into "a great baroque dream which quite naturally touches on the borders of the irrational,"[24] the Lartigue boys will, once they reach the top, see as the tower sees. "The Tower looks at Paris."[25] I liken the tower's bird's-eye view of Paris, in which the city becomes delightfully miniaturized and contained to Lartigue's own miniaturizing of the world through photography. The Eiffel Tower is a giant toy with a view of the world miniaturized: the city as landscaped for a very elaborate miniature railway or as seen from a plane, a balloon. The tower is an erector set grown large (the earliest form of the

"engineering invention as fashion innovation"

"unbelievably stylish small dogs"

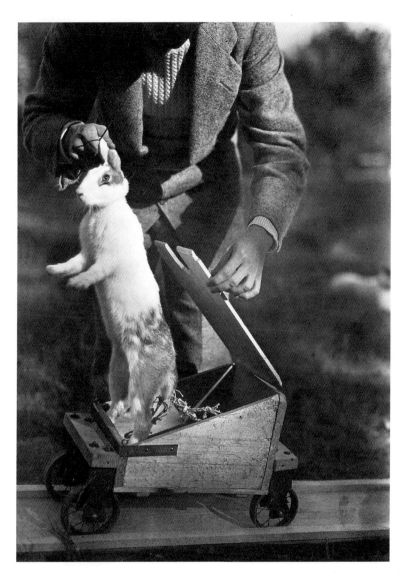

"the family's pet rabbit as animistic plush toy riding
in the miniature roller coaster built by his brother Zissou."

(*above and overleaf*)

"The tower is an erector set grown large"

erector set was manufactured by Mecanno in 1901, two years before the Lartigue brothers stood on Eiffel's composition of "countless segments, interlinked, crossed, divergent"[26]). "The toy," writes Susan Stewart, "is the physical embodiment of the fiction: it is a device for fantasy, a point of beginning for narrative."[27] What fantasies the tower must have given to Lartigue and his brother.

On March 25, 1912, Lartigue produced his own photograph of the Eiffel Tower; this time from above, this time blanketed in snow. Looking down from above we catch sight of the Tower's straddled arch and its toy-like construction. On the ground below, "les taxis=autos" to our left and

"les fiacres" (hackneys, horse-drawn carriages for hire) to our right: it is a picture of the crossroads of modern travel—the old paired with the new. Motorized tires accompanied by spewing clouds of exhaust in the cold-snapped air roll past the clip-clop of hoofs and the whish of wooden wheels. The scene is sweetened because Paris has been fleeced in sugary "Alabaster Wool."[28] How apt that seventeen-year-old Lartigue, straddling the space between childhood and adulthood, should show us the city made even more beautiful (as if it were a lady's cheek) by a powder of snow, her face sheathed by a "crystal veil."[29] My heart races at the sight of the march of horse-drawn carriages and cars turned toy. Lampposts and trees appear like made-to-scale accoutrements for a miniature railroad scene that just might slide out from under the bed of a lucky boy.

The Eiffel Tower is amazing for its metaphorically photographic combination of materiality and immateriality at once, of substance held iron tight in air by the magical particles of impalpable, weightless, light. Barthes likens the experience of walking up the stairs of the tower to seeing a photographic enlargement, in which, say, "the curve of a face . . . appears to be formed of a thousand tiny squares variously illuminated."[30] The tower, photographic in its very structure of segments of iron and light fractured, not unlike the pointillist light painting of Seurat, also both material and immaterial, this structure was originally coated "with several shades of iridescent enamel paint—the poet Tailhade called it the 'speculum Eiffel.'"[31] The crown jewel of the city, the city's very metonymy, is a sign made out of and covered with particles of light: how fitting, given that Paris, in honor of the newly installed gas lighting of Haussmannization, was named the "new City of Light."

Like a photograph, the tower is a hyperrealized structure of miniaturization, which anticipated the birth of aviation, elevating Lartigue's own vision with the appeal of diminutive space. Just as photography made all the world home for Lartigue, the tower makes the viewer feel more "at home" with Paris miniaturized, stripped of its gigantic, monstrous, grotesque municipal problems of dirt, mud, garbage, poverty, sanitation, crowds, crime—all unseen from above. For Gaston Bachelard, the great

912

TAXIS= AUTOS ⟶

⟵ LES FIACR

25 MARS

"The scene is sweetened because Paris had been fleeced
in sugary 'Alabaster Wool.'"

philosopher of phenomenology and lover of the tiny, whether it be inside the miniscule homes of nature (the shell or the nest) or the cultural places of the world miniaturized (our childhood house as contained by pretty memories, the supra-interiorization of a drawer or closet within the already shut-within domestic space, the enclosure of the scientific collection, the walled-in world of the book in our hands) "the appeal of diminutive space begins with its capacity for instilling a feeling of omnipotence in the viewer."[32] Bachelard feels "more at home in miniature worlds":[33] this is in keeping with Winnicott's imagination of the infant whose "illusion" allows him to feel all-powerful and as one with the mother and is a mirroring of Lartigue's magically invented secret world that he snared with his camera. "The cleverer I am at miniaturising the world," declares Bachelard, "the better I possess it."[34]

 With all the serenity of a miniature world peacefully gazed from the blue skies above, imagined or real, Lartigue, preferred to snap the *très beau*. As one art critic has remarked, in his "intimate chronicles of mundanity and philosophical musings meticulously illustrated with his photos and captioned with names, dates and weather conditions," we find that Lartigue seems to have endured only sunny days, or at least mostly sunny days, for at the "top of each page [of his journals], he drew a sun or cloud, noting 'B,' 'T.B.' or 'T.T.B.' for *beau, très beau*, or *très, très beau*."[35] Even bad weather days still give way to pages topped with drawings of suns with unhappy faces, who scour at *vent* (wind) and *nuages* (clouds), so that even when *Monsieur Soleil* is not out, he still makes himself felt in Lartigue's little books. Furthermore, on these bad weather days, we find that Lartigue's comical, Chapmanesque figures—such as a tiny man with umbrella and little spots of snow falling everywhere (1911: 26 Mars, Dimanche), or the lady with umbrella, walking in sheets of rain behind *un fiacre* (1911: 9 Mars, Jeudi)—counteract any chilly feelings with the warmth of tinyness, charm, and the pleasantly comic.

 Like photography, like the Eiffel Tower and its miniature visions, psychoanalysis shares a partnership with childhood—and it too, like glass plates and wet collodion, like iron lacework shooting up to the stars, was born of

"Lartigue seems to have endured only sunny days"

"even when *Monsieur Soleil* is not out,
he still makes himself felt"

"the warmth of tinyness"

the nineteenth century. Childhood dramas set the stage of psychoanalysis, including Freud's theory of the "Oedipus complex" (where boys and girls learn to love and hate Mother and Father according to their blossoming, respective sexual differences) and Freud's "screen memories," which visualize past conflicts as imprinted on our little minds (like old photographs lost), only to be selectively played out later in adult life (like the rediscovery of a lost photograph, or better yet an old family movie). Similarly, Freud's notion of the unconscious as a "mystic writing pad" is like the magic writing slate, the *Wunderblock*, of childhood play that retains pictures, marks, and letters on a waxen tablet, which, though not readily visible, survive as distant, past, and subtle traces of personal dramatic histories. Freud's theory of the "uncanny" (*Unheimlich*) signals the transfer of a "homely" experience into a strange, alien, "unhomely" event, as a scary move from the "familiar" into the "unfamiliar," all through the revival of repressed infantile complexes. (And those are just a few.) Freud, of course, does not stand alone with his emphasis on what Simon Watney has referred to as the problem of the "distinct 'world of childhood' quite separate from and independent of adult life."[36] Recall Lacan's "mirror stage" (where the child attains both image and language), or even Julia Kristeva's notion of "the semiotic" (a pre-Oedipal form of nontraditional language shared between mother and child that exists before, and beyond, speech), and "object-relations theory" (which focuses on a child's use of objects in his or her development — from the mother's breast to a blanket to a soft or hard toy to a song to a piece of string — as imagined and reworked through the studies of Melanie Klein and Winnicott).

Psychoanalysis could not have developed without a childhood as *imagined* and severed from adult life. Even psychoanalysis's history feels appropriately familial, arguably Oedipal, with Charcot as the grandfather of psychoanalysis and Freud (his pupil, surrogate son, child of the Victorian era) as official father of the discipline. Born of the Victorian era, psychoanalysis asks us to lie down on the couch (if only metaphorically), to remember, to account for one's life, to discover the heart (the childhood)

of one's psychosis. Like childhood and photography, psychoanalysis and childhood are also a couple.

Remembering those early days is like foraging for the Proustian cake that will awaken in us our childhood lost. Indeed, the madeleine cake, Proust's most vital souvenir of childhood (as home), prompts all of the memories of yesteryear which became *Swann's Way*. As Proust writes:

> And as soon as I had recognised the taste of the piece of madeleine soaked in her decoction of lime-blossom which my aunt used to give me (although I did not yet know and must long postpone the discovery of why this memory made me so happy) immediately the old grey house upon the street, where her room was, rose up like a stage set to attach itself to the little pavilion opening on to the garden which had been built out behind it for my parents (the isolated segment which until that moment had been all that I could see); and with the house the town, from morning to night and in all weathers, the Square where I used to be sent before lunch, the streets along which I used to run errands, the country roads we took when it was fine. (I, 64; I, 47)

From Proust's cup of tea, which sat on his mother's table inside the old grey house of his childhood, emerged

> as in the game wherein the Japanese amuse themselves by filling a porcelain bowl with water and steeping in it little pieces of paper which until then are without character or form, but, the moment they become wet, stretch and twist and take on colour and distinctive shape, become flowers or houses or people, solid and recognisable, so in that moment all the flowers in our garden and in M. Swann's park, and the waterlilies on the Vivonne and the good folk of the village and their little dwellings and the parish church and the whole of Combray and its surroundings, taking shape and solidity, sprang into being, town and gardens alike, from my cup of tea. (I, 64; I, 47)

As Proust knows and so eloquently writes: "The past is hidden somewhere outside the realm, beyond the reach of intellect, in some material object

(in the sensation which that material object will give us) of which we have no inkling. And it depends on chance whether or not we come upon this object before we ourselves must die" (I, 59–60; I, 44). The possibility of stumbling upon our own personal madeleine cake crumbles with Proustian chance. One is disheartened. Adam Phillips suggests an analyst might provide us with the extra help needed in having a perfect chance encounter. Significantly, as Phillips playfully reminds us, "an analyst," unlike a chance encounter with a madeleine cake, "can at least be arranged."[37] Edmund White sugars the madeleine for us as follows: "Perhaps the theory of the primacy of involuntary memory appeals to readers because it assures us that nothing is ever truly forgotten and that art is nothing but the accumulation of memories."[38] But memories, even when remembered, suffer from fragmentation, our need to fictionalize, the impossibility of recovering a true *true* memory.[39] For as one of my students once remarked: "What is memory itself, except an insufficient narrative?"[40]

Without photographs to document our *innocence* past and without analysis to do the archaeological work of digging it up, our memory of childhood often feels gone, yet weighs heavily on our mind and spirit. The solid nothingness of childhood lost is evoked by the contemporary artist Rachel Whiteread in the surprise and shock of her concrete *Ghost* (1990). No transparency. Nothing gauzy nor light, nor spiritual. No animation of any sort. Rather than haunting, *Ghost* sits big and square. By casting an entire room of an abandoned house in north London, Whiteread transforms the home, specifically a bedroom, from a scene of comfort into a foreboding scene of unrelentingly dense inhabitation. Traditionally, the home itself is a "fantasy of childhood, replete and secure, a boundary against the loss of innocence"[41] (that is why we love Lartigue's photographs, they make the fantasy *real*). But in Whiteread's hands the home evokes annihilation, even suffocation. (One cannot help from imagining the terrifying thought of being caught inside when the concrete was poured.) The hearth is usually a beautiful metaphor for interiorized, homely, intimate sensations of feeling time, warmth, life; it is, as Elvire Perego has written, "the radiating center, the paradigm where the memory of emotions is stored, a constellation of

"The solid nothingness of childhood lost"

shared tenderness and heartbreak which overflows from the center in all directions."[42] But the fireplace of Whiteread's *Ghost* gives no warmth. Likewise, the windows of Whiteread's *Ghost* do not offer glimpses to the world outside as taken from the comfort of the interior home. *Ghost* windows are not for seeing; they are eyes shut tight, blinded. They are the eyes of a death mask. As Arthur Danto has written in regard to *Ghost*:

> We initially perceive [*Ghost*] as a large white cubish structure. It replicates the interior of a child's room in an old house, however. The room serves as the matrix for plaster slabs, which register its architectural details — a door, a fireplace, etc. The slabs were reassembled in such a way

that the interior of the room was reproduced as the exterior of the sculpture. The room was in effect turned inside out. That and its funerary whiteness make it a monument to lost childhood. You cannot enter the room — the door does not open — and this surely is a metaphor for the fact that we cannot revisit childhood. All we can see are its ghosts.[43]

Whiteread's *Ghost* does not evoke the memories of childhood as home churned out by our literary past, by photographs saved, by Super-8 movies, Hollywood movies, or sentimental European movies (such as Ingmar Bergman's *Fanny and Alexander*, set at Christmastime 1908, with plenty of toys, a magic lantern, and other such pastel-colored saucers of "buttery condensations"[44]). Whiteread's *Ghost* stands in frozen white tundra. Although her work shares with photography the notion of the double, of freezing an image, a moment, forever — Whiteread's "capture" of the past is not small like "flies in amber,"[45] it is gigantic, like a huge weighty mammoth preserved from the glacial epoch. Whiteread allows no possibility of Proust's *mémoire involontaire*. Hers may be a house, but his is a home. And "home," as Jon Bird reminds us, "is a fiction."[46]

Proust begins the first part of *In Search of Lost Time* (*Swann's Way*) in bed dreaming a "waking dream" of the past homes and especially bedrooms of his childhood. Here is his memory of one such bedroom in winter, complete with a burning hearth:

> I would revisit them all in the long course of my waking dream: rooms in winter, where on going to bed I would at once bury my head in a nest woven out of the most diverse materials — the corner of my pillow, the top of my blankets, a piece of a shawl, the edge of my bed, and a copy of a children's paper — which I had contrived to cement together, bird-fashion, by dint of continuous pressure; rooms where, in freezing weather, I would enjoy the satisfaction of being shut in from the outer world (like the sea-swallow which builds at the end of a dark tunnel and is kept warm by the surrounding earth), and where, the fire keeping in all night, I would sleep wrapped up, as it were, in a great cloak of snug

and smoky air, shot with the glow of the logs intermittently breaking out again in flame, a sort of alcove without walls, a cave of warmth dug out of the heart of the room itself, a zone of heat. (I, 7; I, 7)

Even Proust's aunt's lime-blossom tea, so responsible for the profound memory that emerges from the dipped madeleine cake, is equated with a nest: "having lost or altered their original appearance" they *now* resemble "the most disparate things, the transparent wing of a fly, the blank side of a label, the petal of a rose . . . piled together, pounded or interwoven like the materials for a nest" (I, 69; I, 50–51). The tightly woven memories of home as nest in the felt padding of *Swann's Way* is a warm Proustian bed (tenderly packed with familiar smells, welcome tastes, and velvety threads to touch), which can be read as a metaphor for the writing of *In Search of Lost Time*. As Walter Benjamin reminds the readers of Proust: "The Latin word *textum* means 'web.' No one's text is more tightly woven than Marcel Proust's; to him nothing was tight or durable enough."[47] Sleeping in his memory of a childhood bed, a home within the home, Proust carefully arranges the exquisite details of material time under continuous pressure, as if they were flowers to be preserved by an old-fashioned flower press, a layer of white cattleyas tucked in between two white cotton sheets of blotter paper, only to be repeated by further layers of flowers (pink hawthorns) and more blotter paper and more flowers (poppies, cornflowers, apple blossoms), all sandwiched between two square boards of thin wood; each paragraph written is a turn of the wingnut, a tightening of screw bolts, so as to squeeze the leaves and petals and pistols and stamens and stems and scent and taste and touch severed from life, day by day for weeks on end, in order to regain childhood lost, in a futile effort to make last what once was. (As Jean-Yves Tadié claims and makes clear in his labyrinthine 986-page biography of Proust: "Proust made use of everything he experienced or thought about during his lifetime.")[48]

Unlike our usual memories and fantasies of the homes of childhood — as exemplified in Proust's tightly woven memories of home as nest in the felt padding of *In Search of Lost Time* to the simplicity of Margaret Wise Brown

"there is a certain sadism, an unnerving childish sadism, to Brown's little book dressed in fur. . . . 'at least 15,000 dead rabbits were needed to keep the little books warm.'"

∴

children's classic *Little Fur Family* ("There was a little fur family/ warm as toast/smaller than most/in little fur coats/and they lived in a warm wooden tree")[49]—Whiteread's *Ghost* freezes childhood and keeps us outside in the cold. (And lest all of the warmth of *Little Fur Family* go unnoticed, the first edition was originally covered in real rabbit fur in a seemingly affectionate and humorous, if unintentional, response to Merit Oppenheim's unhomely *Breakfast in Fur* [1936]. Like Lartigue's bunny as guinea pig in his brother's miniature backyard roller coaster, there is a certain sadism, an unnerving childish sadism, to Brown's little book dressed in fur. Given that the first printing of *Little Fur Family* ran to more than 50,000 copies, "even a rough

estimate suggests that at least 15,000 dead rabbits were needed to keep the little books warm."[50]) Whiteread blocks us from childhood as a warm Proustian bed. As Anthony Vidler has aptly written: "Whiteread seems to deny any nostalgic return to the womb, to refuse all access to domestic familiarity."[51]

In great contrast, Proust spent most of his life in his nostalgic "great cloak of snug"; he spent his life in bed, underneath the down of a childhood that, perhaps, never was. Proust (like a child who enjoys the satisfaction of being shut in from the outer world) feverishly wrote and rewrote amid the service of Céleste Albaret (his beloved nurse, secretary, and housekeeper), the only one besides Maman to gently tie him with the velvet ribbons of unconditional love, mothering him "all night long, bringing him things to drink or eat, filling his hot-water bottles."[52] And there, in bed, "From the honeycombs of memory he built a house for the swarm of his thoughts."[53]

"I Want to Live There"

Likewise, Barthes's *Camera Lucida* is one nostalgic return to the womb, to the original home of mother. While searching for the perfect photograph of his recently deceased mother (the famed Winter Garden photograph), Barthes stops along the way to inhabit Charles Clifford's *The Alhambra (Grenada)*, 1854–56: his fantasy of a sublime image of Mother as home; a dwelling that holds the mother he has lost. This image of otherness ("Arab decoration . . . a Mediterranean tree"),[54] like Barthes's musings on Japan in *Empire of Signs*, or even Proust's mother-cake dipped in tea, which blossoms all of Combray, "as in the game wherein the Japanese amuse themselves by filling a porcelain bowl with water and steeping in it little pieces of paper which . . . the moment they become wet . . . become flowers or houses or people,"[55] hails the maternal as an image of escape, a place to travel to: backward and toward. Barthes becomes a Baudelarian armchair traveler, moving spatially and temporally, "a double movement which Baudelaire celebrated in *Invitation au voyage* and *La Vie antérieure*"[56] Like Barthes

« C'est là que je voudrais vivre... »

"a dwelling that holds the mother he has lost."

(and, of course like Proust), Baudelaire protected his early, happy memories with mother, leading him to famously pronounce that poetry is childhood willfully recovered (*l'enfance retrouvée à volonté*).[57] Both Baudelaire and Barthes conceive of a utopia that is driven by an unselfconscious nostalgia of womb memories that embrace a wild Orientalism. When Barthes writes in *Camera Lucida*, "I wanted to be a primitive, without culture,"[58] or captions *The Alhambra (Grenada)* with "I want to live there,"[59] one hears Baudelaire's "La vie antérieure" ("A Former Life") with the overt colonialist fantasy in hiding:

> So there I lived, in a voluptuous calm
> Surrounded by the sea, by splendid blue,
> And by my slaves, sweet-scented, handsome, nude,
>
> Who cooled my brow with waving of the palms,
> And had one care — to probe and make more deep
> What made me languish so, my secret grief.[60]

Longing to inhabit the maternity that he sees and feels when looking at *Alhambra*, Barthes confesses: "A kind of second sight which seems to bear me forward to a utopian time, or to carry me back to somewhere in myself . . . it is as if *I were certain* of having been there or of going there. Now Freud says of the maternal body that 'there is no other place of which one can say with so much certainty that has one has already been there.'"[61] As Winnicott plainly reminds us: "Home is where we start from."[62] And that first home is the body of the mother.

With my own childish eyes, fixed by juvenile literature read to me in the 1960s, I cannot help from seeing a face in *The Alhambra*. With the pictures of Virginia Lee Burton's enchanting classic *The Little House* angel-snared in my brain, I see *The Alhambra*'s arch as a mouth, its windows as eyes. *The Little House* is my magic lantern memory (although for my generation the device would be the red plastic View-Master that gave us stereoscopic cartoons with every clickety-pull of the yellow plastic lever). I looked into her face and thought "I want to live there."

"I looked into her face and thought 'I want to live there.'"

⁀⁀

Childhood's connection to the home, and in turn to the mother herself, is (of course) pervasive. ("If the first lost object is the mother, then the first lost space is the maternal space.")[63] And childhood's connection to psychoanalysis was there at its onset. Yet it was not until the emergence of object-relations theory in the late 1920s, principally through the work of Melanie Klein and then Winnicott, that children themselves were seriously analyzed.[64] Naturally, by taking on children, both Klein and Winnicott drew heavily on mothers and their role in children's lives, if in radically different ways. Both played with the mother's body: Klein tore it to pieces; Winnicott glorified it. Together they merge to enact Barthes's famous statement: "The writer is someone who plays with his mother's body, in order to glorify it, to embellish it, or even to dismember it."[65] Like the split memory of the interiority of childhood evoked by Proust, so the foundations of object-relations theory (like the maternal bodies of Winnicott and Klein) divide.

"A Boy Cries 'Mama'": Playing with Melanie Klein
in a Normandy House

In her crucial essay "Infantile Anxiety-Situations Reflected in a Work of Art and in the Creative Impulse" (1929), Klein uses Ravel's opera (based on a poem by Colette), *L'Enfant et les sortilèges* (*The Bewitched Child*) to illustrate the child's need to split the mother into a "good" object or "bad" object in order to both destroy his or her mother, as well as to repair her, love her. The opera opens with a boy of "six or seven years" refusing to do his schoolwork. "He bites his penholder, scratches his head and sings softly."[66] Colette describes the setting, the boy's home, as follows:

> The scene presents a room in the country (ceiling very low) opening on a garden. A Normandy house, old, or rather, old fashioned; large armchairs covered with cloth, a tall wooden clock with a decorated dial. Wallpaper depicting pastoral scenes. A round cage with a squirrel in it, hanging near the window. A large fireplace where a small fire burns peacefully. A teakettle purrs, the cat also. It is afternoon.[67]

Oh, what a pleasant scene this is, with the warm fireplace burning, kettle and cat purring, pastoral scenes on the walls, all embraced in the comforting arms of an old-fashioned house: this *mise-en-scène* is a warm bath of "childhood." But it is not appreciated by the "bewitched child." Grumpy and annoyed at the prospect of doing his lessons, the boy dreams that he "might eat up all of the cakes . . . pull the cat's tail very hard. And cut off the squirrel's too! . . . Oh, how . . . [he] would like to make Mama feel very sorry."[68] But all that can be seen of Mama is her "skirt and the lower part of a silk apron, a steel chain from which hangs a large pair of scissors."[69] Given her gigantic size as her shadow looms over the boy in David Hockney's drawing for the Metropolitan Opera House's 1980 production of *L'Enfant et les sortilèges* (entitled *Child with Shadow of Mother*) and given the castrating scissors of Colette's text, she is threatening, to say the least. *The Bewitched Child* sets the "entire scale of the furnishings and all the objects in

exaggerated dimensions in order to make more striking the smallness of the Child."[70] (Now it is the child who is not "at home" in his own house.)

Soon after the curtains part, Mama punishes her "naughty child" by giving a lunch of "sugarless tea and dry bread" and forcing him to "remain alone 'til dinner time."[71] The boy throws a fit, destroys everything, tearing wallpaper off the walls (using "the [fireplace] poker like a sword . . . [he] attacks the little people on the wallpaper"), tears the copper pendulum off of the grandfather clock, breaks a teapot and a cup into a thousand pieces, tears up tablets and books, all the while "laughing uproariously."[72] He even "climbs upon the window sill, opens the squirrel's cage and pricks the little animal with his steel pen. The squirrel wounded, cries out and escapes."[73]

But in the midst of the child's destruction, everything comes alive: from the large armchair, to the china cup and black Wedgwood teapot to the flames in the fireplace to his own arithmetic book which sprouts "a little humpbacked, crooked, bearded old man with a π for a hat, a tape measure for a belt . . . armed with a ruler."[74] Chair, cup, teapot, flame, arithmetic book, and more have become uncanny talking objects who animistically complain of the boy's wicked and cruel ways.

Chasing a black cat and a white cat, "the child finds himself . . . transported into the garden."[75] But even out in the beautiful garden, "throbbing with wings, lively with squirrels . . . a paradise of tenderness and animal joy,"[76] the child finds that all who inhabit his backyard Eden ignore him. Devastated by a lack of attention, the child "in spite of himself . . . calls Mama!"[77] Upon hearing his cry for Mama, Eden is startled by the naughty child's presence; the life of the garden retaliates. "It is a frenzy which becomes a wrestling match, for each animal wants to chastise the Child, single-handed, and the animals begin to tear one another to pieces."[78] The squirrels, frogs, dragonflies, birds, moths, even a tree, are angry at him for his stick, his knife, for destroying a nest. Yet, in the midst of their frenzy, the realization of what they have done, what they are doing, stabs the animals in their own hearts. Ashamed, the animals become motionless. "They separate and surround at a distance the squirrel whom they have injured

"her shadow looms over the boy"

"(Now it is the child who is not 'at home' in his own house.)"

"'a little humpbacked, crooked, bearded old man
with a π for a hat, a tape measure for a belt . . .
armed with a ruler.'"

[in the process]."[79] Then, despite his own injuries and quite unexpectedly, the boy becomes maternal, specifically reparative: "Taking a ribbon from his neck, the child ties up the wounded paw of the squirrel, then falls back weakly."[80] He "unmakes" his mistake. But even though he has repaired the squirrel, the Child continues to suffer, becomes "pale and inert."[81] Feeling helpless, the animals carry him back, "step by step to the house."[82] They recall that the boy had cried a magical "Mama." They begin to sing their own beautiful chant of "Mama, Mama, Mama." "A light appears in the window of the house."[83] Now, the garden is flooded with pure light. The animals slowly withdraw. "The child alone, erect, luminous and blond in a halo of moonlight and of dawn, holds out his arms . . . 'Mama!'"[84]

The Bewitched Child, like so many stories of childhood (from Proust's *Swann's Way*, to Lewis Carroll's *Through the Looking-Glass and What Alice Found There*, to Barthes's *Camera Lucida* to Barrie's *Peter Pan*) are Oedipally structured struggles that are resolved by a return back home: whether

"He 'unmakes' his mistake."

⸎

it be to the memory of Combray that prompts Proust's exploration of Time
that concludes the final pages of *Time Regained*; or to Alice's awakening;
or to the maternal face that Barthes sees in *The Alhambra (Grenada)*; or to
the final nursery of *Peter Pan*, where the grown Wendy's own little daugh-
ter Jane now sleeps in anticipation of Peter. At the heart of these homes is
Mama/Mother. One might argue that the Narrator of the *Search*, that Alice,
that Barthes, that Peter, all tear the mother's body to pieces, only to later
repair her, love her. (Recall, for example, Alice's final treatment of the Red
Queen as Mother: "'And as for *you*,' she went on, turning fiercely upon the
Red Queen, whom she considered as the cause of all the mischief . . . 'I'll
shake you into a kitten, that I will!' . . . She took her off the table as she spoke,
and shook her backwards and forwards with all her might."[85]) But what
interests me, specifically, about Klein's analysis of the opera (as found in
"Infantile Anxiety-Situations Reflected in a Work of Art and in the Creative
Impulse") is how little space she devotes to the love and the reparative work

of the Child. In Klein's destructive hands, unlike Alice's, the destructive act of shaking the mother apart, of tearing her to pieces, does not end with the culpable mother turning into a "softer—and rounder"[86] black kitten. For Klein, "The fundamental aim in life is to live and to live pleasurably."[87] And pleasure for Klein is linked to aggression:

"'I'll shake you into a kitten'"

> We know . . . that aggressive, cruel and selfish impulses are closely bound up with pleasure and gratification, that there can be a fascination or an excitement accompanying gratification of these feelings. For instance, the savage satisfaction, or at least the glee, felt by someone making a cutting retort can often be seen in the eyes. Bloodcurdling and cruel stories, pictures, films, sports, accidents, atrocities, etc., are exciting in greater or lesser degree to all human beings who have not learnt to modify this tendency or to deflect it elsewhere. Most of us feel an elation which is pleasurable on overcoming an obstacle, or on getting our own way. This *pleasure* that is apt to be closely linked with aggressive emotions explains to some extent why they are so imperative, and difficult to control.[88]

Klein spills most of her ink on a detailed analysis of the Bewitched Child's sadistic acts as functioning as a series of attacks on the mother's body. Reading the child's violence as necessary, and very Oedipal, Klein wastes no time in (hetero)sexualizing the narrative. Notably, the squirrel in the cage is read as a symbol of the father's penis in the mother's body, as is

the soon-to-be-wrenched-out pendulum in the clock. What is not blatantly or conventionally sexual (spilled ink, ashes, and steam) is read as a sign of a child's best and most convenient weapon against the mother: soiling with excrement.

Taking Klein's analysis to task, one questions her thorough emphasis on the child's destructive acts and her lack of attention in regards to the boy's feminine (maternal) acts. For, despite Colette's rich description of the Garden of Eden (that is also part of the home), Klein's analysis of the boy's final love and reparative work is never sexualized. In fact, it is hardly interesting at all, despite the libretto's erotic account of the dragonflies' beating wings, the sensuality of the emerging dawn's rose and gold light, the tenderness and touch with the squirrel (apparently once they are out of their cage they fail to represent the Father's penis), or even the sound of the tender calls and whispers of "Mama." Arguably, though a mother herself, Klein seems to fear the maternal in the body of the boy. She, like Winnicott, seems to suffer from Sedgwick's effeminophobia.[89] Playing with the borders of gender roles was apparently a kind of play that proved too messy for Klein.

While I honor Klein's important work on the significance of anger and destruction as necessary connection to the love of the mother (or love for anyone for that matter), my writing is an attempt to *unmake* her mistake of not positively recognizing the maternal (the mother) in the child (who just happens to be a boy).

Splitting

While Barthes, Proust, Barrie, and Winnicott achieved a large part of "their cultural life" through their writings on the mother, Winnicott stands apart in that his writing was not based on experiences with his own real mother; rather, it was his psychoanalytic work with mothers and children. Winnicott's mother, Claire Winnicott, may have been depressed during his childhood, suggesting that the need for the "good-enough mother" may have grown from his own memories of maternal disconnection.[90]

While I honor Winnicott's utilization of the maternal as not only a form

of care but also cure, my writing is an attempt to *unmake* his mistake of not recognizing the utility of the maternal (the mother, the effeminate) in the string boy. Perhaps Winnicott felt gender anxiety about his own emphasis on the mother, about his use of the maternal for the model of his analysis. Perhaps Winnicott's disturbing analysis of the string boy was a defensive response to his own (presumably unconscious) fear of being read as feminized, as mother. Winnicott may have feared being torn up by Klein, the (other) "mother" of object-relations theory. (Interestingly enough, Winnicott analyzed Klein's son, Eric, although he managed to forego Klein's insistence that she should supervise the case. Likewise, Winnicott's second wife, Clare, underwent analysis with Klein.)

Klein claims in "Love, Guilt and Reparation" that the separation of "love" and "hate" (as are manifested in "destruction and reparation") is a false one. Love and hate exist in the human mind in "constant *interaction*."[91] This interaction can be envisioned as the seam that is the cut of Gordon Matta-Clark's *Splitting* (1974) (in which he famously sawed a real house in two), a mak*ing*, a do*ing*, that is never just "split." Yet despite her vision of the splitting, Klein far too often privileged the hate in her analysis, the aggression toward the mother's body, and seemed almost indifferent to the love and the healing. Similarly (but in exact opposition), Winnicott held and loved the mother's body, making light of the need to cut up, tear the body to pieces. His work was a worship of the mother, what Adam Phillips has suggested as a welcome and new theology of mothering.[92]

Unmaking Childhood

Adam Phillips explains in his book *On Flirtation* that both the excavation of dreams in psychoanalysis and the excavation of Pompeii in archaeology do something paradoxical: "By linking the fragments — whether it be of the patient's story, or the shards of the city — it makes possible imaginative reconstruction; and yet this very reconstruction contributes, or even causes, the final destruction and disappearance of the material."[93] Phillips's Pompeian metaphor plays out what I hope the reader already understands:

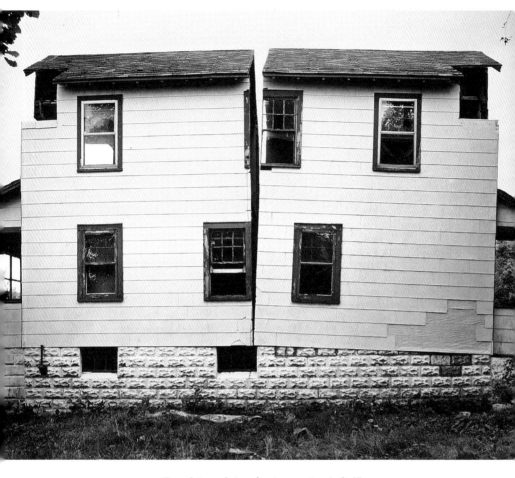

"a mak*ing*, a do*ing*, that is never just 'split.'"

when we dig up the home that our former small self once occupied in order to hastily repair it and make it an unsplit dwelling with an unfragmented story to tell, we overlook the unmaking of childhood that keeps the stacking, knocking, and splitting at hand.[94] In opposition to the adult archaeologist putting the house of childhood lost back together, I am arguing for a continual stacking, knocking, and splitting—what we might call a "child's eye-view of archaeology."[95]

Likewise, in *A Dialogue on Love*, Sedgwick suggests that the "reparative work" that she witnesses in her own "shrink" is less a repairing of the body as a broken vessel than it is a model for the "unmaking of mistakes."[96] If "home is a fiction," then reparative work is fiction and non-fiction: it splits childhood into a dwelling that is both the home with glistening windows and warm hearth as well as the dark house of lived experience. I think of the Bewitched Child's unmaking. I think of the "string boy's" unmaking. In each case, the emphasis is still on making and unmaking; it is a continual process of splitting that makes a house a home and a home a house, the place where children live, the place where childhood can live and breathe.

But where in this unmaking does Lartigue fit? It would seem, given his child-agency, that Lartigue "the boy-photographer" would offer a truer, if not true, gaze of childhood reparatively built around the architectonic split of home and house. Can we be so bold as to argue that Lartigue's pictures pivot on an actual innocent look, a childhood gaze, a child's eye-view of archaeology that unmakes? I think so. Lartigue down on the floor, camera and boy and race cars ready to run as one, one eye squints as he strains to see through his viewfinder a miniature world of automobiles—or Lartigue's slender boy body submerged in the bath while his hydroglider propels away from his impish grin, camera on a floating board, stout Mama ready to snap her boy at play—these are remarkable "childhood gazes," perhaps truer perspectives of childhood, nibbles of madeleine that touch us "like the delayed rays of a star."[97] But like the duplicities that turn on truths inherent to the discourses of psychoanalysis and photography, Lartigue's early photographs, seen by the relatively unencumbered eyes of a French

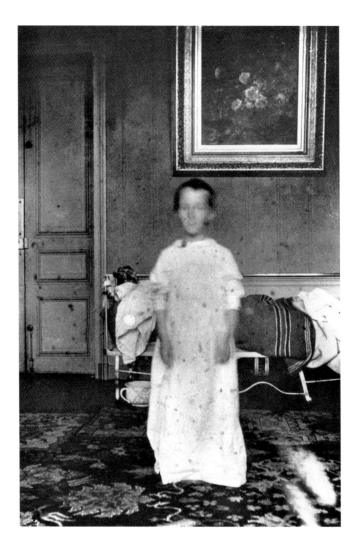

"an injured bird"

boy at the turn of the century, still perpetuate an unreal past that is as easy to swallow as a tea-soaked cake.

But there is a photograph that tastes less sweet, tastes less fresh: an image of Lartigue's cousin André Haguet, nicknamed Dédé, taken in Paris in 1906. In front of his unmade bed, that is in fact a foldout cot, a temporary place to sleep, to inhabit, to reside, we find Dédé as a ghost of a child. Although permanently stuck with his baby name between the pages of Lartigue's photo album, Dédé threatens to float away, evaporate. Already a ghost of a child, his face and body are a blur, not unlike our own memories of our childhood faces and bodies now lost. A chamber pot squats underneath his makeshift bed, above it a darkly painted still life of flowers in a heavy frame. We smell a different childhood here; we smell traces of a body that lives, dies, exhumes. We smell the taste of madeleine as giving way to waste—as when "all night long after a dinner at which" the young Narrator had partaken of asparagus, "they played . . . at transforming [his] chamber pot into a vase of aromatic perfume" (I, 169; I, 119). This perspective of childhood is not at home. Dédé is not "in a great cloak of snug." This could not be Dédé's bed, nor bedroom, nor home. Like the Narrator who is "not at home" with his magic lantern (because it rendered his bedroom unrecognizable), Dédé must have felt uneasy too, as if he were "in a room in some hotel or . . . a place where . . . [he] had just arrived by train for the first time" (I, 10; I, 9). This is not fiction. Dédé is the ghost of childhood past, a wingless insect, an injured bird, a swallow perhaps, that haunts the cracks, the chimneys, the open-timbered roofs of even the most elevated makings of home, of memory, of childhood, of Paris during the *Belle Époque*. It unmakes Lartigue's mistake of picturing only (well at least almost only) sunny days.

PULLING

RIBBONS

FROM

MOUTHS:

ROLAND

BARTHES'S

UMBILICAL

REFERENT

The subject of nostalgia comes into
the picture: it belongs to the precarious
hold that a person may have on
the inner representation of a lost object.
꿋 Winnicott, "Transitional Objects
and Transitional Phenomena"

Now I was no longer
separated from her;
the barriers were down;
an exquisite thread united us.
Besides, that was not all: for surely
Mamma would come.
꿋 Proust, *In Search of Lost Time*

⌐ ON JANUARY 7, 1977, Roland Barthes gave his inaugural lecture at the Collège de France in Paris. The scene: a jam-packed hall with people filling the seats, sitting on the floor, and even spilling out into the halls.[1] All wanted a glimpse of Barthes. All wanted the satisfaction of hearing his velvety voice, "resonant and what the French call *chantante*."[2] "Suddenly the noise died down and Roland came from the back of the hall and walked towards the platform, [his mother] Henriette on his arm as if a marriage was about to take place. Henriette took her seat in the front row while her son took his place behind the microphone on the platform."[3] ("I have never seen a finer love," Barthes's friend and fellow theorist Algirdas Julien Greimas would later claim.)[4] Among the ribbons of infra-language that Barthes pulled from his mouth that day, I am touched by these: "I should therefore like the speaking and the listening that will be interwoven here to resemble the comings and goings of a child playing beside his mother, leaving her, returning to bring her a pebble, a piece of string, and thereby tracing around a calm center a whole locus of play."[5]

Like Proust (whom Benjamin described as "that aged child"[6]), Barthes was a boyish man, forever tied to his mother in both his writings and his day-to-day life. Coming and going, Barthes would always return to her with his own pebbles and string. She was the peaceful center of his life. Even after he was grown, Barthes would come home for lunch with his mother (almost every day) by climbing through a trapdoor that connected their Paris apartments.[7] A gay man, Barthes fulfilled the stereotype of being too passionately close to the mother. Barthes played best (perhaps even solely) with his mother:

> When I was a child, we lived in a neighborhood called Marac; this neigh-
> borhood was full of houses being built, and the children played in the
> building sites; huge holes had been dug in the loamy soil for the foun-
> dations of the houses, and one day when we had been playing in one of
> these, all the children climbed out except me—I couldn't make it. From
> the brink above, they teased me: lost! alone! spied on! excluded! (to be

excluded is not to be outside, it is to be *alone in the hole*, imprisoned under the open sky: *precluded*); then I saw my mother running up; she pulled me out of there and took me far away from the children—against them.[8]

In the last chapter, I highlighted Barthes's famous statement, "The writer is someone who plays with his mother's body," in my discussion of play and object-relations theory.[9] The critic Susan Suleiman suggests persuasively that Barthes closes off the mother from the space of playing.[10] I am choosing to see Barthes's mother as playing *outside* of his games (of literature, theory, semiotics, etc.)—but playing in a shared space, "far away from the children—against them."

Barthes's playful words at his inaugural Collège de France lecture, his description of "the comings and goings of a child playing beside his mother, leaving her, returning to bring her a pebble, a piece of string, and thereby tracing around a calm center a whole locus of play," mirror the mise-en-scène of Winnicott's "good-enough mother": the mother who gives both herself and her child independence, sitting peacefully with her own work, perhaps reading or knitting, while the child plays in the light of her enveloping (not smothering) nurture.

Barthes's inaugural lecture was a "foretaste of the book he had just completed and would publish three months later with the title *A Lover's Discourse*,"[11] a book that would draw a whole area of play around the mother, with references to Winnicott's work. The Winnicottian scene nourished Barthes—he was like a child in touch with the presence of a "good-enough mother"—enabling him to weave the texture not only of his inaugural speech and *A Lover's Discourse*, but also, several years later, *Camera Lucida*. (One wonders what Henriette was doing, thinking, playing through her mind, while she sat below the stage of her son's performance at the Collège de France.)

Barthes's longtime friend and frequent translator, Richard Howard, observed Barthes and his mother on a trip to New York in the mid-1960s: Henriette was wearing her traveling costume (evidence of the source of Barthes's

own love of a "certain kind of 'British' tailoring"[12]). Looking back, Howard recalled that "one saw from their way of being together, from an interest in each other quite without inquisitiveness, that this mother and this son were able—rarest of family rituals—to enjoy the world they shared. It was not necessarily his world (or hers) . . . My discovery that his mother did not read his books, and that Roland did not expect her to, eased some family tensions of my own; this was but one of many lessons my friend was to impart."[13] Barthes touches on this subject himself in *Camera Lucida*:

> I never educated my mother, never converted her to anything at all; in a sense, I never "spoke" to her, never "discoursed" in her presence, for her; we supposed, without saying anything of the kind to each other, that the frivolous insignificance of language, the suspension of images must be the very space of love, its music.[14]

Henriette provided Barthes with something more honorable, more precious than semiotic squibbles or heavy cultural observations: a world partaken together, their world, out of this world.

Led out by his mother's hand (her apron strings), Barthes returned (as he would again and again) to Maman. ("From the brink above they teased me . . . *alone in the hole*, imprisoned under the open sky: *precluded* . . . then I saw my mother running up; she pulled me out of there and took me far away from the children—against them.") In *The Pleasure of the Text*, Barthes paraphrases his boyish, indeed effeminate, arguably queer desire to be dependent: "*The Pleasure of the Text* is not necessarily of a triumphant, heroic muscular type. No need to throw out one's chest. My pleasure can very well take the form of a drift."[15] The pleasure of reading and writing becomes a drift, a cruise. In the words of Barthes: "I must seek out this reader (must 'cruise' him) *without knowing where he is*. A site of bliss [jouissance] is then created."[16]

Henriette was Barthes's bliss, his jouissance.[17] His passion was for her. (It was not passion as in a passion for theater, Havana cigars, opera, a little Campari, film, Japanese meals, white peaches, too cold beer, Pollock—other, smaller passions of Barthes's.)[18] Barthes's maternal appetite was

bodily and beyond language. "Pleasure can be expressed in words, bliss cannot. Bliss is unspeakable, inter-dicted."[19]

Yet, as Barthes tells us, bliss is not far from boredom. If boredom is "desire for desire," — Adam Phillips's attentive take on it[20] — then one must use the body to crack, sever, fissure boredom's shell, so as to come into the bliss (desire itself) that awaits us. (In Benjamin's eloquent words: "Boredom is the dream bird that hatches the egg of experience.")[21] For Barthes, when the body cuts into the text, in an involuntary act separate from one's intellectual pursuits, the "prattle-text" is transformed into exquisite sensation, into bliss. "If the prattle-text [*le texte-babil*] bores me personally, it is because in reality I do not like the demand. But what if I did like it (if I had some maternal appetite)? Boredom is not far from bliss: it is bliss seen from the shores of pleasure."[22] In other words, to be bored is to merely see pleasure, as one sees the shore of a utopic island from the mainland, and to see pleasure (to read it) is not necessarily to experience it: one must inhabit it. (The mother is not bored by the prattle of her child: spoken from a body that was once a graft upon herself, the words from the mouth of her now-detached little one caress her own ears, a site of bliss is created — there is no distance here, no shore from the other side.) To experience pleasure as *of the body* — as opposed to merely seeing it, writing it, picturing it, speaking it, reading it from a distance — is to come into bliss, one might even say to suffer from it. "My body does not have the same ideas I do,"[23] writes Barthes. Overwhelmed with sensation — whether of the "composite odor" of his childhood summers spent in "Petit-Bayonne (the neighborhood between the Nive and the Adour)," with its smells of "the rope used by the sandal makers, the dim grocery shop, the wax of the old wood, the airless staircases, the black of the old Basque women . . . Spanish oil . . . the dust in the municipal library (where I learned about sexuality from Suetonius and Martial), the glue of pianos being repaired . . . chocolate"[24] — or whether of "the rumpled softness of [his mother's] crêpe de Chine and the perfume of her rice powder," awakened in an old photograph in which "she is hugging me, a child, against her"[25] — Barthes feels bodily desire as passionately at odds with consciousness.

One can, it seems, only happen upon this maternal appetite—it finds you. In *The Pleasure of the Text*, Barthes calls it *jouissance*. In the *Search*, Proust expresses it as "une mémoire involontaire." (Whose writing did Barthes love more than Proust's?) The odor of Proust returns often in the textures of Barthes's perfume. When it finds you, this maternal appetite, then one can indulge in the taste of the madeleine. And whether this maternal appetite is an appetite *for* the mother or *of* the mother, Barthes is purposely ambiguous, although one feels relatively sure that it is both. In Barthes's hands, just like the pleasure *of* the text, the maternal becomes both the object and the subject of his bliss. As this book has repeated, from its introductory appetizer that looks forward to dessert, to eat the madeleine cake is to eat the mother as well as to become her. To quote Proust again on his taste of his maternal cake: "It had the effect, which love has, of filling me with a precious essence . . . not in me, it was me" (I, 60; I, 44). Tiny and almost impalpable, this maternal appetite is best evoked in Barthes's tender love for certain photographs, where the referent plays there and gone, hide and seek, just like a mother.

The Spool Hits His Heart: Camera Lucida

In *Camera Lucida* (the book that Barthes wrote after his mother's death, the last book that he would publish before his death), the referent's "umbilical" connection to the actual photograph is a queer metaphor informed by Barthes's relationship to his mother. Just as Barthes's search for perfect lovers in *A Lover's Discourse*—and also in the posthumously published *Incidents*—often hinges on memories of, or experiences with, the mother, Barthes's search for the most meaningful, most moving, most touching, most poignant, most wounding photograph turns out to be a search for the perfect photograph of *her*, for *the* perfect photograph: "la Photographie du Jardin d'Hiver" (the Winter Garden Photograph), taken of Henriette at age five in 1898. Threading together incidents, anecdotes, and semiotic squibbles on the meaning of photography, *Camera Lucida*'s well-strung speech suspends Barthes and his stories like old-fashioned pearls, forever

clasped around his mother's tender neck. For Barthes, the link of the photo-graph to its referent is maternal.

Camera Lucida developed quickly—between April 15 and June 3, 1979—like a photograph. In fact, it developed extra quickly, like a Polaroid pic-ture, like purple spring crocus, like a last breath before death. Barthes died in 1980, the year that *Camera Lucida* was published. Critically injured when "knocked down by a laundry truck while crossing the street in front of the Collège de France,"[26] Barthes lingered, as if toying with death, as if playing with the idea of going with his mother. "Though he recovered sufficiently to receive visitors, he died fours weeks later."[27] It has been suggested that he died of a broken heart, of broken heartstrings. In *Camera Lucida*, Barthes himself predicts his death by lethal sorrow: "Once she was dead I no longer had any reason to attune myself to the progress of the superior Life Force (the race, the species) . . . From now on I could no more than await my total, undialectical death."[28] In his last letter to Richard Howard, four months be-fore the accident, the broken Barthes, bereft of desire, writes: "Don't think me indifferent or ungrateful—it's just that since Maman's death there has been a scission in my life, in my psyche, and I have less courage to under-take things. Don't hold it against me. *Ne m'en veuillez pas*."[29]

Without his mother, Barthes fears that he will desire nothing, that he will no longer speak his mother tongue (*la langue maternelle*). He finds himself to be alone. As Barthes remarks in *S/Z*, long before his loss of Maman: "When it is alone, the voice does no labor, transforms nothing: it [merely] expresses; but as soon as the hand intervenes to gather and intertwine the inert threads, there is labor, there is transformation."[30] For Barthes, the labor that comes from the body, the hand that intervenes, produces "*text, fabric, braid*: the same thing." But without his mother, labor might no longer be possible: the braid (the umbilical cord) is under the dark shadow of the scissors. To be reduced to a "unity of meaning" is "to *cut the braid*."[31]

The first page of *Camera Lucida* is not text, but just image, a just image. *Polaroïd*, as it is called, is a photograph of a bed taken in 1979 by Daniel Boudinet. (We are born from mothers in bed. We die in bed. We have sex in bed. We write in bed. We eat in bed.) It is the only photograph in the

"(We are born from mothers in bed. We die in bed.
We have sex in bed. We write in bed. We eat in bed.)"

book about which Barthes says nothing. For me, *Polaroïd* is the companion of the Winter Garden Photograph: the photograph that Barthes talks most about but never reproduces.[32] As he writes in *Camera Lucida*: "In front of the photograph of my mother as a child, I tell myself: she is going to die: I shudder, like Winnicott's psychotic patient, over a catastrophe which has already occurred."[33] *Polaroïd* has no text: the Winter Garden Photograph has no image. They are a queer couple (not unlike Barthes and his mother).

Womb-like, the light from *Polaroïd*'s window is diffused by gauzy curtains. Bits of light creep in through the loose weave of the fabric. Light leaks (where the curtains barely part, near the pillow) and drifts (through a small number of thin, select tears in the fabric). By invoking at once a watery membrane and aging sagging skin at once, the curtains pull at the delicate and somber texture of *Camera Lucida*. Soaked in precious robin's-egg blue, *Polaroïd* is the only color photograph among a total of twenty-five. The lovely color, a range of creamy green blues, gray green blues, and charcoal blues, infused with flickers of white light, is a surprise. Barthes does not like color photographs. He writes in *Camera Lucida*: "I always feel . . . that . . . color is a coating applied *later on* to the original truth of the black-and-white photograph. For me, color is an artifice, a cosmetic (like the kind used to paint corpses)." [34]

Polaroïd is one of only two pictures in *Camera Lucida* without people— the other is Joseph Niépce's *The Dinner Table* (circa 1823). Barthes's words dress *Polaroïd* not only in death, but also in the eyes of his mother. Searching through old photographs of Henriette, Barthes reminisces on the luminosity of her eyes. "For the moment it was a quite physical luminosity, the photographic trace of a color, the blue-green of her pupils."[35] As Diana Knight so cleverly points out: "This . . . is the mediating light that will lead him at last to the essence of her face, a blue-green luminosity which is also that of the Boudinet polaroid."[36]

Polaroïd is both domestic and erotic. The late artist Félix González-Torres, himself a lover of Barthes (at least of his words), must have been inspired by Barthes's use of the Boudinet picture; González-Torres's own beautiful billboard of an empty bed is alive with crumpled sheets and the indexical re-

"alive with crumpled sheets and the indexical remains of loss."

mains of loss.[37] I am moved by the indentation, where a head once rested on the white, white pillows. (Now familiar with González-Torres's work and biography, I understand that it was the head of his lover, Ross, that left the indexical trace in the pillow; but initially I could dream of who had been in his rumpled bed. Himself? An unnamed lover? His mother?) Barthes's use of Boudinet's picture also takes me back to Imogen Cunningham's *The Unmade Bed* (1957), a portrait of an empty bed, save for a few hairpins which, despite their small size and their delicate being, take over the picture. The hairpins (a heavyset threesome and a lanky twosome) are the kind that women used to wear when it was popular, perhaps even necessary, to have long hair that could be pulled up in chignons or wrapped up in buns. They are evidence of hair taken down for its erotic effects. Forgotten in a bed, the hairpins become iconographic signs of something lost. Perhaps the braid has been cut; the hairpins are now catastrophic signs of remainder without

return. (Is sex ever without loss?) Yet, the hairpins also stubbornly (and pleasurably) point back to a grandmother's white hair. (Mine bought these pins in silver, not black. They were hard to find.) The hairpins may poke at eroticism, but (for me at least) they also poke at a maternal grandmotherly goodness which (rightly or wrongly) is not accustomed to traveling in erotic circles. Prosthetic tongues, these hairpins waver and bend their own secret letters, so as to sound out "mother" and "erotic" ("motherotic"), in an unfamiliar, if welcomed, mother tongue.

Camera Lucida is dark. The book, as if it were a night-blooming cereus, opens in darkness and then quickly fades. Barthes, as we have previously seen, writes that he wants to "be a primitive, without culture,"[38] without light. His labor is to patch light leaks. Like the photographer who pulls a

"these hairpins waver and bend their own secret letters, so as
to sound out 'mother' and 'erotic' ('motherotic')"

"'My stories are a way of shutting my eyes.'"

black cloth over his head in order to see the upside-down image reflected on the camera's back, Barthes can see better in darkness; this is his photopathy. "In order to see a photograph well, it is best to . . . close your eyes . . . My stories are a way of shutting my eyes."[39] He shuts his eyes and dreams about *her*. Barthes confesses: "I dream only about her."[40]

Barthes lives his mother's memory like a photograph: as both there and gone. (Fort/da.) Just as Freud's young grandson Ernst invented a game in order to cope with his mother's absence, Barthes invents a game for reading photographs in order to cope with the loss of his mother. Barthes throws

the contradictory there–gone *condition* of the photograph back and forth. All photographs play there and gone. But when a photograph specifically touches Barthes, moves him, wounds him, his "spool" hits his heart. "The text no longer has the sentence for its model [but the mother]; . . . it is a powerful gush of words, a ribbon of infra-language."[41] Barthes discovers photographs which speak to him, which whisper *her* voice (*her* grain[42]), which awaken in him "the rumpled softness of her crêpe de Chine and the perfume of her rice powder."

In *Camera Lucida*, Barthes's mother becomes other than "mother," what Barthes calls elsewhere "family without familialism."[43] When Barthes is caring for her at the end of her life, she becomes the child, his child, "his little girl." Barthes writes: "During her illness, I nursed her, held the bowl of tea she liked because it was easier to drink from than from a cup; she had become my little girl, uniting for me with that essential child she was in her first photograph."[44] Henriette is Barthes's Ariadne; she gives him the thread to photography (to life).

In the theater of *Camera Lucida*, Henriette plays not only mother-turned-daughter, but also mother-turned-wife, as is dramatically implied by Barthes's caption for Nadar's photograph of his wife Ernestine: "The Artist's Mother (or Wife)." In Nadar's photograph, Ernestine is paralyzed, partially bedridden, her hair is soft, white, appealingly disheveled, she plays with our expectations, she (an old woman!) flirts with the camera, her husband, *or* her son. Ernestine, whom Nadar called "Madame Bonne,"[45] sensually holds a bouquet of violets to her mouth, as if she were a young girl, as if she were Édouard Manet's *Street Singer*. When writing about Nadar's picture, Barthes compares the unknown photographer of the Winter Garden Photograph to Nadar, just as he compares the photograph of Henriette at the age of five (taken in 1898) to the photograph of the elderly Ernestine (taken in 1890). Barthes writes:

> The unknown photographer of Chennevières-sur-Marne [who took the Winter Garden Photograph] had been the mediator of a truth, as much as Nadar making of his mother (or of his wife — no one knows for cer-

"she plays with our expectations, . . . he compares the photograph
of Henriette at the age of five (taken in 1898) to the photograph of
the elderly Ernestine (taken in 1890)."

tain) one of the loveliest photographs in the world; he had produced a supererogatory photograph which contained more than what the technical being of photography can reasonably offer.[46]

Those familiar with the history of photography understand that Barthes is playing with the possibility that this late photograph of Nadar's could have been taken by his son Paul. But in Barthes's hands (the hand of an eternal boy-child), the picture plays with love between a grown son and his mother as erotic, as too close, as unnatural, as inverted — as many understood Barthes's relationship to his Maman, his Henriette, to be. (As Barthes writes of the mother in Bertolt Brecht's *The Mother*: "She is not the expected figure of maternal instinct, she is not the essential mother: her being is not on the level of her womb."[47])

Tied to the Mother-Tongue

As a sign for his utopic travels, which thrust him forward and backward at once (fort/da), Barthes metaphorically reunites with the maternal through the umbilical cord. Almost organ, but not, this strange form is exceptional: both sexes share it while still in the womb. Originally and always neither the child's nor the mother's, it dramatically connects to both *him* and *her*, maintaining (as Luce Irigaray celebrates in "(W)rest(1)ing with the Mother") an ethics of sexual difference through connection and nurturance.[48] Connecting mother to child and child to mother, the umbilical cord with its surreal "neither-nor" sex performs its beauty as fort/da toy. For Barthes, the umbilical cord doubles as a sign for his connection to his mother (both there and gone), and for the photograph's connection to its referent (both there and gone). Mother and photography owe their "genius" to their relation to the real: one is certain of having been there (in the mother's body), and one can also say for certain (at least Barthes can) that the person photographed was there. Barthes adheres to his Maman, just as the referent adheres to the photograph.

Barthes's love for his mother is the archetype not so much for the *photo-*

graph but, rather, for *the condition of* photography.[49] Led by the thread of words caught in a(maze)ment for her, Barthes's photographic discourse becomes the maternal body: a place that was always already there, a place where he was sure that he had once been, a place that he could never fully leave . . . the maternal body as *the* place:

> All the world's photographs formed a Labyrinth. I knew that at the center of this Labyrinth I would find nothing but this sole picture . . . The Winter Garden Photograph was my Ariadne, not because it would help me discover a secret thing (monster or treasure), but because it would tell me what constituted that thread which drew me toward Photography.[50]

Confusingly, Barthes posits the Winter Garden Photograph as both monster ("at the center of this Labyrinth") and his Ariadne. As a result, Barthes's emphasis is less on the *real* maternal body represented in the Winter Garden Photograph (the presumed "secret thing"), than on "that thread." (Barthes: "I cannot reproduce the Winter Garden Photograph. It exists only for me. For you, it would be nothing but an indifferent picture.")[51] Barthes gives us the thread (which in his hand is desire), but no "treasure." Following the thread is difficult, at times impossible. One gets so tangled, so tied up. Barthes writes: "I tie up my image-system (in order to protect myself and at the same time to offer myself)."[52] Barthes's web, full of desire, is as protective as it is generous. Barthes's connector thread travels toward meaning (the mother) without ever really getting there, just as the photograph travels endlessly toward the referent. Only Barthes can have *his* mother, *his* Maman.

Barthes's writing on the Winter Garden Photograph, with its emphases on being within Mother, within language, is caught, like the photographic work of Lesley Dill, within a "kind of body language turned inside out."[53] Barthes comes out with his mother's body on the tip of his tongue, his own "mother-tongue." Dill opens up mouths to speak visible words that float like the precious letters shared between Virgin and angel in Simone Martini's and Lippo Memmi's *The Annunciation and Two Saints* or in Jan

"'vocal writing'"

van Eyck's *The Annunciation*. Such images are especially lovely in that the words emanating from the angels' mouths give a sense of immediacy, of what Barthes might call "vocal writing."[54] The painted salutations from the angel that heat up the Virgin's ear, "encourage viewers themselves to say the words aloud."[55] ("If it were possible to imagine an aesthetic of textual pleasure, it would have to include: *writing* aloud . . . what it searches for [in a perspective of bliss] are the pulsional incidents, the language lined with flesh, a text where we can hear the grain of the throat, the patina of consonants.")[56]

The ribbons of emanating speech in Dill's *A Mouthful of Words* imitate the banderoles of medieval and late gothic paintings—they are like the ribbons of letters that defy gravity, that have minds of their own, in Robert Cam-

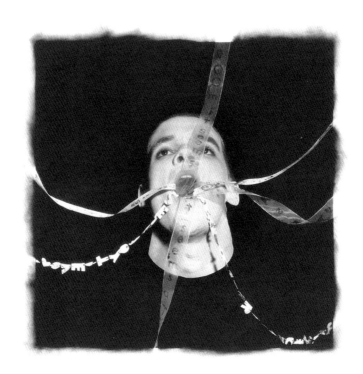

"'a text where we can hear the grain of the throat,
the patina of consonants.'"

"ribbons of letters that defy gravity"

pin's *Nativity*: a young man with his mouth open (perhaps in song); his eyes cast upward (perhaps toward heaven); and barely legible Emily Dickinson poems issuing umbilically from his mouth. Letters are twisted, backward, reversed. Some are cutout paper letters strung together on thread, evoking the garlands of metallic cardboard letters that spell HAPPY NEW YEAR or HAPPY BIRTHDAY. And, much as in the full-page illumination from *Les heures de Rohan* (circa 1418), *Office of the Dead*—where a blue background is host to a wallpaper pattern of angels and stars in gold, where text flows in ribbons from the dead man below and from God above, but also on God's gold-trimmed pink robe and moonlike halo, where the ground is littered with tiny bones that sometimes cross into xs or curve into cs, where the pattern of the blue cloth that the dead man lies on is evenly sprinkled with tiny circles that are also os, where the rectangle of text begins with a violet D that is filled with a skull—there is not so much a tension between text and image in *A Mouthful of Words* as there is an emphasis on text as image.

The banderoles of Dill's *A Mouthful of Words* and the *Office of the Dead* speak the fetishistic language of *the condition of* the photograph: a moment forever lost (dead) and forever sustained (living). The photograph is life and death pictured *utopically*, at once. *A Mouthful of Words* speaks to the photograph's fragile (yet strong) umbilical link between life and death—the ribbons connect to the dead, perhaps to Dickinson herself, via the heavens of the earthling's directed gaze. In the *Office of the Dead*, there is no doubt that the banderole of the emaciated dead man is directed to God. The Latin on the phylactery emerging from his mouth is a "prayer for the dying" from Psalms 31:5: "In manus tuas, Domine, commendo spiritum meum; redemisti me Domine, Deus veritatis" (Into your hands I commit my spirit, redeem me, O Lord, the God of truth).[57] God answers him in French verse, paraphrasing the words of Christ to the repentant thief: "Pour tes Péchés pénitence feras. Au jour du Jugement aveques moi seras." (For your sins you shall do penance. On Judgement Day you shall be with Me).[58]

Like a photograph, the *Office of the Dead* captures both death and life,

"making strange bedfellows out of emulsion and the love of God."

making strange bedfellows out of emulsion and the love of God. The tiny soul of the dead man, represented in the form of a naked adolescent, held momentarily by Satan, while "the Archangel Michael hurls himself down with lifted sword to attack the devil, whom he seizes by the hair, and who is pierced by spears held by warriors of the heavenly host."[59] Only archangels, like Gabriel or Michael, are said to move between the mortal (the terrestrial) and the immortal (the heavenly). Like the umbilical cord, angels occupy the neuter, moving "between one order and another while being identified with neither."[60] The "shimmering, always moving being"[61] is the angelic texture of Barthes's most hedonistic texts. (For the cover of *A Lover's Discourse*, Barthes chose a fragment of *Tobias and the Angel*, a painting by a follower of Andrea del Verrocchio, featuring the laced arm of the Archangel Raphael, disguised as a man, tenderly, lovingly, erotically, homoerotically, holding the hand of Tobias. Unfortunately for English readers, Barthes's perfect choice of a visual image for *A Lover's Discourse* was not honored in its translation.) The *Office of the Dead*, like Barthes's *Camera Lucida*, like a photograph, like *A Mouthful of Words*, is an angel caught between life and death.

When the connection to a photograph is especially profound (as in Barthes's connection to his mother, as in his connection to the Winter Garden Photograph), Barthes experiences punctum, the moment when a piece, a fragment, a bit of the photograph punctuates, interrupts, wounds, "shoots out . . . like an arrow, and pierces" the viewer.[62] Like Marta Maria Pérez Bravo's photograph from her *Para Concebir* (To conceive) series (1985–86), "Barthes's *punctum*-pictures pull at the beauty and the horror of all that is metaphorically implied by the small scar that cuts into the smoothness of all of our bellies, our navel: the irreducible mark of our birth and our guaranteed death. Our umbilical scar always pulls at the lost mother, just as photography pulls at its lost referent . . . That is why (some) photographs *wound* Barthes: he feels it like a stab in the abdomen."[63]

Punctum is always personal (not universal like the studium of a photograph, which speaks clearly to a docile subject with intended meanings

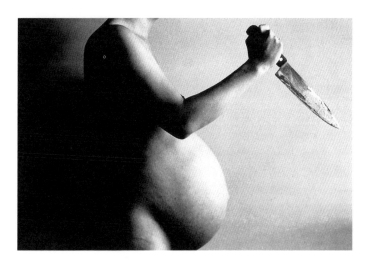

" 'That is why (some) photographs *wound* Barthes:
he feels it like a stab in the abdomen.' "

that are unproblematically discerned). Punctum comes unexpectedly, just as pleasure (jouissance) does in *The Pleasure of the Text*. "The studium is ultimately always coded, the *punctum* is not."[64] As a student once wrote in one of my courses: "For me, the text outside of the secretive punctuation is my *studium*, and what lay within, my *punctum*. While *Camera Lucida* can only be described as a personal journey, it is within the parentheses that I find the author . . . They are the gaps in the text, where contradiction finds a home."[65] Punctum is bodily: it is as if one were being punctured and stitched, resewn to the mother's body. The umbilical cord becomes real/ reel, a "carnal medium":

> The photograph is literally an emanation of the referent. From a real body, which was there, proceed radiations which ultimately touch me, who am here; the duration of the transmission is insignificant; the photograph of the missing being, as Sontag says, will touch me like

the delayed rays of a star. A sort of *umbilical cord* links the body of the photographed thing to my gaze: light, though impalpable, is here a carnal medium, a skin I share.[66]

and,

> Thus the air is the luminous shadow which accompanies the body; and if the photograph fails to show this air, then the body moves without a shadow, and once this shadow is severed, as in the myth of the Woman without a Shadow, there remains no more than a sterile body. It is by this tenuous *umbilical* cord that the photographer gives life; if he cannot, either by lack of talent or bad luck, supply the transparent soul its bright shadow, the subject dies forever.[67]

A photograph is but a shadow of what once was there, but now is gone — not unlike the mother, whom we all have to live without "sooner or later."[68] She comes and she goes.

Mother-Lover: Incidents and A Lover's Discourse

> Let the other appear, take me away, like a mother who comes looking
> for her child.
> —Roland Barthes, *A Lover's Discourse*

The posthumous *Incidents* can make you twinge with embarrassment and even sadness for its strangely maternalized sexuality. There is the uneasiness one feels (along with Barthes) when he lies his head on his lover's shoulder, as if his lover were his Mam: "In the elevator, I kissed him, rested my head on his shoulder; but whether this wasn't his sort of thing, or because of some other reticence, he responded only vaguely."[69] There is Barthes's relief when a boy prostitute, paid in advance, does not show up — yet, like the mother who waits for her grown son, Barthes also feels stupid and silly for even pretending to believe that the beautiful young man would show as planned. And there is the moment when Barthes, as he walks the late-night

streets of Paris, catches himself walking home to Mam, as if it were the old days, when Mam was not really gone, when Mam was not dead: "I climb the stairs and pass my own floor without realizing it, as if I were returning to our apartment on the fifth floor, as if it were the old days and Mam were there waiting for me."[70]

Barthes writes himself and his lover as a mother-child couple. Just as Winnicott subtly eroticizes the early relationship between mother and child as a couple, Barthes maternalizes his erotic relationship with his lovers. For Barthes, a pair of lovers is no more or less erotic and nourishing than the mother and child pair—nor is it any less of a catastrophe. Barthes moans of a lost love, "the amorous catastrophe,"[71] in *A Lover's Discourse*:

> I shut myself in my room and burst into sobs: I am carried away by a powerful tide, asphyxiated with pain; my whole body stiffens and convulses: I see in a sharp, cold flash, the destruction to which I am doomed. . . . This is clear as a catastrophe . . . an abrupt sexual rejection . . . seeing oneself abandoned by the Mother.[72]

Barthes feared, must have always feared, his mother's absences. Barthes writes in *A Lover's Discourse*:

> Endlessly I sustain the discourse of the beloved's absence; actually a preposterous situation; the other is absent as referent, present as allocutory. This singular distortion generates a kind of insupportable present; I am wedged between two tenses, that of the reference and that of the allocution: you have gone (which I lament), you are here (since I am addressing you). Whereupon I know what the present, that difficult tense, is: a pure portion of anxiety.
>
> Absence persists—I must endure it. Hence I will *manipulate* it: transform the distortion of time into oscillation, produce rhythm, make an entrance onto the stage of language (language is born of absence: the child has made himself a doll out of a spool, throws it away and picks it up again, miming the mother's departure and return: a paradigm is created). Absence becomes an active practice, a *business* (which keeps

me from doing anything else); there is a creation of a fiction which has many roles (doubts, reproaches, desires, melancholies). This staging of language postpones the other's death: a very short interval, we are told, separates the time during which the child still believes his mother to be absent and the time during which he believes her to be already dead. To manipulate absence is to extend this interval, to delay as long as possible the moment when the other might topple sharply from absence into death.[73]

As Winnicott himself writes in "Transitional Objects and Transitional Phenomena": "If the mother is away over a period of time which is beyond a certain limit measured in minutes, hours, or days, then the memory or the internal representation fades."[74] A few pages later, Winnicott dramatically elaborates: "Before the limit is reached the mother is still alive; after this limit has been overstepped she is dead."[75]

A Lover's Discourse is knitted into familiar cardigans of love, which give like a mother, even when it hurts or, perhaps, especially because it does hurt. ("Barthes surprises us in . . . *A Lover's Discourse* by making love, in its most absurd and sentimental forms, an object of interest.")[76] In these delicate, nearly invisible, always elegant twists of beautiful somber yarn (olive, sienna, charcoal), button holes, horn buttons, careful darning done with the exactly right color, even a fragment under the heading of "Blue Coat and Yellow Vest,"[77] Barthes uses Winnicott to cast off his maternalized discourses of love (along with Proust, and also Goethe's young Werther).

The blue coat and yellow vest is of course the "costume à la Werther."[78] It is the costume that Werther first wore when he danced with his love, the object of his indefatigable crush, Lotte. He wore it constantly until it wore out. Forlorn and threadbare as his uniform, Werther had another blue coat and yellow costume sewn. Ultimately, Barthes understands Werther's blue coat as a sign for his Mother, his Mam, his Madonna (the color of the Virgin Mother is blue), who stood alone, not for mankind, but for him. As Barthes writes in *A Lover's Discourse*:

It is in this garment (blue coat and yellow vest) that Werther wants to be buried, and which he is wearing when he is found dying in his room. Each time he wears this garment (in which he will die), Werther disguises himself. As what? As an enchanted lover: he magically re-creates the episode of the enchantment, that moment when he was first transfixed by the Image. This blue garment imprisons him so effectively that the world around him vanishes: *nothing but the two of us*: by this garment, Werther forms for himself a child's body in which phallus and mother are united, with nothing left over.[79]

Going back to his lover, Werther is, according to Barthes, backstitch-ing to the body of mother. Barthes, too, wears the "perverse" costume of Werther, just as enthusiasts of *Die Leiden des Jungen Werther* did during the height of the novel's popularity.[80] Barthes is also wearing his mother's blue coat, mantle, veil. Queerly, boyishly, Barthes wears his love for Werther and his love for his mother on his sleeve, in one sartorial, Freudian gesture, so that his body just might remain that of "child": "phallus and mother are united."

Barthes comes out in *A Lover's Discourse* as a queer man whose relation-ship with his lover mirrors the crisis of the infant who, without transitional objects, believes that the breast is still under his magic control. Only for Barthes, the breast becomes a "being," a lover:

> The being I am waiting for is not real. Like the mother's breast for the infant, "I create and re-create it over and over, starting from my capacity to love, starting from my need for it": the other comes here where I am waiting, here where I have already created him/her. And if the other does not come, I hallucinate the other: waiting is a delirium.[81]

Barthes purposefully refuses to open, or close, the trapdoor between illu-sion and disillusion, between being one with the mother and being separate from the mother.

Barthes is an eternal boy. As a boy, he wants to be loved by boys. But as Barthes writes in the year before his death (in "Soirées de Paris," the

intimate journal that concludes *Incidents*), he is no longer desired by boys, by his lover/boy, "Olivier G.": "I sent him away, saying I had work to do, knowing it was over, and that more than Olivier was over: the love of *one* boy."[82] Aged, Barthes no longer has the privilege of loving a boy. Before sending Olivier away, Barthes records the following incident:

> I asked him to come and sit beside me on the bed during my nap; he came willingly enough, sat on the edge of the bed, looked at an art book; his body was very far away—if I stretched out an arm toward him, he didn't move, uncommunicative: no obligingness; moreover he soon went into the other room. A sort of despair overcame me, I felt like crying. How clearly I saw that I would have to give up boys, because none of them felt any desire for me, and I was either too scrupulous or too clumsy to impose my desire on them; that this is an unavoidable fact, averred by all my efforts at flirting, that I have a melancholy life, that, finally, I'm bored to death by it.[83]

Barthes feared boredom all his life. He feared seeing bliss only "from the shores of pleasure." As he writes in *Roland Barthes*:

> As a child, I was often and intensely bored. This evidently began very early, it has continued my whole life, in gusts (increasingly rare, it is true, thanks to work and to friends), and it has always been noticeable to others. A panic boredom, to the point of distress: like the kind I feel in panel discussions, lectures, parties among strangers, group amusements: wherever boredom *can be seen*. Might boredom be my form of hysteria?[84]

If in boredom, as Adam Phillips argues, the child waits for something to happen, for the reliable mother to come,[85] what happens to Barthes at the end of his life, without Maman, without boys? Barthes is caught between what he desires (boys and Maman) and what he cannot have (boys and Maman). Seen only from a distanced shore, their pleasure could not be experienced. Bliss was out of reach: no strings attached. Perhaps Barthes was truly bored to death.

In *A Lover's Discourse*, Barthes relates his fear of losing a lover to the child's fear of losing his mother. By recalling Winnicott's "string boy," Barthes, too, becomes a boy in hopes of reconnecting, of staying connected, with his mother. The boy's string becomes an umbilical referent, inspiring Barthes to play (in *A Lover's Discourse*) with the body of his lover as if his lover were his mother. We have already heard that the string boy's parents observed that their seven year old "had become obsessed with everything to do with string, and in fact whenever they went into a room they were liable to find a cushion, for instance, with a string joining it to a fireplace."[86] In response, Winnicott compared the boy's use of the string to the use of the telephone: "I explained to the mother that her son dreaded the separation he was attempting to deny, by pulling on the string, just as we deny our separation from a friend by resorting to the telephone."[87] (One, too, wonders about Winnicott's attachment to string and the female body, when one recalls, as was first highlighted in the first chapter of this book, that his father, Frederick Winnicott, was a merchant, "specializing in women's corsetry."[88])

Barthes invokes the string boy's attachment to his mother through the Winnicottian metaphor of the telephone:

> Freud, apparently, did not like the telephone, however much he may have liked *listening*. Perhaps he felt, perhaps he foresaw that the telephone is always a *cacophony*, and that what it transmits is the *wrong voice*, the false communication. . . . No doubt I try to deny separation by the telephone — as the child fearing to lose its mother keeps pulling on a string; but the telephone wire is not a good transitional object, it is not an inert string; it is charged with a meaning, which is not that of junction but that of distance.[89]

The telephone, despite being a sign of both separateness and union, is not a "good enough" transitional object for Barthes. Barthes prefers a state of sustained illusion, with both his mother and his lovers.

Calling up Freud again, Barthes recognizes that Winnicott's transitional object is yet another form of Freud's game of fort/da. Braiding the three

together (Ernst, Freud, Winnicott), Barthes configures his relationship to his absent lover after the fashion of Ernst's longing (and playing) for his absent mother: "Language is born of absence: the child has made himself a doll out of a spool, throws it away and picks it up again, miming the mother's departure and return: a paradigm is created."

In addition to using Winnicott's theories of the transitional object to illuminate the mise-en-scène of lovers' talk in *A Lover's Discourse*, Barthes also deploys Winnicott's image of the "good-enough mother" to signal how one is *expected* to love without loving too much, without being overly possessive. In fact, Barthes founded his creative play on an intriguing pattern of unweaned threads by turning the "transitional object" and the "good-enough mother" inside out. In one illuminating twist on Winnicott in *A Lover's Discourse*, Barthes lays out the impossible task of being a "good-enough lover":

> (. . . I know *right away* that in my relation with x, y, however prudently I restrain myself, there is a certain amount of *being-in-love*), it is also true that in *being-in-love* there is a certain amount of *loving*: I want to possess, fiercely, but I also know how to give, actively. Then who can manage this dialectic successfully? Who, if not the woman, the one who does not make for any object but only for . . . giving? So that if a lover manages to "love," it is precisely insofar as he feminizes himself, joins the class of *Grandes Amoureuses*, of Women Who Love Enough to Be Kind.[90]

The "class of *Grandes Amoureuses*, of Women Who Love Enough to Be Kind," is made up, of course, of those women who like "good-enough mothers," are able to squelch their overwhelming love (whether for their children or lovers), so that they can give their "loves" space.

The "good-enough" lover or mother also appears in a second lengthy passage from *A Lover's Discourse*. Barthes makes direct reference to Winnicott's notion of the perfect setting for play, in which the mother is lovingly there, but is in no way controlling or interfering with her child's creativity.

And again, just as Barthes "had nursed [his mother], held the bowl of tea she liked because it was easier to drink from than from a cup," turning his mother into his "little girl," Barthes becomes the mother-lover:

> In order to show you where your desire is, it is enough to forbid it to you a *little* (if it is true that there is no desire without prohibition). x wants me to be there, beside him, while leaving him free *a little*: flexible, going away occasionally, but *not far*: on the one hand, I must be present as a prohibition (without which there would not be the right desire), but also I must go away the moment when, this desire having formed, I might be in its way: I must be the Mother who loves enough (protective and generous), around whom the child plays, while she peacefully knits or sews. This would be the structure of the "successful" couple: a little prohibition, a good deal of play; to designate desire and then to leave it alone.[91]

Barthes travels between being a smothering lover and a distanced lover, but like "x" he was never able to be "good-enough" (though I do not think he ever actually desired to be among those "Who Love [*dispassionately*] Enough to Be Kind"). Yet, like Ernst and the unnamed "string boy," who pull and play with Mother's strings—taking us to and from metaphors of Ariadne, apron strings, and telephones as well as to the heartstring itself: the umbilical cord—Barthes's pull on lovers (in *A Lover's Discourse* and *Incidents*) or photographs (in *Camera Lucida*) is ultimately an exaggerated, if obsessive, tug on the skirt of Maman.

◁ IN THE INTRODUCTION to *Playing and Reality*, Winnicott draws attention to the "*paradox* involved" in using a transitional object: what is significant "is not the cloth or the teddy bear that the baby uses—not so much the object used as the use of the object."[92] Likewise Barthes's emphasis on the Winter Garden Photograph is not so much an emphasis on "the object used as *the use of the object*." Both Winnicott and Barthes use the string and umbilical cord to symbolize a maternalized paradox of separateness and

"these two bulbs, entwined in umbilical electric flex, are lit by love."

union, whether in the transitional object (whose paradox plays between reality and illusion, me and not me) or the photograph (whose paradox plays between real and not real, dead and alive, there and gone).

Just as *Camera Lucida* grew from loss, from a fear of being just one (without Henriette), Félix González-Torres's *"Untitled" (March 5th) #2* (1991) grew from loss, from a fear of being just one (without Ross). Gonzalez-Torres's subtitles almost always refer to his perfect lover: Ross. March 5 is Ross's birthday. Ross died in 1991, the year that *"Untitled" (March 5th) #2* was made — *Camera Lucida* was written in 1979, the year that Henriette died. In *"Untitled,"* we learn, "one bulb will dim first leaving the other to light the way,"[93] in the same way that Ross dimmed first, leaving Félix to light the way. Another piece that González-Torres executed in 1991 is *Untitled (Lover Boys)*, in which two battery-operated clocks almost touch, as if in a near kiss, but not quite, they "tick in unison until one begins to wind down."[94] The bare light bulbs of *"Untitled" (March 5) #2* are naked, just born, new, destined to die: they kiss too. Suspended in their becoming womb, these two bulbs, entwined in umbilical electric flex, are lit by love.

NESTING:

THE

BOYISH

LABOR

OF

J. M. BARRIE

MRS DARLING: My dear,
when I came into this room
to-night I saw a face
at the window.
MR DARLING: A face at the
window, three floors up?
Pooh!
MRS DARLING: It was
the face of a little boy;
he was trying to get in.
George, this is not the first time
I have seen that boy.
⤳ J. M. Barrie, *Peter Pan*

Like faces in windows
calling you home,
like flying, like flight.
⤳ Eliza Minot, *The Tiny One*

AS CHILDREN WE BELIEVED WE COULD FLY. Flying is escape artistry. J. M. Barrie dreamed of delicious, childish flight, of being with the stars, of being a bird, of not being a man.[1] Perhaps, when Adam Fuss made his photogram of a tiny, tiny, fragile, many-runged enchanted ladder leading to a luscious butterscotch-taffy-tangerine-nasturtium bird (from his series "In Between"), he too was dreaming of flight. Such dreams were possible when one felt tiny — "like a titmouse which the breeze gently rocks at the tip of a sunbeam" (I, 8; I, 8) — when one's weight would not break a dream-rung, when one believed one could safely get to the final rung and fly away.[2]

To dream of flight, as Barrie did, before World War I (1914–18) was a form of boyish labor far from death, couched in the height of the airy Belle Époque, a sweet soufflé before the time of its fall, before bombing sorties, before the British Royal Navel Air Service hit and destroyed the first Zeppelin on October 8, 1914.[3] To look at the frame of a Zeppelin shot down by WWI bomber planes is to look at an albatross of joyous flight turned dinosaur bones: "hurt and distraught . . . the flier's hobbled step."[4] How telling that in the stage production of *Peter Pan*, the play's famous line, spoken by Peter, "To die will be an awfully big adventure" (*PP*, 125), was dropped in 1915.[5]

Off to a Flying Start

In 1904, Barrie was but "a wisp of a man,"[6] "still very thin,"[7] but it was a big year: *Peter Pan* took off from the London stage at the Duke of York's Theatre and has been flying high ever since. Barrie had written a Christmas play, a fairy play, that was magical, beautiful, maddening, fun, and mean, just like children, who are, as the author famously concludes in *Peter and Wendy*, "gay, innocent and heartless."[8] Wise, never-growing Peter knows that children and adults love naughtiness. In the words of the stinging, dare I say Peter-like, childhood critic James Kincaid: "Wise children figure out that what we are after is the enticing naughtiness that comes from disobedience, *their flight leaving open* the child's spot so that we can occupy it."[9]

"Barrie dreamed of delicious, childish flight"

With a sadistic piece of drama that cleverly flirts with childhood innocence, Barrie lets Peter fly so that we might all become children, "right on the spot." Right from the start of *Peter and Wendy* (the novel is even fuller with sarcasm and sadism) Barrie toys with his audience, who listen, their breath held, as Mr. and Mrs. Darling are destined not to reach the nursery before John, Michael, and Wendy fly: "Will they [Mr. and Mrs. Darling] reach the nursery in time? If so, how delightful for them, and we shall all breathe a sigh of relief, but there will be no story" (*P&W*, 101).

On December 27, a little past Christmas, we finally get our present, our story. Peter too was running late. *Peter Pan* was to open on December 22,[10] so as to bring in Christmas with plenty of magic — but we all know "that it is quite impossible to say how time does wear on in the Neverland, where it is calculated by moons and suns and there are ever so many more of them

"'hurt and distraught . . . the flier's hobbled step.'"

Zeppelin shot down near Colchester; its back broken, towers above a nearby farm.

"history was buoyant with travels through the air:
like bubbles blown from a Cornellian clay pipe . . .
like bubbles blown from the pipe-turned-toy in
John Everett Millias's famous *Bubbles*"

⁂

than on the mainland" (*P&W*, 136). "Not so much a play as a spree," hailed the *Morning Post*.[11] Time flew fast, thanks to the pleasures of the complicated flights of Peter Pan, John, Michael, and Wendy (tough hang-ups, both as stage production and cultural metaphor).

By the time the curtain went up to reveal the Darlings's nursery and the children began to fly, history was buoyant with travels through the air: like bubbles blown from a Cornellian clay pipe . . . like bubbles blown from the pipe-turned-toy in John Everett Millais's famous *Bubbles* . . . like Edouard Manet's Boy *Blowing Bubbles* . . . like C. V. Boys's book, *Soap Bubbles and the Forces Which Mould Them*. (These were the boy-muses for Cornell's "Soap Bubble" boxes.)

As early as September 1783, Joseph and Etienne Montgolfier had in-

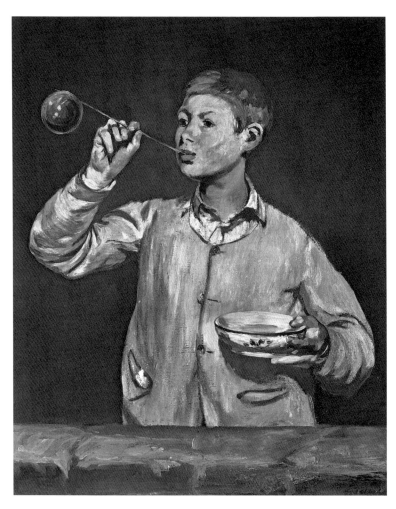

"like Edouard Manet's *Boy Blowing Bubbles*"

vented the first hot-air balloon, sending up a sheep, a rooster, and a duck as its first passengers. Only the duck, with the genes of recent and ancient winged migrations, could have been at home, high in the air, in the Easter-basket nest, held by heavy strings to the enchanting floating taffeta globe puffed up with hot air from the continual fire of moist straw and chopped wool (and even old shoes), that rose above the Grandville threesome and propelled this aeronautic curiosity.[12] (While staying at their Château de Rouzat in the mountains of Auvergne, Lartigue's father brought wonderfully decadent toys back from Paris for the princely boys to play with: "a whole crate of huge paper balloons, known as "montgolfières" after the Montgolfier brothers."[13] Lartigue plucked an image of this colossal, but weightless butterfly—beautifully patterned as a Vermeer checked floor, wistful as a cloud— out of the air on July 31, 1911, before it could float off forever into the sky.)

95¢

A CLASSIC OF SCIENCE LITERATURE

SOAP BUBBLES

AND THE FORCES WHICH MOULD THEM

BY C. V. BOYS

A Doubleday Anchor Book

"like C. V. Boys's book, *Soap Bubbles and the Forces Which Mould Them.*"

Between 1891 and 1896, Otto Lilienthal, dubbed "the first man of flight," constructed bird-like gliders out of willow rods and waxed cotton. When Lilienthal took off, "'the wind playing wild tunes on the tense cordage of the machine,' the image was unforgettable: 'The spectacle of a man supported on huge white wings, moving high above at racehorse speed.'"[14]

On October 19, 1901, 5 feet 4 inch Alberto Santos-Dumont circled the spire of the Eiffel Tower in his innovative flying machine, making him the toast of Paris. Staying aloft for a full twenty-nine minutes and fifteen seconds, Santos-Dumont even managed to bring the airship with its magical rudders back to its starting point. When his workmen grabbed the guide

"Lartigue plucked an image
of this colossal, but weightless
butterfly—beautifully patterned as
a Vermeer checked floor, wistful as
a cloud—out of the air on July 31,
1911, before it could float off
forever into the sky."

"On October 19, 1901,
5 feet 4 inch Alberto Santos-
Dumont circled the spire of the
Eiffel Tower in his innovative
flying machine, making him
the toast of Paris."

rope and reeled him in like a yo-yo toy, Santos-Dumont "was showered with flower petals that swirled like confetti."[15] (However, the tiny aeronaut's flower-petal days would shrivel into deep depression with the onset of air combat, a despair that would last for his entire life. Eventually — on July 23, 1932, in a hotel room in Brazil — Santos-Dumont's grief would culminate into total darkness. After hearing a plane fly past and bomb a target, the famed "le petite Santos" was soon found dead, hanging from "two bright-red ties from his flying days in Paris."[16] His last words, spoken to the elevator operator: "I never thought that my invention would cause bloodshed between brothers. What have I done?"[17] Perhaps you can see a glimmer of that despair in Lartigue's photograph of Santos-Dumont and Zissou (Maurice) Lartigue in a row boat, from November 30, 1914.)

On December 17, 1903, in Kitty Hawk, North Carolina, Wilbur and Orville Wright launched their Wright Flyer: an erratic 605-pound pterosaur, sporting a wingspan of forty feet, four inches and a cheeky four-cylinder, water-cooled engine.

While the Wright Brothers were claiming to be first in flight and Santos-Dumont was arguing that he had conquered air years before, Barrie launched, perhaps, the most spectacular flights on stage. Peter, Wendy, Michael, and John flew as never before, all without the "ungainly umbilical cord" that had restricted stage soaring before. As Andrew Birkin writes:

> George Kirby's Flying Ballet Company had been in operation since 1889, but the scope of his flying apparatus was limited to primitive aerial movements; moreover the harness was extremely bulky, and since it took several minutes to connect it to the flying wire, an actor was invariably attached to his ungainly umbilical cord throughout the scene in which he had to fly. While conceiving the play of Peter Pan, Barrie contacted George Kirby and asked him if he could produce a flying system that could overcome these restrictions. Kirby accepted the challenge, and invented a revolutionary harness that not only allowed for complex flight movements, but could also be connected and disengaged from the flying wire within a matter of seconds.[18]

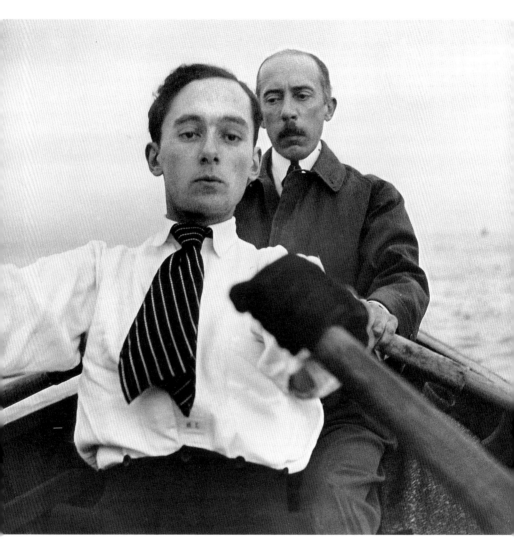

"Perhaps you can see a glimmer of that despair in
Lartigue's photograph of Santos-Dumont and Zissou (Maurice)
Lartigue in a row boat, from November 30, 1914."

If the Belle Époque was the time of great escape, is it no wonder that flight is in its wings? According to Michael Balint, such flights of fancy escape might be regarded as, I think we could say, a boyish return to the maternal:

> Flying dreams and the oceanic feeling are to be regarded as repetition either of the very early mother-child relationship or of the still earlier intra-uterine existence, during which we were really one with our universe and were really floating in the amniotic fluid with practically no weight to carry.[19]

Balint is hovering over Freud's notion of the oceanic, as is referred to in *Civilization and Its Discontents* (1930): "a sensation of '*eternity*,' a feeling as of something limitless, unbounded—as it were, 'oceanic.'"[20] The "oceanic feeling," Freud argues, is a form of infantile regression, in which the individual seeks to return to early childhood experiences of breast feeding; likewise, it is associated with personal mysticism and spirituality.[21] Flight, then, according to Balint, is deliciously pre-Oedipal (oceanic) in that it hails the free-floating feeling of being in amniotic waters. Accordingly, *Peter Pan*'s pre-Oedipalness is marked by its *eternalized*, maternalized flights. Peter flies to and from mothers from start to forever. (When Wendy grows up, Peter comes back for her daughter Jane, and when Jane grows up, Peter will come back for her daughter Margaret. "When Margaret grows up she will have a daughter, who is to be Peter's mother in turn; and thus it will go on. [*P&W*, 226].) Peter, even sleeps "in the air without falling, by merely lying on his back and floating . . . he was so light that if you got behind him and blew he went faster" (*P&W*, 103). In the fairy-bird wings of Barrie, flying is boyish labor, his eternal play, which culminates in his long-running, endlessly popular *Peter Pan*.

Writing about the stage history of *Peter Pan*'s first fifty years, Roger Lancelyn Green writes: "On December 27, 1954, *Peter Pan* will enter upon its second half-century. . . . No other play has performed in the country of its origin ten thousand times in fifty years. . . . *Peter Pan* still plays to packed houses in London. . . . No other play is still in its original production after

half a century of revivals."²² (During its first fifty years on stage, *Peter Pan* missed only two Christmas seasons in London, 1939–40 and 1940–41, "due solely to war-time conditions."²³ In 2004, *Peter Pan* celebrated its 100th birthday and is still tirelessly popular.) Barrie's boyish stage is magically fixed in the air, like a photograph.

Being boy eternal is its own kind of labor: "But such a day tomorrow as today/And to be boy eternal," claims Polixenes in Shakespeare's *The Winter's Tale*.²⁴ Though it is alluring to see that "he had all his first teeth" ("it was the most entrancing thing about him" [*P&W*, 77]) and even his "first laugh," ("the loveliest of gurgles" [*P&W*, 94]) — Peter Pan knows how hard it is to live pressured by smallness. But Barrie is not just boy eternal, he is also, as writer of the modern era's most famous fairy play, fairy. And yes, I invite you to flutter with all of its queer connotations. (Fairy as a slang term for a male homosexual, according to the *Oxford English Dictionary*, first appeared in 1895 in the *American Journal of Psychology*²⁵ — almost a decade before Peter and Tinker Bell hit the stage — to describe "the peculiar societies of inverts" which include "coffee-clatches, where the members dress themselves with aprons," entertaining themselves with knitting, crochet, and gossip — and balls in Europe, "where the men adopt the ladies' evening dress" — and even a secret society of homosexual men in New York who call themselves "The Fairies."²⁶)

The fairyishness of Peter Pan flies in out of the text. On the most palpable level, Peter is queerly an eternal boy who flies in and out of the Neverland to hang out with Lost Boys. His femininity was recognized when the play first hit the stage, in that Peter is traditionally played by a girl-woman. Not only does this reflect the femininity of the boy who would never be a man, who "was a lovely boy, clad in skeleton leaves and the juices that ooze out of trees" (*P&W*, 76), not unlike "Tink," who also is "exquisitely gowned in a skeleton leaf" when we first meet her (*P&W*, 88), who wears green tights (at least on stage) and whose hands are sticky with fairy dust — one supposes that this traditional casting also powders the homosexual overtones, makes the cake easier to swallow, so that we can enjoy each tasty morsel as Peter *gayly* flies on his way. When Peter was played by Nina Boucicault, Cecilia

Loftus, Pauline Chase, Zena Dare, Marjorie Manners, Madge Titheradge, Gladys Gaynor, Unity More, Eva Embury, [27] and on and on, Peter's look at the stars ("We are all in the gutter," claims Oscar Wilde, "but some of us are looking at the stars"[28]) is tempered by the maternal stature of the on-stage Peter Pan: often thick in form and maternality, she is sexless, because he/she hails mother; yet, she is full of sex, because she/he is adolescent, androgynous, arousing. Such inversions, which complexly butter and sugar powder sexuality (every time I think I've got it, it slips out of my hand, every time I think I see it, it vanishes) are seemingly the secret ingredients of most of the cast. Nana the dog, who is the children's nanny, is always played by a man. Likewise, Peter shares a strangely feminine touch with Hook. After all, "in . . . [Hook's] dark nature there was a touch of the feminine as in all great pirates, and it sometimes gave him intuitions" (*P&W*, 147–48). And certainly, Hook's feminine nature was accentuated by "his hair [which] was dressed in long curls, which at a little distance looked like black candles" (*P&W*, 115). Peter's invisible wings butter him as bird, baby, and boy, but like Tinker Bell, he is also "fairy."

But Barrie is not just fairy, or at the very least, fairyish; he is a hard laborer, he is a laboring fairy, much more Ariel (*The Tempest*), than Polixenes. Barrie is more Tinker Bell than Ariel. For, as Peter explains in *Peter and Wendy*: "She is quite a common fairy . . . she is called Tinker Bell because she mends the pots and kettles" (*P&W*, 94). Tinker Bell is a nostalgic twinkle in Barrie's eye carried forward from his boyhood. (Soon enough we will rehearse Barrie's common origins in the little weaving town of Kirriemuir, Scotland.) But Barrie is not just fairy, laborer, and boy, he is *also* (like Peter) bird. When *Peter Pan* was in rehearsal, in the weeks before it had even flapped its wings in front of a live audience of fairy-believers, Nina Boucicault (the first to play Peter on stage), feeling defeated by her part, asked Barrie himself (who was present for all of the rehearsals), the fundamental question:

"What *is* Peter Pan?" she asked. "How much is he human and how much fairy?"

"Tinker Bell is a nostalgic twinkle in Barrie's
eye carried forward from his boyhood."

But all that Barrie would reply was:
"Well, he was a bird a day old."[29]

Birds not only fly, they make their homes (usually up high) in the form of the nest. In this book's introduction, I called on Michelet's poetic working of the nest as a home built by a beating (writing) bird's breast, as an apt metaphor for Barthes's own bodily writing. Again, I cite this passage by Michelet (whom Bachelard describes as "one of the greatest of dreamers of winged life"[30]), but this time with Barrie's suffering, bird-like writing in mind:

> [The nest is] less a *weaving* than a *condensation*; a felting of materials, blended beaten, and welded together with much exertion and perseverance. . . . The tool really used is the bird's own body — his breast — with which he presses and kneads the materials. . . .
>
> Thus, then, his house is his very person, his form, and his immediate effort — I would say, his suffering.[31]

The nest was the material outcome of Barrie's boyish labor.

Child-Loving: The Llewelyn Davies Boys

As Barrie aficionados know, *Peter Pan* was hatched years before the stage production, in 1902, in a very odd, dark, childish, and also quite popular book that has been described as an "adult novel,"[32] entitled *The Little White Bird*. And just as Lewis Carroll was very fond of the three Liddell girls, especially Alice — Barrie was very fond of the five Llewelyn Davies boys:[33] George, Jack, Michael, Nico, and, of course, a Peter. All of the Peter stories were based on Barrie's adventures with the boys, not just *The Little White Bird* (1902) and the play *Peter Pan* (1904), which itself went through many revisions over the years, but also other related versions of the story: the novel that directly grew out of the play, which we now most commonly call *Peter Pan* but is most accurately called by its original title *Peter and Wendy* (1911), and the novel *Peter Pan in Kensington Gardens* (1906), which is a re-

duced version of *The Little White Bird* that focuses on Peter.[34] And just as Carroll took pictures of his girls, Barrie took lots of snaps of "his boys."

In fact, we can find the tiniest embryo of *Peter Pan* even earlier than 1902's *The Little White Bird* in the self-published *The Boy Castaways* (1901), a recording of Barrie's exploits with the Llewelyn Davies boys on holiday at Black Lake Cottage.[35] Although Peter did not *yet* figure in the story, many of the Neverland essentials were in attendance: Indians, a South Seas Lagoon, a Saint Bernard dog, and pirates.[36] The sixteen chapter headings, without any further text, are coupled with pictures of the boys in an escapade reminiscent of *Coral Island*, as in "IV. It was a coral island glistening in the sun." (Written in 1857 by another Scot, R. M. Ballantyne, *Coral Island* was a vital adventure book, critical to Barrie's imagination, his favorite book as a boy.) Two copies of the charming *Boy Castaways* were made, one for Barrie and the other given to the father of the Llewelyn Davies boys. Carroll made the original manuscript of the Alice story, *Alice's Adventures Underground* (1864), as a gift to "his girl"[37] and Barrie made the original Neverland story, *The Boy Castaways*, as a gift to "his boys." (The dedication to *Peter Pan in Kensington Gardens* reads: "To Sylvia and Arthur Llewelyn Davies and Their Boys (My Boys)."

And just as Alice Liddell was haunted all of her life by Wonderland, Peter Llewelyn Davies suffered from Neverland. Even in middle age, Peter Llewelyn Davies still referred to *Peter Pan* as "that terrible masterpiece."[38] Peter revealed his feelings in the *Morgue* (his six-volume unpublished title for his compilation of family letters and papers, linked with occasional comments of his own): "What's in a name. My God, what isn't? If that perennially juvenile lead, if that boy so fatally committed to an arrestation of his development, had only been dubbed George, or Jack, or Michael, or Nicholas, what miseries would have been spared me."[39]

But George was Barrie's favorite of the five, and it is he who is the semi-fictitious David of *The Little White Bird*: the little boy that is championed, adored, revered, and pursued by the book's narrator: a childless man, like Barrie himself, named Captain W. Barrie first met the real George in Kensington Gardens, "romancing" him daily at The Round Pond, where still

"'his suffering.'"

"especially Alice"

"and, of course, a Peter."

"'IV. It was a coral island glistening in the sun.'"

today you can find children pushing toy boats with their sticks. In *The Little White Bird*, David and Captain W. whittle away their own hours in happy mindless play in Kensington Gardens.

Bird-Boy-String

According to *The Little White Bird*, Peter Pan lives on an island in the middle of the Serpentine, the lovely man-made lake that divides Kensington Gardens and Hyde Park. It is on Peter's island that "all the birds are born that become baby boys and girls."[40] (Today, the island is a bird sanctuary.) David knows, as does Captain W., that all children in their "part of London were once birds in the Kensington Gardens; and that the reason there are bars on nursery windows and a tall fender by the fire is because very little people sometimes forget that they have no longer wings, and try

"But George was Barrie's favorite of the five, and it is he who is the semi-fictitious David of *The Little White Bird*: the little boy that is championed, adored, revered, and pursed by the book's narrator: a childless man, like Barrie himself, named Captain W."

to fly away through the window or chimney" (*L WB*, 21). Every time that David tells the story of how he, too, came from bird to boy, when he comes to the part about the "string he rubs his little leg as if it still smarted" (*L WB*, 23). This is because David was "caught by the leg with a long string and a cunning arrangement of twigs near the Round Pond" (*L WB*, 23). In fact, David's bird-like qualities can be found hopping throughout the feathered words of *The Little White Bird*: he does not walk, he "alights"; when he was a baby (bird), he was specifically a "misselthrush"; the account of his "birth" reads—"at eighteen minutes to four we heard the rustle of David's wings" (*L WB*, 43)—and David squawks just like his father, "he must have learned it like a parrot" (*L WB*, 46). Indeed, the reader becomes so attached to David's toddler-birdie years that when one discovers that the boy has forgotten his bird language the effect is a chirrup turned melancholic. (In the words of the greatest melancholic of all time, Robert Burton: "Methinks I court, methinks I kiss, Methinks I now embrace my miss."[41])

While no other may have celebrated the birdish quality of the boy and its connecting image of boy-bird-string quite like the author of *The Little White Bird*, it is not solely Barrie's invention. The troping of bird-boy-string is nested in a range of famous and not-so-famous images.

In John Brewster's "beguiling" painting of "two-year-old Francis Osborne Watts"[42] in his own boyish, lightish blue gown (1805)—blue like Francis's own eyes, blue like the "forget-me-not" blue eyes of Captain Hook "of a profound melancholy" (*P&W*, 115), blue like Hook's eyes which were also "as soft as the periwinkle" (*P&W*, 180), blue like Sylvia Llewelyn Davis's blue dress so loved and fondly remembered as *her image*,[43] blue like the umbilical string that unconvincingly keeps the delicate bird on Frances's leash—bird and boy are tied together in a pre-Oedipal innocence before flight. (By age three, the development of language and sexual difference push the child out of the nest.[44]) The bird's forked tail suggests that it may be a swallow. (Peter had particular sympathy with swallows, as we shall soon see.) Purity and innocence, before the leap, before the flight, are the subjects of this painting, painted by a man who spoke in signs:[45] Brewster was a deaf mute from birth.

"when he comes to the part about the
'string he rubs his little leg as if it still smarted.'"

One wonders where the little bird might take the artist as muted boy: to or away from the chatter of speech? Looking at Francis, on the eve of speech, who looks to the little bird for a sign, summons the phrase "a little bird told (whispered to) me." The phrase derives its silent signification from the noiseless flight of a bird, as is captured on Ecclesiastes 10:20: "Do not revile the king even in your thoughts, or curse the rich in your bedroom, because a bird of the air may carry your words, and a bird on the wing may report what you say."[46] The quietude of speech is emphasized by Julia Kristeva in the pre-Oedipal body that talks *also* and *differently* in touch and smell, what Kristeva calls the "semiotic" (a place before and beyond traditional language). Kristeva's notion of the "semiotic" is usurped from Saussurian linguistics and Lacanian thought as she redefines the term as pre-Oedipal speech—a place before and, then, later beyond speech, which disrupts the Law by drawing on the sensate body in a touching-smelling-sounding-feeling-tugging-nattering-babble-prattle. If you will recall, *The Little White Bird* (in the form of Barrie's birdie chatter) claims that when David comes to the part about "the string he rubs his little leg as if it still smarted." That little bit of smarting on David's leg, is the remainder of a kind of utopian baby speech, before the world imposes masterful speech on us: meaning the sentence and narrative itself, all of which turn, according to scholars like Teresa de Lauretis[47] and Barthes, on an understanding of sexual difference. As Barthes notes in "Introduction to the Structural Analysis of Narratives": "it may be significant that it is at the same moment (around the age of three) that the little human 'invents' at once sentence, narrative, and the Oedipus."[48]

What is broadly referred to as the pre-Oedipal—and which has been hailed, among other terms, as "oceanic feelings" (Freud), "semiotic" (Kristeva), the "imaginary" (Jacques Lacan) and "illusionment" (Winnicott)—is also a space tethered to the uncodified bodily tales of Barthesian punctum, Proustian involuntary memory, and the untranslatable jouissance. Growing up is a problem; it comes with loss. While Barthes and Freud seemed settled on a turn at age three and Lacan suggests eighteen

months for his famed "mirror stage,"[49] Barrie is settled on age two as "the beginning of the end." Here goes the first paragraph of Peter and Wendy:

All children, except one, grow up. They soon know that they will grow up, and the way Wendy knew was this. One day when she was two years old she was playing in a garden, and she plucked another flower and ran with it to her mother. I suppose she must have looked rather delightful, for Mrs. Darling put her hand to her heart and cried, "Oh, why can't you remain like this for ever!" This was all that passed between them on the subject, but henceforth Wendy knew that she must grow up. You always know after you are two. Two is the beginning of the end (*P&W*, 69).

Francis Osborne Watts was in danger of losing his bird on a string, when Brewster painted him at age two, right on the cusp of the beginning of the end.

Indeed the connection of boys to enchanted birdliness, darkly folded, can also be found in the tradition of high European painting as in Goya's *Don Manuel Orsorio Manrique de Zuñiga* (1784–92). The princely portrait of the "little boy red" (with a white satin cummerbund, lacy collar, satin shoes, and page-boy hair) is of the son of the Conde de Altamira. Don Manuel is playing with a chattery pet magpie on a string. The magpie, who holds Goya's calling card in his beak, must look like dinner to the three cats, especially so to the wide-eyed black-and-white feline in clear view. A cage full of finches hails innocence according to Baroque iconography. Furthermore, in Christian art, birds (as seem to be the case with Barrie as well) symbolize the soul. The picture with the magpie ready to be eaten and the finches trapped in the cage suggest fleeting innocence and our desire for the child to stay tied to the just-a-thread-break-away sweetness of birds, which is especially delicate in the presence of cats and dark shadows, in the sartorial violence of red. Perhaps the ominous quality of the painting grew out of the fact that it may have been painted after the child's death in 1792. Just as *The Little White Bird* gained its balefulness from all that arose from Barrie's brother's fatal slip on the ice, Goya's bird-boy may also be the picture

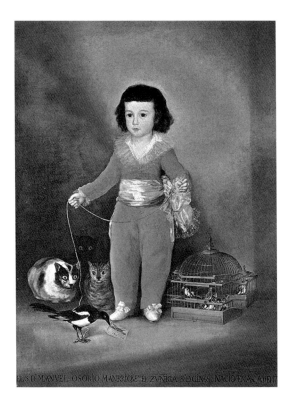

"our desire for the child to stay tied to the just-a-
thread-break-away sweetness of birds"

of a lost lad. (More on David Barrie's tragic and untimely death later.) The
dark melancholic magpie metaphorically makes music of being a grounded
bird, of being a prisoner of both the flightless child and the hungry cats,
while aping the artist's identity.

In popular fairy-tale culture, we find bird-boy-flight at the heart of
Antoine de Saint-Exupéry's *The Little Prince* (1943): the fantastical sweet
tale of a small boy's experience as he travels throughout the universe. The
clever, wise, philosopher-boy escapes his planet ("hardly bigger than a

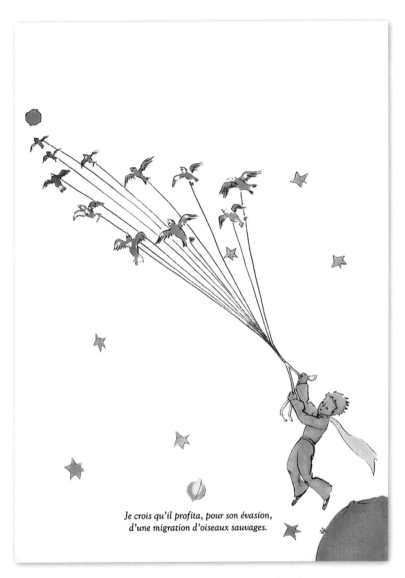

Je crois qu'il profita, pour son évasion,
d'une migration d'oiseaux sauvages.

"The clever, wise, philosopher-boy escapes his planet
('hardly bigger than a house!') by taking 'advantage of the
migration of a flock of wild birds.'"

house!"[50]) by taking "advantage of the migration of a flock of wild birds."[51] As Adam Gopnik has noted, "Saint-Exupéry [beloved by Joseph Cornell], gets the mushy-stuff pass [along with Cornell] that only one or two artists per generation are permitted."[52] (I wonder if Gopnik has forgotten "Combray" and "Swann's Way"? Lartigue?) Saint-Exupéry, born in 1900 with the first breath of the twentieth century, was also a pilot in "real" life, "who attempted to spend as little time as possible on earth."[53] "Saint-Ex's"[54] celestial navigation was driven by the stars (not unlike Cornell's own dreamy armchair travel to Venus through the Big Dipper and beyond, as certified in the box artist's collages that often bring to light astronomical maps), like a flock of migratory birds, like Peter flying from the window with Wendy, John, and Michael. While he lived long past boyhood, Saint-Ex is forever mysteriously connected to the melancholy little interstellar traveler, who lives on a planet so tiny that you can see "the twilight whenever you wanted to."[55] One day, the little prince witnessed an awe-inspiring sum of forty-four sunsets:

> [Little Prince] "You know, when you're feeling very sad, sunsets are wonderful . . ."
> [Narrator] "On the day of the forty-four times, were you feeling very sad?"
> But the little prince didn't answer.[56]

On July 31, 1944, at the age of forty-four, Saint-Ex's plane came down on a clear day during a wartime reconnaissance mission. Suicide has always been in the wings. The author's plane was finally discovered in 2004 off the coast of Marseille. One of the divers who found the pieces of wreckage reported: "There was no bent propeller, no bullet holes, . . . Looking at the pieces, we are thinking of a hypothesis of a near-vertical dive at high speed."[57] It seems almost as if Saint-Ex, like one of Barrie's "Boy Castaways," had "set out to be wrecked."

A very recent example of a boyish figure attempting to soar with birds on strings is Robert and Shana ParkeHarrison's *Flying Lessons*, 2000. This surreal-enchantment makes use of paper negatives, like a photograph of the

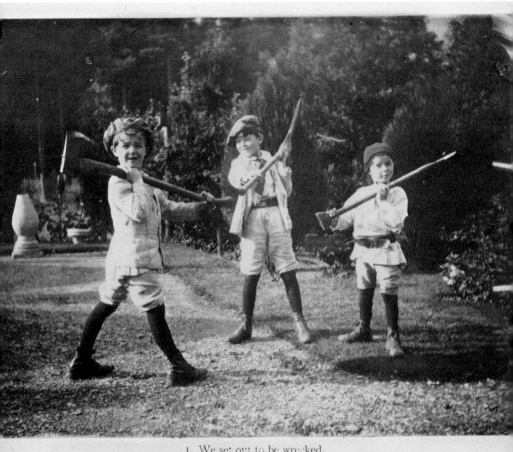

I. We set out to be wrecked.

"It seems almost as if Saint-Ex, like one of Barrie's
'Boy Castaways,' had 'set out to be wrecked.'"

past, to soften and nostalgically present their Charlie-Chaplinesque theatricality and dark humor of an impossible feat. The ParkeHarrisons have lifted Saint-Exupéry's boy-bird image out of the hands of the child and have tied it to the wrists of a downed man in a black suit too small. (His adult body no longer fits.) Large birds futilely aim high and flap their wings, escaping their cage, uselessly going nowhere. (You can never go back home, back to your little planet the size of a house, unless you are the little prince of fairy tales.) We may clap if we believe in fairies, but no amount of clapping will elevate Robert ParkeHarrison's static situation, memorialized by Shana's shutter click. The image could be an illustration of Saint-Exupéry's sweet but sad dedication that starts *The Little Prince* off on a melancholic note: "All grown-ups were children first. (But few of them remember it)." The ParkeHarrisons knew this when they pictured their black nostalgia that goes nowhere: that is their flying lesson. No need to waste the fairy dust on the adult body. This sad flying lesson is a culminating moment at the end of *Peter and Wendy*, when we find Wendy as a grown woman with her own daughter Jane:

> "Why can't you fly now, mother?"
> "Because I am grown up, dearest. When people grow up they forget the way."
> "Why do they forget the way?"
> "Because they are no longer gay and innocent and heartless. It is only the gay and innocent and heartless who can fly" (*P&W*, 222).

While Brewster, Goya, Saint-Exupéry, and the ParkeHarrisons show the birdliness of boys (or at least the boyish-man in the case of the latter), Peter Pan, according to *The Little White Bird*, stands (and flies) apart from all other children in that he never fully metamorphosized from bird to boy. Peter Pan is a betwixt-and-between boy—neither human, nor bird, but rather both. "He escaped from being a human when he was seven days old; he escaped by the window [there were no bars!] and flew back to the Kensington Gardens" (*LWB*, 132). And he never grew up, never had a birthday, "nor is there the slightest chance of him having one" (*LWB*, 132). By the

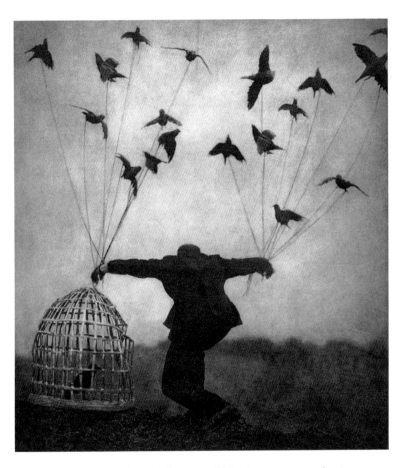

"We may clap if we believe in fairies, but no amount of
clapping will elevate Robert ParkeHarrison's static situation,
memorialized by Shana's shutter click."

᠁

time Peter Pan becomes more refined, more purely boy in the classic *Peter Pan*—he no longer is bird, but he sure can fly and still "he crows like a cock" (*PP*, 99). And, as if to make sure that the play with the bird-turned-little-boy-phallus is not lost on the reader, Barrie playfully spells it out: "To put it with brutal frankness, there never was a cockier boy" (*P&W*, 91).

Barrie as Good-Enough Mother

The little white birds are the birds that never have a mother
—J. M. Barrie, *The Little White Bird*

While the Llewelyn Davies boys did have a mother (and a father), they lost their parents when they were still very young. Arthur Llewelyn Davies, an extremely handsome man, died of jaw cancer in 1907. Sylvia (whom Barrie was possibly in love with), was the charming and lovely match for gorgeous Arthur. Sylvia, with her own appealing beauty, "had a tip-tilted nose, wide-spaced grey eyes, black hair and a crooked smile"[58] and was the daughter of George du Maurier,[59] and sister of the actor Gerald du Maurier. It seems that Barrie was in love with her, if only because she was the beautiful mother of "the boys." Sylvia died in 1910 of a cancer that was "too close to the heart to operate."[60] "The five" were between the ages of seven and seventeen. Rather hauntingly, George (seventeen), Jack (sixteen), Peter (thirteen), Michael (ten), and Nico (seven) were immediately adopted by Barrie. Barrie made sure that his "ownership" was secured in writing. In recopying the second of the two slightly different wills that survived past Sylvia's death, Barrie made a slender, but huge mistake or change: he *slipped in* (perhaps as a kind of slip of the tongue in ink) the name "Jimmy" for "Jenny." ("Jimmy" being the name those closest to Barrie affectionately and diminutively called him). While Sylvia noted throughout both of her wills how involved she hoped Barrie would be in the lives of the boys, she officially requested that Mary Hodgson (the governess and long-time second mother to the boys) take care of the boys with "Jenny" (Mary Hodgson's sister), *not*

" 'The little white birds are the birds
that never have a mother.' "

"Jimmy." All very confusing, the story is, *perhaps*, best explained by Birkin, Barrie's sympathetic biographer:

> The mistranscription was no doubt unintentional, although the word "Jenny" is clear enough, and Barrie can have had no illusions that his presence at Camden Hill Square would be "nice for Mary." In the event, Jenny's services were not called upon, and Mary was obliged to tolerate Barrie's omnipresence at Campden Hill Square, in accordance with Sylvia's supposed last wishes. Even before the discovery of the will, it was clear to all concerned that only Barrie had both the time and the means to assume full responsibility for the boys. [61]

As Jackie Wullschläger writes: "A few years after Peter Pan, Barrie's life was transformed: from an unhappily married oddball looking onto other lives, he became a single, *boyish* man in charge of five lost boys—as close to a live, adult version of Peter as could be imagined." [62]

Shadow Play

> Any one that has ever loved one true child will have known the awe
> that falls on one in the presence of a spirit fresh from God's hands,
> on whom no shadow of sin has fallen.
> —Lewis Carroll, cited in Morton Cohen, *Reflections in a Looking Glass:*
> *A Centennial Celebration of Lewis Carroll, Photographer*

Barrie was enormously sympathetic, if not a little hungry, when it came to the boys' loss. Barrie had experienced his own sense of, if not actual, "motherlessness" when his brother David died at age thirteen on the eve of his fourteenth birthday. The Barrie family received word of David's death on a frosty day with Kirriemuir in a blanket of winter snow. That day would freeze David (years before Peter Pan) as eternal boy. (Minot's *The Tiny One* returns from the first chapter of this book: "How can something so big fit into such a little thing like a day? I can't get it . . . The day was just another

"'How can something so big fit into such a little thing like a day? I can't get it. . . . The day was just another day and then something stopped. Something else began.'"

day and then something stopped. Something else began."[63] Like a season, *The Winter's Tale* also returns: "But such a day tomorrow as today/And to be boy eternal."[64]):

> They [Barrie and two of his sisters Sara and Isabella] were at the far side of the yard, intent on their snowball, and the telegraph boy's footsteps must have been muffled in the soft snow, for they did not hear anything until he knocked on the door. Then they stopped work on the snowball and stared in surprise at the blue uniform and the pill-box hat, for they had never seen a telegraph boy in the Tenements before.
>
> They ran to the door. Just as they reached it, it opened and [Barrie's mother] Margaret Ogilvy stood there.[65] ["Ogilvy had been her maiden name, and after the Scotch custom she was still Margaret Ogilvy to her old friends."[66]]

David had been away at school. While skating with his friend Alexander, Alexander had accidentally slipped into David. David fell and hit his head on the ice. Barrie would never see his brother alive again. The year was 1867, and the close-knit family was shattered by the death of their second son — Margaret Ogilvy's apparent favorite. Barrie's mother never really recovered — as Barrie writes in his biography of his mother, *Margaret Ogilvy by Her Son*: she was "always delicate from that hour."[67] Barrie describes the scene in the little house: David was laid out on the kitchen table and "I peeped in many times at the door and then went to the stair and sat on it and sobbed."[68] The interior door to the family's upstairs kitchen became a door that knocked open upon death. The stairs became betwixt-and-between, like a nest in a tree, neither up nor down, but rather halfway — like life and death, bird and boy, boy and man, mother and son. In the words of A. A. Milne's childish poem:

> Halfway down the stairs
> Is a stair where I sit:
> There isn't any other stair quite like it.
> I'm not at the bottom,

"The stairs became betwixt and between, like a nest in a tree, neither up nor down, but rather halfway — like life and death, bird and boy, boy and man, mother and son."

I'm not at the top:
So this is the stair where I always stop.

Halfway up the stairs
Isn't up, and isn't down.
It isn't in the nursery, it isn't in the town:
And all sorts of funny thoughts
Run round my head:
"It isn't really anywhere! It's somewhere else instead!"[69]

From then on, David would become Barrie's shadow, sewn on to him deftly, just as Wendy sews on Peter's crumpled shadow.

> [Peter] "I can't get my shadow to stick on . . ."
> [Wendy] "It has come off?"
> "Yes."
> Then Wendy saw the shadow on the floor, looking so draggled, and she was frightfully sorry for Peter. "How awful!" she said, but she could not help smiling when she saw that he had been trying to stick it on with soap. How exactly like a boy!
> Fortunately she knew at once what to do. "It must be sewn on," she said, just a little patronisingly.
> "What's sewn?" he asked.
> "You're dreadfully ignorant."
> "No. I'm not."
> But she was exulting in his ignorance. "I shall sew it on for you, my little man," she said, though he was as tall as herself, and she got out her housewife,[70] and sewed the shadow onto Peter's foot.
> "I daresay it will hurt a little," she warned him.
> . . . soon his shadow was behaving properly, though still a little creased. (*P&W*, 90–91)

Wendy, like Margaret Ogilvy, was an accomplished seamstress. "James himself always wore the clothes handed down from his brothers. Clothes

that Alexander had worn many years before had been passed on to David and then, with slight alterations, to him, but so cunning was Margaret with her needle and thread that his clothes looked as if they were brand new, even the knickerbockers that David had been sliding down the brae in not very long before."[71]

In turns out that wearing David's knickerbockers was not just an economic necessity, it provided a sheath to become David, to walk in his older brother's shadow. As Barrie writes in *Margaret Ogilvy*: "When he was thirteen and I was half his age the terrible news came, and I have been told the face of my mother was awful in its calmness as she set off to get between Death and her boy."[72] Thus began Barrie's childhood mission to relieve his mother's dark anxiety by becoming so like David that she could not see the difference. In anticipation of unveiling himself to his mother as David, Barrie went so far as to secretly practice his "cheery way of whistling," just as David did. He practiced standing with "his legs apart, and his hands in his pockets of his knickerbockers," just as David did.[73] Then, wearing his brother's clothes, he slipped into his mother's room:

> Quaking, I doubt not, yet so pleased, I stood still until she saw me, and then — how it must have hurt her! "Listen!" I cried in a glow of triumph, and I stretched my legs wide apart and plunged my hands into the pockets of my knickerbockers, and began to whistle.[74]

Barrie must have felt this shadow of David's to be a bit creased, a bit difficult to stick, like Peter's. Another Peter, Peter Stallybrass, has movingly described wearing the well-worn leather jacket of his deceased longtime friend and writing partner Allon White. Lecturing in front of an academic audience, Stallybrass unexpectedly found himself awash in tears: the body and memory of Allon had suddenly come through, unsolicited, out of the blue.[75] Allon had rushed Stallybrass's body and had become "of him,"[76] just as the crumb of tea-soaked madeleine cake abruptly filled Proust with the memories of his Combray childhood. It is in this way that the crumpled and wrinkled shadow of brother David that lived in his knickerbockers

"Next to his diminutive size, Barrie's most notable
characteristic were the dark rings under his eyes."

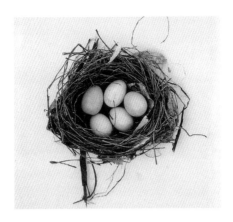

"before the five were . . . his"

(and certainly a range of objects throughout the Ogilvy-Barrie home in tiny Kirriemuir) darkening "Jimmie's" life only to be replaced (or perhaps more accurately reinforced) with the shadows of the Llewelyn Davies boys. David Barrie's shadow nests in the shadows of "the five" — and their shadows nest like swallows under the eyes (the eaves) of Barrie. Next to his diminutive size, Barrie's most notable characteristic were the dark rings under his eyes.

The shock of David's death was so great that Barrie's mother became emotionally lost, spiritually if not physically gone, for a painfully long time. Of course, it is no coincidence that David of *The Little White Bird* shares the name of Barrie's brother who had died tragically at such a young age. David Barrie was the first boy to never grow up and in his shoes grew the forever-boy-David of *The Little White Bird*, and Peter Pan himself. But even before the five were legally his, the Llewelyn Davies boys were part of the weaving of Barrie's nest, his nest of boyish labor that he began felting and weaving when his brother David did not grow up.

Eternally Mauve

Your greatest misery: Early School
Your pet flower and colour: Wood Sorrel. Mauve.
Your favourite novelist: Robert Louis Stevenson.
— George Llewelyn Davies's 1911 entry in Barrie's Querist Album,
reproduced in Andrew Birkin, *J. M. Barrie and the Lost Boys*

One could argue that the Edwardian Era itself was boyish. In 1901, William Byron Forbush published *The Boy Problem*.[77] Edward was King for little more than nine years, but he was Prince of Wales for a whopping fifty-nine. There was a sense that the bad boy "Edward the Caresser" (as he was privately named) was forever the boy-king. The sailor suit that he first wore under the direction of his Queen Mother became extremely popular (and remained popular throughout the Edwardian era). In the words of Jackie Wullschläger: "The Victorians liked little girls; the Edwardians worshipped little boys."[78] Barrie, one of the most boyish boys of the Edwardian era, like Edward himself, was born under the heavy wings of Queen Victoria.

In 1858, Queen Victoria wrote to her daughter on being pregnant: "It tired me sorely; one feels so pinned down — one's wings clipped — in fact, at the best . . . only half oneself."[79] Two years after the Queen's weighted words, Barrie — now inseparable from the fictional Peter Pan, the boy who could fly, the boy who never grew up — was born to his beloved mother Margaret Ogilvy, in Kirriemuir, the small weaving town, his "little red town," in Scotland's countryside. A place that was once, in Barrie's words, "a nest of weavers."[80]

At 9 Brechin Road, the clackety-clack of flying shuttles must have grown silent that day, but every other house could hardly have taken notice in this hardworking town of linen weavers. With his father's loom in the tiny downstairs (as was tradition) and only two little box beds in the equally tiny upstairs for the growing family that now housed eight (not counting his elder brother Alexander who came home during the holidays from Aberdeen University), space was tight. It was a small nest.

" 'Your greatest misery: Early School
Your pet flower and color: Wood Sorrel. Mauve.
Your favourite Novelist: Robert Louis Stevenson.'
George's Llewelyn Davies's 1911 entry in Barrie's
Querist Album"

"The sailor suit . . . remained popular
throughout the Edwardian era."

A THRUMS WEAVER

"A place that was once, in Barrie's words, 'a nest of weavers.'"

To walk into the house was to enter a nest of children, of threads and string. Later in 1892, Barrie would write *A Window in Thrums*, his sentimental story of life grown small as taken from his sentimentalized Kirriemuir. Certainly it is no coincidence that the tiny thatched roof house on the brae (with a handloom inside) that begins *A Window in Thrums* is not only as cozy as a nest (the thatched house as nest), but also features bird eggs: "Over the chimney-piece with its shells in which the roar of the sea can be heard, are strung three rows of bird's eggs."[81] Eggs, like nests, are miniature homes.

Thrums, the term used by weavers for the short strands of waste threads used for repairing broken threads and faults, is a fitting name for the impoverished but useful town of Barrie's boyhood. Thrums, which evokes Tom Thumb, Thumbelina, and all places small is a longing for home miniaturized, the perfect setting for the tiny Barrie (the man who wrote the story of the boy who eternally claims: "I don't want ever to be a man . . . I want always to be a little boy and to have fun" [*P&W*, 92], the man who in "real life" only grew up to be "5'3 and ½."[82] Barrie, the Scot, was a half an inch

shorter than Santos-Dumont, the famous Brazilian of Paris, the other, if more aeronautic, high-flying eterniday boy of the time.)

One wonders, was Barrie ever a man? As Tommy says in Barrie's partially autobiographical[83] novel *Tommy and Gri{el* (1900): "Have I been too cunning, or have you seen through me all the time? Have you discovered that I was really pitying the boy who was so fond of boyhood that he could not with years become a man?"[84] Tommy like Barrie, is Peter-like: he is filled (even when grown) "with boyish eagerness";[85] he waxes nostalgically about the days when he had "wings";[86] rises like a bird at "the earliest hours."[87] Even as an adult, as Grizel laments, he cannot give his wife children, cannot love her like other men: "He was a boy only. She knew that, despite all he had gone through, he was still a boy. And boys cannot love."[88] Despite being a hugely successful author, who was less winning in his childless marriage to the tiny actress Mary Ansell,[89] Barrie escaped development, remaining caught like a fairy-fly in amber ("Every time a child says 'I don't

"Santos-Dumont, . . . the other . . . high-flying eterniday boy of the time."

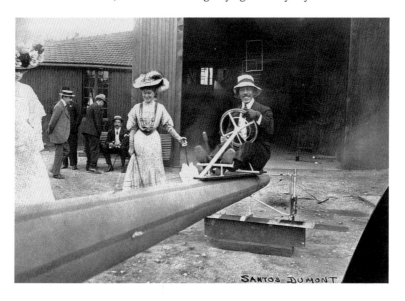

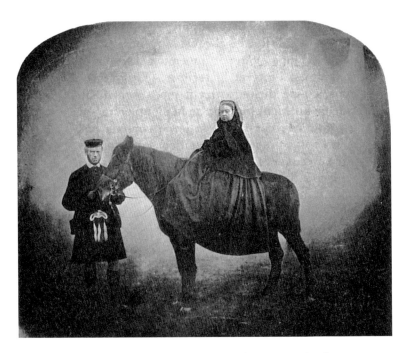

"she settled like a house, growing shorter and squatter, ending her reign
at 4 feet 7 inches with an impressive 48-inch waist."

believe in fairies' there is a little fairy somewhere that falls down dead,"
[*P&W*, 93]), forever on the glass plate, forever not-man, forever fairy-bird,
forever the dark forever-boy of his dreams and desires.

Likewise, but in reverse, it seems that Queen Victoria was never a girl.
While Barrie will always be remembered for his youth, "Queen Victoria has
never been remembered for her youth, but for her seemingly never-ending
old age: her years of mourning, her black dress, her dour expression, her
iconic stature."[90] Although she started off her reign very young, just eigh-
teen years old, and very small, just 4 feet 11 inches with a 17-inch waist[91]—
she settled like a house, growing shorter and squatter, ending her reign at 4
feet 7 inches with an impressive 48-inch waist.[92] Almost completely round,

she had become the big English penny that commemorated her. For most of Queen Victoria's subjects, the depiction of their Queen on coins was one of the few ways in which they would have known what she looked like. And during her sixty-four-year reign, the changing portraits on the coinage reflected the Queen as she moved from a young woman, to a mother of nine and a widow in mourning. Barrie refers to Queen Victoria as a "Big Penny," when, in *The Little White Bird*, the narrator gives a "tour" of Kensington Gardens: "You now try to go to the Round Pond, but nurses hate it, because they are not really manly, and they make you look the other way, at the Big Penny and the Baby's Palace" (*LWB*, 122).

Barrie's "Big Penny" is the ugly statue of Queen Victoria made in marble by her daughter Princess Louise and the "Baby's Palace" is Kensington Palace, where Queen Victoria was born. While Lynne Vallone's book *Becoming Victoria* is an attempt to make the becoming of the Queen more interesting—it is also solid evidence for the fact that the Queen's girlhood was perceived and projected as a secured, blossoming innocence that reinforced the "cult of the little girl" that colors the Victorian period as pink and white. In the picture book *The Fairies Favourite, or the Story of Queen Victoria Told for Children*, published on Commemoration Day, 1897, we learn that when Queen Victoria was born, "She was so pretty and so pink that the Fairies came to see her."[93] And as Jane Gallop has pointed out, pink (for girls) is eternal. "Pink . . . is one of our markers of sexual difference and . . . unlike its diacritical partner blue, remains—way past the nursery—marked as feminine."[94] Pink is always sissy and girlish; blue may or may not be boyish. Barrie plays out the dichotomy of pink and blue, of heterosexuality and sexual difference, with clever, swishy boyishness, when Wendy explains: "The mauve ones [fairies] are boys and the white ones are girls, and the blue ones are just little sillies who are not sure what they are" (*P&W*, 217). Even though Barrie, perhaps in reality was more of a fairy who did not know who he was, he certainly strove to be an eternal mauve fairy boy.

Of note is the fact that the color mauve, "the colour that had chanced to change the world,"[95] was a Victorian invention: as the first synthetic

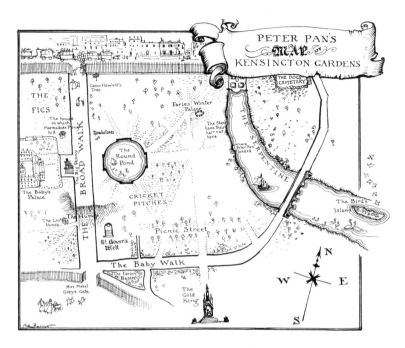

"'You now try to go to the Round Pond, but nurses hate it,
because they are not really manly'"

"'they make you look the other way,
at the Big Penny and the Baby's Palace.'"

dye (made by the British scientist Sir William Perkin), it soon became the perfect feminine souvenir of the era. The Empress Eugénie (who was the wife of Napolean III) was noted in the *Illustrated London News* for her love of all things mauve.[96] Possibly this is why Queen Victoria chose a mauve gown to wear to the marriage of her eldest daughter the Princess Royal to Prince Frederick William in January 1858: "The train and body of her Majesty's dress was composed of rich mauve (lilac) velvet . . . the petticoat, mauve and silver."[97] Mauve mania was soon noted in *Punch*, telling of how London had been gripped by "mauve measles." "*Punch* described the disease as infectious, beginning with the eruption of 'a measly rash of ribbons' and ending with the whole body covered in mauve."[98] Mauve fever, spawned by the Victorian passion for all things royal, soon

" 'She was so pretty and so pink that the Fairies came to see her.' "

became associated with gaiety, and perhaps that is partly why the mauve fairy-boys of Peter and Wendy strike us as funny. But the lightheartedness and pageant did not hold; by the early 1860s, "mauve had transformed itself from the colour of frivolity and display to the colour of mourning. In 1863, before her marriage to the Prince of Wales (Edward the Caresser) and two years after the death of Prince Albert, Princess Alexandra (of Denmark) made a grand entrance into London in a half mourning dress of pale mauve poplin."[99] Four years after losing Albert, Queen Victoria "graduate[d] from black to mauve."[100] (While off in the Neverland, homesick Wendy ponders: "Perhaps mother is in half-mourning by this time!" [*P&W*, 132]. With this

"he miniaturized her into a coin . . .
that he carried in his pocket."

exclamation, Wendy knew that this meant that Mrs. Darling would be re-lieved of black, by a dress of pale violet: the mauve of a mournful, con-fused fairy.) Perhaps I am overreading all things mauve, but with its his-tory of feminine frivolity, which is always queer in a man, coupled with its association of loss and bereavement, Barrie turns out to be a mauve fairy indeed.

Queen Victoria and her era had an odd hold on Barrie; a strong looming fierce maternal hold that he just might rather shake. As Vallone points out, when, in *The Little White Bird*, Barrie's text moves from the Baby's Palace to the Big Penny, Victoria grows from Baby to Queen in a flash. But this is no surprise, Barrie cared little for girls and their adventures. (Sure, Wendy could fly, but she was shot down.) It was as if Barrie's eternal boyishness was a necessary reaction to the biggest, darkest mother of all time: Queen Victoria. To do so, he shrank her, he miniaturized her into a coin (worth very little) that he carried in his pocket. As Barrie writes of Peter: "Not only had he no mother, he had not the slightest desire to have one. He thought them very overrated persons" (*P&W*, 90). Queen Victoria was not Barrie's, nor Peter's, kind of mother. Barrie liked his mothers to be like Sylvia Llewelyn Davies: "a beautiful woman who embodied motherhood, [with] a brood of boys who epitomized boyhood."[101]

Hélène Cixous claimed Lewis Carroll was an "ancient, masochistic ado-lescent."[102] Walter Benjamin, as we have already learned, called Marcel Proust that "aged child."[103] Even in old age, Lartigue was a self-proclaimed eternal boy—explaining to a *Life* reporter: "I am truthfully neither a painter nor a writer nor a photographer, but simply an ancient little boy, running after the ghost of his game of terrestrial paradise."[104] Barrie, too, like Proust, Lartigue, and Polixenes, is an eternal boy, a point now driven into the ground, like Lost Boys claiming land. As Barrie affirms in *Margaret Ogilvy*: "Nothing that happens after we are twelve matters very much."[105] Recall that by the time he writes *Peter and Wendy*, he begins with the fact that "two is the beginning of the end" (*P&W*, 69).

Littleness and Interiority

Smallness governs Barrie's writings. Even his actual handwriting was very, very tiny—and grew even tinier after he suffered from what was called "writers' cramp," forcing him to begin writing with his right hand; Barrie had been a "leftie" as a child.[106] Although his writing actually became more legible in its right-handed smallness, Barrie "liked to claim that he thought more darkly down his left arm."[107] While the figures of Peter Pan, the fairies of Kensington Gardens, and especially Tinker Bell, obviously turn on smallness, the particularity of Barrie's little things turn on their associa-tion with an interiority housed by the very idea of childhood. The purpose of the miniature is unabashedly that of tiny pleasure, childish pleasure. As Roland Barthes writes in *The Pleasure of the Text*: "I cannot avoid the fact that in French "pleasure" refers both to a generality (*"pleasure principle"*) and to a miniaturization. (*"Fools are put on earth for our minor pleasures"*).[108] Picture again Tinker Bell, "exquisitely gowned in a skeleton leaf, cut low and square, through which her figure could be seen to the best advantage" (*P&W*, 88). This is what the scholar Eva-Lynn Jagoe has referred to as "the erotics of tininess."[109] ("Although the fairies described before 1594 [*A Mid-summer Night's Dream*] do not seem to be particularly diminutive, it is the convention by the late Renaissance in England to depict them as miniature

human beings.")[110] The miniature is a world of childish control as is made manifest in the world of toys. As Baudelaire so imaginatively writes in "A Philosophy of Toys": "All children talk to their toys; the toys become actors in the great drama of life, reduced in size by the camera obscura of their brains."[111] Consider the charm of dollhouses (as were built by Lartigue's father, as we will see in the next chapter) and "to scale" tiny railroads or the world as captured small by the suprainteriority of the camera. But most important to this chapter on Barrie is the *nest as the image of the miniature home*. In the words of van Gogh, who painted numerous nests: "The cottage with its thatched roof made me think of wren's nest."[112] This is a fairy-tale world, as Bachelard jests with us in regards to nests: "I like to tell myself that a little king lives in that cottage."[113]

A Nest Is a Bed Is a Boat

Nests, which are often built under the eaves of houses or hidden in trees or even underground, are dark places. Likewise, nests, especially in literature are also childish. As Bachelard writes: "In short, in literature, the nest image is generally childish."[114] In the wings of all of the play and all of the Peter stories, the nest is the material outburst of the boyish labor of flight itself. (Cornell seemed to know all about this, often using nests in his artwork and storing them in boxes, homes of sort, among his other outbursts of collecto-mania.) Barrie's stories are dark (from the black of bittersweet chocolate to the black bile of the deepest suffering melancholic body) boyish nests.

The Little White Bird is especially dark. There, Peter can only be seen at night. Dead children are buried by Peter in Kensington Gardens. Ghosts are dead mothers, who come back shocked to unrecognizable grown children: "The only ghosts, I believe, who creep into this world, are dead young mothers, returned to see how their children fare. . . . What is saddest about ghosts is that they may not know their child. They expect him to be just as he was when they left him . . ." (*L W B*, 40).

But coupled with the darkness of Barrie's nest-work is the sweetness associated with bird-like wonder. For example, when, in *The Little White Bird*, a

"Cornell seemed to know all about this, often using nests in his artwork and storing them in boxes, homes of sort, among his other outbursts of collectomania."

ᴥᴥ

little girl by the name of Maimie Mannering gets locked in for the night in Kensington Gardens, the good fairies find her and build a perfect, charming, and very nest-like house around her to protect her from the cold. Even a pleasant dream was dropped down the chimney. Maimie "slept until the dream was quite finished and woke feeling deliciously cosy just as morning was breaking from its egg" (*LWB*, 193). This sweetness has the taste of erotics: awakened, "she [Maimie] turned round and saw a beautiful naked boy regarding her wistfully. She knew at once that he must be Peter Pan" (*LWB*, 195). Peter, then, tells Maimie that the reason he loves her is because she is "like a beautiful nest" (*LWB*, 200).

Bittersweet darkness also flavors the special nest that Captain W. and David cherish and regularly visit in Kensington Gardens. They discov-

" 'she . . . turned round and saw a beautiful naked
boy regarding her wistfully. She knew at once that
he must be Peter Pan.' "

ered it near the melancholic "Dog's Cemetery." At first find, the nest was beautiful, "containing four eggs with scratches on them very like David's handwriting," which the two understood to be a "mother's love-letter to the little ones inside" (*LWB*, 130). Dropping crumbs for the mother bird, David and Captain W. soon became her friends. But one day, there were only two eggs in the nest. It was then that the mother bird became spiteful and angry. She thought that David and Captain W. had stolen them. "The next time there were none" (*LWB*, 130). From then on, the empty nest was "quite white" and "very sad" (*LWB*, 130).

The supposed egg-stealing incident in *The Little White Bird* is a strong prognosis of Barrie's own "illicit parenting"[115] of George and eventually all of the Llewelyn Davies boys. In the language of the ornithologist, Barrie inverts brood parasitism. Brood parasites (like cuckoos and cowbirds) lay their eggs in nests established by other birds and their eggs are raised by the unsuspecting hosts. As Bachelard wittily remarks in regard to the cuckoo, "Nature seems to enjoy contradicting natural morality. The imagination, whetted by exceptions of all kinds, takes pleasure in adding resources of cunning and ingenuity to the characteristic of this bird squatter."[116] Perhaps Arthur Llewelyn Davies was all too aware of Barrie's "nature" — an inverted cuckoo desire to contradict natural morality with his own greedy illicit parenting. Perhaps, this is why Arthur just happened to lose one of only two copies of *The Boy Castaways*. Arthur left the book, filled with photographs of "his" boys (Arthur's or Barrie's?), on the train. It was a story he chose to leave behind. Arthur wanted the boys to remain in the "nest of soft country moss and dream herb"[117] built by the beaks and the breasts of their *natural* parents. But its seems that the tree that housed his nest could never reach high enough nor far away, could never reach beyond Barrie's Neverland.

And not only does *The-Little-White-Bird* Peter Pan love a girl for being like a nest, he sleeps in a large nest. The thrushes, who live with Peter in the Gardens, wove the outside of his nest-bed from grass and twigs and lined its interior with nice soft mud. Sweet and small, the nest is a place of discovery (many of us remember the wonder of finding a nest, especially a

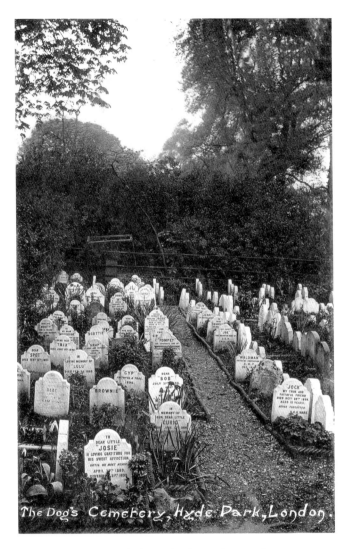

The Dog's Cemetery, Hyde Park, London.

"Bittersweet darkness also flavors the special nest
that Captain W. and David cherish and regularly visit
in Kensington Gardens. They discovered it near
the melancholic 'Dog's Cemetery.'"

living nest[118] with eggs as a childhood memory of fantasy, escape, refuge), a place of home, a place to grow out of and fly from.

But not only is Peter's nest a bed, it is also a boat. He turns his bed into a boat in order to sail down the Serpentine and reach the Gardens. How fitting that Peter's bed is a boat:[119] for, just as Peter can leave the confines of his body by flying, dreams allow us to leave our bodies, to slip, to fly out of consciousness, even to escape adulthood, while remaining (tight) within.

In order to transform his bed-nest into a boat, Peter eerily fashioned his own sail out of his old nightgown. (In *The Little White Bird*, Peter prefers to be always bare-naked, just as Barrie had a predilection for taking photographs of his "lost boys" without clothes, swimming in the lake or on the

∽∾

"brood parasitism."

THE BOY
CASTAWAYS
OF BLACK LAKE ISLAND

BEING A RECORD OF THE TERRIBLE
ADVENTURES OF THE BROTHERS
DAVIES IN THE SUMMER OF 1901
FAITHFULLY SET FORTH BY

PETER LLEWELYN DAVIES

LONDON
Published by J. M. BARRIE
in the Gloucester Road
1901

"left . . . on the train."

beach.) Like the bed, the nightgown is a symbol of slipping away. Peter's own nightgown functions as a maudlin trace of the boy that Peter once was. It signifies the "death" of the boy. It is a sartorial memorial.

Similarly in *Peter and Wendy*, when Peter finds himself caught on a rock (in an effort to escape Hook in the mermaid's lagoon) and is ready to be submerged by the rising tide, we find the nest reincarnated as a boat. This is the only time that we find Peter "afraid at last. A tremor ran through him" (*P&W*, 152). But this fear, in the boy who tended to forget everything, did not last for long. "Next moment he was standing erect on the rock again,

with that smile on his face and a drum beating within him. It was saying [yes], 'To die will be an awfully big adventure'" (*P&W*, 152). But he does not die, he was saved by the Never bird who lends him her nest. "He got into the nest, reared the stave in it as a mast, and hung up his shirt for a sail" (*P&W*, 155).

Perhaps, the shirt, and then more originally, the nightgown, as sail is a memory, a trace for the boy who never grew up, which first found its threads in *Margaret Ogilvy*. After the death of Barrie's brother David, the "first thing that . . . [Barrie's mother] expressed a wish to see was the christening robe."[120] "And when it was brought back to her she took it in her arms as softly as it might be asleep, and unconsciously pressed it to her breast; there was never anything in the house that spoke to her so eloquently as that little white robe; it was the one of her children that always remained a baby."[121] In the technical jargon of sewing, as Stallybrass has noted, and as was already threaded in this book's first chapter, "wrinkles . . . are called 'memory.'"[122] Margaret Ogilvy, a great seamstress, knew this. Adam Fuss's christening gown form his series *My Ghost* (1999), wrinkles with a life, a narrative, a life cut short. The image, a photogram, which is the most direct form of capturing light, the purest form of photography, sheds light on the fact that David is a ghost who will never grow up. (Ghosts have no shadows, like Peter Pan at the beginning of his story and play.)

The nightgown is also an erotic image that points to the most sexual moment of *The Little White Bird*, when Captain W. has boy-David to his house for a "sleep over." In the words of Captain W: "David and I had a tremendous adventure. It was this, he passed the night with me. We had often talked of it as a possible thing, and at last Mary [David's mother] consented to our having it" (*LWB*, 209). Before sleep, Captain W. undresses David, removing his blouse while he sat on his elder's knee; it "was a delightful experience" (*LWB*, 211). And when the nursery was dark, David leaves his room to come sleep in bed with Captain W., who tells David: "It is what I have been wanting all the time" (*LWB*, 213).

But this wanting will be stilled by time as an ever-wanting, an eterniday of night, as in William Blake's lovely small engraving *I want! I want!* from

" 'wrinkles are called "memory." ' "

"'It is what I have been wanting all the time.'"

his witty and dark *For Children/The Gates of Paradise* (1793). (A copy of this enchanting, surprisingly Surrealist, print is owned by Adam Fuss, the maker of both the butterscotch-taffy-tangerine-nasturtium bird hovering over a very delicate ladder that began this chapter and the photogram of a christening gown.) However, despite Blake's *For Children* title, only a very wise child, a kind of Blake-boy or Brontë-girl, would "divine . . . meaning or profit by it."[123] No more than five of the diminutive Blake books have been known to survive, "and there is evidence in only one of these that it found its way to the hands of a child . . . Harriet Jane Moore, aged five, the daughter of a surgeon."[124] The plates for the prints (averaging a tiny 8 x 6.5 cm in size) grew only a wee bit (the original drawings for the etchings were

an even tinier 7 x 5 cm), out of a sketchbook that had belonged to William's younger brother Robert, who died at home: he was only nineteen years old. William and Robert were "closely united in their affection for one another and in their devotion to art.[125] After Robert's death, William treasured anything that had belonged to him. Among his effects was a sketchbook used by him and containing on five of the earlier pages . . . [his] drawings."[126] William would use this cherished book to plan his book of emblems, turning it around and starting from the other end.[127] He nested his drawings in those of his warbling-lost brother. Like Margaret Ogilvy with David's christening robe, or Barrie in David's knickerbockers, William saw visions of his lost boy through Robert's notebook: after his death, Robert appeared to William as an apparition, showing Blake a new method for engraving.

But just as the young boy in Blake's engraving stands at the bottom of the ladder on the edge of the earth among a sky peppered with winking stars, a celestial map for winged travelers, we and the embraced lovers who look upon him, know that with each year, with each step on the ladder's rungs, the moon of our desire grows farther away. Margaret Ogilvy will never reach her David-moon, William will only see his Robert-moon in dreams, Barrie will only sleep with a nesty boy under the moon-turned-nightlight of *The Little White Bird.*

Nevertheless, our wanting never ceases, "I want! I want!," as is highlighted by a second wanting in *The Little White Bird*, also erotically driven. This time the image of a boy sleeping with another boy, turns out to be Peter Pan nestled with an unknown *real boy* indexically represented by a kite:

> Once [Peter thought, and this was before the Thrushes had built him his nest-bed-boat-house] he really thought he had discovered a way of reaching the Gardens. A wonderful white thing, like a runaway newspaper, floated high over the island and then tumbled, rolling over and over after the manner of a bird that has broken its wing. Peter was so frightened that he hid, but the birds told him it was only a kite, and what a kite is, and that it must have tugged its string out of a boy's hand, and

soared away. After that they laughed at Peter for being so fond of the kite; he loved it so much that he even slept with one hand on it, and I think this was pathetic and pretty, for the reason he loved it was because it had belonged to a real boy. (*LWB*, 142)

Just as Barrie's mother slept with the christening gown, here to sleep with a kite (a metaphor for the boy in flight, the boy on a string) is to sleep with a lost boy; to sleep with a kite was as close as Peter could get, perhaps as Barrie could get, to sleeping with a real lost boy.

The nest as a tight-fitting home that has everything to do with the body, hails the supra-interiority of Barrie's little houses that fit Maimie and, later, Wendy (recall "The Little House" of *Peter Pan* and *Peter and Wendy*), like a glove:

> "Ay, she will die," Slightly admitted, "but there is no way out."
> "Yes, there is," cried Peter, "Let us build a little house round her" . . .
> In a moment they were as busy as tailors the night before a wedding. They skurried this way and that, down for bedding, up for firewood. (*P&W*, 127).

Wendy's "little house" was not just a replica of the red-walled houses of Kirriemuir ("I wish I had a pretty house,/The littlest ever seen,/With funny red walls/and roof of mossy green," sings Wendy [*P&W*, 129]) — but most specifically of the little wash house behind Barrie's own tiny home at 9 Brechin Road, where he first performed plays with his childhood friend.

Barrie's dreams of miniature worlds, of nests and houses and boys that are eternally small are not only a place of refuge, but they are the immediate outcome of "his suffering." For as Barrie knows and writes in *The Little White Bird*: "Children in the bird stage are difficult to catch" (*LWB*, 121). As we have seen, *The Little White Bird* embraces all of the metaphors of children as birds, a theme that is taken up throughout *Peter Pan* and *Peter and Wendy* as well. Gleeful with fighting Hook with a sword on the pirate ship, Peter exclaims: "I'm youth, I'm joy, I'm a little bird that has broken out of his egg" (*PP*, 145). When the children first leave the nursery, we are told:

"'Children in the bird stage are difficult to catch.'"

"The birds had flown" (*P&W*, 101). Peter, not only crows like a cock, his "cockiness" tortures Hook as if the latter were "a lion in a cage into which a sparrow had come" (*P&W*, 176); when the pirates spot Wendy flying, as she arrives at Neverland, Nibs claims "A great white bird . . . is flying this way" and Slightly reminds him that "there are birds called Wendies" (*P&W*, 122), etc. Likewise, just as the dream of a child, turns on the bird, the "gentle" dream of the home turns on a nest.

Photographs Are Fairyish

> The loveliest tinkle as of golden bells answered him. It is the fairy
> language.
> —J. M. Barrie, *Peter and Wendy*

Childhood is as fairyish as a nest. Finding a glen of fairies is even better than finding a nest or madeleine.

> What is the best time for seeing fairies? I believe I can tell you all about that.
> The first rule is, that it must be a very hot day—that we may consider as settled: and you must be just a little sleepy—but not too sleepy to keep your eyes open, mind. Well, and you ought to feel a little—what one may call "fairyish"—the Scotch call it "eerie," and perhaps that's a prettier word.[128]

In a story now made famous, there are five "eerie" photographs taken by two girl-cousins, Elsie Wright (1901–88) and Frances Griffiths (1907–86), in Cottingley, a village near Bradford, England. The first image was taken in July 1917 of Frances (who was then ten) by the sixteen-year old Elsie. (Yes, the day was "brilliantly hot and sunny."[129]) It all came about when the girls were discouraged from playing again in Cottingley beck. In protest, Frances explained that she must return to the glen; for, she did not want to miss seeing the fairies play. Naturally, the adults (who had long lost the magic of childhood) laughed at her. They did not believe in the fantas-

"What is the best time for seeing fairies? I believe that I can tell you
all about that. The first rule is, that it must be a very hot day — that we
may consider as settled: and you must be just a little sleepy — but not
too sleepy to keep your eyes open, mind. Well, and you ought to feel
a little–what one may call 'fairyish' — the Scotch call it 'eerie,'
and perhaps that's a prettier word."

"Yes, the day was 'brilliantly hot and sunny.'"

"'the fairies are on the plate — they are on the plate!'"

tic creatures that Frances and Elsie had seen offering posies, leaping, and playing pipes. Determined to make believers out of the adults who mocked them, the girls begged to borrow Elsie's father's camera and he complied. That night, with Elsie tightly squeezed next to her father in his darkroom, a converted cupboard, the fairies magically appeared. It was as if they had been hidden (like "borrowers") under the floorboards and behind the cupboards. When Elsie "saw the forms of the fairies showing through the solution, she cried out . . . to [Frances] who was palpitating outside the door: '. . . the fairies are on the plate — they are on the plate!'"[130]

Famously, the photographs gained attention from Edward L. Gardner, who was at that time the president of a lodge in the Theosophical Society in London,[131] and from Arthur Conan Doyle, the creator of Sherlock Holmes, who, not coincidentally, was also the nephew of Richard Doyle, the great fairy illustrator of the immensely popular *In Fairyland* (1870). (Doyle also

used to play cricket with Barrie, perhaps the most fairyish of sports, in that its name hails the miniature through the musical winged insect with which its shares its name. Incidentally, in order to see a fairy, not only should it be hot and eerieish, "the crickets shouldn't be chirping" [Carroll][132]). The fairy photographs made believers out of Gardner and Doyle. With the encouragement of these two men, the girls took four more photographs: one more in 1917 and three others in 1920. The 1920 Christmas issue of *Strand Magazine* features Doyle's testimony to the reality of the Cottingley fairies.

"The height of this belief in the fairy child is . . . Edwardian."[133] The Edwardian era welcomed not only childhood's most famous little costume (the sailor suit, worn first by Edward himself), along with the one child who never grew up (Peter) and his twinkling-like-a-camera-flash cohort (Tinker Bell, the most famous fairy of all time) but also Kodak's invention of the Brownie, making the snapshot possible. Now, truly everyone could take cheap pictures of their little people. In 1900, a Brownie was both a fairy and a camera. The Brownie of folktale tradition is a small, sturdy, little fairy man, Scottish in origin and a very hard worker, like Barrie himself. Brownies only appear at night, like photographs developing in the darkroom.[134] Advertised in December 1900 with a couple of "fairy-folk," one dancing a jig and another loading the film, the $1.00 Brownie was toy-like, just in time for the holidays: "Any school-boy or girl can make a good picture with one of the . . . Kodak . . . Brownie Cameras . . . Take a Brownie Home for Christmas." A little later in 1903, Kodak advertised "The Boy With a Brownie," featuring a very boyish boy, plus a kite and some string, so as to hail Peter Pan's love for the lost kite in Kensington Gardens ("he loved it so much that he even slept with one hand on it, and I think this was pathetic and pretty, for the reason he loved it was because it had belonged to a real boy"). This boy decked out in his Edwardian costume, as if a Boy Castaway, serves (as does Peter) *as a medium* for the era (all snap and flight and boy) as he speaks to the fairyishness of photographs themselves.

Correspondingly, Frances and Elsie were mediums. Just as the sensitized photographic plate can steal an image, so could the girls hail a fairy or two. Such romanticism of the magical and alchemical qualities of pho-

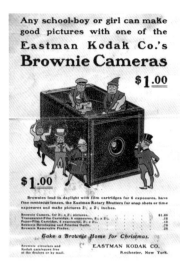
"In 1900, a Brownie was both a fairy and a camera."

"('he loved it so much that he even slept with one hand on it, and I think this was pathetic and pretty, for the reason he loved it was because it had belonged to a real boy')."

tography as a medium was there from its very onset. For example, the great nineteenth-century French photographer Nadar claimed that the miracles of the steam engine, electric light, bacteriology, anesthesiology, the radio, psycho-psychology "pale when compared to the most astonishing and disturbing one of all . . . the power to give physical form to the insubstantial image that vanishes as soon as it is perceived, leaving no shadow in the mirror, no ripple on the surface of the water."[135] In sum, "seeing is believing" and the photograph, like Frances and Elsie was the perfect *medium*. In the words of Tom Gunning, writing on the Theosophist's close cousin, the Spiritualist:

> Just as spiritualism depended on mediums whose passivity and sensitivity allowed the spirit message to come through clearly (such mediums were chiefly women, who were believed to possess these qualities more strongly then men), photography depended on the sensitized plate, which could capture the image of the world exposed before it. If these two sensitive mediums were combined—the photographic plate and the Spiritualist seer—then an image might be reproduced.[136]

Gardner, the Theosophist charmed by Elsie's and Frances's fairies, argued that the girls were not able to obtain further photographs, because of the onset of puberty. Because Elsie and Frances were growing up, they could no longer be mediums: adult sexuality was getting in the way of *innocent truth*. Attempting to photograph the fairies again in 1921, the nature spirits came out, but they would not use Frances's aura (she was both a clairvoyant and a medium, while Elsie was simply a clairvoyant). "With a sort of gesture of dislike . . . [the fairies] retreated almost at once."[137]

It is this loss of the "camera obscura of our little brains," this failure of child-like wonder which inspires us to become children again, to become artists. Baudelaire knew this when he wrote that the skill of an artist turned on his ability to find "*childhood* recovered at will."[138] For "the child sees everything in a state of newness [novelty]; he is always *drunk* [*intoxicated*]."[139] As the contemporary artist and photographer Christian Boltanski suggests, we make art to stand in or to find childhood lost. In his own

words: "I began to work as an artist when I began to be an adult, when I understood that my childhood was finished, and was dead. I think we all have somebody who is dead inside of us. A dead child. I remember the Little Christian that is dead inside me."[140] J. M. Barrie, "who was old" when he wrote *Peter Pan*, "but not quite grown up"[141] also sought art to remain eternally boyish. Part of his art was to cast spells over the many children in his life, even beyond the lovely Llewelyn Davies boys. Pamela Maude recalls Barrie's ready use of the erotics of tininess to communicate with enchanting small people like herself:

> He [Barrie] was a tiny man . . . Our parents called him "Jimmy." He was unlike anyone we had ever met. . . . Mr. Barrie talked a great deal about cricket and wanted . . . [my sister] to like it and be boyish, but the next moment he was telling us about fairies as though we knew all about them. . . . In the evening, when the strange morning light had begun to change, Mr. Barrie held out a hand to each of us in silence, and we slipped our own into his and walked, still silently, into the beech-wood. We shuffled our feet through leaves and listened, with Mr. Barrie, for sudden sound, made by birds and rabbits. One evening we saw a pea-pod lying in the hollow of a great tree-trunk, and we brought it to Mr. Barrie. There inside, was a tiny letter, folded inside the pod, that a fairy had written. Mr. Barrie said he could read fairy writing and read it to us. We received several more, in peapods, before the end of our visit.[142]

Fairies bring back the magic of childhood, like a photograph. One might even go so far as to say that photographs themselves are fairyish. Barrie tells us that "when the first baby laughed for the first time, its laugh broke into a thousand pieces, and they all went skipping about, and that was the beginning of fairies" (*P&W*, 93). Such glass breaking and fragmentation hails wet-collodion glass plates and the infinite reproducibility of the photographic image.

Akin to Barrie's photographic fairy language is the fairy-tale notion of the suspension of time, of nodding off as if stuck in wet collodion. In

"To photograph is, in a sense, to act as Perrault's good fairy:
to make the world ' "doze off" into the permanence of a single,
monotonous, and interminable moment.' "

Charles Perrault's version of "Sleeping Beauty," the good fairy—worried that when the beautiful Ophelia-like, princess-beauty wakes up after one hundred years of sleep, that she will be quite perplexed to find herself all alone in the castle—like a camera, puts to sleep everything that was in the castle—even "the whole process of cooking is literally suspended" (as if in emulsion). To photograph is, in a sense, to act as Perrault's good fairy: to make the world " 'doze off' into the permanence of a single, monotonous, and interminable moment."[143]

As Susan Stewart has remarked: fairies are associated with taking signs of nature and turning them into culture.[144] Recall once again how Tinker Bell wears "a skeleton leaf, cut low and square, through which her figure could

be seen to the best advantage" (*P&W*, 88). In the fairy world of *The Little White Bird*, a nest is a bed and a boat. In the fairy world of *Peter Pan*, Wendy wears an acorn, which has already been transformed into a kiss, which she then wears on a chain as a necklace. ("You remember she had put it [Peter's acorn-turned-kiss-for-her] on a chain that she wore round her neck" [*P&W*, 126]). Red sap becomes Wendy's "pretty house . . . With funny little red walls" (*P&W*, 129), just like those in old Kirriemuir; likewise, moss becomes a green roof and carpet all around. At other times, cultural signs just magically (and childishly) become other signs: the sole of Tootles's shoe becomes a door knocker; John's hat becomes a chimney (*P&W*, 130, 131).

Photographs, like fairies and their tales, turn natural signs into cultural artifacts, as in a photograph of a landscape.[145] Yet, in fairy-tale fashion the inverse can happen too, turning culture into nature. Consider photographs of the nude child. As Stewart argues: "Modern skeptics might interpret Charles Dodgson's [Lewis Carroll's][146] interest in photographing little girls in the nude as a prurient one, this interest must as well be linked to the place of the photograph in cultivating the natural. The body has become a garden, remote from the uncontrolled sexuality of the natural sublime."[147] And here, I would add Barrie's less artful, yet perhaps no less erotic, photographs of the Llewelyn Davies boys from behind, often nude at Black Lake or at the seaside. Here, the perfect little boy, loved by Barrie, like Peter loves Maimie, because he (whether he be Jack, Peter, George, Michael, or Nico) is "like a beautiful nest" (*LWB*, 200).

To Eat Is to Grow Is to Die

Not only is *Peter Pan* marked as pre-Oedipal by its delicious maternalized flights and nesty labor, it is marked as such by its oral fixations (plenty of kisses, albeit in the form of thimbles and acorns[148]) and an almost obsession with food — that shares an anorectic link with Proust's maternal appetite. "We could tell of that cake the pirates cooked so that the boys might eat and perish; and how they placed it in one cunning spot after another;

"the perfect little boy, loved by Barrie, . . . because he . . .
is 'like a beautiful nest.'"

but always Wendy snatched it from the hands of her children" (*P&W*, 138). Furthermore, not only did Hook and his pirates make a rich, damp cake that could kill, Hook also "had boiled down into a yellow liquid quite unknown to science . . . the most virulent poison in existence" (*P&W*, 182). When Peter is asleep, Hook slips this poison into Peter's medicine cup. Tinker Bell saved Peter from this poison liquor when she got "between his lips and the draught, and drained it to the dregs" (*P&W*, 184). That is when Tink almost died and the audience at the play or at home, "dreaming of the Neverland . . . boys and girls in their nighties" (*P&W*, 185), must clap if they believe in fairies . . . so that Tink will not perish . . . so that her light will not go out forever.

Worried about growing up, it was as if Barrie willed himself not to grow. Anxiety about growing bigger devoured Barrie so much so that worrying became his "peculiarly intense ravenous form of eating" (Adam Phillips).[149] While Alice greedily eats her way through Wonderland, Barrie's bird-fairy-child worlds are anorectically driven, as if to eat is to grow is to die. Repeating the anorectic pattern that we have already encountered in Proust and Barthes, it comes as no surprise to discover that little Peter Pan (in *The Little White Bird*) literally eats like a bird, living on tossed pieces of bread and cake.

At the start of *Peter and Wendy*, Wendy cannot tell the difference between real hunger and pretend hunger and notices that Peter does not eat like other boys. While flying, she broods:

Did they really feel hungry at times, or were they merely pretending, because Peter had such a jolly new way of feeding them? His way was to pursue birds who had food in their mouths suitable for humans and snatch it from them; then the birds would follow and snatch it back; and they would all go chasing each other gaily for miles, parting at last with mutual expressions of good-will. But Wendy noticed with gentle concern that Peter did not seem to know that this was rather an odd way of getting your bread and butter, nor even that there are other ways. (*P&W*, 102)

In fact, even after they arrived in the Neverland and Wendy had taken on her duties as full-time mother to Peter and the Lost Boys, "you never knew exactly whether there would be a real meal or just a make-believe, it all depended on Peter's whim":

> He could eat, really eat, if it was part of a game, but he could not stodge [as in to make oneself gorge in order to experience that delicious rich filling quality], just to feel stodgy, *which is what most children like better than anything else*; the next best thing being to talk about it. Make-believe was so real to him that during a meal of it you could see him getting rounder. (*P&W*, 135; emphasis is mine).

Wendy worries that they will never eat—Captain Hook makes a poison cake that could kill the Lost Boys—and the crocodile *eats* time—for it has swallowed a clock which goes tick tick tick inside it. After Peter had cut off Hook's arm, Peter flung it at a crocodile passing by. That particular crocodile liked the taste of Hook's arm so much, that he has followed the wicked pirate "from sea to sea, from land to land, licking its lips" (*P&W*, 119). It would have eaten Hook long ago but, because of the clock, he is always warned by "the tick and bolt" (*P&W*, 119). In *The Little White Bird*, Peter does not have a dagger for cutting off arms, but he has an ominous spade, which enables the Gardens to swallow the child: "But how strange for parents, when they hurry into the [Kensington] Gardens at the opening of the gates looking for their lost one, to find the sweetest little tombstone instead. I do hope that Peter is not too ready with his spade. It is all rather sad" (*LWB*, 208).

If we understand kissing to be an oral gratification, like eating, but without the dangers of fleshy plenitude, we can see why Barrie's tiny morsels of eating are always upstaged by cupfuls of kissing—although Peter's kisses take the form of thimbles and acorns. Kissing, in Phillips's fairy-tellish words, "involves some of the pleasures of eating in the absence of nourishment."[150] (In Neverland and Kensington Gardens, fairy food is boyish, even stunting, sharing some of the anorectic tendencies of our more "serious" French authors: Proust and his devotee Barthes.)

"If we understand kissing to be an oral
gratification, like eating, but without the dangers
of fleshy plentitude, we can see why Barrie's tiny
morsels of eating are always upstaged by
cupfuls of kissing"

To eat is to grow is to die.

But, although there are stories of Peter Pan taking children who have died part of the way, "so that they should not be frightened" (*P&W*, 75), he never dies, he just dreams of death.

Apart from the Neverland, yet far from their English homes, real lost boys were dying not from eating and growing, but in battle, in the real life of World War I, casting an even darker shadow on Peter's famed naive,

heartless, and childish line: "To die will be an awfully big adventure." By the time the line had been dropped from the traditional Christmas London revival of the play (December 26, 1915–February 3, 1916), it was too late for George, boy-beautiful, the original Peter Pan who was imagined to be boy-eternal. George Llewelyn Davies had already been killed in the early hours of March 15, 1915, outside Voormezeele. Nico, who had been asleep in the night nursery with Mary Hodgson, recalls hearing the sounds of yet another telegram, of a young man's early death, brought to Barrie:

> Suddenly there came a banging on the front door, and the door-bell ringing and ringing. Mary got out of bed and went downstairs, while I sat up with ears pricked. Voices came up the stairs, but stopped short of the landing. Then I heard Uncle Jim's voice, an eerie Banshee wail — "Ah-h-h! They'll all go, Mary — Jack, Peter, Michael — even little Nico — This dreadful war will get them all in the end!" [151]

This time, it was not the fairies of Kensington Gardens who built a house around the fallen child, nor the Lost Boys of the Neverland, but the Lost Boys of the War, one of which was Tennyson's son, Aubrey, who wrote to Peter Llewelyn Davies of the final bed made for George: "They took a lot of trouble making the grave look nice, & planting it with violets." [152]

Growing up means growing into battle, but with the war, the glory of fighting battles, even if they be adventure wars with pirates and Indians had been diminished. The war shadowed flight and other boyish play. In his last letter to reach George alive, written on the evening of March 11, 1915, Barrie says it all. Cryptic, haunting, tender, erotic, it leaves me, as it must have George, at a loss:

> I don't need this to bring home to me the danger you are always in more or less, but I do seem to be sadder to-day than ever, and more wishing you were a girl of 21 instead of a boy, so that I could say the things to you that are now always in my heart. For four years I have been waiting for you to become 21 & a little more, so that we could get closer & closer to each other, without any words needed. I don't

have any little iota of desire for you to get military glory. I do not care a farthing for anything of the kind, but I have the passionate desire that we may all be together again once at least. You could not mean a featherweight more to me tho' you came back a General . . .

. . . I have lost all sense I ever had of war being glorious, it is just unspeakably monstrous to me now.

Loving

J.M.B.[153]

Barrie's letter to George is tangled-Oedipal, even more of a fantasy weaver of Sophocles's story than Freud, changing matter altogether, spinning straw into gold Rumpelstiltskin-style, turning friend into father (or is it mother?) into suitor and boy into son into man into girl into girlfriend. Long before the tragedy of war, the tragedy of George, the narrator of *The Little White Bird* informs us that Kensington Gardens is the quick road to Oedipus. There, in the gardens, children turn three before you know it. As quick as a wink, they begin to wear their "knickerbocker face":

All perambulators lead to the Kensington Gardens.

Not, however, that you will see David in his perambulator much longer, for soon after I first shook his faith in his mother, it came to him to be up and doing, and he up and did in the Board Walk itself, where he would stand alone most elaborately poised, signing imperiously to the British public to time him, and looking his most heavenly just before he fell. He fell with a dump, and as they always laughed then, he pretended that this was his funny way of finishing.

That was on a Monday. On Tuesday he climbed the stone stair of the Gold King, looking over his shoulder gloriously at each step, and on Wednesday he struck three and went into knickerbockers. For the Kensington Gardens, you must know, are full of short cuts, familiar to all who play there; and the shortest leads from the baby in long clothes to the little boy of three riding on the fence. It is called the Mother's Tragedy. (*LWB*, 108)

After wearing his own brother David's knickerbockers (face), Barrie, as a little white bird who no longer had an emotionally involved mother, was moved to write *The Little White Bird*, inspired by George as both the novel's Peter and David. Little did Barrie know then that he would become George's mother-father and would face a far bigger tragedy than seeing him in knickerbockers or even long pants. *"How can something so big fit into such a little thing like a day? I can't get it . . . The day was just another day and then something stopped. Something else began."* It makes you want to never eat again.

I want to stop; I want it to stop; but the shadow of death keeps growing like the dark circles under Barrie's eyes. In 1921, while away at Oxford, Michael Llewelyn Davies drowned with his friend in a possible suicide pact. London's *The Evening Standard* carried it as follows:

THE TRAGEDY OF PETER PAN

SIR J. M. BARRIE'S LOSS OF AN ADOPTED SON

There is something of the wistful pathos of some of his own imaginings in the tragedy which has darkened the home of Sir James Barrie. Almost the first remark of friends, on hearing of the death of the adopted son of the dramatist to-day . . . was: "What a terrible blow for Sir James!" The young men, Mr. Michael Llewelyn Davies and Mr. Rupert E. V. Buxton. . . . were drowned near Sandford bathing pool, Oxford, yesterday. The two undergraduates were almost inseparable companions. Mr. Davies was only 20 and Mr. Buxton 22 . . . The "original" Peter Pan was named George, [who] was killed in action in March 1915 . . . Now both boys who are most closely associated with the fashioning of *Peter Pan* are dead. One recalls the words of Peter himself: "To die would be an awfully big adventure."[154]

And then there is Peter. After reading and sorting through all of the family papers for his Morgue, he gave up the project when he came to Michael's death. The Morgue begins in the 1840s and ends in 1915. It was too depressing. Peter Llewelyn Davies, at the age of sixty-three in 1960,

threw himself under a London underground train and perished. Headlines read "THE BOY WHO NEVER GREW UP IS DEAD"; "PETER PAN'S DEATH LEAP"; "THE TRAGEDY OF PETER PAN."[155] Peter Llewelyn Davies could never escape the shadow of Peter Pan, even in death.

It has become unreal melodrama. By now we are all growing tired of shadows. Couldn't Peter have left it off altogether?

Tired of Shadows

Stitched together in this way, the story unrolls without shadows . . .
He is tired of shadows, of complications, of complicated people.
—J. M. Coetzee, *Disgrace*

Coetzee's recent *Disgrace* is at odds between the paper sheets of this book—for *Disgrace* is not about Peter Pan, but rather about a communication studies professor, named David Lurie, who is bored and troubled by adult life (his adult daughter, his aging body, his ridiculing ex-wife, racial terror in South Africa, violence against animals, his love for a prostitute, his intrusions "into the vixen's nest," his daughter's rape, the prohibition on sexual affairs with students, his teaching, his faculty meetings, "the weight of the desiring gaze"[156]). It would be a big stretch to argue, that in any sense Professor David Lurie longs for youth in a Peterkin kind of way. Nevertheless, both the professor who loves Byron and the eternal boy long for stories, stories without shadows. David Lurie spends the span of the entire *Disgrace* trying to lose his shadow. As the narrator of *Disgrace* tells us about the failed professor's rather Peterish longing for life: "Stitched together in this way, the story unrolls without shadows . . . He is tired of shadows, of complications, of complicated people."[157] Barrie also grew "tired of shadows." Living in the shadow of his brother David, Barrie tried to shake himself of shadows: by whistling a tune for his mother, by inventing an eternal boy without death. But eerily Peter stands apart, in that he loses his shadow, but he wants it back.

For Barrie, the maternal is a cord (unsevered) to the night light of boyish

reading, as it is for all of this book's boyish-centered authors and artists (as stated in the first chapter). As Barrie writes in *Peter and Wendy*, literally making use of the symbolic play of "night-lights": "When you play at it by day with the chairs and table-cloth, it is not in the least alarming, but in the two minutes before your go to sleep it becomes very nearly real. That is why there are night-lights." (But in "the Neverland . . . there were no night-lights" [*P&W*, 106]. It is a dark place, disconnected from the maternal. In Neverland, the maternal is never more than play.)

Night lights, for Barrie, are mother's watchful eyes, as we learn at the beginning of *Peter and Wendy*. Before Mrs. Darling is leaves for the party (during which her three children, John, Michael, and Wendy, will be stolen) she has an eerie feeling that can be felt even by her youngest child; Mother and child want to believe that the family will be protected by night lights. But night lights also make shadows:

> A nameless fear clutched at her heart and made her cry, "Oh, how I wish that I wasn't going to a party tonight!"
>
> Even Michael, already half asleep, knew that she was perturbed, and he asked, "Can anything harm us, mother, after the night-lights are lit?"
>
> "Nothing, precious," she said: "they are the eyes a mother leaves behind to guard her children." (*P&W*, 86)

And while the night lights did protect, for a little while, like a mother's watchful eyes, the "night-lights by the beds of the three children," burned only as long as the oil held out. Eventually "Wendy's light blinked and gave such a yawn that the other two yawned also, and before they could close their mouths all the three [night lights] went out" (*P&W*, 88). And that is when Peter (and his cohort Tinker Bell) arrived: "his hand . . . messy with . . . fairy dust" (*P&W*, 88). For, "no one can fly unless the fairy dust has been blown on him" (*P&W*, 67). He flew in to teach the children the erotics of flight, so that he could steal them away. And he has flown in to get his shadow. To get the shadow is to get one's children — to, in the words of one of Barrie's (and George's) favorite authors, Robert Louis Stevenson, "to stick to nursie as that shadow sticks to me!"[158]

(I)n(c)est

As Barrie writes in *Margaret Ogilvy*: "If readers discovered how frequently and in how many guises . . . [Mother] appeared in my books—the affair would become a public scandal."[159] Here, Barrie's nest is woven within the suggestion of (i)n(c)est. Perhaps, stating what has already become obvious: it may be that it is not so much the homosexual impulses and acts in the lives and work of Barrie (Proust and Barthes) that makes readers anxious (albeit it is a driving force of unease for many, especially when it involves a love for boys)—but something incestuous. As Brigid Brophy, Michael Levey, and Charles Osborne note in their essay on *Peter Pan*:

> The incest theme is announced at once. The children are introduced during a let's-pretend game in which John and Wendy, who are brother and sister, play-act being husband and wife and claim their brother Michael as their son. This prefigures the relation between Wendy and Peter Pan, an erotic relation, in which they flirt over a kiss and provoke Tinker Bell to sexual jealousy, but also a relation in which Wendy mothers Peter. In the Never Land, Peter introduces her to the boys as "a mother for us all"; she is even addressed as "mummy"; yet presently Peter is playing father.[160]

Likewise, Winnicott's string boy's fears are kited, I contend, not so much by the homosexuality that the doctor names, but by the incest that nests in the margins. "*The tie-up with the mother's depressive illness remained, so that he could not be kept from running back to his home* [his nest]."[161] As Winnicott notes in *Holding and Interpretation: Fragment of an Analysis*, our society does not frown as much on the "seduction" between a daughter and father "as much as it does on incest between son and mother."[162] Even Winnicott's own language is very telling, even revealing: between father and daughter, the situation is softened by the term "seduction," which bids love, desire, and loss of agency, while between mother and son the situation is hardened by the term "incest," which summons the unpardonable, the shocking, and the stomach-turning.

"'her arms are kindly wings'"

In Barrie's 1899 photograph of Sylvia Llewelyn Davies with Peter on the beach, the boy appears caught by the rustling, large, white wings of his mother. One wonders if Barrie had this lovely photograph in mind when he wrote, in *The Little White Bird*, of the beauty of passing by David's mother on the street: "At such times the rustle of her gown is whispered words of comfort to me, and her arms are kindly wings that wish I was a little boy like David" (*LWB*, 4–5).

For Barrie, in the spirit of Eve Kosofksy Sedgwick's *Between Men: English Literature and Male Homosocial Desire*,[163] his love for the boy (and boys) was actualized through a love for the mother: as was the case in his real-life doting on Sylvia Llewelyn Davies. *The Little White Bird*'s Mary, like Sylvia Llewelyn Davies, gives Captain W. what he really wants—the boy: "It was a scheme conceived in a flash . . . to burrow under Mary's influence

"Barrie is Juliet."

with the boy . . . [in order to] take him utterly from her and make him mine" (*LWB*, 107). Barrie's story and story-life is not so much *Between Men* as *Between Boys*. When Barrie photographs Michael playing Romeo to Sylvia's Juliet (1905), it is through Sylvia that Barrie is reaching Michael. Barrie is Juliet. As Roland Barthes writes in *A Lover's Discourse*: "A man is not feminized because he is inverted but because he is in love."[164]

Barrie wants all the lightness of childhood—of flight—the new century—to stay aloft, because to really go back home is a grave loss. As he writes in *The Little White Bird*:

But he [Peter] has still a vague memory that he was a human once, and it makes him especially kind to the house-swallows when they revisit the island, for house-swallows are the spirits of little children who have died. They always build in the eaves of the houses where they lived when they were humans, and sometimes they try to fly in at a nursery window, and perhaps that is why Peter loves them best of all the birds. (*LWB*, 206)

Barrie's books of flight appear light but are riddled with the darkness of his own lived life. Barrie is a fly-by-night, addicted like Peter to nocturnal excursions, to stealing children (like the Llewelyn Davies boys) from their parents in order to beat time (eat time like the Neverland's crocodile). To fly off is to take another course away from time. Barrie tried to fix himself in flight, on a pre-Oedipal stage, in a long-running play. But, like Peter, John, and Wendy with the help of George Kirby's Flying Ballet, we can see his wire, we can trace his cordage to his Ariadne: Margaret Ogilvy, and, by

35 Ardgown st Greenock

Dear Peter Pan. I would love
if you would give me.
Johns wire. for I would
love to fly.
if you can send a note.
I saw you at the Kings
theatre. you were so good
love to Wendy. Michael and
John. with love.

from Margot webb.

look over the paper xxxxxx
+++

"we can see his wire"

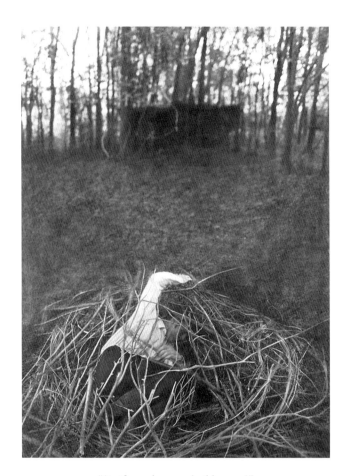

"'As if one alone can build a nest.'"

the final act, to the Llewelyn Davies boys that he awkwardly and tragically mothered. For Barrie did not really get fixed at a boyish stage, he grew in years (if not in height and mind) and so did "his boys." Not living happily ever after, Barrie woke up to find himself tangled in the nest of his own labor, with no one to push him out, with no wings to fly: stuck under the dark eaves (and eyes) of homes that he thought that he had left long ago (his nest of "thrums" at 9 Brechin Road — the Round Pond in Kensington Gardens — 23 Kensington Gardens, where the boy-birds lived when he first met them — Black Lake Cottage where "his boys" took holidays of adventure, where *The Boy Castaways* was played and documented — the fantastical Darling house at No. 27, where "there had been a slight fall of snow" (*P&W*, 86) the night the children flew — Wendy's house — the wash house); Barrie got stuck with the muddy heft of a nostalgia turned black with melancholia.

꿈

As if one alone can build a nest.

—J. M. Barrie, *The Little White Bird*

CHILDHOOD

SWALLOWS:

LARTIGUE,

PROUST, AND

A LITTLE

WILDE

"Do you know," Peter asked,
"why swallows build in the eaves
of houses? It is to listen to the
stories. O Wendy, your
mother was telling you
such a lovely story."
⤳ J. M. Barrie, *Peter and Wendy*

"Goodbye, goodbye," said
the swallow and flew away again
from the warm countries, far away
back to Denmark. There it had a
little nest above the window where
the man lives who can tell fairy tales,
and there it was that the swallow sang
"Tweet, tweet!" to him . . . And that's where
the whole story comes from.
⤳ Hans Christian Andersen, "Thumbelina"

⌐ LIKE MRS. DARLING'S KISS, "like the tiny boxes, one within the other, that come from the puzzling East" (*P&W*, 69), Lartigue's high-flying pictures made of light open onto Proust in his honey-colored cork-lined room,[1] which then opens onto the night garden of Oscar Wilde's fairy tale, "The Happy Prince": "However many you discover there is always one more" (*P&W*, 69). Lartigue, Proust, and Wilde each swallow childhood a little bit darker: from milk chocolate to dark chocolate to chocolate unsweetened, as bitter as mud.

Lartigue: Swallowed in Light

The Child and the Photograph owe their "genius" to their relationship to the real. As Barthes has commented, "the Photograph" itself, because it embodies what we understand as an absolute, true, almost innocent link to the referent, "suggests the gesture of the child pointing his finger at something and saying: *that there it is, lo!*" (*Ta, Da, Ça!*).[2] That is why we might view the Child like the Photograph, and the Photograph like the Child, as beyond philosophy, as a "weightless, transparent envelope,"[3] as honest, as faithful. Yet Childhood (always steeped in imagination) is more fanciful than adulthood; thereby, making Childhood *also* less bound to the big daddies (the Real, the Truth, etc.). And yet, again, it is only through photography that I am certain of having been there. "Look," I say to my boys as I point to a picture, "I, too, was a child." It is hard for them to believe, but the proof is in the pudding (the photograph). It is only through photography that I am certain, that they are certain, that *I was there*, that I was small. Only a world away from clapping because we believe in fairies, we swallow the image of child-me like a magic pill, and exclaim, as only believers can, "Mom was a kid!" Just as Barthes adheres to Maman as *the referent* of seemingly every photograph, I adhere to the Child that I was (and, in turn, to my children) with a similar umbilical indexicality, which may be more ghostly than bodily, even fairyish and eerie.

"'If this photo of my little garden at Pont-de-l'Arche
has an air of enchantment and a climate of mystery, I owe it
certainly to the touch of a good fairy'"

In 1903, Lartigue took a picture of his garden at the family's estate at Ponte de l'Arche in the Normandy countryside, not far from their mansion in Paris; indeed, this boy was born into "a circle of fairy godmothers . . . blessed with all the benefits they could bestow,"[4] a golden world of glittering privilege, because he was the son of one of the wealthiest bankers of the time. Photography was Lartigue's alchemy of making all the world precious in an elixir of longevity, which is apparent, even in this very early, eerie portrait of his *enchanted* garden.

If this photo of my little garden at Pont-de-l'Arche has an air of enchantment and a climate of mystery, I owe it certainly to the touch of a good fairy, and not, as they always tried to convince me, to the prosaic

fact that my badly washed plate had been corroded by hyposulphite (at that time, film did not yet exist, at least in France; the emulsion was fixed on glass plates).[5]

More brownie than man, Lartigue, it seems, was always a good-natured spirit of the fairy order. (In 1906, Lartigue's father took this picture of Jacques Henri with his mother, his Uncle Van Wers, and his Brownie Number 2.) Lartigue's wondrous and charmed life, at once little and big, prompts stories like the magic of a photograph. My boy-photographer (both here and gone) becomes my referent. I close my eyes and I receive Lartigue's Peter-Pan body, like a breeze through the upstairs bedroom window. As if I were a medium, I become (an)Other: the Boy. ("Who am I? If this once I were to rely on a proverb, then perhaps everything would amount to knowing whom I 'haunt,'" André Breton most famously wrote.)[6] Lartigue's child self comes through me, like a ghost, like the double exposure of his brother Zissou en fantôme.[7] On the verge of becoming a boy photographer, Lartigue's voice resonates within me, as if I were a swallow nesting in the eaves of his boyhood home, listening to stories:

As a spectator, I enjoy myself. But suddenly this morning an idea began to dance around in my head, a fairy-tale invention, thanks to which I will never again be bored or sad: I open my eyes, shut them, open them again, then open them wide and hey presto! I capture the image, everything: the colors! the right size! And what I keep is moving smelling living life. This morning I took a lot of pictures with my eye-trap.[8]

And even though Lartigue would soon become dismayed at the ultimate failure of his bodily eye-trap, causing him to write, "I thought I could put everything down on paper after having caught it in my eye-trap . . . No, not even with my colored crayons does it work"[9]—hence, driving him to mechanical photography—I choose to overlook that part of the story: I *innocently* and *fancifully* use *my eye-trap* to see him, to go back to the him that I never knew. He becomes an eye/I that I can stage, if only temporarily. I speak Lartiguish. I become the boy, the boy Lartigue:

"More brownie than man, Lartigue, it seems, was always a good-natured spirit of the fairy order."

"his Brownie Number 2."

5 - CHATEL: GUYON -

ZISSOU

"Lartigue's child self comes through me, like a ghost, like the double exposure of his brother Zissou en fantôme."

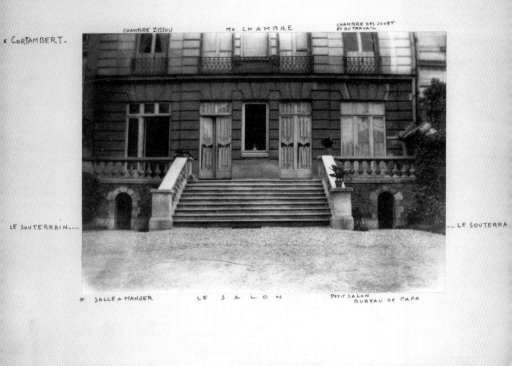

902. PARIS.

E CORTAMBERT.

CHAMBRE ZISSOU

MA CHAMBRE

CHAMBRE DES JOUET
ET DU TRAVAIL

LE SOUTERRAIN----

----LE SOUTERRA

* SALLE A MANGER

LE SALON

PETIT SALON
BUREAU DE PAPA

"Lartigue's voice resonates within me, as if I were a swallow nesting in the eaves
of his boyhood home, listening to stories"

"'I open my eyes, shut them, open them again, then open them wide . . .
This morning I took a lot of pictures with my eye-trap.'"

A spring day. The year is 1904. The place is Merlimont, a small seaside town in France. I am ten years old and I am strolling among the lovely sand dunes. I am carrying my camera. I am looking for magic. In my journal I have scribbled: "Photography is a magic thing."[10] I am looking for seaweed, bird feathers, an "occasional quivering shrimp or a scuttling crab,"[11] and precious seashells. I love all things beautiful and small. A seashell is a marvel of the universe: it is a house that grows in proportion to one's own body.[12] And seashells, like photographs, like empty nests ("shells are nests from which birds have flown"[13]), invite lovely daydreams for me—daydreams of being alone and away in a tent . . . a cabin . . . the sky.[14] "Seashells not only reference transport to another place by way of the sea—but as fossils they are also the geological bookmarks of time."[15] I think of my own secret walled-off places: my notes and drawings on paper, my bedroom of toys, my toy boat, the beautiful dollhouses that Papa builds (even one with an upstairs gymnasium),[16] my collection of birds' nests, my photographs, even my camera that I am carrying with me. I love everything. I want to keep everything.

As I walk and smell the salty ocean and dry sand all around me and hear the calls of the sea birds, I begin to daydream and to reflect. "Under my bare feet the beach advances, like an immense rug—both hard and very soft—and I feel as free as a sparrow."[17] I think back and I remember my other way of preserving memories, before I began carrying my camera far and wide, before I took pictures like "a kind of sport, like plucking butterflies out of the air."[18] I return to the time of the discovery of my "eye-trap," before I was even seven years old, to the day at home when I hid a little special something: "a small piece of paper, with a mysterious sign on it."[19] I gently stuffed this hush-hush treasure into a crack in the shiny parquet floor. I made sure that it would be safe forever. Like my treasured photograph of my race cars ready to run and my picture of Papa and Maman from 1902 (the second photograph that I ever took), images that I secretly keep in a beautiful blue lacquered box in my dresser's top drawer—only I know that my mysterious sign is there in the floor waiting for me. The day I put my little paper out of sight in the tiny crevice in the parquet, like a seed in the

"I am looking for magic."

"I think of my own secret walled-off places: my notes and
drawings on paper, my bedroom of toys, my toy boat, the beautiful
dollhouses that Papa builds (even one with an upstairs gymnasium),
my collection of birds' nests, my photographs, even
my camera that I am carrying with me."

"'like plucking butterflies out of the air.'"

ground, I thought of how my memory of that day would grow: "And when I find it again, I'll be able to remember today."[20] "Today," I think as I stroll through the warm sand, "the thing is [still] there. I know it. It knows it. It loves me, like everything that exists around me."[21] Like a string on the kite of the always fading image of childhood—"like Ariadne's thread, the tiny scrap of paper"[22] will enable me to find my way back to the boy I had been. Later, when I am seventy years old, I will understand that I am preparing my madeleines in advance.[23]

I put another tiny seashell, another treasure, into my pocket. Maman has been worrying that I am hurting myself by carrying my camera everywhere. Maybe I am but I don't care. If you look closely at the photograph of me with my 9x12 cm plate camera, my mother and my grandmother (taken by

1889 : ILS SE SONT MARIÉS

PHOTO MARCEL LARTIGUE

PAPA ET MAMAN ____

1902 - JARDIN DE LA MAISON DE PONT DE L'ARCHE : MA 2ᵉᵐᵉ PHOTOGRAPHIE
AVEC CHAMBRE EN BOIS A PLAQUES 13×18 - OBJECTIF SANS OBTURATEUR - VOILE NC

"Like my treasured photograph of my race cars ready to run and my picture of Papa and Maman from 1902 (the second photograph that I ever took), images that I secretly keep in a beautiful blue lacquered box in my dresser's top drawer—only I know that my mysterious sign is there in the floor waiting for me."

"Like a string on the kite of the always fading image of childhood"

Papa) you might agree with Maman that my right shoulder is slightly sloped from constantly strapping my camera, my toy of all toys, across my chest. My camera is a magical object that bottles all things that make me happy.[24] (Still so little, I have no idea that by the time of my death at age 92, I will have taken over 280,000 pictures of my happy French life.) Today I am carrying a smaller camera with me: a "Block-Notes." But Maman still worries! But how can I care about the weight and my shoulder and all of Maman's worries when the camera can give me an entire album of pictures?

Look at that! There it is! Lo! A sea swallow nesting bank, riddled with holes! It is so beautiful. Sea swallows, you know, are not really swallows—they are terns, but they look like swallows. I love sea swallows because they lay their lovely eggs in nests of grass and feather at the ends of nice warm, deep tunnels. (Long after, this day will revisit me, like an old friend, as I finally read *Swann's Way* [I am 76 years old!][25] and learn how Monsieur Proust

"(Still so little, I have no idea that by the time of my death at age 92, I will have taken over 280,000 pictures of my happy French life.)"

would "enjoy the satisfaction of being shut in from the outer world (like the sea-swallow which builds at the end of a dark tunnel and is kept warm by the surrounding earth), and where, the fire keeping in all night, [he] would sleep wrapped up, as it were, in a great cloak of snug" [I, 7; I, 7]).

Because sea swallows like to be with one another (like me and Maman and Papa and my brother Zissou and my cousins and my aunts and my uncles and all their friends—"birds of a feather flock together"), because they, too, like a crowd, they make their babies in large colonies. The nesting bank of the little sea swallow (sometimes called a hooded tern, or a sterna minuta, or a little tern or, my favorite, a fairy bird) can become riddled with holes all over. I bend down on my hands and knees and squint one eye closed, just like I do when I look through the lens of my Block-Notes Gaumont 4 x 6 or my Brownie No. 2. (Papa keeps giving me cameras that are lighter and easier to handle!): I want to see inside one of the larger sea swallow nesting holes, to see what I can see! But my ten-year-old body is on the verge of being called away by a huge bird of another kind, even bigger than a stork. It is Gabriel Voisin soaring twenty yards in his glider. It is the moment that I have been waiting for. I hear Papa calling and see Zissou and my Uncle Raymond waving excitedly. It is finally time to see the daring Voisin stretched out between the wings of his glider. Of the crowd that has come to witness the historic flight, only I have a cam-

"'enjoy the satisfaction of being shut in from the outer world
(like the sea-swallow which builds at the end of a dark tunnel
and is kept warm by the surrounding earth), and where, the
fire keeping in all night, . . . [he] would sleep wrapped up,
as it were, in a great cloak of snug.'"

"'birds of a feather flock together'"

"Of the crowd that has come to witness the historic flight,
only I have a camera with me."

era with me. I snap a picture of the funny people and a couple of donkeys
that have gathered for the show. Look at the people perched at the top of
the sand hill and below; they look like flocks of birds. If you cannot see the
donkeys, look behind the mother who is walking the child whose knitted hat
looks like a black-and-white target. The child steals the show with arresting
theatricality, like a gay little wind-up toy, smack dab in the center; but the
donkeys are there, soft and grey, behind the mother's shoulder. Oh, the first
flight has not made it off the ground, the glider is once again being dragged
up the crest of the dune. Voisin tries again. He makes it! He soars for twenty
yards. Zissou is screaming with delight as I snap the only picture of the first
public flight of an airplane in France. I am a hero.

⌐ After its final landing of the day in the dunes, I get Zissou to lie in the sand next to Gabriel Voisin's plane, so that I can take another picture. Always fun, Zissou likes to pose for me. In my viewfinder I see not only Zissou basking in the sand, but also Voisin's "bird," which now looks archaeological, as if it were a perfectly preserved carcass from another era. It is now a memory fallen to the ground. (Much later in my life, in 1968, as man, as man-boy, I will write: "I am not a photographer-writer-painter. I am a taxidermist who stuffs things that life offers in passing."[26]) Before long on this day, I also take a picture of my Uncle Raymond pretending to be a Voisin-bird-man plane. In

⌐⌐

"Zissou is screaming with delight as I snap the only
picture of the first public flight of an airplane in France."

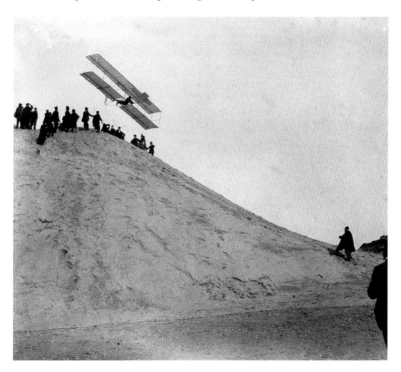

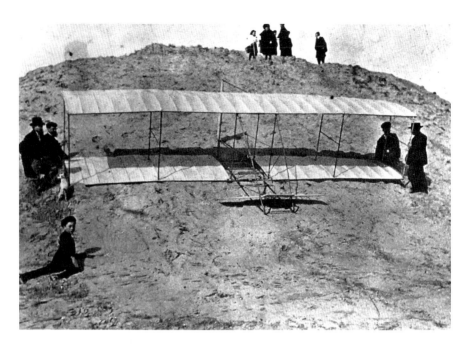

"a memory fallen to the ground."

both instances of flight — the actual plane hoisting Voisin up and Uncle Raymond pretending to be a plane — I "caught happiness on the wing."[27]

⊰ AS AUTHOR OF THIS BOYISH BOOK, I open my eyes, shut them, open them again, as wide as I can. But it is no use. Already my mind has begun to think of other things and is now littered, as is the room that I am working in, with gifts that my sons have made over the years (a pinch pot, a drawing of bats and foxes) — piles of books — papers, papers, papers — a clock with a practical face — photographs, always photographs — the odds and ends that people have given me — a mass of disparate images. My eye-trap fades.

"I 'caught happiness on the wing.'"

⌁ JUST AS LARTIGUE'S "EYE-TRAP" made him fervent with photography, as soon as Zissou had seen Voisin sail over the dunes, he became smitten by flight.[28] (I love the way that Zissou's own nickname sounds like a race car, a speedy motor, a flying invention.) Sometimes Zissou, or ZYX as he is abbreviated in the journals (making his named sound even more high performance), experimented with just a stone wall and an umbrella. It was as if he had seen Leonardo's journal sketch of a linen parachute and read the accompanying words: "A man . . . will be able to throw himself down from any great height without sustaining any injury."[29] And in the same Leonardo-spirit, Zissou also built gliders, not out of linen, but out of bedsheets. Lartigue's family, rich with paid help and kind neighbors, would mobilize "the whole household, including . . . valets, chambermaids, the carpenter, even the farmer's wife"[30] to stretch bed sheets across the framework of the wings. In 1909, Lartigue took a picture of Zissou stretching out a long sheet in preparation for making the rather disastrous ZYX22. (Lartigue has captioned the image: "The fabric bought by Mama is to be used for making sheets.")[31] As he turns Maman's sheets into the dream of flight, Zissou looks a bit like another Frenchman, Christo, working on his 24.5-mile, white fabric *Running Fence* (1974) that panted its way in wavy gusts until a final slip into California's luscious Pacific. Lartigue took many pictures of the inevitable crashes of ZYX22. But in 1910, he did catch the remarkable, if tiny, success of the ZYX24. I think that it is Dédé who is holding the cordage as Zissou takes off, his body barely dangling from his great kite-plane: at once homespun and revolutionary, not unlike his little brother's photographs.

In 1908, Lartigue was fourteen. That year, he felt extra energized about being a member of the Ligue Aérienne (Aerial League) (although he would not actually go up in a plane until 1916).[32] As a result, Lartigue was able to document the innovative flights of all the prominent "French aviation stars at Issy-les-Moulineaux, the nearby airfield that authorities had set aside for trial airplane flights":[33] Roland Garros, Latham, Paulhan, Lefèvre, Farman, Blériot. In his filmstrip journal drawings he sketches these flying

"he became smitten by flight."

"bed sheets across the framework of the wings."

men turned miniature, mechanical bird-toys: preparing for flight, soaring, falling, getting rescued. In one of the photographs that Lartigue took at the airfield, he captures Garros indulging in the acrobatics that made him famous, while a Farman biplane hovers like a giant wasp near the ground. A couple who must have been in awe of it all, with a baby in a pram who probably hardly took any notice at all, stroll below Garros's fantastic bird. Lightness, play, and hope prevail: the photograph is euphoric, high on the Belle Époque. Euphoria comes from the Greek *euphoros*, which means easy to bear, well-borne. Proust knew all about this when he wrote, in anticipation of the Narrator's emotional and physical *flight* (albeit on a train) to the sea, to Balbec: "To prevent the suffocating fits [asthma], which the journey might bring on, the doctor had advised me to take a stiff dose of beer or brandy at the moment of departure, so as to begin the journey in a state of what he called 'euphoria'" (II, 311; II, 11).

"As he turns Maman's sheets into the dream of flight, Zissou looks a bit like another Frenchman, Christo, working on his 24.5 mile, white fabric *Running Fence* (1974) that panted its way in wavy gusts, until a final slip into California's luscious Pacific."

"I think that it is Dédé who is holding the cordage as Zissou takes off, his body barely dangling from his great kite-plane: at once homespun and revolutionary, not unlike his little brother's photographs."

"men turned miniature, mechanical bird-toys: preparing for flight, soaring, falling, getting rescued."

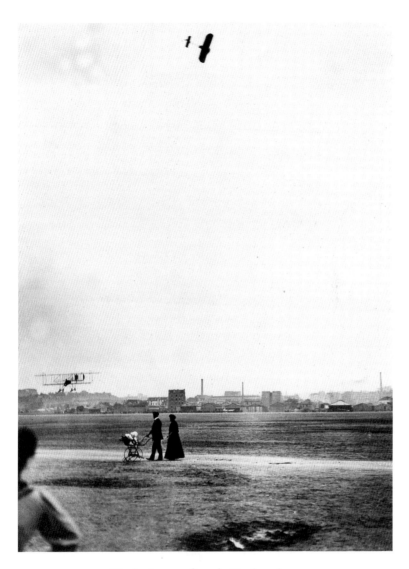

"Euphoria comes from the Greek *euphoros*,
which means easy to bear, well-borne."

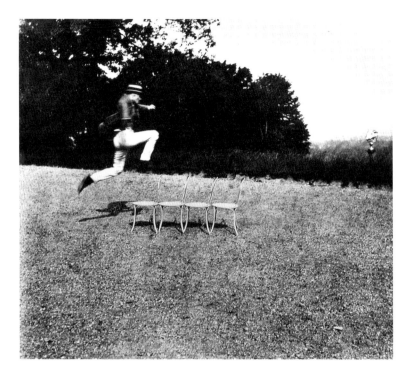

"How like a sea swallow he looks, with his black-banded hat
and coat tails like wings, he is a fairy-man, a fairy bird."

In 1908, Jacques also took some of his best pictures of euphoric flight
without gliders or kites, including one of Raymond Van Weers, nicknamed
Oléo, caught in the air of a steeplechase. How like a sea swallow he looks,
with his black-banded hat and coat tails like wings, he is a fairy-man, a
fairy bird. In the same year, Jacques snapped Boubotte (Marthe, sister of
Raymond/Oléo) jumping off a wall, her light and lovely dress and petti-
coats catch the air as a makeshift parachute all-a-flutter. Light and as pretty
as cake, Boubotte opens her mouth wide. Boubotte, is caught forever in
the lightness of air. She is a madeleine cake of whipped egg whites, sugar,
and fluff on the tip of our tongue, before first bite. Boubotte: a spirited,

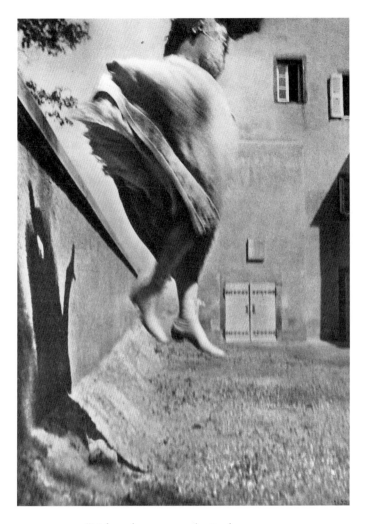

"Light and pretty as a cake, Boubotte opens
her mouth wide. Boubotte is caught forever in
the lightness of air. She is a madeleine cake
of whipped egg whites, sugar, and fluff
on the tip of our tongue,
before first bite."

"Lartigue nests the innocence of childhood memories, by cracking out of his shell at the height of the Belle Époque."

cotton-candy cloud. In the words of Barthes, referring not to Proust but to another utopian thinker, Fourier, who happened to love spice cake: "A man's desire can grow out of a child's dream (here the dream of Candyland, of lakes of jam, of chocolate mountains.)"[34]

Like Lartigue's photographs of his childhood past taken by the unencumbered (innocent eyes of the child), the madeleine cake embodies all the innocence and lightness of youth. Just as the truest, most innocent memories are perceived by Proust and his followers to be the involuntary memories — *les mémoires involontaires* — Lartigue's pictures are celebrated as truer, more innocent because they were taken by so-called innocent eyes. Since we already tend to see the past as a silken child, at first as light and as innocent as a newly hatched bird, growing into our supra-encumbered, weighted down, adultified present ("all history is kiddie-lit"[35] claims that child-ruiner-critic James Kincaid) — Lartigue nests the innocence of childhood memories, by cracking out of his shell at the height of the Belle Époque. (As in William Blake's *For Children, The Gift of Paradise,* which almost broke into the nineteenth century: "At length for hatching ripe, he breaks the shell" [1793].)

After all, we envision the Belle Époque as a happy developing child — with all of the weightiness of all things Victorian, its general heaviness, being laid to rest. Oscar Wilde must have felt the lightness coming when he claimed shortly before his own death, in the coldness of November 1900, with his own heavy wit: "If another century began and I was still alive, it would really be more than the English could stand."[36] Like the Belle Époque's own

"lightness, lightness"

~~~

image of itself, like Lartigue's image of himself as perpetual, eternal small boy, Lartigue's photographs-turned-immediate-memories are as light as air. Lartigue's lightness, lightness, lightness is emphasized in his balloons, his images of balls, his cat caught in midair. Lartigue's are all joyful, prettied up, *elevated* images of both childhood and Paris. While photographs often make us fall back into memory, Lartigue seemed to be after a utopic condition of asking us to jump up into a winged Memory, to flutter her, to fly her into the air — making all the world below small, all the world toy.

It is tempting to relate Lartigue's desire to find lightness everywhere to George MacDonald's tongue-in-cheek fairy tale "The Light Princess" (1864). Deprived of gravity by her "atrocious aunt,"[37] the princess floated and bounced everywhere. The "flesh-and-blood princess" weighed "nothing at all."[38] And she was as light in spirit as she was in weight. She was saccharine sweet. "If you heard peals of laughter resounding from some

"lightness"

"While photographs often make us fall back into memory, Lartigue seemed to be after a utopic condition of asking us to jump up into a winged Memory, to flutter her, to fly her into the air—making all of the world below small, all the world toy."

�„∿

unknown region, you might be sure enough of the cause."[39] Light-hearted, light-headed, and insanely light-footed, "she never could be brought to see the serious side of anything. When her mother cried, she said: 'What queer faces mamma makes! And she squeezes water out of her cheeks! Funny mamma!'"[40] When asked of her longing, she replied: "'To be tied to the end of a string—a very long string indeed, and be flown like a kite . . . [to] rain rose-water, and hail sugar plums, and snow whipped-cream.'"[41] MacDonald's "Light Princess" unknowingly makes light of Lartigue before Lartigue.

Likewise, as our spree with Barrie highlighted, the free-flying image of the Belle Époque was as of yet sheltered from the world wars to come, un-

aware of the terrors of its technological innovations. As a result, the pictures seized by the famed boy-photographer might be described as an enchanted *photographie involontaire*. Like a bit of starry sugary madeleine, Lartigue's photographs escape the hands and weight of time, soaring as a sunny day without yesterday. Although *taken* from a world of straw, this little trickster named not Rumplestiltskin, but Jacques Henri Lartigue, spins them as gold. It is all very Proustified, but for Proust, the spinning is weaving and the gold is emerald — as he writes:

> If after an interval of several years I rediscovered in my memory a mere social acquaintance or even a physical object, I perceived that life all this while had been weaving round person or thing a tissue of diverse threads which ended by covering them with the beautiful an inimitable velvety patina of the years, just as in an old park a simple runnel of water comes with the passage of time to be enveloped in a sheath of emerald. ( VI, 416–417; VI, 551)

Even with the coming of both World War I and World War II and with the loss of his precious three-month-old daughter Véronique (born and died in 1924),[42] two failed marriages, Lartigue's oeuvre (if not always the man) remained almost entirely sunny and downy.

In keeping with the sun-drenched, buoyant optimism of his photographic records, Lartigue's journals are equally striking for their steadfast optimism. For example, Lartigue hardly ever mentions World War I. Too underweight to serve in the military, he chauffeured officers around Paris. His journal — like a shell, like a nest, like a child's bedroom, like a bed of snug — served as protection from the outside world at war. He barely noted the fighting, but certainly noted his first mistress ("the most desirable woman in Paris"[43]), the good weather, etc. Lartigue himself explains in 1971:

> If this "journal" doesn't mention the war, it is first of all because this is *not* a "journal." It is my little secret ruse for preserving joys, my happiness, my immense happiness, all perfumed with inexplicable things. And at the same time protection.[44]

This is not to say that there are not photographic exceptions, fine ones at that, which begin to scratch away at Lartigue's protective emulsion, but they are all routinely at the end of a long string, far from reality, spun with gold, and enveloped in emerald. Below the photograph from 1911 that shows the French army guarding an airfield taken before the war, Lartigue captioned the image in his album "1914—August 1—war . . . Paris." This picture "has often been used to illustrate texts on the first world war,"[45] but we know differently. We know that "Lartigue never set foot anywhere near the front line."[46] (The problematic magic of photography.)

Even when his dear friend Oléo is killed in the war (we first met him as a "fairy bird" flying over chairs) Lartigue chooses to diminish the grave tragedy with typical Lartiguian sunshine. Above and below an uncharacteristically isolated and small image of Oléo, Lartigue has written in his album: "Oléo killed, my friend Oléo, so lively! Eccentric! Well turned-out!"[47] But this happy, almost shockingly distanced, annotation is not just a result of Lartigue's joyous imagination and disposition, it has been elevated by time: the caption was written long, long after the loss of his friend, when Lartigue was assembling and reassembling his life into a protective narrative of photo albums (probably in the 1970s). And perhaps, this is what the fairy bird would have preferred.

Shelley Rice sees World War I as strengthening Lartigue's desire to preserve the past to turn inward into a self-proclaimed bird of another sort, childishly presented as an ostrich:

> The war turned the young man inward, away from the world, and solidified his yearning for the past. It was around this time that Lartigue

OLÉO TUÉ

MON AMI OLÉO
SI VIVANT! EXCENTRIQUE!
COQUET!.. ..

"'Oléo killed, my friend Oléo, so lively! Eccentric! Well turned-out!'"

began to think of himself as "the ostrich," remarking in his diary that if the only way to be happy was to be an ostrich with his head buried in the sand, then so be it.[48]

As one interviewer of Lartigue so succinctly and confidently claims: "Photography was literally child's play for Lartigue."[49] Lartigue perpetuated this vision of play. In his own words: "When I was a little boy . . . I played with my toy boat for hours. The camera was like a bigger boat. To play with it, I thought nothing of waiting until the right time to use it."[50] So innocent and true was his gaze that the boy-Lartigue saw no need to wait for the right photographic moment; he *naturally* snapped up all that he saw with his voracious camera-eye. But even so, he could not help but grow. In a journal entry from 1910, the grown boy bemoans growing up: "At night, in my bedroom, I have a night-light that Mama turns on when I go to bed . . . I don't want to grow up. 'Dear Jesus, please make me stay small.'"[51] As he wrote in his diary in December 1914, at the very adult age of twenty-one: "Each moment I find myself full of sorrow because I'm growing up. I would like to be able to stay as I am. . . . Or better, I would like to be even smaller. . . . Often I cried because I was getting bigger. . . . This happiness will not last forever."[52] Even his camera as a "bigger boat" cannot take him away from what lies on the edge of the cliff.

For Lartigue, "motion was linked to [the] gaiety and pleasure" of childhood itself—"as if framing a loved one in midair would keep him carefree forever."[53] Likewise, it is this sense of movement that marks Lartigue's own style of photography. Lartigue's photographic ecstasies of release, flight, hustle and bustle, commotion, flurry, buzzing, purring, whishing, swishing, sweeping, alighting, lighting, slipping and sliding, jumping, turning, and dashing, make for instant gay nostalgia. In the words of Svetlana Boym:

> [Lartigue] worked against the media; instead of making his photographic subjects freeze in a perfect still, he captured them in motion, letting them evade his frame, leaving blurry overexposed shadows on the dark background. Fascinated by the potential of modern tech-

"'Will I feel giddy at the cliff edge?'"

≺∴≻

nology, Lartigue wanted photography to do what it cannot do, namely, capture motion. Intentional technical failure makes the image at once nostalgic and poetic.[54]

Before his death, just to make sure that he flew from this earth bathed in light and lightness — "Will I feel giddy at the cliff edge?" he writes in 1977[55] — Lartigue drew a big yellow sun with all the power of a child's sun-lit scrawl and wrote: "This sign is to be stuck on the last page of the last album of my photos, on the page following the one with the last photo(s) on it. The End."[56] While the other little sign stuffed into the shadows of a crack in the parquet floor is long gone, the one made by the ancient little boy still shines.

## Proust Swallowed in Honey-Colored Mud

It is likely that in 1908 Proust began writing his masterpiece, *In Search of Lost Time*, the same year that Lartigue became a member of the Ligue Aérienne and took some of his best photographs of flight, including those without planes, like Oléo caught in the air of a steeplechase or Boubotte jumping off a wall with her petticoats all-a-flutter like a parachute. Although Proust loved photography, he was not a photographer. As we learned in the last chapter, it was not until the turn of the century with Kodak's invention of the Brownie that the snapshot became readily possible to more than audacious amateurs. Proust's childhood was the era of professional photographers. Nevertheless, photography made Proust's vision of his childhood possible. As the photographer Brassaï has written: "Photographic art is at the heart of Proustian creation: the author takes his inspiration from the techniques of photography for the description of his characters, the composition of his narrative, and utilizes an infinite variety of photographic metaphors in order to elucidate the very process of his creation."[57] Or in Proust's own words:

> Pleasure in this respect is like photography. What we take, in the presence of the beloved object, is merely a negative, which we develop later, when we are back at home, and have once again found at our disposal that inner darkroom the entrance to which is barred to us so long as we are with other people. (II, 616–617; II, 227)

Even Céleste Albaret claims Proust as photographic: a tendency that Proust, himself, emphasized in conversation with her. Note how Proust's photographic powers began as a child and how they hail Lartigue's eye-trap, both of which can be pronounced as "caught on the wing":

> He [Proust] had fabulous powers of observation and a tenacious memory. For example, each of the two or three times he looked through the kitchen window of rue Hamelin at Mme. Standish and her family at dinner, he made only a brief appearance, as if he were just passing by. But in

thirty seconds everything was recorded, and *better than a camera could do it*, because behind the image itself there was often a whole character analysis based on a single detail — the way someone picked up a salt cellar, an inclination of the head, a reaction he had *caught on the wing*.

When I expressed surprise at this he said:

"But Céleste, it isn't a gift. It is an intellectual bent that can be cultivated until it eventually becomes a habit. Lots of activities were forbidden to me, so I spent more time than most people sitting and watching, and to pass the time, if for nothing else, I used to observe what other people did. Sometimes I watched them with envy, and that made me observe all the better. It started when I was still a child. Once I began to have asthma I had to walk instead of run, both in the Champs-Elysées and the Pré Catalan at Illiers . . ."

He pointed to his eyes and brow and said: "It's all recorded here, Céleste . . . But it is never finished."[58]

Proust, like Lartigue, wanted to hold onto his memories and especially the memories of his beloved childhood, with a recording eye. Proust the grown man and Lartigue the boy may have walked past each other in the Bois de Boulogne, but they never met in the flesh. Lartigue did not discover Proust until he was an old man (and Proust was long dead), reading the *Search* under the advice of the American photographer Richard Avedon.[59] At the Donation Lartigue, there is written evidence of Lartigue's late discovery of Proust, a life that was nevertheless always already Proustified. My favorite reads: "There are butterflies of day and butterflies of night. Proust was the big butterfly of night. Me, I am nothing but a blue butterfly who flies into the sun."[60] Another snippet of writing comes below a typed passage from *Time Regained*. There, the photographer reveals a sense of wonderment with Proust, for the writer had already written what Lartigue was trying to perform with the camera.[61] Similarly, the photography critic Clemént Chéroux writes that Lartigue had typed a passage on memory from one of Proust's letters. This time the ancient little boy annotated his Proust quote with the short phrase: "Without knowing, when I was small,

that was what I was chasing after with my *eye-trap*."[62] (He was melting butter, whipping eggs with plenty of sugar, and folding in flour to fluff and bake his madeleine cakes, stored in an airtight tin called photography.)

While the most vital souvenir of Lartigue's childhood was the camera itself, the most vital souvenir of Proust's childhood was, of course, the famed madeleine cake, which like a Barthesian photographic punctum prompted memories of his childish past and has punctuated nearly every chapter of this book. Beyond the nibble of madeleine soaked in tea, the essence of other objects also trigger childhood (spirit-photograph) memories. The final volume of the *Search*, *Time Regained*, is especially rich in objects from which genies of days gone by slither out from things as if they were magic (lantern) lamps unto the past: the pair of uneven paving stones, the sound of a spoon chiming on a plate, and, especially the stiff napkin that makes the Narrator remember a starchy towel he had dried off with when he was a boy:

> The napkin which I had used to wipe my mouth had precisely the same degree of stiffness and starchedness as the towel with which I had found it so awkward to dry my face as I stood in front of the window on the first day of my arrival at Balbec, and this napkin now, in the library of the Prince de Guermantes's house, unfolded for me—concealed within its smooth surfaces and its folds—the plumage of an ocean green and blue like the tail of a peacock. ( VI, 258–59; IV, 447)

Like the madeleine, the starched napkin retains the past in its crevices. The *fold*, like the wrinkle, is a memory of sorts, one that is perhaps more formal, but also bodily: children fold their arms around their mother's neck; birds fold their wings close to their bodies when alighting. In French, *pli* is a pleat, a crease, a wrinkle, a fold.

Is it no wonder then that Proust's most beloved character Albertine (her name occurs 2,360 times in the novel, more than any other character) is most cherished when dressed in the famous folds of a Fortuny gown. (After learning that she coveted Fortuny gowns, the Narrator plans to buy one for her as a special gift and ends up ordering six: one fold unfolds upon another

fold and another fold and so on and so on, "like the tiny boxes, one within the other, that come from the puzzling East," like the many Albertines, like caressing Albertine on one's lap, which meant "touching no more than the sealed envelope of a person who inwardly reached to infinity" [V, 520; III, 888].) While most critics steadfastly insist that Albertine is a stand-in for the author's beloved, if unscrupulous, secretary Alfred Agostinelli, I understand Albertine as Memory herself. Imperfect, the Narrator tries to keep her captive, tries to perfect her by not allowing her to enter the bodies of others: "I had suddenly wanted to keep Albertine because I felt that she was scattered about among other people with whom I could not prevent her from mixing" (V, 475; III, 855). He asks of orphaned Albertine what he has already asked of the madeleine: "Where did it [she] come from? What did it [she] mean? How could I seize and apprehend it [her]?" (I, 60; I, 44). But to make her captive meant that "the sea breeze no longer puffed out her skirts . . . [for, he] had clipped her wings, and she had ceased to be a winged Victory" (V, 500–501; III, 873). Nevertheless, even as captive, the Narrator still searches for what keeps Albertine aloft. And like the search for the mystery buried within the memory-provoking madeleine (a secrecy that generates the entire unfolding of the long novel in all of its volumes), the Narrator spends the whole of the entire Albertine volume (*The Captive*) "trying to guess what was concealed in her" (V, 490; III, 865). Fortuny gowns are famed for their magnificent colors and patterns. ("The Fortuny gown which Albertine was wearing that evening seemed to me the tempting phantom of that invisible Venice . . . overrun by Arab ornamentation, like Venice . . . like the columns from which the oriental birds that symbolized alternatively life and death were repeated in the shimmering fabric, of an intense blue which, as my eyes drew nearer, turned into a malleable gold . . . the sleeves were lined with a cherry pink which is so peculiarly Venetian that is called Tiepolo pink" [V, 531; III, 895–96].) But the true mystery of the Fortuny gown is how its innovative pleats that so gracefully respond to the body were achieved. (Today there are coveted Fortuny gowns in the famed Delphos style that still are holding their pleats.) A Fortuny gown, especially when worn by Albertine, is a sartorial madeleine. Magically it

recalls in its folds the past and the present at once, "faithfully antique but markedly original," neither "collector's item," nor "sham antique" (V, 497; III, 871).

Because Proust's memories wrinkled and folded, as both the childhood bud and the flower grown dead at once, they are as much like, if not more like, Nadar's weighty pictures than Lartigue's poofed with light and lightness. As Shelley Rice so eloquently observes in her book *Parisian Views*: Nadar pictures Paris with the darker light of mourning, emphasizing how memories, how his specifically photographic memories, in the words of Proust's beloved Baudelaire, "weigh more than stone."[63] (As Baudelaire writes in "The Swan": "Paris may change, but in my melancholy mood/Nothing has budged! New palaces, blocks, scaffoldings,/Old neighbourhoods, are allegorical for me,/and my dear memories are heavier than stone."[64]) Even Nadar's images of flight seemed to be weighed down, not only by the period's more primitive nature of both photography and flight, but also by a past dead, by a heavy funerary past that lie in the catacombs beneath Paris. Nadar's anticipatory photographs of flight are emphatically still, like death itself: whether they be his studio self-portrait in a balloon gondola (1865) or his Surrealist-looking little prototypes of his "beloved propeller machines," held by very tiny cords to give them the artificial effect of looking airborne. Although the actual machines could laboriously fly for a few seconds, it was technically impossible to photograph them during flight, and even if he could, the rotation of the blades would have blurred the image.[65] Blurred motion was the stuff of our boy photographer, not of the great photographer of the famous and the bizarre as stilled life. Nadar's photograph of the interior of *Le Géant* is a suffocating image of 20,000 meters of silk, half in thousands of wrinkles, half billowing into its eventual monumental pregnancy of air. Again, as with Proust, we experience wrinkles and folds as memory. Nadar's interior of the *Géant* inflating is aerial in nature, but it is weighed down by the memories of age, of Paris undergoing change, of the wrinkles of Paris. After the balloon crashed, Nadar did not give up his quest for aerial navigation, nor did he let go of the weightiness that seemed to metaphorically, if not actually propel the work. In his own words: "Be

"As Baudelaire writes in 'The Swan': 'Paris may change, but in my melancholy mood/Nothing has budged! New palaces, blocks, scaffoldings,/Old neighbourhoods, are allegorical for me,/and my dear memories are heavier than stone.'"

"emphatically still"

denser—heavier—in order to *master* the air."[66]

As Benjamin learned from Proust: "The wrinkles and creases on our faces are the registration of the great passions, vices, insights that called on us; but we, *the masters, were not home.*"[67] In sum, what wrinkles us, what ages us, is that we cannot "charge an entire lifetime with the utmost awareness,"[68] that none "of us has time to live the true dramas of the life that we are destined for."[69] The occasion of the famous goodnight kiss (in which the Narrator not only got the kiss he was plotting for, but also got his mother to spend the night with him), smacks at longing fulfilled, thereby turning into loss, so as to purse childhood into a sweet for Time to sadly swallow. "That . . . evening opened a new era, would remain a black date in the calendar" (I, 51; I, 38). Never again would a kiss be the same. Never again could Maman spend the night with her "little chick," her "little canary" (I, 52; I, 38). Proust's bird stage was over. The kiss that locked in loss (and swallowed the key) created such emotion in both mother and child that the Narrator felt that he had "with an impious and secret finger traced a *wrinkle* upon her soul and brought out a first white hair on her head" (I, 52; I, 38). White hairs and wrinkles mark defeat in both mother and child. First wrinkle, first white hair, *first and last* goodnight kiss of such intense innocence, purity, and sentiment. Proust tried to unwrinkle time through the writing of the *Search*. Photography, the flattest and smoothest of all the arts, is his medium of time. Proust wrote his book *photographically*, "so as to prolong the time of respite" (I, 15; I, 13), so as to

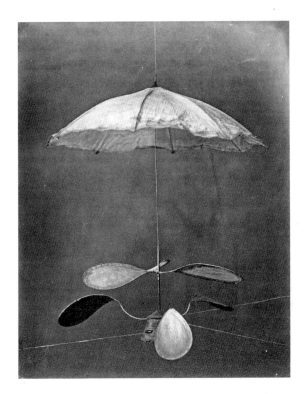

"'beloved propeller machines,' held by very
tiny cords to give them the artificial effect of
looking airborne.'"

❧

allow time to unfold forevermore. But at a cost. To read his novel is to *book
into* the heft of his labor: the *hôtel du travail.*

While for Lartigue and, especially, Barrie, flight is at the heart of the
bird-like child, Proust is less enamored with air travel. Even when writ-
ing about flight, one feels the continuous pressure of Proust's memory-
grounding, burial-nest aesthetic. (Proust reflects: "A book is a vast ceme-
tery."[70]) For example, when Proust describes the "flying angels" of Giotto's

"a suffocating image of 20,000 meters of silk"

"'reminiscent of an extinct species of bird'"

◦⟨∶◦

Arena Chapel in Padua, who are lovely beings which the Narrator had seen in all of their glorious blueness with his mother — he fills the angels not only with the lightness and the hope of Belle-Epoquian flight, but also (if subtlety) grounds them as lost dodos stuffed in a museum of natural history. In Proust's hands, Giotto's angels are the pupils of the famous French aeronaut Garros (who was photographed by Lartigue) and they are also extinct birds:

> Watching the flight of these angels . . . [with the] childlike obedience . . . with which their minuscule hands are joined, they are represented in the Arena chapel as winged creatures of a particular species that had really existed . . . since they are real creatures with a genuine power of flight . . . soaring upwards, describing curves, "looping the loop," diving earthwards head first, with the aid of wings which enable them to support themselves in positions that defy the laws of gravity, and are far more reminiscent of an extinct species of bird, or of young pupils of Garros practising gliding, than of the angels of the Renaissance and later periods. ( V, 878–879; IV, 227)

We find the splendor of the beauty of flight matched with a "funeral gloom"[71] in Proust's gift to his famed boyfriend-chauffeur-secretary: Alfred Agostinelli. While, as Jean-Yves Tadié has pointed out, "Marcel would always be closer to Baudelaire than to [Mallarmé] the author of the 'Le Cygne' sonnet . . . it is this sonnet that the Narrator would have engraved on Albertine's yacht [named the *Swan* according to Albertine's wish (V, 613)], and Marcel on Alfred Agostinelli's aeroplane."[72] The words of the poem suggest, perhaps, Proust's dream of flight swallowed by the fear that Agostinelli would fly away:

> A swan of olden times recalls that he,
>> Splendid yet void of hope to free himself,
> Had left unsung the realm of life itself
>> When sterile winter glittered with ennui.[73]

Swallowed up into the sea—a possible suicide—not unlike Saint-Exupéry—who was off to take photographs from the sky when he was swallowed up by the ocean.

WHILE PROUST AND LARTIGUE (and, of course, Barrie) all share a predilection for the protection of the nest, Proust's nest feels exceptionally protective. Proust's life was lived and written between the sheets of his bed and his eternal book. For Proust, who struggled for most of his life for breath, to receive a visitor with a flower in his lapel was life threatening (at least in his mind). The outside world of flowers and petrol and dust and pollen were a constant threat embodied by *both* the Narrator and his author. Proust's supra-interiorized existence could even be picked up in the smell of his books. "When I pick up a book that has been in your room," says Albertine to her captor, "even if I'm reading it out of doors, I can tell at once where it's been because it still has a faint whiff of your beastly fumigations" (V, 16; III, 530). Sadistically tearing open the cocoon before she leaves the Narrator forever, Albertine loudly flings open her bedroom window, deliberately threatening her profoundly asthmatic vanquisher: "I was

afraid of draughts, nobody must ever open a window at night . . . more funeral than the hoot of an owl . . . that sound of the window which Albertine had opened" (V, 541–42; III, 903).

For Proust, a *catastrophic* threat such as World War I provided insulation in ways akin to Lartigue's notion of himself as an ostrich. Strangely, the threat of the war filled Proust not necessarily with bravery, but rather a perplexing, if protective, unresponsiveness. Enemy bombs could not drive him into the basement where "Antoine, the concierge, and his wife [were] shaking with fright," Proust preferred to remain upstairs where it was easier to breathe, away from "the dust and smell."[74] Once, even, Proust traveled the streets when the antiaircraft guns were shooting and returned with bits of shrapnel in the brim of his hat. Céleste Albaret tells the story:

> "Monsieur, look at all this metal!" I said. "Did you walk home, then? Weren't you afraid?"
>
> "No, Céleste," he said. "Why should I be? It was such a beautiful sight."
>
> And he described the searchlights and the shellbursts in the sky and the reflections in the river. Then he said he'd had a very pleasant evening at Francis Jammes's [the first to have written favorably about *Swann's Way*]. . . .
>
> It was so unlike him, who never set foot in the street, to have trudged so far.[75]

The "beauty" of the war at night will later appear in *Time Regained*, when Proust romanticizes the fighter planes in a World War I air raid, as the character Robert Saint-Loup (a military soldier) explains:

> "And perhaps they are even more beautiful when they come down," he said. "I grant that it is a magnificent moment when they climb, when they fly off in *constellation*, in obedience to laws as precise as those that govern the constellations of the stars—for what seems to you a mere spectacle is the rallying of the squadrons, then the orders they receive, their departure in pursuit, etc. But don't you prefer the moment,

when, just as you have got used to thinking of them as stars, they break away to pursue an enemy or to return to the ground after the all-clear, the moment of *apocalypse*, when even the stars are hurled from their courses? And then the sirens, could they have been more Wagnerian? (VI, 98–99; IV, 337–338)

Or, on the topic of the colors of a Zeppelin raid, the Narrator sounds as if he might be discussing a vase of peonies painted by Manet:

I remarked apologetically to Robert how little one felt the war in Paris. He replied that even in Paris it was sometimes "pretty extraordinary." This was an allusion to a Zeppelin raid which had taken place the previous night and he went on to ask me if I had had a good view, very much as in the old days he might have questioned me about some spectacle of great aesthetic beauty. At the front, I could see, there might be a sort of bravado in saying: Isn't it marvelous? What a pink! And that pale green!" (VI, 98; IV, 337)

The patina of "beauty" of cast on Paris as reimagined by Proust's World War I is a continual, often nostalgically presented theme in Proust's final volume. When dining late one evening in a restaurant with Robert, after the regulation of lights out by 9:30, the Narrator romanticizes the meal in "mysterious half-darkness," by comparing the *mise-en-scène* with that of being in "a room in which slides are being shown on a magic lantern," as if he were back in Combray (VI, 64; IV, 313). Similarly, the regulated darkness of Paris nights during the war "helped to create the illusion that one had just got out of the train and arrived to spend a holiday in the depth of the country: for example the contrast of light and shadow on the ground that one had all round one on evenings when the moon was shining. There were effects of moonlight normally unknown in towns . . . when the rays of the moon lay outpoured upon the snow on the Boulevard Haussmann, untouched now by the broom of any sweeper" (VI, 65; IV, 314).

The war provided Proust with even more moss, more lichen, and more fallen feathers to build his nest of snug. In fact, as if lining his bed (nest)

with "the corner of [his] pillow, the top of [his] blankets, a piece of shawl, the edge of [his] bed, and a copy of a children's paper," cemented together, "bird fashion" (I, 7; I, 7). In fact, the tragedy of World War I gave Proust more time and more layers of subject matter. In the words of Tadié:

> By 1914, we have a novel of which two thirds had been printed, and one third had been written a few years earlier. Suddenly the book was thrown into confusion by the character Albertine . . . Over the last eight years of Proust's life, the work doubled in size. As we know, the creation of Albertine was not the only cause; another reason was the First World War, which obliged Grasset to suspend publication and also provided the novelist with new subject matter.[76]

Proust's nest of supra-insulation is the underground nest of the sea swallow writ large: it is a dark place, a "darkroom." Brassaï has tenderly commented on how Proust evokes the dark room often in his writing, conscious of how he is like a photographer, loaded "with images he has managed to wrest from light," and thereby must withdraw to "a dark place in order to bring them to visibility."[77] Proust elaborates on his ark turned (d)arkroom in the dedication of his early book *Pleasures and Regrets*, to Willie Heath:

> When I was a small child, the fate of no other character from the scriptures seemed to me to be quite so miserable as that of Noah, because of the flood which kept him trapped in the ark for forty days. Later on I was frequently ill, and for days on end I also had to remain in my "ark." It was then that I understood that nowhere could Noah have had a better view of the world than from the ark, despite the fact that it was closed up and that night ruled over the earth. When I began to get better, my mother, who had never left my side and even stayed with me through the night "opened the door of the ark" and left. Yet just like the dove "she returned that evening." Then when I was completely cured, like the dove, "she did not come back again." It was necessary to start to live again, to turn away from oneself, to listen to words which were harsher than my mother's; worse still, the words she used, always so

gentle up till then, were no longer the same, but were marked with the severity of life and its duties which I was to learn from her.[78]

Brassaï has noted how Proust's ark-like evasion enabled his photographic vision:

> Despite impulses of evasion, despite complaints against enforced captivity which filled certain of his letters, Proust judged that his withdrawal was the very condition of his creation. "I am the man," he wrote to Léon Daudet, "who has withdrawn from the world in order to more vividly relive it. . . . Like Plato's cave." Proust's cavern only rarely permitted him a direct vision of the world, but like Noah, he could see it more vividly, thanks to his remarkable visual memory, having accumulated over the years everything of interest that the world has to offer to his eyes: flowers, women, youths and young girls, steeples, glances, gazes.[79]

As Brassaï seems to suggest—from the fictional "Combray" (which itself is an envelope for the real Illiers)—to Proust's sleepy dreams of all the bedrooms that he has slept in, which then became the hammering of the first nails in the timber of his ark—to the cork-lined room of his apartment at 102 Boulevard Haussmann—to the resonance of the book within a book within a book that takes you deeper into the shelter of the *Search* that takes a year (far more than forty days to get through) to journey through, so that you may see the light from whence you came (in sum to get from madeleine to madeleine): darkness is the residence that gives way to every glimmer of illumination in his creation.

And it is from Proust's ark that Barthes found "the very condition of his creation." (Within the nesting dolls of my book, where the big doll is the hollow but full mother who splits apart to give way to large, medium, and tiny wooden carved boys, my own words return as I work my way back from petit Lartigue to Barthes and his final illuminated manuscript for Maman, *Camera Lucida*.[80]) Recall that Barthes wrote that he wanted to "be a primitive, without culture,"[81] without light. That his labor is to patch light

leaks. That, like the photographer who pulls the photographer's black cloth over his head in order to see the upside down image reflected back at him on the camera's back, Barthes can see better in dark. Cradle his words, like a boat rocking on the ocean: "In order to see a photograph well, it is best to . . . close your eyes."[82] Remember that Barthes told us that, "My stories are a way of shutting my eyes."[83]

Likewise, but without Proust or Barthes, Lartigue opened his eyes, shut them, opened them again, then opened them wide, to take his pictures with his camera-less but nevertheless photographically informed "eye-trap." And soon after, the darkroom would give him much pleasure, always doused with the sunny: "It's fun developing in the dark, when one has just been running in the sun."[84]

Just as Proust could not write a word that was not drenched with meaning, the personal objects that made his ark home were also carefully selected: filled with meaning, they were, more often than not, unattractive. His objects and furniture were thick with swarms of memories—but without the lightness of things that have no personal (heavy) meaning. As Proust wrote to Madame Catusse in 1906: "To my mind any picture that one hasn't coveted, bought with pain and love, is horrid in a private house."[85]

Proust's home, it seems, was always heavy, as is suggested through the famous anecdote of Wilde's visit to his family home. In 1891, Proust met Wilde, "who at the time was at the height of his fame . . . Apparently, Proust, just twenty, invited the powdered, perfumed, puffy Irish giant to his family's apartment for dinner but Wilde, after taking a single glance at the *heavy*, dark furniture, said, 'How ugly everything is here,' and left.'"[86] In fact, As Edmund White writes: "All his life Proust would remain faithful to the ugly furnishings his parents and relatives had accumulated"[87]— whether it be the heavy French tastelessness of his aunt's house in Illiers-Combray or his apartment at 102 Boulevard Haussmann that he would move into in 1906, after his mother's death. Heavy with dark memories, "he had watched his old uncle Louis Weil die in the bedroom that he would later occupy."[88] He chose this apartment because he had often come to dine there with his mother. Proust wanted to move into an apartment that his

mother had known. He wanted to, in his own words, re-create "the lost motherland."[89] There he would write most of the *Search*.[90] When setting up his nest to write, Proust brought all his ugly furniture with him, keeping "all the furniture that could be found room for in the apartment,[91] because he loved the memories that it held. "The important principle in furnishing the rooms was to retain the memories of rue de Courcelles, the last apartment where Marcel had lived with his parents . . . 'the place where for him his mother lay.'"[92] The bedroom where Proust wrote most of the *Search* would feature his now famous brass bed; his uncle's desk would remain.

But the walls of the bedroom at 102 Boulevard Haussmann were stark: "Bare walls represented the space in which the mind could cut itself off in order to create."[93] Diana Fuss has compared the Proust's darkroom, a barely lit "sanctuary from the sights sounds and smells of the city"[94] to a Jewish synagogue, mirroring his mother's religion. As Fuss has commented: "With its bare walls and muted lighting, Proust's quiet bedroom interior comprises an intimate devotional space, a private tabernacle of ecumenical design. The bedroom's refusal of representational art and preservation of literary manuscripts calls to mind a Jewish synagogue, with its ban on graven images and its veneration of the sacred text."[95]

Yet the bedroom-turned-writing-temple was not just Judaic in its quiet, dark mysticism; it was also Christian. Echoing the marriage of his Jewish mother and Catholic father, Proust's bedroom at Boulevard Haussmann was "a hybrid of synagogue and church."[96] For, visible from Proust's writing bed was "a small white statue of the infant Jesus wearing a crown of grapes."[97] The statue was placed on the same small rosewood chest that held his "thirty-two black leather notebooks"[98] used for writing the *Search*, bringing to mind the makeshift altar that the Narrator's aunt Léonie kept next to her bed in Combray. Aunt Léonie was patterned, of course, after Proust's real aunt Élisabeth Amiot (from his father's Catholic side). She was hostess to the family's summer visits in Illiers and seemingly was a model for Proust's own neurasthenic behavior. Like a sickroom and little Christian church at once, like Proust's (d)arkroom at Boulevard Haussmann with the bed at center stage, Aunt Léonie's bedroom, with its own chest and a statue

of the Virgin, nests within the author's rosewood chest with its infant Jesus wearing a crown of grapes. The Narrator describes Aunt Léonie's Catholicized chamber as follows:

> At one side of her bed stood a big yellow chest of drawers of lemonwood, and a table which served at once as dispensary and high altar, on which, beneath a statue of the Virgin and a bottle of Vichy-Célestins, might be found her prayer-books and her medical prescriptions, everything she needed for the performance, in bed, of her duties to soul and body, to keep proper times for pepsin and vespers. (I, 70; I, 51)

But more than the darkness (whether it be the ark turned darkroom or even "a miniature version of the [famed] windowless Madeleine [church] located only a few streets away"[99]), more than the packed-in ugly furniture full of memories, more than the Judaic bare walls, more than the kitschy Christian statuary, and more than the chamber's heavy punctuation of Far East exoticism that wafted and wafts from the Chinese screen, which still stands today next to Proust's brass bed at the Musée Carnevalet's re-creation of his bedroom (hinting at a time when France understood the Jew as foreign and oriental) — the author's writing chamber is most famous for being lined with cork, creating in the already sunless room, a "placenta-like inner lining."[100] It was in 1910 that Proust, seeking even the bareness of sound, had his bedroom walls lined with cork, like the mud of a swallow's nest.

Although the swallow is often a metaphor for the coming of spring, the swallow — if one recalls Barrie's *The Little White Bird* (1902) — is also a very dark image. Allow me to rehearse an important passage from the last chapter ("Nesting") that reveals why Peter *darkly* loves swallows:

> He [Peter] has still a vague memory that he was a human once, and it makes him especially kind to the house-swallows when they revisit the island, for house-swallows are the spirits of little children who have died. They always build in the eaves of the houses where they lived when they were humans, and sometimes they try to fly in at a nursery window, and perhaps that is why Peter loves them best of all the birds. (*LWB*, 206)

Barrie renders her a dark image, because she is a creature of return. Again, I quote the words of the famous French historian Michelet (initially discussed in the first chapter of this book in relation to nostalgia as a process of return): "She [the swallow] is the *'bird of return.'* And if I bestow this title upon her, it is not alone on account of her annual return, but on account of her general conduct, and the direction of her flight, so varied, yet nevertheless circular, and always returning upon itself."[101] The swallow returns upon itself, perhaps not unlike Proust whose "withdrawal was the very condition of his creation."[102] At age twenty, in 1890, as a typical party game of the times, Proust was given a questionnaire asking a series of likes and dislikes. His favorite bird? "The Swallow."[103]

## Wilde: Swallowed by the Dark Side ("The Other Half") of the Garden

> I went down the primrose path to the sound of flutes. I lived on honeycomb. But to have continued the same life would have been wrong . . . I had to pass on. The other half of the garden had its secrets for me . . . Some of it is in 'The Happy Prince.'"
> —Oscar Wilde, Letter to Lord Alfred Douglas (January–March 1897) in Rupert Hart-Davis, *The Letters of Oscar Wilde*

The swallow is not only Proust's favored nest maker (at least when he is a sea swallow) and Peter Pan's most-loved bird (at least when he is a house-swallow making his nests in the eaves of houses), it is also a come-again bird (in the spirit of Michelet), who *broods* darkly at the center of Oscar Wilde's unsettling fairy tale: "The Happy Prince." As both noun and verb, "swallow" is suggestive and wide-ranging. We have seen time and again how the swallow is the bird-turned-metaphor for the homesick boyish man who spins his yarn, each and every time back to Maman. In China, the swallow's nest is made into a sweet soup[104] which has all the earmarks of anorectic hedonism, because it is decadent (costly, rare, for some an aphrodisiac, cooked in sugar) and ascetic (because it is made entirely of bird

I

LORSQUE J'AVAIS SIX ANS j'ai vu, une fois, une magnifique image, dans un livre sur la forêt vierge qui s'appelait *Histoires vécues*. Ça représentait un serpent boa qui avalait un fauve. Voilà la copie du dessin.

On disait dans le livre : « Les serpents boas avalent leur proie toute entière, sans la mâcher. Ensuite ils ne peuvent plus bouger et ils dorment pendant les six mois de leur digestion. »

J'ai alors beaucoup réfléchi sur les aventures de la jungle et, à mon tour, j'ai réussi, avec un crayon de couleur, à tracer mon premier dessin. Mon dessin numéro 1. Il était comme ça :

J'ai montré mon chef-d'œuvre aux grandes personnes et je leur ai demandé si mon dessin leur faisait peur.

1

"as if she were Saint-Exupéry's boa constrictor
who has swallowed an elephant whole."

⁓

saliva).[105] And to swallow is a peculiar kind of embodiment, suggesting not only images of the Eucharist, or the incestuous madeleine (mother-cake), but also the pregnant body which looks like a snake who has swallowed her prey—as if she were Saint-Exupéry's boa constrictor who has swallowed an elephant whole.

Given Wilde's penchant for disenchantment, it is not surprising that his fairy tales *swallow* childhood differently than Proust and Lartigue. Never-

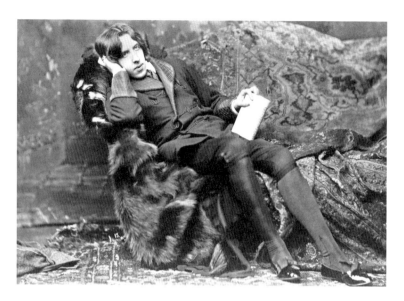

"Irish Giant"

theless, the darkness of Wilde's fairy-tale swallow is analogous to Bar-
rie's gloomy swallows, spirits of dead children, in keeping with Michelet's
maudlin image of her as well: "So nearly dost thou caress me, that I feel in
my face the wind, almost the whirr of thy wings. Is it a bird? Is it a spirit?
Ah if thou art a soul, tell me frankly, and reveal to me the barrier which
separates the living from the dead."[106] Whereas Lartigue, mostly, shows
childhood happiness at the cost of the real, and Proust (as Benjamin writes)
illustrates not the *real* thing but a "blind, senseless, frenzied quest for happi-
ness"[107] — Wilde, the Irish Giant, wrote his fairy tale beyond the parameters
of the tiny self, far from the miniature and even the minutiae of our self-
proclaimed "ancient little boy" (Lartigue) and our "aged child" (Proust).

Wilde's story takes the typical animation of the inanimate — so typical of
fairy tales and children's stories, or even of the general animistic energy of
Lartigue's pictures (especially his *Collection of Racing Cars Ready to Run*) —

backward and forward. For Wilde's heavy tale is the story of a prince who, after he died, became a fixed statue "high above the city," "gilded all over with thin leaves of fine gold," with "two bright sapphires" for eyes," and a "large red ruby" that "glowed on his sword-hilt";[108] but, before he had become a much-admired object of art with a lead heart, he had been a live boy with "a human heart" (*HP*, 97). With a kind of complex cinematic twist, "The Happy Prince" begins as animate, as a real boy (yet feels nothing but happiness and has no experience with tears) and becomes an inanimate sculpture (yet becomes gravely unhappy and cries real tears for the city below him).

When the Happy Prince had a human heart he lived in the Palace of Sans-Souci, "where sorrow is not allowed to enter" (*HP*, 97). It was there and then, when he was full of childhood mobility and energy, that the Happy Prince used to play all day with his companions in his garden. "Round the garden ran a very lofty wall, but [he] never cared to ask what lay beyond it, everything about [him] was so beautiful" (*HP*, 97). At that time, he "did not know what tears were" (*HP*, 97). So he lived and he died. "If," as Wilde questions, "pleasure be happiness," (*HP*, 97) then you could say that The Happy Prince was very happy.

Although Proust's writing is weighted by tears, wrinkles, gloom, boredom, loss, disappointment, Proust shares with Lartigue, and the Happy Prince, the blind bourgeois notion of pleasure as happiness, of life without work. In the words of Jacques Rivère: "Marcel Proust died of the same inexperience which permitted him to write his works. He died of ignorance of the world and because he did not know how to change the conditions of his life which had begun to crush him. He died because he did not know how to make a fire or open a window."[109] This inability to do life's simple things was put to a test during Proust's brief stint as soldier; naturally, he was typically protected, having a civilian billet rather than sleeping in the barracks, and was exempted from the most tiring and violent drills. One night, while on invitation to the prefect's house, the captain invited to put Proust up for the night. Céleste Albaret tells the story in her employer's own words: "When

I got into the guest room I found the bed hadn't been made up—there was just a pile of sheets and blankets. I was annoyed because I had never made a bed, and I got myself all entangled with the sheets. I ended up sleeping on the bare mattress."[110]

Although Proust spent most of his life in bed, he did not even know how to make one.

I imagine that Lartigue could and did make beds; he grew up, traveled, married three times, and had two children. But he and Zissou did not have to go to school and lived in an enchanted make-believe world: his father "built up the eighth-largest fortune in France . . . [and] entrusted his sons with a mission—to be happy above all—and gave their dreams form by organizing a fairy-tale world for them."[111] Not one to disobey, Lartigue took the cue from his father and lived life to its fullest: he wanted, he said, "to send the sun into people's bellies."[112]

THE SWALLOW IS FAMED for being the bird of hard work. I learned this as a child.

I grew up in California, and my own childhood is riddled with memories of the famous swallows that return every March 19, on Saint Joseph's Day, to Mission San Juan Capistrano. Coming home all the way from Goya, Argentina, the swallows return to the same mud nests every spring. And, if the nests have not survived the winter, the remarkable birds will often rebuild in the same place. Every year, they leave Goya at dawn on February 18 and arrive at San Juan Capistrano exactly thirty days later. The flight is 15,000 miles. There and back is almost a complete flight around the earth. In order to prepare for their unbelievably taxing flight, they eat heartily for 120 days: ingesting 1,000 flies, spiders, and worms daily. Yet, during their flight, as if they were writing the *Search*, they do not eat or drink. They elegantly flap their wings and serenely coast from dawn to sunset. (I am reminded of how the Narrator surprises the reader by announcing his habit of coming to quiet orgasms with Albertine while she is asleep, "a pleasure that was less pure," via the metaphors of a flying bird: "I . . . allowed my leg to dangle

"Although Proust spent most of his life in bed,
he did not even know how to make one."

against hers, like an oar which one trails in the water, imparting to it now
and again a gentle oscillation like the intermittent wing-beat of a bird" [V,
87; III, 580]. Likewise, I am reminded of how Peter slept and ate while in
flight to the Neverland.) Wasting no time. Wasting nothing. Nearly wasting
away.

Dedicated to the Happy Prince, Wilde's Swallow embodies the work
ethics of the cliff swallow: he is a strong working partner, a comrade, with

the golden statue. But the Swallow is also lovingly devoted the prince. The homoerotic overtones of the kissing Swallow and Prince are reinforced by Wilde's own dedication of the story to a young American boy (too old to be just a boy, too young to be yet a man). In Wilde's words: "Faery-stories for one who lives in Faery-Land."[113]

As statue, the dead Prince sees all of the ugliness and the misery of the city: he has gained a socialist and sympathetic vision. The Swallow enables the Prince to act on the misery that he sees by first pecking out the ruby on his sword-hilt and delivering it to a tired seamstress whose young boy is sick with fever—only to peck out one of his sapphire eyes to deliver to a tired, cold, poor, young playwright—only to peck out his other sapphire eye and deliver it to a little match-girl whose father will beat her if she does not bring him some money. The Prince sacrifices his beauty, becoming outwardly uglier, for the suffering youth below him, all the while achieving "spiritual beauty."[114] Blinded and ugly, the Swallow (who had long been planning to fly to Egypt) decided to remain with the Prince and go with him to "the House of Death."[115] Thereby, "the Swallow also achieves perfect beauty by sacrificing its life for the love of the Prince."[116] Wilde "trembles":[117] "But you must kiss me on the lips, for I love you" (*HP*, 102), said the Prince to the little Swallow. The Swallow then "kissed the Happy Prince on the lips, and fell down dead at his feet" (*HP*, 102). The tale is Christian,[118] socialist, and homoerotic.

When the University's Art History Professor deems the statue of the Happy Prince as no longer useful because it is no longer beautiful—the townspeople melt the statue in the furnace. But the lead heart would not melt, "so they threw it on a dust-heap where the dead Swallow was also lying" (*HP*, 103). As the short tale closes, God asks one of His Angels to bring Him the two most precious things in the city, "and the Angel brought Him the leaden heart and the dead bird" (*HP*, 103).

Lartigue is the world agreeably miniaturized. Lartigue, like the "Light Princess," flew with the pleasure of the movement over the sight of seeing from above. Proust is the microscopic collected until it grew into his

"'and the Angel brought Him the leaden heart
and the dead bird.'"

enormously long masterpiece of intense gravity. Wilde's, at least the world of "The Happy Prince," is a bird's-eye view that takes in (swallows) the ugliness of class struggle. Starkly beautiful, "The Happy Prince" is tight-lipped, refusing to swallow childhood like it was a piece of cake.

⸭

The sky was more darkened than during the swallows' exodus.

—Proust, *In Search of Lost Time*

# MOUTH

# WIDE

# OPEN

# FOR

# PROUST:

# "A SORT OF

# PUBERTY

# OF SORROW"

To endure his book
like a form of fatigue,
to accept it like a discipline,
build it up like a church . . .
cosset it like a little child.
⌐ Proust, *In Search of Lost Time*

Part of the freedom of being fourteen—
or at least the freedom one has to fight for,
is the freedom to sleep-walk; the freedom,
that is to say, to do things in one's own way.
⌐ Adam Phillips, "Clutter: A Case History"

*Cathedral-Novel*

There is a color slide of my adolescent-yawning self, taken in front of West-
minster Abbey. (I am a fifteen-year-old American teenager from Califor-
nia.¹) Behind me is the great church stuffed with over three thousand graves
(Edward the Confessor, Henry V, Darwin, Tennyson, Charles Dickinson,
Mary Queen of Scots). Beneath me is a great, royal rug of manicured green,
green velvety English lawn. The green leaps out of the picture; it is satu-
rated with the rich color of oil painting, like the green in the bride's cas-
cading dress in Jan van Eyck's *The Arnolfini Portrait* (1434) or the dramatic
green that plays in the folds of the curtains behind the two learned men of
Hans Holbein's *The Ambassadors* (1533). Even though *The Arnolfini Portrait*
and *The Ambassadors* were mere miles away in London's National Gallery,

"'like a form of fatigue, . . . like a discipline, . . . like a church'"

I did not know such images then. I did not yet know that I would become an art historian. (I am not even sure that I knew such a profession existed.) I did not yet know that I would later write on Lacan's interpretation of Holbein's anamorphic skull, which lies between the two learned men. I did not yet know that van Eyck's groom's strange discarded, elongated, wooden, pointy clogs, like two slices of scruffy apple tart, and his big, black straw hat, above his heavy-lidded, half-asleep eyes would later be of great fascination to me in my career as a university professor. I did not yet know there were objects, bits and pieces, effects and feelings all around me that would later become vital to my life. In a Proustian sense, I did not yet know what I was "apprenticing" to. Gilles Deleuze uses this term to describe the tight-weaving of Proust's life with his work.[2]

Like an old gothic church that has been built upon for centuries, Proust provides us with a seemingly endless provision of signs (like too much food on the table, like Françoise's Sunday luncheon in Combray of "eggs, cutlets, potatoes, preserves . . . biscuits . . . a brill . . . a turkey . . . cardoons with marrow . . . a roast leg of mutton . . . spinach . . . apricots . . . gooseberries . . . raspberries . . . cherries . . . cream cheese . . . an almond cake . . . a brioche . . . and . . . a chocolate cream" (I, 97; I, 70). When we are reading the *Search*, we never know what will surface for us as meaning, as a signified.

Proust constructed his book as a vast sphere of signs, of experiences to be tasted, perhaps resulting in a madeleine or two for ourselves. He gave us the world and its words to dream, drift, and at times to be pinched. Proust wrote his *Search* for his readers, in a manner that relentlessly insists that we be *readers of ourselves*:

> To return to my own case, I thought more modestly of my book and it would be inaccurate even to say that I thought of those who would read it as "my" readers . . . but the readers of their own selves, my book being merely a sort of magnifying glass like those which the optician at Combray used to offer his customers — it would be my book, but with its help I would furnish them with the means of reading what lay inside themselves. (VI, 508; IV, 610)

Today, but not then when I was fifteen, I look at the green in front of the great Westminster Abbey through the *Search*'s magnifying glass usurped from Combray: the grass and its environs beckon me, perhaps even kiss me, with what Proust has called "the vigorous and luxuriant growth of a true work of art" (VI, 516; IV, 615). In Proust's sorrowful words, which grew out of Hugo's own resurrecting light and gloom:

> *Grass must grow and children must die.* (Victor Hugo)[3]
> To me it seems more correct to say that the cruel law of art is that people die and we ourselves die after exhausting every form of suffering, so that over our heads may grow the grass not of oblivion but of eternal life, the vigorous and luxuriant growth of a true work of art, and so that thither, gaily and without a thought for those who are sleeping beneath them, future generations may come to enjoy their *déjeuner sur l'herbe*. (VI, 516; IV, 615)

Barrie, Barthes, Lartigue, Proust, and Winnicott, authors of "true works of art," have left much behind, providing me, even before I knew them, a place to enjoy my *déjeuner sur l'herbe*. I may have responded to the first taste of my luncheon with a long, interminable, *thoughtless*, adolescent yawn, but today I am interested in the full meal, savoring each bite and all of the memories and thoughts it awakens.

Living for Proust was always already inseparable from the "research" (*recherche*). Proust who made use, or tried to make use, of everything in his day-to-day life was in a constant apprenticeship to something that was not yet formed: the book as his life, the many volumes of the *Search*. (Twenty-five pages or so from the end of the final volume, he writes: "I seemed to see that this life that we live in half-darkness can be illumined, this life that at every moment we distort can be restored to its true pristine shape, that a life, in short, can be realised within the confines of a book!" [VI, 507; IV, 609]). As the great Proust scholar Jean-Yves Tadié has remarked in his own 986-page biography of Proust (952 pages in the original French): "Proust made use of everything he experienced or thought about during his lifetime."[4] (What a curse!) In Proust's essay on Reynaldo Hahn (the charmed

and charming composer and Proust's lover for a couple of years—they met when Proust was twenty-three and Hahn was eighteen), Proust holds on to this inescapable tight-knit image of life and art, when he musically writes: "Everything in an artist's life is connected to the implacable logic of inner revolutions."[5]

Is it no wonder then, that (to stay within our thread of churches), Proust would seemingly make use of everything in Église Saint-Jacques, the church of Illiers-Combray, which we know as Saint-Hilaire in the book? It would take Proust a lifetime to sort out the clutter (within its interior and beyond) that congregates in Illier's Saint-Jacques in order to construct his book like a cathedral, as he remained forevermore "apprentice" to all signs that life had to offer him. Proust first discusses the notion of constructing a book like a cathedral in *Swann's Way*, where Saint-Hilaire is offered as a notable structure for its mapping. In the words of Roger Shattuck: "Its sturdy architecture, handsome stained-glass windows, secret crypt and distinguished bell tower belong to an edifice more imposing and more ordered than any other in the village."[6] By the final volume, Proust will come out with it: he will "build it [the book] up like a church" (VI, 507; IV, 610).

While Proust could not have known it when he was just a boy, Saint-Jacques would become the overlooking steeple-eye to all of Proust's carefully chosen words: "So slender and so pink that it seemed to be no more than scratched on the sky by the finger-nail of a painter" (I, 86; I, 62). Yet, as every reader of Proust knows, the tenderness of the steeple far from undermines its dominance in Combray, nor in the *Search*: for "it was the steeple of Saint-Hilaire that shaped and crowned and consecrated every occupation, every hour of the day, every view in the town" (I, 88; I, 64). And like Monet's haystacks or even more appropriately Monet's own cathedrals at Rouen, Proust's steeple changes, blushes, darkens with each moment passing; not only is it a pink scratch, it also becomes "thrust like a brown velvet cushion against the pallid sky" (I, 89; I, 64) or even a giant loaf of bread "baked golden-brown ... with gummy flakes and droplets of sunlight" (I, 88; I, 64).

Always metamorphosizing, the church, its steeple, and all of its buried memories will by the end of the *Search* come to its own destruction during

World War I, taking much with it, including, one assumes: "the old porch by which we entered, black, and full of holes as a colander" (I, 80; I, 58); "memorial stones, beneath which the noble dust of the Abbots of Combray ... lay buried" (I, 80; I, 58); the beautiful stained glass, "never so sparkling as on days when the sun scarcely shone" (I, 80; I, 58–59); "two tapestries of high warp representing the coronation of Esther . . . to which the colours, in melting into one another, had added expression, relief and light" (I, 82; I, 60); "the graceful Gothic arcades . . . like a row of grown-up sisters" (I, 83; I, 61); "the shadowy vault, powerfully ribbed like an immense bat's wing of stone" (I, 84; I, 61); Mme Loiseau's gone-astray fuchsias, which would "go and cool their purple, congested cheeks against the dark front of the church" (I, 85; I, 62). Saint-Hilaire, perhaps less church than character, suffers and grows in her own right. Who would have guessed her death by war? Not the author, who memorialized her in *Swann's Way*, years before the war. Writing, in fact, is not unlike going to war. In the words of Robert Saint-Loup, who will himself be killed in action: "A general is like a writer who sets out to write a certain play, a certain book, and then the book itself, with the unexpected potentialities which it reveals here, the impassable obstacles which it presents there, makes him deviate to an enormous degree from his preconceived plan" (VI, 102; IV, 341).

Although the bigger church, the amazing church, Chartres (where the family had "to change trains . . . [and] sometimes stopped to admire the spires"[7]) was only twenty-five kilometers away, Saint-Jacques was Proust's enveloping nest-home-church: the cover, sleeve, shroud, bandage, sheath, swaddle to every book, from the early drafts of the abandoned and never-finished *Jean Santeuil* to his notes on and translation of Ruskin's *The Bible of Amiens* to the final words of *Time Regained*.

In contrast to the never-ending enjoyment of the steeple of Saint-Jacques, the spires of Chartres symbolized loneliness and separation for Marcel, as metonymic and metaphoric signs of "seeing his mother off" on return trips to Paris.[8] Even today, when making the pilgrimage to Saint-Jacques, you still must change trains at Chartres, and the sugary spires inspired by Abbé Suger's Abbey of Saint-Denis reign over the station with all of the unreality

"I changed trains"

⚜

of Disneyland's Matterhorn Mountain as seen from the California freeway (the *sign* that the magic is near) or the strange sight of Walt Disney World's Cinderella castle in Florida (actually inspired by French architecture of the twelfth and thirteenth centuries[9]). Today, there is still something sad about the station at Chartres, mobbed with tourists (just like Disneyland), which overwhelms one with a sense of blueness, like the unearthly radiance of the "Chartres blue" stained glass inside the church. But on my Proustian pilgrimage, I took delight in passing up the most famous of late Gothic churches in favor of Saint-Jacques: a bird's house in comparison. (I changed trains; I looked out the window to read the sign — *Chartres*.)

In *Jean Santeuil* (began in 1895, abandoned in 1899),[10] Illiers appears nakedly under its real name, but here, at the very start of *everything*, "everything took place around the church":[11]

It was actually a town which was dominated by its church, criss-crossed by processions, decked out with moveable altars, in which the priest lived here, the sacristan there, the nuns there, filled with the sound of the church bells which, on the days of the high mass, aroused the stream of people on their way to mass, and with the smell of the cakes prepared for the lunch that followed.[12]

Proust's love of Saint-Jacques was an early (if unconscious) juvenile apprenticeship to his mature study of the work of the British art historian John Ruskin: an inkling of what was to become his adult religion, his "cult of the cathedral,"[13] always already bathed and prompted by his nostalgia for Illiers. (He spent Easter and summer vacations in Illiers until he was fifteen, the age that I was as I yawned in front of Westminster Abbey.) Proust's second publication (after *Plaisirs et les Jours* [*Pleasures and Days*][14] in 1896) was a translation, plus notes and introduction, of Ruskin's last major work: *The Bible of Amiens* (1884). *Le Bible d'Amiens* (1904) is a record of Proust's passionate study of Ruskin, the latter famed for falling in love with the cathedrals of Amiens and Abbeville and other Gothic master-pieces of the region. Later Proust would translate and annotate Ruskin's *Sesame and Lilies* (1906), which includes his very lovely essay "On Read-ing" (tasted in this book's introduction). Indeed, Ruskin had much to do with Proust's cathedral-approach to reading and writing. In the words of Diane Leonard:

> During the period of his Ruskin translations, Proust had found the conception of narrative structure which he was seeking. In *The Bible of Amiens*, he had encountered the idea of reading a cathedral like a book—therefore, why could not he, as a writer, create a book that could be read as a cathedral? He had amused himself by sketching for Reynaldo Hahn humorous drawings of stained-glass windows and cathedral statues depicting Reynaldo and himself as characters in brief narrative situations. It was only a short step from that point to con-ceiving a "cathedral-novel"—a narrative constructed like a cathedral, inscribed in a figural picture-language.[15]

Proust even went so far as to consider giving each part of his book the titles: "Porch I, Stained-Glass Windows of the apse, etc."—but gave up these "architectural titles" because he found them "too pretentious."[16] Per-haps, however, not only were these architecture titles pretentious, they also delineated themes within the novel in a way that was antithetical to Proust's

own breathless, peripatetic (if in bed), beautiful, soulful voice. (As Jean Cocteau, "the poet-playwright-impressario-filmmaker"[17] [he wrote and directed the haunting, lyrical 1945 *Beauty and the Beast*] recalled: "Just as the voice of a ventriloquist comes out of his chest, so Proust's emerged from his soul."[18]) Like Joseph Cornell—the wanderer who, like a panting butterfly landed on Emily Dickinson, then a bubble pipe, then a Medici prince, then a coin, then an etching of a ballerina, then Saint-Exupéry, then a bird's nest, then some cork, then a nest, then *Paul and Virginia*, then a mustard label, then a chocolate bar wrapper, then a shell, then a blue marble—Proust suffered from too much too-muchness. Like a cathedral, Proust's seeming lack of structure is understood as being built on forever. ("How many great cathedrals remain unfinished!" [VI, 508; IV, 610].)

Consider the dramatic continual adding on so present in the most famous cathedrals, as in the cluttered and cluttering Westminster. With traces from the eleventh century, Westminster is famed as an architectural masterpiece of the thirteenth to sixteenth centuries—yet, bits, but not much, of the original medieval stained glass remains—while the North Rose Window is from the early eighteenth century, most of its glass is from the nineteenth and twentieth century, etc., etc. Where one part begins and another ends, it is impossible to tell. As is necessitated by conflict, war, disease, feast and famine, weather, population, and fashion, Westminster's architecture, like that of all great cathedrals (small and large), is a complex weaving of historical threads.

Inside, the disorder (as if it were a character undergoing analysis) continues. Westminster is stuffed with dead bodies, sculpture, candles, music, worshippers, tourists: clutter which is subject to change; clutter which is like memory; clutter which is like (Proustian) writing. I close my eyes and sleepwalk through Westminster's walls, like you can in a dream, like you can in a novel. I barely, barely scratch the Abbey's surface; it is a mess of building life. I imaginatively reach for two candlesticks bought with money bequeathed by the serving maid Sarah Hughes in the seventeenth century. I step up to the Shrine of Edward the Confessor, which was erected in 1368

but dismantled by the monks and stored during the Reformation and then partially restored (in an unskilled way) during the reign of Mary I. I hear the choir of twenty-two boys and twelve Lay Vicars (men of the choir) who sing the daily Services. I smell age past and present. I contemplate sitting on the magnificent, oaken Coronation Chair made by King Edward I, in 1300–1301, to enclose the famous Stone of Scone. Since 1308, almost every monarch has been crowned in this Coronation Chair. Queen Victoria, herself, sat in this chair during the 1887 Golden Jubilee Services held in the Abbey. The back of the chair is scrawled with schoolboy graffiti, courtesy of Westminster boys, who scratched the chair with their names and sayings during the eighteenth and nineteenth centuries. (I must confess that the schoolboy scrawl is my favorite part of the Abbey tour — it really lights the guides up.) When I come to the Lady Chapel, I peer over a white marble effigy of Mary Queen of Scots: she lies beneath an elaborate canopy; she wears a close-fitting coif, a flared ruff, and a long mantle fastened by a brooch. At her feet is the Scottish lion crowned. She was originally buried in Peterborough Cathedral, after her death in 1587, and she was moved to the Abbey in 1612. And on and on. The effect makes time indistinct, like being inside and outside of a book, like being half-awake, like knowing that you are dreaming. Proust says it best, right on the first page of the *Search*: "Then," it began "to seem unintelligible, as the thoughts of a previous existence must be after reincarnation; the subject of my book would separate itself from me, leaving me free to apply myself to it or not; and at the same time my sight would return and I would be astonished to find myself in a state of darkness . . . I would ask myself what time it could be" (I, 1; I, 3).

So miniature in comparison to the great cathedrals, so hollow inside its simple hallowed hall, it is nevertheless worth noting that Proust's *real* Saint-Jacques is also a building life. It was destroyed during the Hundred Years' War and rebuilt in the fifteenth century, with its own subtle, but remarkable, changes over time. For example, looking at the photograph of the church from 1910, sold by the little old ladies that run *L'Office du tourisme* in tiny Illiers-Combray, the old shops built onto the side of Saint-Jacques

have been torn down and clear black-and-white signs have been added for the Proustian pilgrim. Saint-Jacques, like so many cathedrals, was built and then sacked and reduced to rubble and then grew back bigger (in scale and history and meaning). Like the *Search*, like verdant life, Saint-Jacques continues to grow, to die, to reseed. ("Grass must grow and children must die.") Much has been made of the fact that Céleste Albaret burned thirty-five of Proust's famous *cahiers* used for the writing of the *Search*. But like the round sandstone arch on the north side of Saint-Jacques, a remnant of the original church before it was destroyed, ninety-five of Proust's exercise books still survive and can be read at the Bibliothèque nationale.[19]

Proust's writerly church, then, is "not a stable form like geology but a dynamic form like music,"[20] which is easily likened to Proust's other great model for writing, stitching, and cutting the words of his book as if he were sewing a dress made by Françoise. For like the successive styles of the Combray church, which "records motion in time and becomes a 'ship sailing through the centuries from bay to bay, from chapel to chapel,'"[21] Françoise sews, like a church. Just as Proust writes with the old and makes it new, Françoise makes the Narrator's great-aunt's old cloak and hat into a delightful, perfect, charming costume. By removing the bird from the great-aunt's hat and adding a "velvet band, the loop of ribbon that would have delighted one in a portrait by Chardin or Whistler," Françoise proves her "simple but unerring taste" (II, 309; II, 10). By turning the cloak, which had been "decorated with a hideous pattern and jet beads" (II, 308; II, 10) inside out to expose an "'inside' of plain . . . faded cherry-coloured cloth" (II, 308–09; II, 10), Françoise metamorphosizes the once shabby coat into a lovely one: "The discreet nap of her fur collar, brought to mind one of those miniatures of Anne of Brittany painted in the Books of Hours by an old master, in which everything is so exactly in the right place" (II, 309; II, 10). Like Chardin, Whistler, or an old master who paints Books of Hours, Françoise is as we have seen before, a great artist-writer-seamstress in her own right.

## A (Madeleine) Shell in a Church

> "A shell stands out from the usual disorder that characterizes most perceptible things."
> —Paul Valéry, *Les merveilles de la mer: Les coquillages*, as cited in Bachelard, *The Poetics of Space*

Amid the clutter (like minnows after bread pellets in a lilac-bordered river; like one of Leonardo's delicate, flying, bubble animals, made of wax, filled with air, blown by breath; like the "bubbles [that] would rise through the cider, in such multitudes that others were left hanging on the side of the glass,"[22] "like a song taken up again in a 'head voice,' an octave above" [I, 88; I, 63], like light[ness] itself), it is the madeleine shell turned sponge cake that emerges most dramatically from the architecture, the sea, the mother (la mer, la mère) of the Proustian church of the *Search*.

Granted, when we first think of *Search's* cathedral, we are sent traveling not to the bottom of the sea for a scallop shell, but, of course, to that steeple of Saint-Jacques. But what lives on, what everyone (even those who have never read a word of Proust) will come to remember is the madeleine cake. Today the madeleine cake is made in bakeries for tourists, but the cake grew out of the clutter of Saint-Jacques. William C. Carter takes us from the steeple to the scallop shell inside:

> As [Proust's father] Adrien and his boys [Marcel and Robert] made their way back from Tansonville [to Illiers], it was the steeple of Saint-Jacques, appearing now and then in the sky as they mounted a hillock or rounded a bend, that beckoned them home. Proust later used a motif from the church's sculpted wood as one of the most powerful symbols of his art. On either wall behind the altar stands a wooden statue of a saint above whose heads are placed scallop shells.[23] Such shells are the emblem of Saint James (Jacques in French) and, in the Middle Ages, were worn by the pilgrims on their way to Santiago de Compostela. The church of Saint Jacques was a stopping point on the route to Spain.[24]

In fact, the church is filled with scallop shells, which are a subtly painted in gold on a large expanse of the lovely church's crimson walls and even, below the wooden statue of Saint-Jacques, in a beautiful almost-kissing, but not, pair: pretty and illustrative, they might appear as an engraved design for the chapter heads in a gorgeously designed book. Once you are taught to see through the madeleine-eyes of Combray, the shells enchantingly emerge from the skin of the church, like those magic watercolor pages of my childhood: with a brush of telling water, a simple line picture of a beach ball, a puppy, a seashell, would rise to the surface of what had once been a blank page. (Usually the magic ink would be blue.)

Just as Proust urged his fellow countrymen to visit "Ruskin's memory by making pilgrimages to the places '. . . qui gardent son âme . . .' ['which retain his soul']"[25] I, too, tried to get to Proust's soul by visiting Saint-Jacques. I even deposited my Euro in the collection box and lit one of the votive candles. (The simple glass candles lined up on a scruffy table within one of Saint-Jacque's little side chapels are emblazoned with red crosses and scallop shells. Precious objects, I had to have one. So, in order to bring one home with a little less guilt, I dropped a few more Euros into the collection box. In my mind's eye and in my heart, the candle, which now sits on my grandmother's old wooden tea cart, retains bits and pieces of Proust's childhood — like a magic writing slate, like a Freudian *Wunderblock* — marks and letters on a waxen tablet — invisible-but-there pictures [not unlike my magic watercolor page] — which, though in need of a Combray magnifying glass, survive as distant and subtle traces that *proustifier* [Proustify][26] its paraffin surface. The fact that Proust's paternal grandparents had a general store in tiny Illiers, at 11 place du Marché, in which they made their own

wax, honey, candles, and chocolate, sensual objects to touch, hold, and taste—the stuff of the *Search*—further illuminates my embezzled prize.) And, just as today when devotees of Proust, just like me, travel to Illiers-Combray and go to *Le Florent* (and buy miniature madeleine cakes, edible souvenirs of their journey, right across the street from Saint-Jacques), the pilgrims of Saint James bought scallop shells as a sign that they had been to Santiago.[27] For, when going to Santiago, German pilgrims of Saint James from the fifteenth and sixteenth centuries would buy their scallop shells near the fountain in front of the north entrance to the cathedral and they would fasten them to their hats and bread pouches. According to guidebooks of the day, the pilgrimage from Germany to Santiago, although led by professional guides, still took about a year; about the time that it takes many of us to make it all the way from *Swann's Way* to the final pages of *Time Regained*.

(However, the pilgrimage for me still remains in its apprenticeship stage, still unfinished like a great cathedral. For one reason or another, I have never been able to secure my own *petite madeleine* in Illiers-Combray. And as of my last journey, despite my determination to have my bit of cake, not only was *Le Florent* closed, it was for sale. But if I would have eaten my madeleine, I would not feel such an urge to return; so, perhaps it is just as well.)

Once one bakes the madeleine cake with traces of ingredients from the cookie-like badges of Saint James, Proust, by association, scatters the paths of Saint James's pilgrims across Germany, France, and Spain (like bread crumbs dropped by lost fairy-tale children who fear being eaten and forgotten) going in and out of churches and cathedrals: much to my delight, the "little scallop-shell of pastry, so richly sensual under its severe, religious folds" (I, 63; I, 46) pops up in the hats and coats and facades as badges of memory. Stopping in at the little cathedral of Tübingen, one encounters an especially lovely Saint James in pilgrim's attire: his floppy, yet serene, hat is pinned back with a scallop shell badge that looks good enough to eat, looks as delicious as the curls on his head and the twists of his long otherworldly beard. I imagine that the sugar-meringue-twists of the beard on his face and the butter-cream spirals of the hair on his head may have been fanci-

"Once one bakes the madeleine cake with traces of ingredients from
the cookie-like badges of Saint James, Proust, by association, scatters the
paths of Saint James's pilgrims across Germany, France, and Spain (like
bread crumbs dropped by lost fairy-tale children who fear being eaten
and forgotten) going in and out of churches and cathedrals"

fully piped with culinary perfection through Françoise's own pastry bag.
All of this in keeping with Françoise's Sunday lunches in Combray, so sen-
sitively, elaborately, and exquisitely prepared as to be "like the quatrefoils
that were carved on the porches of cathedrals" (I, 97; I, 70). Or, in keeping
with the young Narrator's own taste of food, for just a bit of food, for a bit
of food with *history*: while picnicking with his friends on the highest point
of a cliff, the Narrator refuses the sandwiches and would "eat only a single
chocolate cake, sugared with *Gothic tracery*" (II, 660; II, 257; emphasis is
mine). As the Narrator comments:

> This was because, with the sandwiches of cheese or salad, a form of
> food that was novel to me and was ignorant of the past, I had nothing

"his floppy, yet serene, hat is pinned back with
a scallop shell badge that looks good enough to eat,
looks as delicious as the curls on his head and the
twists of his long otherworldly beard."

in common. But the cakes understood, the tarts were talkative. There
was in the former an insipid taste of cream, in the latter a fresh taste of
fruit which knew all about Combray, and about Gilberte, not only the
Gilberte of Combray but the Gilberte of Paris, at whose tea-parties I
had come across them again. They reminded me of those cake-plates
with the Arabian Nights pattern, the subjects on which so diverted my
aunt Léonie when Françoise brought her up, one day Aladdin and his
Wonderful Lamp, another day Ali Baba . . . (II, 660–61; II, 257).

⌐ IT HAS BEEN REMARKED that Ruskin ties many threads onto his loom ("Throughout, Ruskin will tell you about everything!"[28])—and Proust learned to spin from him.[29] There is something bodily and intuitive in the work of both of these men, which is highly structured but not. They share *an art* of excursion. (And here, without professing that I in any way share any of the talents of these great writers, I must confess that I, too, suffer and take pleasure in this disease of digression, an illness, a bug so clearly fed by Proust's and Ruskin's nostalgia:[30] no *cordon sanitaire* [sanitary zone] for me.[31]) How all their materials take their form is a spiritual mystery. Ordered and mud(dled), their weaving of feathers, twine, sticks, leaves, and more, is as disordered as it is well built. In Ruskin's own words: "Does a bird need to theorize about building its nest?"[32]

## Clutter: Teenage Wasteland

> Clutter has rather an ambiguous status . . . It invites us, in other words, to do something puzzling, or even uncanny; that is to make meaning— as in, just say something about—the absence of pattern. Clutter, like all the orderly disorders we can describe in language, tantalizes us as readers of it. We can't be sure who the joke will be on if we say some- thing intelligible or persuasive about it.
> —Adam Phillips, "Clutter: A Case History," in *Promises, Promises*

Approaching the end of his life and the end of the novel, the Narrator ex- plains how memories arise out of the clutter of one's mind, discovering things that you did not even know you were looking for: "I now merely stumbled upon things in my memory by chance in the way in which, when you are tidying your belongings, you find objects which you had forgotten even that you had to look for" (VI, 517).[33] As Roger Shattuck writes, the structure of the *Search* is lost and found, for both the reader and the au- thor. Proust's cluttered cathedral-novel is a mess, so that something lost can be found, and what is found (whether it be as poignant as "madeleine" or

something lesser) it all depends on chance. It finds us. Things find us, as if we were playing a squiggle game with Winnicott.

When we are searching through our clutter, we sometimes find something that we did not know we were looking for. Clutter, then, can help us sort things out, just as boredom can give us the space to find new or lost desires. Both clutter and boredom are actively adolescent. Teenagers are seemingly always bored and find almost everyone to be a bore. Likewise, their rooms are as often as cluttered and disordered as their parents fear their blossoming "character" might be. Analysts, like Adam Phillips, know all about this:

> When they [mothers, not so often fathers] want to give a full account of how impossible their child it, the adolescent bedroom is *the* symptomatic scenario. This story is set in the cross-fire between the parents' view of the adolescent's bedroom, and the adolescent's view of the adolescent bedroom. The adolescent, it should be noted, rarely complains about the parents' bedroom.[34]

Phillips, as we have already seen in our discussion of Barthes, is not only good on getting to the bottom of clutter (more clutter to come), he is great on boredom. (And there will be even more boredom in this book's final chapter.) As a flirtatious, teasing advocate for boredom, Phillips dares us to sit still, to waste time. He argues that the adult must "hold" the experience of the child's boredom, in order "to recognize it as such, rather than to sabotage it by distraction . . . The capacity to be bored can be a developmental achievement for the child."[35] It is in this way that Proust treats us childishly; like a mother or father, he "holds" the experience of our boredom, he makes us find our own treasures amidst the heaps of text. For Proust, boredom is "integral to the process of taking one's time:"[36] it is something to strive for; through him, it becomes our necessary privilege.

The drawing of boredom as a good thing or even a blissful thing, as played out by Barthes and Phillips, feeds the beauty of time wasted in the *Search*. (Boredom and waste are good friends. One might ague that boredom is a kind of anorectic desperation and waste is a kind of hedonist pleasure.) As

Deleuze has illustrated, "what constitutes the unity of . . . [the] *Search* . . . is not simply . . . an exploration of memory. . . . Lost Time is not simply 'time past'; it is also time wasted."[37] Recall how the Narrator is chastised by his aunt Léonie for reading boyishly in the garden, for wasting his time:

> While I was reading in the garden, a thing my great aunt would never have understood my doing save on a Sunday, that being the day on which it is unlawful to indulge in any serious occupation, and on which she herself would lay aside her sewing (on a week-day she would have said, "What! Still amusing yourself with a book! It isn't Sunday, you know!"—putting into the word "amusing" an implication of childishness and waste of time). (I, 139; I, 99)

And this necessary wasting of time (taking us all of the way to boredom) enables us without us knowing what we are doing to "pursue an obscure apprenticeship until the final revelation of 'lost time'" comes, breaks through.[38] (This experience is not so far from the task of cleaning up one's cluttered writing desk, with piles and piles of dead papers and notes, a boring task indeed, perhaps even a waste of time, when one should be writing or reading—but then, suddenly, out of the confusion and untidiness, a phrase, an idea emerges. It is an aha! moment that sends our heart racing with pleasure—as if, we were just kissed by just the right person—as if, the tea were a perfect match to our bite of cake—as if, we just had our first morning coffee and the whole beautiful day was before us—as if, we were in animated conversation with a friend in the middle of the night and all of our laughter was coming easily.) In other words, we often have to wait within the boredom, wade within the clutter, until knowledge is enabled, until knowledge is allowed to intervene: a process that brings forth the interpretation of the sign. Aha! But this interpretation, as Proust shows us, comes *long* after the initial (primal) experience.

Interpretation postponed is a repeated theme of the *Search*: "I had recognised the taste of the piece of madeleine soaked in her decoction of lime-blossom which my aunt used to give me (although *I* did not yet know and *must long postpone the discovery* of why this memory made me so happy)"

(I, 64; I, 47; emphasis is mine). Or, "I had not gone in search of the two uneven paving-stones of the courtyard upon which I had stumbled" (VI, 274; IV, 457). Or, when leaning over to unbutton his boots, he suddenly remembers his grandmother a year after her burial: the Narrator feels something "divine,"[39] as the act gives way to an involuntary memory of her; yet, his tears become a symptom of the fact that he finally understands her as forever gone. Joy turned to pain, the bud of the signified that had resided so long within his body unexpectedly bursts open with the unbuttoning of his boots, with all the surprise of the audible pop of the opening of an evening primrose at sundown. The blossoming came long after, "because of the anachronism which so often prevents the calendar of facts from corresponding to the calendar of feelings" (IV, 211; II, 153).

Phillips manages to turn boredom and clutter inside out. He makes me feel good about leaving my children to entertain themselves. He makes me feel good about their messes and mine and, in turn, Proust's.[40] What we thought was an obstacle to our desire, all the clutter in our life, turns out to be an advantageous situation that can get desire rolling. In Phillips's own words:

> It is perhaps one of the most useful, indeed pleasurable Freudian insights that the way we defend ourselves tells us, in disguised form, what it is we desire. If clutter . . . [is an] obstacle to desire, it . . . [can also be] an object *of* desire. In clutter you may not be able to find what you are looking for, but you may find something else instead, while you are looking for it. Clutter may not be about the way we hide things from ourselves but the way we make ourselves look for things. It is, as it were, self-imposed hide and seek.[41]

The problem and appeal of clutter is central to Proust's "On Reading" (the preface to his translation of Ruskin's *Sesame and Lilies*). There, Proust nostalgically recalls his beloved room where he spent his boyhood vacation time at his aunt Leónie's house in Illiers. It was a place to read, read, read. As a *mise-en-scène of* boyish reading, it is a taste of the cathedral-novel yet to come: Proust even goes so far to call the room of boyish reading a

"chapel." Allow me to quote this very long and beautifully cluttered passage (in a long, yet still abbreviated form that Proust would certainly disapprove of). At its start, Proust begins by unapologetically calling attention to the room as antithetical to William Morris's anti-Victorian, anticlutter aesthetics:

After lunch, my reading resumed immediately . . . William Morris's theories . . . decree that a room is beautiful only on the condition that it contain solely those things which may be useful to us and that any useful thing, even a simple nail, be not hidden but visible. Above the bed with copper curtain-rods and entirely uncovered, on the naked walls of those hygienic rooms, [only] a few reproductions of masterpieces. To judge it by the principles of this aesthetics, my room was not beautiful at all, for it was full of things that could not be of any use and that modesty hid, to the point of making their use extremely difficult, those which might serve some use. But it was precisely through these *things which* were not there for my convenience, but seemed *to come there for their own pleasure*, that my room acquired for me its beauty. Those high white curtains, which hid from sight the bed placed as if in the rear of a *sanctuary*; the scattering of light silk quilts, of counterpanes with flowers, of embroidered bedspreads, of linen pillowcases, under which it disappeared in the daytime, *like an altar in the month of Mary* under festoons and flowers, and which in the evening, in order to go to bed, I would place with care on an armchair where they consented to spend the night; by the bed, the trinity of the glass with blue patterns, the matching sugar bowl, and the decanter (always empty since the day after my arrival by order of my aunt who was afraid to see me "spill" it) . . . those little crocheted openwork stoles which threw on the backs of the armchairs a mantle of white roses that must have not been without thorns, since every time I finished reading and wanted to get up I noticed I remained caught in them . . . that glass bell under which isolated from vulgar contacts, the clock murmured intimately to shells . . . and to an old sentimental flower . . . that very white guipure tablecloth . . . the

chest of drawers adorned with two vases, a picture of the Savior, and a twig of blessed boxwood . . . the triple layer of little bolting-cloth curtains, of large muslin curtains, and of larger dimity curtains, always smiling in their often sunny hawthorn whiteness, but in reality very irritating in their awkwardness and stubbornness in playing around their parallel wooden bars and entangling themselves and getting all in the window as soon as I wanted to open or close it. . . . [All of these many things in my room] filled it with a silent and multifarious life, with a mystery in which my person found itself lost and charmed at the same time; *they made of this room a kind of chapel.*[42]

Returning to the slide of me as bored adolescent, completely unaware of my apprenticeship, my fifteen-year-old mouth is in a giant unsuppressed yawn in front of the colossal six-hundred-year-old architectural masterpiece: my body gives way to a small full circle that is mirrored behind me by the cathedral's famous, spectacular, round North Rose Window. I was bored. I had desire for desire. I had not yet entered the cathedral. In a Proustian sense (if I may repeat his words again), "I had not gone in search of the two uneven paving-stones of the courtyard upon which I had stumbled" (VI, 274; IV, 457). Or: "One has knocked at all the doors which lead nowhere, and then one stumbles without knowing it on the only door through which one can enter—which one might have sought in vain for a hundred years—and it opens of its own accord" (VI, 254–55; IV, 445).

My face reflects the "hours of anguish which I should have to spend" inside Westminster; I felt myself (like Proust's adolescent Narrator) to be facing the "terrifying abyss that yawned at my feet" (I, 31; I, 24). Boredom paints the photograph of me with its unintelligible shadows, just as boredom glazes the story of "Combray" and, I imagine, everyone's adolescence. Indeed, the boredom of Proust is not only and most obviously bourgeois, it is adolescent in its ability to hold "a sort of puberty of sorrow" (I, 51; I, 38).

My mother always used to tease me about this photographic slide of my yawning-self in front of Westminster Abbey. While I understood the humor of the image, and the laughter that it would provoke, I always felt a bit of

"the perfect image to open my mouth and close
my eyes, to form the words and pictures"

pain and confusion while enduring the picture in front of friends and family
(amid the warmth of the projector and the vibrating hum of the fan in the
dark). Layers of history sucked in and out by an adolescent yawn of bore-
dom: I now see it as the perfect image to open my mouth and close my eyes,
to form the words and pictures of this chapter on Proust. I had not yet dis-
covered what I could not know at the start: that I "was already apprenticed
to signs" when I supposed that I was "wasting time."[43]

Consider, now, for a little while, the coarse hand sign that Gilberte gestures to the Narrator early in the novel: a sign that Proust suggests and infers, but in the end, never clearly spells out, so as to keep the signified, the meaning, always already at play, always in our hands.

Some two hundred pages into the first volume, we find the Narrator, an adolescent, wasting time with his father and grandfather around Swann's park, Tansonville. Here, and quite famously, the Narrator takes in the beauty of the highly sexualized coming-of-age pink hawthorns, which he judges to be even lovelier than the white ones, a kind of beauty more evident to the eyes of children, like the "most expensive biscuits . . . whose sugar was pink" (I, 196; I, 138) or cream cheese tinged with "crushed strawberries" (I, 196; I, 138). It is there and then that he spots her: Gilberte Swann. Gilberte who would become the object of his first crush, could be seen over the delicious hedge of pink hawthorns "among which the stocks held open their fresh plump purses, of a pink as fragrant and as faded as old Spanish leather" (I, 197; I, 138). Staring at the Narrator and his grandfather out of the corner of her eye, she soon exposed a "half-hidden smile" and "sketched in the air an indelicate gesture" (I, 199; I, 139–40). Yet, the sign would remain a mystery, an unsignified until the Narrator meets Gilberte again in the end of his book, the end of his life, in *Time Regained*. While the Narrator understood the sign as naughty, improper, and coarse, he cannot reconcile the beautiful girl in braids with the gesture. What did the sign mean?

By the end of the novel, the life, Gilberte has become an older woman. Although he had long lost his adolescent love for her, the Narrator had always worried that Gilberte had no desire for him. In other words, that she had no desire for (his) desire. This emptiness is an empty sign understood as part of the Narrator's perpetual ennui (his insatiable desire for desire). As a result, the Narrator had always assumed that Gilberte's gesture was not sexual: he could not believe that she would have or could have made a sexual play of signs at him. "I signalled to you so vulgarly that I'm ashamed of it to this day" (VI, 5; IV, 269). Yet, that is all that Proust gives us after reading all of those pages. As readers, the vulgar "sign" still remains a mystery. What, *exactly*, did she do with her hands? We can imagine, but that is

all. At the start of the novel and at the end of the novel, Gilberte's gesture is at once empty and full. Empty and full, a mirroring of bored and cluttered, is also a sign of the wasting adolescent body.

The adolescent wastes time. I worry that my own beautiful teenage boys sleep too much—that they do not like to read—that they are always on the computer—that they wander about aimlessly. But why? Is it my own fear of death and time lost? (Yes.) Do I envy their ability to be happy wasting time? (Yes.) As we grow older, especially if we have ambitions to be an artist or writer, it is painful to reconcile that in order to regain time through art, it must come as a result of time lost, which is also the time one wastes. Yet, when one is old, one panics at the thought of wasting time. In Deleuze's own words: "Why must one waste one's time, be worldly, be in love, rather than working and creating a work of art?"[44] The adolescent has life before him. He can laugh at the artist's ambitions. He does not need art to find that narcissistic "adolescent reverie"[45] (albeit colored with the deep lows and struggles of teenage life): dream, vision, illusion, fancy, figment, fantasy, even trance, all words that define reverie. A teenager does not have to *use* one's time. (Phillips, again: "Part of the freedom of being fourteen—or at least the freedom one has to fight for, is the freedom to sleep-walk; the freedom, that is to say, to do things in one's own way.) Adolescent reverie was Proust's in Illiers. Adolescent reverie was the Narrator's in Combray.

The adolescent has time. The adolescent, perhaps, is the one who in actuality does not waste his time, but simply *takes his time*, like the old man who (finally) lives his days like he wants to. In the words of James Vincent Cunningham's poem "Coffee": "Time is my own again./I waste it for the waste."[46]

The *Search* is an adolescent production. Significantly, Proust, like the young Narrator's favorite writer, Bergotte, might be accused of wasting our time, of being a "sterile and precious artist, a chiseller of trifles," yet it is "the secret" of Proust's, and Bergotte's, "strength." (II, 178; I, 547). In fact, Bergotte's style (and, in turn Proust's) is not only wasteful, it is "flaccidly" and nonreproductively queer. As Roger Shattuck points out:

The teenage Protagonist has developed a cult-like admiration for the prose style of a much talked about author, Bergotte. He speaks of this admiration to the Marquis de Norpois, an eminent ex-ambassador who comes to dine with his parents. Norpois does not prevaricate in his response. . . . "'Good Heavens!' exclaimed M. de Norpois . . . 'I do not share your son's point of view. Bergotte is what I call a flute-player . . . But when all is said, there's no more to it than that. Nowhere does one find in his flaccid works what one might call structure. No action—or very little—but above all no range'" [II, 60–61; I, 464].[47]

And the queer, feminized, *wasteful* metaphors hardly stop there. Bergotte, according to M. de Norpois, maternally "lulls" the reader "into forgetting." And while Bergotte's "manner" is "seductive," "taken as a whole," his writing "is all very precious, very thin, and altogether lacking in virility" (II, 61; I, 464–65). The teenage protagonist, and by implication ourselves, are seduced by this wasteful writer, who is a tantalizing, woven braid of Bergotte, the Narrator (the teenage protagonist himself), and Proust. A chiseler of trifles, Proust writes seductively, in a writerly way,[48] so that his readers might become writers, "pierced," like "the blue ice of a sunny day in winter with the gimlet note of a fife,"[49] so that his readers might find what "lay inside themselves" (VI, 508; IV, 610).

"Flaccid" as the flute player, Bergotte hails a range of images from Manet's own boyish *Fifer* (1866)[50]—to the cruel laughter of high school days directed at boys who play flute in the orchestra—to Yasumasa Morimura's divine photographic reproduction of his queer Japanese self-remake of Manet's *The Fifer: Shounen II* (1988). (In Morimura's native language *shounen* means youth man or pretty boy.)[51] In *Shounen II*, the Japanese man, culturally stereotyped by Western aesthetics as "thin," emasculated, boyish, "without range," but "with a great deal of mannerism, of affectation" (all qualities attributed to Bergotte by Norpois) is perfectly handled by Morimura's photographic manipulation. Here, the "man" (the artist) never grows up, his eternal adolescence is reflected in a sexually liquid self-portrait, that daringly, obscenely, and crassly plays with sexual and racial

stereotypes. (The crotch of the Japanese man-boy, caught with his pants down, is grabbed by a disembodied hand of a black man, an image of rampant male sexuality, contradicted not only by the Asian-boy-body, but also by the touch of Baroquely painted gold nails.) Although far from Proust, Morimura shares with Proust a queerly, liquid (adolescent) approach. Like Proust, the Morimura-fifer-boy can be described as "very pale, with eyes . . . like Japanese lacquer."[52] While the wind of Morimura's "fifer player" is haltingly loud, deafening really, a far cry from the writerly fingers of Proust's white bourgeois world, we might understand Morimura as rehearsing the Narrator's recollection of masturbation, in the spirit of the repetition of Vinteuil's little phrase,[53] only more *basely*:

> I ran up to the top of the house to cry by myself in a little room beside the schoolroom and beneath the roof, which smelt of orris-root and was scented also by a wild currant-bush which had climbed up between the stones of the outer wall and thrust a flowering branch in through the half-opened window. Intended for a more special and a *baser* use, this room . . . whose door I was allowed to lock, whenever my occupation was such as required an inviolable solitude: reading or day-dreaming, tears or sensual pleasure. (I, 14; I, 12; emphasis is mine)

Here, so caught up in the gay erotics of Bergotte and a return to the baser pleasures of the water closet scene cited above — what Proust has named in an earlier, rawer version of the above masturbation scene as a "shimmering jet," a "spurt," a "fountain," and eventually a "trail on the leaf, silvery and natural as a thread of gossamer or a snail-track"[54]) — I have nearly lost my thread. I was on the trail of waste, clutter, and boredom, but was led elsewhere. I admit that I enjoy the wasteful ephemera of being off course, not unlike the Narrator of the *Search* who claims, "I was disappointed when . . . [Bergotte] resumed the thread of his narrative" (I, 131; I, 94). Proust has a taste for the nonstory, the wasteful tale. As Joseph Litvak has taught me: taste makes waste.[55]

In fact, it is Joseph Litvak who first apprenticed me into the wasting of time, as *the work* necessary in order to travel from adolescence to adulthood.

"'very pale, with eyes . . . like Japanese lacquer.'"

"'with a pleasure of a different kind from other pleasures . . .
a pleasure that was solid and consistent, on which I could lean for
support, delicious, soothing, rich with a truth that was lasting,
unexplained and sure.'"

And Litvak, quite naturally, learned that lesson from the strange gourmand, Marcel Proust, for whom, even the smell of, waste is critical to his ability to metamorphosize life into literature. We have already visited the water closet in Combray, which smelled not only of orrisroot and whatever else was contained in the little room that could be locked. But do not overlook the new lavatories in the Champs-Elysées "covered in a green trellis"(II, 87; I, 483), referred to "by an ill-judged piece of Anglomania [as], 'water-closets'" (II, 88; I, 483) in which the "cool, fusty smell" (II, 88; I, 483) fills him "with a pleasure of a different kind from other pleasures . . . a pleasure that was solid and consistent, on which I could lean for support, delicious, soothing, rich with a truth that was lasting, unexplained and sure" (II, 88; I, 483). Yet, he would not understand until later that significance of the fact that the smell reminded him of his uncle Adolphe's "little sitting-room at

Combray" (II, 91; I, 485). In the words of the teenage protagonist: "But I could not understand, and I postponed until later the attempt to discover why the recollection of so trivial an impression had filled me with such happiness" (II, 91; I, 485). However, he does recognize that there is something perverse, even queer, in the love of this smell, which he likens to his love for the author Bergotte: "I had preferred hitherto to all other writers one whom he [Norpois] styled a mere 'flute-player,' and a positive rapture had been conveyed to me, not by some important idea, but by a musty [wasteful] smell" (II, 91; I, 485), specifically the wasteful smell of the water closets in the Champs-Elysées. And let us not forget the smell of post-asparagus urine linked to the work of fairies: "These hinted rainbows, these blue evening shades, that precious quality which I should recognise again when, all night long after a dinner at which I had partaken of them, they played (lyrical and coarse in their jesting like one of Shakespeare's fairies) at transforming my chamber pot into a vase of aromatic perfume" (I, 169; I, 119). But these examples are only from the first two volumes. Litvak finds the quintessential waste to be, not surprisingly, in *The Guermantes Way* (vol. 3), where even less happens, perhaps, than in the other volumes. It is in this wasteful way that one might even go so far as to argue that *The Guermantes Way* is more "queer" than even *Sodom and Gomorrah* (vol. 4):

In search of *temps perdu* — time *wasted* in addition to time lost — Proust manifests an insatiable appetite *for* waste. Nowhere is this appetite more evident than in *The Guermantes Way* (1920–21), the third volume of the *Recherche*: preeminently the book of waste. [In Deleuze's own words: "Les signes mondaines impliquent surtout un temps qu'on perd."[56]] According to the recuperative logic of the *Recherche*, however, nothing ever really *goes* to waste: what looks like its slackest, least "composed," volume may in fact constitute the transitional center of the work as a whole; as for the activity described in this volume, what looks like so much aimless, profligate hanging out around so many vacuous aristocrats turns out, in the best tradition of the *Bildungsroman*, to have been the decisive passage from adolescence to adulthood.[57]

But does Proust ever really make that passage? Litvak's passage, as well as one's general passage into adulthood are, I would argue, promisingly ambivalent. For, while there is a sense that by the end of the novel, the Narrator has moved forward, has found the secret to writing his book, he is also still at the same place. After all, the Narrator, like Proust, like Bergotte, has really provided "no action—or very little." Proust's adolescent appetite is still intact, is still "incestuous, delicate, elusive and diluted in tea."[58]

Proust's boring, cluttered, wasteful text is spoken from a body that comes in waves between adult and child: he is a "boy-man."[59] By making the Narrator an author who is *not yet* writing, but who *is going to write*, the age of the young man in the novel is kept as liquid as its author's Japanese-lacquer eyes. Proust's great, big book is appropriately adolescent: boyish. Barthes writes in "The Death of the Author": "How old is he [the Narrator] and who is he?"[60]

Barthes's famous student, Julia Kristeva, celebrates the space of adolescence as the desired space of the writer:

> Betrayal by and of the page, bisexuality and cross-dressing, filiations, fledgling seducers: These certainly do not exhaust the adolescent images and conflicts that articulate the great moments of novel writing. To these characteristics could be added the sort of Bildungsroman that recounts the close connection between adolescents and the novel. (Tristam Shandy, Julien Sorel, Bel Ami). Nevertheless, these themes provide a general indication of the degree to which the polyphony of the novel, its ambivalence, and its postoedipal (albeit perverse) flexibility are indebted to the *open adolescent structure*.[61]

By the end of the *Search*, we are still with the madeleine cake, which we first nibbled at the very start. But now the Narrator has *grown* old and is "terrified by the thought that the stilts" beneath his "own feet might already have reached" their final, most stretched "height"—soon he would be "too weak to maintain" his "hold upon a past which already went down so far" (VI, 531; IV, 625). Nevertheless, he has just experienced a profound

PENDANT QUE J'AI ENCORE UNE OMBRE

FLORETTE

"But now the Narrator has *grown* old and is 'terrified by the thought that the stilts' beneath his 'own feet might already have reached' their final, most stretched 'height' — soon he would be 'too weak to maintain' his 'hold upon a past which already went down so far.'"

involuntary memory: the famous trip on the uneven paving stones (which I have already tripped on twice in this chapter). The Narrator in an "absent-minded state" (as if he were a sleep-walking fourteen-year-old) trips on the "uneven paving stones" in front of the coach-house in the courtyard of the Guermantes mansion. This trip sends him traveling through time. The Narrator finds himself, in the past, standing on two uneven paving stones in the baptistery of Saint Mark's, Venice. But the trip also trips (as in to release, to trigger) other body-deep memories including the Narrator's memory of savoring the memory-prompting bite of madeleine: "The happiness which I had just felt [as a result of the uneven paving stones] was unquestionably the same as that which I had felt when I tasted the madeleine soaked in tea" (VI, 255–256; VI, 445).

We are stuck. And if you have gotten this far with the *Search*, you have *gone all the way* to the final volume, and you are also happily in love with what Litvak so accurately names as Proust's "narrativizing behindsight."[62] A behindsight which "insists preposterously on going back *and staying back*, dwelling on, and in, everything a normal mind [i.e., not only *not queer*, but also *not adolescent*] will have learned to disregard as beneath serious consideration."[63] To be passionately stuck on Proust, then, is to hold his misery, his narcissism, his waste, his taste, his boredom, his obsessions, his observations as adorable. We get something like young love, just when we had thought our stilts had already taken us to what had once been an un-imaginable summit, "taller than church steeples" (VI, 531; IV, 625). To be stuck on Proust is to decisively refuse that passage into adulthood, at least a *full* passage (even if we have many years beneath us, even if we are "trem-bling like a leaf" [VI, 531; IV, 625] upon our great long stilts). Like hungry young birds, jammed into the nest, Proust flies off before he remembers to push us out of the nest, leaving us behind as (immobile) adolescents, with our mouths wide open. (Hunger? A yawn?)

Thanks to photography and in tribute to Proust, I stand forever waiting at the church, my mouth as testimony to an *open adolescent structure*.

"Thanks to photography and in tribute to Proust,
I stand forever waiting at the church, my mouth as
testimony to an *open adolescent structure*."

Note: My mother may have teased me for my adolescent attitude
as I stood before Westminster, but so did the Narrator's mother when
she was about to leave her sulking son, not long before he was off to
see the church at Balbec. In the words of Mamma: "'Well, and what
would Balbec church say if it knew that people pulled long faces
like that when they were going to see it? Surely this is not the
enraptured traveller Ruskin speaks of'" (II, 308; II, 9).

# SOUFFLÉ/

# SOUFFLE

"The Ambassador,"
my mother told her
[Françoise], "assured me
that he knows nowhere where
one can get cold beef and
soufflés as good as yours."
↳ Proust, *In Search of
Lost Time*

Françoise: "It was very
nicely done . . . the soufflés
had plenty of cream."
↳ Proust, *In Search of Lost Time*

⌐ **WHEN YOU HOLD A SEASHELL UP TO YOUR EAR,** you can hear the ocean waves; you can hear the breath of winds. Seashells, like Proust, carry the breath of the past. Proust, whose very serious trouble with asthma began when he was nine years old, would spend a lifetime struggling for breath.[1] In the novel, Dr. Cottard the physician treats the disease of the boy's breath by prescribing a milk diet for the adolescent of some fourteen or fifteen years,[2] as if sending the Narrator back to his baby days of easy breath and easy food: "Milk for some days, nothing but milk. No meat" (II, 96; I, 489).

As readers, we feel Proust's own struggle for breath, his fits of breathlessness, when confronted by his Nile-long sentences. When are we to breathe? When will he let us catch our breath? We go on for pages in a kind of asthmatic gasping. Where are these sentences leading us? We become disoriented in our struggle: oxygen deprived, yet a bit dreamy. Proust's form of writing is touristic: it "doesn't settle in one place any more than a bird . . . but skips, flutters, moves, 'out of *breath*' (*'à perte d'haleine'*)."[3] We too, like the Narrator, have "some of these fits of suffocation" (II, 94; I, 488). The struggle for breath is a struggle for words, for writing, for *correspondence*. But eventually we find our gift: something in Proust finds us and we experience not only relief from the onslaught of words without periods, sentences without paragraph breaks, pages without chapters, we experience extreme pleasure, a sensual sign. "These [the sensual signs] are true signs that immediately give us an extraordinary joy, signs that are fulfilled, affirmative and joyous."[4] Proust knew all about this when he wrote his *Search* riddled with the magical appearances of *charming* signs. In the passage below, contemplate two little Proustian treasures: a much-desired letter from Gilberte and boxes made of shells and branches of coral found at the bottom of the sea. Never mind that the Narrator's discovery of these pleasurable signs was far from happenstance and was likely prearranged by Mamma. Such maternal anticipation makes them no less true; in fact, it may make them more *sensual*, like the original Mamma-madeleine, "so richly sensual under

its severe, religious folds" (I, 63; I, 46). When reading this extract, also, consider how we too, as readers (not so much below the sea as gasping for air in the depths of the *Search* ), make our own discoveries, *secretly* enabled by Proust, as if *he* were Mamma:

> Life is strewn with these miracles for which people who love can always hope. It is possible that this one [the longed-for letter from Gilberte] had been artificially brought about by my mother who, seeing that for some time past I had lost all interest in life, may have suggested to Gilberte to write to me, just as, when I first went sea-bathing, in order to make me enjoy diving which I hated because *it took away my breath*, she used to secretly hand to my bathing instructor marvellous *boxes made of shells*, and branches of coral, which I believed that I myself discovered lying at the bottom of the sea. (II, 99–100; I, 493; emphasis is mine)

Breath-shells.

"Squat, plump little cakes . . . moulded in the fluted valve of a scallop shell." (I, 60; I, 44)

Breath as food.
Food as breath.

One of the most lovely things about a soufflé, beyond eating one (whether it be made of cheese or chocolate), and beyond watching it arrive in all of its puffed-up glory at your table, is that "souffle" means breath. (And in the kitchen, breath [souffle] actually does puff up to become a soufflé.)[5] A soufflé is enhanced by its fleeting nature; its breath cannot be held, cannot be saved for later. The soufflé demands to be enjoyed, remarked upon, eaten up immediately. A kind of onomatopoeia of food (soufflé sounds like a satisfying exhale), I like to think about food being breath, being language, becoming correspondence.

The snobbish Legrandin knows all about breath as an entry into a correspondence with the past, when he asks the boy-Narrator to dine with him in an effort to return to his own boyish past. He wants to sit across from

the boy and take in his air. Take note of Legrandin's (Proust's) emphasis on traveling with the past through the coupling of olfaction and breath in this unbelievably flowery and purple speech:

> "Come, and bear your aged friend company," he had said to me. "Like the nosegay which a traveler sends us from some land to which we shall never return, come and let me breathe from the far country of your adolescence, the scent of those spring flowers among which I also used to wander many years ago. Come with the primrose, the love-vine, the buttercup." (I, 176; I, 124; as spoken by the character Legrandin to the adolescent Narrator)

There is a poem by Baudelaire, entitled "Correspondences" (1857): the sonnet is understood as key to Baudelaire's aesthetics, and, in turn, to Proust's. As Roger Shattuck has written: "The writing itself emits a powerful sense of the links among the things around us and our experiences of them."[6] Proust writes from "deep inside the world of Baudelaire's *correspondances*," a world of sensory connections, reminiscent of Leonardo's highly visual universe, in which the painter claimed to see lines connecting objects, making geometry's invisibility visible.[7] As Baudelaire's title tells us, "Correspondences" seeks to seep through the barriers of time, of difference; or in the words from the poem itself: "Having dimensions infinitely vast,/Frankincense, musk, ambergris, benjamin."[8] Allowing the past to enter one's life, to breathe in the past is the fruit of correspondence, it is the "magic of distance."[9] The etymology of "correspond" suggests that "the word was formed to express mutual response, the answering of things to each other."[10] Proust's threads of breath pull, unravel, dangle, and blow in correspondence with Baudelaire's own "Correspondences." Proust's breath and that of the characters fill his novel like a soufflé. You bite into the *Search* as a soufflé-novel and their breath becomes part of yours: a correspondence. Allow me, now, to quote Baudelaire's exquisite "Correspondences" in full, which is full of pleasures that invade the senses, like the "plump" madeleine itself:

Nature is a temple, where the living
Columns sometimes breathe confusing speech;
Man walks within these groves of symbols (*forêts de symboles*),[11] each
Of which regards him as a kindred thing.

As the long echoes, shadowy, profound,
Heard from afar, blend in a unity,
Vast as the night, as sunlight's clarity,
So perfumes, colours, sounds may correspond.

Odours there are, fresh as a baby's skin,
Mellow as oboes, green as meadow grass,
— Others corrupted, rich, triumphant, full,

Having dimensions infinitely vast,
Frankincense, musk, ambergris, benjamin,
Singing the senses' rapture, and the soul's.[12]

"Correspondences" — with its emphases on the bewilderment of life's "groves of symbols," in a landscape where "perfumes, colours, sounds may correspond," under "dimensions infinitely vast" — is Proustian in nature. "Correspondences," like the *Search*, is feminized by an emphasis on smell, sometimes even over sight.[13] Smell is a way of taking in, a kind of tasting, not with the mouth, but with the nose. Because smell rides on inhalation and is released by our own exhalations (we, even, imagine that flowers exhale their perfumes), it seems particularly apt that Proust would emphasize scent: the breathy sense.

Recall in Proust (as we previously noted): the scent of "orris-root" and "wild currant-bush" in the bathroom in Combray (I, 14; I, 12) — the musty smell of the lavatory in the Champs-Elysées — and the Narrator's chamber-pot, a "vase of aromatic perfume," after eating asparagus (I, 169; I, 119). But, as all readers of the *Search* know, the whole novel is invented out of a

cloud of evocative smells, including, but not limited to these chosen selections.

In Combray, the staircase that the Narrator climbs before having to go to bed, gives off an odor that gives way to emotional despair:

> That hateful staircase, up which I always went so sadly, gave out a smell of varnish which had, as it were, absorbed and crystallised the special quality of sorrow that I felt each evening, and made it perhaps even crueller to my sensibility because, when it assumed this olfactory guise, my intellect was powerless to resist it. (I, 36; I, 27)

Setting out for Saint-Hilaire, for the "Month of Mary" devotions, the Narrator falls in love with the hawthorns inside the church, which smell of woman and cake in the spirit of the original madeleine:

> When, before turning to leave the church, I genuflected before the altar, I was suddenly aware of a bitter-sweet scent of almonds emanating from the hawthorn-blossom, and I then noticed on the flowers themselves little patches of a creamier colour, beneath which I imagined that this scent must lie concealed, as the taste of an almond cake lay beneath the burned parts, or that of Mlle Vinteuil's cheeks beneath their freckles. Despite the motionless silence of the hawthorns, this intermittent odour came to me like the murmuring of an intense organic life with which the whole altar was quivering. (I, 158; I, 112)

Whenever Gilberte was not playing at the Champs-Elysées, the Narrator would lead Françoise to the woman-scent of the Allée des Acacias in the Bois de Boulogne (the "Garden of Woman") planted with botanical beauties and "certain women of fashion," like Mme Swann herself:

> And like the myrtle-alley in the *Aeneid*, planted for their delight with trees of one kind only, the Allée des Acacias was thronged with the famous beauties of the day. As, from a long way off, the sight of the jutting crag from which it dives into the pool thrills with joy the children who know that they are going to see the seal, so, long before I reached

" 'That hateful staircase' "

the acacias, their fragrance which, radiating all around, made one aware of the approach and the singularity of a vegetable personality at once powerful and soft. (I, 593; I, 411)

During the Narrator's second stay at the Grand Hotel, Balbec, the whole landscape of the seaside rushes back to him, while washing his hands:

I could see, on the first evening, the waves, the azure mountain ranges of the sea, its glaciers and its cataracts, its elevation and its careless majesty, merely upon smelling for the first time after so long an interval, as I washed my hands, that peculiar odour of the over-scented soap of the Grand Hotel—which, seeming to belong at once to the present moment and to my past visit, floated between them like the real charm of a particular form of existence in which one comes home only to change one's tie. (IV, 222; III, 161)

While living with Albertine, in his mother's Paris apartment, when Fran-
çoise throws twigs on the fire, Combray returns to the Narrator:

The scent, in the frosty air, of the twigs of brushwood was like a frag-
ment of the past, an invisible ice-floe detached from some bygone win-
ter advancing into my room, often, moreover, striated with this or that
perfume or gleam of light, as though with different years in which I
found myself once more submerged, overwhelmed, even before I had
identified them, by the exhilaration of hopes long since abandoned. (V,
25; III, 536)

Smell, as Baudelaire writes in "Correspondences," "sing[s] the senses'
rapture, and the soul's." Scent is remarkable for its ability to seep through
barriers: like breath, like wind, like air itself. As embodied by the above
quotes from the *Search*, olfaction breaks through real and metaphorical
walls, including, but not limited to: *intellect* (the odor of the staircase); *in-
animate objects and organisms of different kingdoms* (the hawthorns smell not
only of their botanical selves, but also of almond cakes and Mlle Vinteuil's
cheeks); *vision and the unseen* (you can smell the acacias, and in turn "cer-
tain women of fashion," before you see the Alleé des Acacias in the Bois de
Boulogne—in other words "though you may not see her, you can certainly
smell her"[14]); and, perhaps most effectively and overwhelmingly, *time*—the
Narrator's first visit to Balbec returns, long after, through the fragrance of
the "over-scented soap of the Grand Hotel"—and, the Narrator's childhood
in Combray returns, long after, through the aroma of burning twigs, when
he is living with Albertine in Paris. As is true with Baudelaire, there are also
"aural" signs which lead to correspondences, as in memories evoked from a
servant's chance knock of "a spoon against a plate" (VI, 257; IV, 446)—but
overall, as Proust says of the madeleine, "taste and *smell* alone, more frag-
ile, but more enduring, more immaterial, more persistent, more faithful,
remain poised a long time, like souls, remembering, waiting, hoping, amid
the ruins of all the rest; and bear unflinchingly, in the tiny and almost im-
palpable drop of their essence, the vast structure of recollection" (I, 63–64;
I, 46; emphasis is mine).

And when the correspondence is profound, as the Narrator suggests in the *Search*, it is "a sensation of the same species as the taste of the madeleine" (VI, 335; IV, 498). While in the *Search*, the Narrator actually turns to Baudelaire's notion of "correspondences," not in the poem of that name, but rather to "Le Chevelure" and "Parfum exotique," the point is the same: in Baudelaire, there is this kind of "*transposed* sensation" ("*sensation transposée*") (VI, 335; IV, 499; emphasis is mine), which is an embodiment of history, which foregoes the violence of a full "translation." While the words transpose and translate are almost interchangeable, my emphasis, here, is to resist the notion of a final, even definitive, translation in order to embrace an open, even tentative, transposition. According to the *Oxford English Dictionary*, "transpose" may mean "to translate,"[15] but, by and large, its meaning is more airy, less transformed, less solid than its close cousin. Transpose offers up such senses as "to give a different direction," "to adapt," "to alter the order of," "to put into a different key."[16] To be translated is violent. Translation makes the "other" (even, perhaps when the other is simply the past) feel "radically misunderstood in a peculiarly disabling way";[17] that is why, Adam Phillips tells us, "that when my patients say that I have translated what they have been saying, they feel I have done them a kind of violence."[18]

Benjamin, as a devotee of Proust, and especially Baudelaire, took air from his two French, crafty heroes and thereby exercised a breathy, likeminded transpositioning of life into a writing that was part historical, part commentary, and very literary. Benjamin's transpositioned approach is, perhaps, best exemplified by the collectomania of his never-ending, unfinished *The Arcades Project*—a Cornellian, Proustian endeavor if there ever was one. Originally intended to be entitled *A Dialectical Fairyland*,[19] *The Arcades Project* teaches us that "the historian should no longer try to enter the past; rather, he should allow the past to enter his life."[20] Benjamin knew history as man-made, yet based on reality, not unlike a dream, not unlike the start of the *Search*. Below are fragments of Proust's surrealist freefall into the *Search*, an excellent "expression" as Benjamin would write, into "the irresistibly growing discrepancy between literature and life"[21]—as

real and as literary as both history and the dream, as "waking dream" (I, 7; I, 7):

> For a long time I would go to bed early. Sometimes, the candle barely out, my eyes closed so quickly that I did not have time to tell myself: "I'm falling asleep." . . . Then it would begin to seem unintelligible, as the thoughts of a previous existence must be after reincarnation . . . I would ask myself what time it could be . . . I would fall asleep again, and thereafter would reawaken for short snatches only, just long enough to hear the regular creaking of the wainscot, or to open my eyes to stare at the shifting kaleidoscope of the darkness . . . These shifting and confused gusts of memory never lasted for more than a few seconds. (I, 1, 1, 1, 2, 7; I, 1, 1, 1, 2, 7)

Benjamin sought to "carry over the principle of montage into history. That is, to assemble large-scale constructions out of the smallest and most precisely cut components. Indeed, to discover in the analysis of the small individual moment the crystal of the total event."[22] Tasting like the crumb of the *Search*, or feeling Barthes's punctum-turned-correspondence (that moment when a piece, a fragment, a bit of the photograph punctuates, interrupts, wounds, "shoots out . . . like an arrow, and pierces"[23] the viewer), Benjamin "draw[s] on the [imagination's] ability to 'interpolate into the infinitesimally small.'"[24] Benjamin, too, embraces the Deleuzian apprenticeship, the study of signs yet to be signified: like house plans, like a blueprint of something yet to come.[25] In his blueprints, Benjamin emphasizes the materiality of things unbuilt, by focusing on the essence of objects that are not materially whole—especially rags, trash, the crumbling, the overly mature, and the tattered. Hand in hand with Proust's hands grown chilly from lack of substance, who held his own hand with Baudelaire's "frail, determined hand,"[26] Benjamin turned to nineteenth-century Paris and uncovered an old worn world of dreamed things (the Arcades), awakening our understanding of the present to see the dusty light of a better future: to breathe, if with difficulty, the breath of correspondence.

Benjamin, Proust, and Baudelaire all breathe in the past and the present, as a form of inhalation and exhalation, as transposition (not translation), but it is Proust who makes use of the metaphors of breath most readily. Nevertheless, even Barrie plays with the metaphors of breath and history through Peter who frolics in a boyish-presentness, who is renowned for having no memory, for always forgetting the past. Indeed, Peter chokes off the past by using his breath to kill off the bodies of memory-laden, *historical* adults. Always sadistically antihistorical, Peter chooses to suffocate the adult of the real world, who lives in real time, historical time:

> [Peter] was so full of wrath against grown-ups, who, as usual, were spoiling everything, that as soon as he got inside his tree he breathed intentionally quick short breaths at the rate of about five to a second. He did this because there is a saying in the Neverland that every time you breathe, a grown-up dies; and Peter was killing them off vindictively as fast as possible. (*P&W*, 167–68)

Breath, when inhaled, exhaled, and held through Proustian lungs draws in history (the past, whether it be personal or academic), but not without (home) sickness. Barthes's other writing hero, not Proust this time but Michelet, suffered from a homesickness (a longing for the historical past), which brought on his migraines, "that mixture of vertigo and nausea," prompted by "everything,"[27] not excluding his writing of "History."[28] Like Proust, Michelet lived to write, but writing was also his physical demise. In the words of Barthes: "This man, who produced an encyclopedic oeuvre of sixty volumes, inveterately declares himself 'dizzy, sickly, empty-headed, weak.' He writes constantly (during fifty-six-years of his adult life) yet is always in a state of physical collapse."[29] Michelet suffers from a history-sickness (which I understand as nostalgia). Michelet's physical plunge into history, often asthmatically took his breath away. As Barthes writes:

> This double apprehension ["the discomfort of progress" as conflicted by "the euphoria of panorama"] is the whole of Michelet's History. Of course, the most numerous moments are the discomfort, the fatigue

of a forced march through a grim historical region of petty and faded motives, one that is in fact too close to the historian-traveler. This is what Michelet calls "rowing" ("I am rowing through Louis XI. I am rowing through Louis XIV. I swim laboriously. I am rowing vigorously through Richelieu and the Fronde"). Yet *the plunge involves an incomplete assimilation of History, a failed nutrition, as if the body, thrust into an element where it does not breathe* (il ne respire pas), *found itself stifled by the very proximity of space*.[30]

As "historian-swimmer," Michelet "lifts his head for a breath of air, takes a respite from the asphyxiation of his anxious history, and then re-submerges."[31] Michelet's rhythmetic, almost asthmatic, process of history writing is not unlike that of Proust's. Michelet-like, Proust submerges himself in the *Search*, diving for "shells" at the bottom of the sea and then comes up to be rejuvenated, resuscitated by the winds of the past carried by the ocean air. As Proust writes in the final volume, the freshest, the newest air, is the air that we have breathed before. Madeleine-like, it "is awakened and reanimated as it receives the celestial nourishment that is brought to it" (VI, 264; IV, 451). It is a joyful breath: "a minute freed from the order of time" (VI, 264; IV, 451). It is the air of paradise, "an air which is new precisely because we have breathed it in the past, that purer air which the poets have vainly tried to situate in paradise and which could induce so profound a sensation of renewal only [because] . . . it had been breathed before, since the true paradises are the paradises that we have lost" (VI, 261; IV, 449).

To *correspond* with Proust then, is to suck in history-air of Michelet, of Baudelaire, of Benjamin, of Barthes (they all inhale and exhale each other). To read them is to take in and to have our breath taken away. (Hugo, in a letter to Michelet: "I have just received your book [*Histoire de France*, XIII], and I have read it through, without drawing a breath [*sans respirer*]"[32]).

It is in this metaphorical capacity of the lungs (yet real when one recognizes Proust's asthma and Barthes's tuberculosis) that the contemporary artist Lesley Dill (whom we first encountered in chapter 4, "Pulling Ribbons from Mouths") is oxygenated by her own transposing adaptation

of history, what she proclaims as "breath, and the words that are floated on breath."[33] Consider Dill's *Man Reaching* (1997), who sensually appears to be blowing in the wind, whose threaded fingers reach high to catch the breeze of a lover, friend, mother, brother, maybe even Gilberte. With Dill's *Man Reaching* at hand, call to mind the fact that the *Search*'s Narrator is overtaken with desire when he hears the word "Swann," the last name of his beloved Gilberte. "The name Swann had for me become almost mythological, and when I talked with my family I would grow sick with longing to hear them utter it; I dared not pronounce it myself, but I would draw them into the discussion of matters which led naturally to Gilberte and her family" (I, 202; I, 142). The Narrator, then, elaborates on the bodily effect that the sound of "Swann" had on him: "And then I would be obliged to catch my breath, so suffocating was the pressure, upon that part of me where it was for ever inscribed, of that name which, at the moment when I heard it, seemed to me fuller, more portentous than any other, because it was heavy with the weight of all the occasions on which I had secretly uttered it in my mind" (I, 203; I, 142). With these words of Proust, I see yet another lovely image of Dill's: *I reach along the chords of speech.*

Likewise, far into the oceanic depths of the novel, the breath of the name "Guermantes," brings back a rush, an inhalation of a Combray long gone: "And the name Guermantes of those days is also like one of those little balloons which have been filled with oxygen or some other gas; when I come to prick it, to extract its contents from it, I breathe the air of Combray of that year, of that day, mingled with a fragrance of hawthorn blossom blown by the wind" (III, 5; II, 312). With these words, I see Lartigue's beautiful page of Santos-Dumont's balloons of flight.

~ MOST BEAUTIFULLY AND MOST POIGNANTLY, toward the end of "Combray," the object of desire (Gilberte) enters the young Narrator's life, his body, through such a *correspondence*, breath (souffle):

On hot afternoons, I saw a breath of wind ( *je voyais un même souffle*) emerge from the furthest horizon, bowing the heads of the corn in dis-

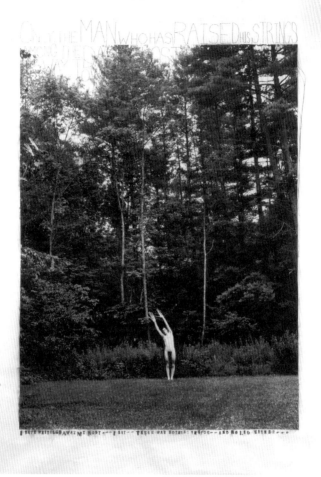

"threaded fingers reach high to catch the breeze of a lover,
friend, mother, brother, maybe even Gilberte."

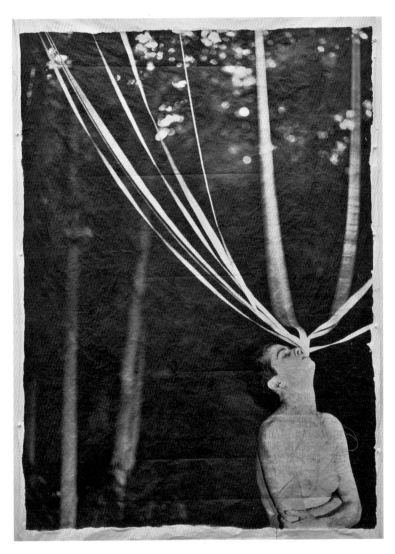

" 'And then I would be obliged to catch my breath' "

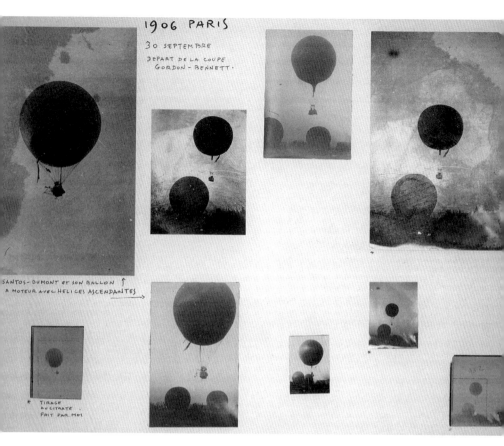

1906 PARIS

30 SEPTEMBRE
DEPART DE LA COUPE
GORDON - BENNETT.

SANTOS - DUMONT ET SON BALLON
A MOTEUR AVEC HELICES ASCENDANTES

TIRAGE
AU CITRATE
FAIT PAR MOI

"'And the name Guermantes of those days is also like one of those
little balloons which have been filled with oxygen or some other gas; when
I come to prick it, to extract its contents from it, I breathe the air of Combray
of that year, of that day, mingled with a fragrance of hawthorn blossom
blown by the wind.'"

tant fields, pouring like a flood over all that vast expanse, and finally come to rest, warm and rustling, among the clover and sainfoin at my feet, that plain which was common to us both seemed then to draw us together, to unite us; I would imagine that the same breath of wind (*ce souffle*) had passed close to her, that it was some message from her that it was whispering to me, without my being able to understand it, and I would kiss it as it passed. (I, 205; I, 144)

# KISSING

# TIME

I would imagine that the same breath
of wind had passed close to her, that it
was some message from her that it was
whispering to me, without my being
able to understand it, and I would
kiss it as it passed.

꙳ Proust, *In Search of Lost Time*

I had thought it impossible . . .
that I should ever get used to
going to bed without kissing
my mother.

꙳ Proust, *In Search of Lost Time*

Often he is seated on the nervous
knees of one of his friends, cheek
to cheek, body to body, and he
discusses with him Aristotle's
philosophy and Euripides's poems,
while the two of them kiss and caress
each other and say elegant and wise things.

꙳ Proust, cited in Edmund White, *Marcel Proust*

Like one anxious to keep an appointment,
she frequently consulted her watch, looking
long at it, as if it were one of those watches
that do not give up their secret until you have
made a mental calculation. Once she kissed it.

⤙ J. M. Barrie, *The Little White Bird*

He [Peter Pan] was very like Mrs. Darling's kiss.

⤙ J. M. Barrie, *Peter and Wendy*

⤙ **BY BOWERING WITHIN FLOWN-DISTANT MOTHER-WINGS,** Proust, Barthes, and Barrie inverted the restless hands of Father Time. Ducking Father's kiss, each blew a kiss (a pneumatic message, blue-with-sadness) toward Mother, so that she just might catch *his* breath from far away, even as far as death. Barthes blew his *petit bleu*[1] as epithet through Boudinet-blue curtains, the color of Henriette's eyes. Barrie blew his on the tail winds of Peter, taking Mrs. Darling's hovering, unlanded, unplanted "one kiss" that even "Wendy could not get" (*P&W*, 69) all the way through to the final pages of the book, only to s(t)eal the final pages of "that terrible masterpiece"[2] with a kiss:

> And then he flew away. He took Mrs. Darling's kiss with him. The kiss that had been for no one else Peter took quite easily. Funny. But she seemed quite satisfied. (*P&W*, 218)

When the Narrator of the *Search* wanted his illustrious kiss goodnight, he blew his school-boy-scrawl note to Françoise, who then floated it on to the butler, who then secretly slipped it into Mamma's hand when the finger bowls were put round, just after the ice stage. When Mamma read the almost illicit note from her kiss-longing son, her mouth was filled with the taste of flavored ice "with burned nuts in it" (I, 39; I, 30), and her not-so-little boy had already "carefully" chosen "in advance the exact spot on her cheek" where he would "imprint" this kiss (I, 35; I, 27). Swann too understands the link between kissing and (photographic) imprinting: "Before

kissing Odette for the first time, he had sought to imprint upon his memory the face that for so long had been familiar before it was altered by the additional memory of their kiss" (I, 538; I, 372). And the ever-illusive Albertine who is everything and nothing, who is nothing more and nothing less than a kiss: she gives kisses like Mamma. Albertine's kisses, like Mamma's can bestow "peace" or, its inverse, "anguish" (V, 140; III, 618):

> When I was kissing Albertine . . . It was a soothing power the like of which I had not experienced since the evenings at Combray long ago when my mother, stooping over my bed, brought me repose in a kiss. (V, 93; III, 584–85)

or,

> Unfortunately, the evening that followed was one of those when this appeasement was not forthcoming, when the kiss that Albertine would give me when she left me for the night, very different from her usual kiss, would no more soothe me than my mother's kiss had soothed me long ago, on days when she was vexed with me and I dared not call her back although I knew that I should be unable to sleep. (V, 108; III, 595)

When it came to kissing Albertine, the Narrator keeps her captive as both mother and lover, as he did with his own mother-lover mother. "Albertine by my bedside, at once as a mistress . . . and as a mother too, of whose regular good-night kiss I was beginning once more to feel the childish need" (V, 140–41; III, 619).

First kisses are born from sucking at the mother's breast, a desire for nursing without nourishment. Consider the baby who continues to suck when all of the milk is gone, sometimes producing a painless sucking (kissing) blister, giving his sweet upper lip the bee-sting fullness of a Pre-Raphaelite portrait; or, the infant who barely sucks, just kisses the breast, because his tummy is full; or, the toddler who sucks in his sleep, even in the absence of Mamma, as if kissing in the air: in all three cases, the child does not want to let go of the nonnutritive pleasures of eating, he is beginning to kiss. A kiss, as Phillips has repeatedly taught us along the way of this book (one kiss is,

after all, never enough) is an example of "the mouth's extraordinary virtuosity, it involves some of the pleasures of eating in the absence of nourishment."[3] Such first kisses that grow from the fact that the breast is no longer "under the baby's magic control"[4] can be read as a Winnicottian transitional object. Kissing comes when the child fills in the loss of the breast (the mother) with symbolic *play* that takes the form of eating in the absence of nourishment, as if using a blankie or playing with string. The child is exercising that space between me and not me, here and gone, which will *play* into adult life, as a kiss goodnight, a kiss hello, a kiss unexplained, a kiss stolen like sweets, a final kiss.

To kiss is to covet the mother's body. To kiss is to love her with one's mouth. Our first contact with the maternal is the nursing kiss, and it is often the last touch. When the grandmother of Proust's *Search* is breathing the last few breaths of her life, the Narrator dries his eyes and bestows upon her a final, final kiss: "When my lips touched her face, my grandmother's hands quivered, and a long shudder ran through her whole body" (III, 470; II, 640). The Narrator's boyish kiss is the last kiss, the kiss of death; but when she dies, as if foreshadowing the spirit of Barthes's own mother's final days (when she had become his "little girl . . . that essential child she was in her first photograph"[5]), the grandmother too becomes a young girl: "On that funeral couch, death, like a sculptor of the Middle Ages, had laid her down in the form of a young girl" (III, 471; II, 641). Kisses travel back into the lost land of pre-Oedipal oral pleasures, kisses travel back, *like a photograph*, to the original referent: the Mother.

Phillips argues (through the work of the psychoanalyst Sandor Ferenczi) that when the infant is weaned, he turns to other activities to reconstruct the trauma of the lost breast and must "take *flight to his own body*."[6] Often he sucks on his thumb, which can be understood as an *attempt* to kiss oneself. But amid the "undeniable feelings of being deserted"[7] (Ferenczi), he may also, or alternatively, "stroke or suck himself [other places than the thumb], or even kiss other people and things, but he will not kiss himself [because one cannot kiss one's own lips]. Eventually, [as] Freud writes in the *Three Essays on the Theory of Sexuality*, he will kiss other people on the

mouth because he is unable to kiss himself there."[8] According to Phillips, he begins to plot for kisses. In other words, the desire to kiss another person on the mouth is a belated infantile response to being abandoned by the mother. And the plotting for kisses is, as Phillips points out, especially active in adolescence:

> At certain periods of our lives we spend a lot of time plotting for kisses, not only as foreplay but also as ends in themselves. It is of course considered adolescent—*and by adolescent boys effeminate*—to be a connoisseur of such things, although adolescence too easily involves, as only adults can know, the putting away of the wrong childish things.

Phillips graphs kisses as particularly adolescent. (Undoubtedly, as adolescents, many of us spent more time plotting for them, or avoiding them, than actually receiving and planting them.) The "first kiss" is the topic of much adolescent discussion, even if the talk never surfaces as more than an interior monologue (talking without sound). As annex of the maternal, kissing is, then, not only adolescent, it is also feminine. Perhaps the effeminacy, and in turn the effeminophobia, of kissing, is even more true of today than it was during the youths of my authors, especially if the kissing is between a mother and her adolescent son (unthinkable in my household); nevertheless, it is clear that Proust's father (as we shall soon see) thinks that the boy is too old for such shenanigans. The mother must do more than move out of the picture, she must be cut out of the picture. (Even if she hovers on the landing of the stairs of the home, betwixt-and-between, as *offstage* she approaches the image of the obscene. The etymology of obscene is offstage.) Adolescent and feminine, the kiss has a special place in reading boyishly.

*To read boyishly*, then, is not only "to covet the mother's body as a home both lost and never lost," it is also *to plot for kisses*. Thereby, Winnicott's adolescent string boy plots for kisses, when he ties up the domestic or when he sews trousers for a family of bears or when he keeps returning to mother. And so does Proust as he pursues the goodnight kiss. (What age is this Narrator-boy-man who is sent to bed at eight o'clock? His need for a kiss seems almost infantile, while his watcher-eyes are astonishingly preco-

cious.) Naturally, Barthes as a kind of mother-identified eternal adolescent looking for punctum (with pursed lips) is also *plotting*. And even Lartigue is a kiss-plotter, who kisses all that is fleeting in the world with the flutter of his beloved "angel-snare"-turned-camera-shutter. And last but not least, Barrie who takes flight in Peter's body, eternally plots for kisses as stars, which twinkle and wink in the nighttime sky. Because of the prohibition against the mother, and the impossibility of kissing oneself, the project is doomed, but perhaps this is part of the fun, to be forever "plotting." (Things could be worse than being stuck in forever foreplay, stuck with kisses, childishly holding on to what adulthood insists we put away.)

Between the pages of this book, kisses have recurrently and readily popped up. At its very start, we brushed against reading as a form of eating, which turns out to be a form of kissing in Phillips's understanding of the term. Proust knew full well that to "press on from the half-measure of kissing to biting" is to turn reading into eating, as to savor a "cleaving to mouth and throat like an icy aromatic jelly . . . lightly veined with the smell of cherries and apricots."[9] Similarly, "that frail and precious kiss which Mamma used normally to bestow on me when I was in bed and just going to sleep" (I, 29; I, 23) is the essence of the madeleine cake, the mother that we all desire to eat like a kiss (whether or not we have such a mother to desire). Or, when the Narrator finds himself flinging upon Albertine to kiss her, as if recalling the goodnight kiss that colors the entire *Search*, he understands himself as ready "to discover the fragrance, the flavour which this strange pink fruit concealed" (II, 701; II, 286). (Ah, but Albertine rejected the kiss by ringing the bell with all her might, thereby sounding in the Law of the Father and hailing, once again, Papa's long-standing prohibition against such childish things.) Along with the taste of kisses, we have caught the sound of an approaching kiss through the swishy resonance of Mamma's "garden dress of blue muslin, from which hung little tassels of plaited straw, rustling along the double-doored corridor" (I, 15; I, 13) as she came to give her boy his nighttime little smack. But more than taste and sound, the boyish kisses that gather their way through this book are glossed and tinted with unattainability. We know only too well that Mrs. Darling's

"sweet mocking mouth had one kiss on it that Wendy could never get, though there it was, perfectly conspicuous in the right-hand corner" (*PP*, 1–2). And Barthes is after that one kiss that cannot be seen by his readers, the kiss as *the* photograph (the Winter Garden Photograph). So, just as the Narrator of the *Search* and Wendy are after that one elusive kiss, and just as Barthes is after a kiss that he cryptically calls punctum — I think that what resides in Winnicott's maternal handbag is also *a* kiss: further evidence of our desire for that which "can't be got." The object that resides within mother's *purse*, the desired but always *one ungotten* transitional object, is nothing less than a material stand-in for a Proustian, Barrieish, Barthesian kiss of *pursed lips*. Searching for the illusive kiss, Winnicott's child turns mother's handbag inside out in a childish act of inversion.

## A Photograph Is a Kiss

"When we kiss [writes Phillips] we devour the object by caressing it; we eat it, in a sense, but sustain its presence":[10] the kiss, then, is like a photograph. Capturing what is fleeting, the camera's famed *devouring eye* is as much mouth as eye. If Proust, as Kristeva has claimed, loves "people and places with his mouth,"[11] by extension Lartigue's camera loves people and places as a mouth. Lartigue's shutter kisses are a manifestation of butterfly kisses. Both the kiss and the photograph are stories of taking and preserving the object, especially, if the kiss is on the mouth, which distinctly "blurs the distinctions between giving and taking."[12] In other words, just as kissing can be described as "aim-inhibited eating,"[13] photographs can be described as "aim-inhibited" picture production: it takes and it gives.

The photograph, because it makes a home for both death (of the moment) and eternity (of the moment) is a queering of Father Time and Women's Time. In the history of art, as Erwin Panofsky writes, time has been traditionally represented by Father Time, with scythe or hourglass as paternal iconic tools of mortality.[14] (Like Proust's father slashing through those "impalpable threads of golden silk which the setting sun weaves slantingly downwards from beneath . . . [the apple-tree leaves] . . . without

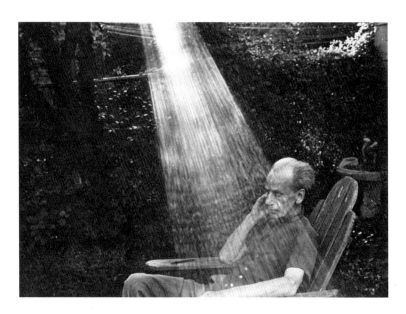

"'impalpable threads of golden silk'"

ever making them deviate" [I, 205; I, 144]). Differently, "Women's Time" as Julia Kristeva argues, is apart from "Father's time," apart from "history," in that it evokes "the *space* of generating and forming the human species."[15] One need only to think of the nursing mother, whose time is (un)structured by feedings every three hours: day *and* night. Likewise we imagine the earth in its seasons as a female body with cycles. The belief that the body of the Virgin Mother does not die but moves from one spatiality to another, via the Assumption, is a mirroring of this eternal maternal body. Eternity/maternity is the monumental time achieved through reproduction, in which the mother's gestating body cheats death.

Through this lens of gendered time, the kiss goodnight is fetishistic, as it, too, seeks to cheat death. For a maternal goodnight kiss says "see you in the morning," stamping tomorrow and morning light on the lips or cheek of her child: alleviating not only the child's own fear of death, but perhaps

more importantly, the child's fear of his mother's or grandmother's death. (The British essayist John Berger, in his moving essay "Mother," has written eloquently on the protective and damaging habituals of "goodnight," which shield like a cloak of snug, but also wound. As Berger begins: "From the age of five or six I was worried about the death of my parents."[16]) But like any good fetish, the kiss is not only a protection against loss (Women's Time with her fostering milk), it is also an acknowledgment of loss (Father Time with his scythe). The fetish, always personal and strange, has its own queer tendencies.

Both the kiss and the photograph (the fetish *par excellence*) queer time. Proust's famous goodnight kiss is *specifically* a queering of Women's Time and Father Time, in that the kiss is a habit repeated, a ritual kept that the Narrator's father would like to put an end to. Yet, the kiss still (like a photograph) always ends in loss, for Mamma would always go downstairs after just one kiss. Allow me to quote this famous passage in full:

> My sole consolation when I went upstairs for the night was that Mamma would come in and kiss me after I was in bed. But this good night lasted for so short a time, she went downstairs again so soon, that the moment in which I heard her climb the stairs, and then caught the sound of her garden dress of blue muslin, from which hung little tassels of plaited straw, rustling along the double-doored corridor, was for me a moment of the utmost pain; for it heralded the moment which was to follow it, when she would have left me and gone downstairs again. So much so that I reached the point of hoping that this good night which I loved so much would come as late as possible, so as to prolong the time of respite during which Mamma would not yet have appeared. Sometimes when, after kissing me, she opened the door to go, I longed to call her back, to say to her "Kiss me just once more," but I knew that then she would at once look displeased, for the concession which she made to my wretchedness and agitation in coming up to give me this kiss of peace always annoyed my father, who thought such rituals absurd, and she would have liked to try to induce me to outgrow the need, the habit, of

having her there at all, let alone get into the habit of asking her for an additional kiss when she was already crossing the threshold. And to see her look displeased destroyed all the calm and serenity she had brought me a moment before, when she had bent her loving face down over my bed, and held it out to me like a host for an act of peace-giving communion in which my lips might imbibe her real presence and with it the power to sleep. (I, 15; I, 13)

Just as Proust's bedchamber at 102 Boulevard Haussmann resonates with his mother's Judaism and his father's Catholicism, producing a queer, Orientalized space for the mythical atheist to write,[17] the kiss as held out from his mother "like a host for an act of peace-giving communion" appears Catholic,[18] but is queered by his mother's Judaism. For, As Edmund White points out, the kiss is a kiss repeated from that abandoned youthful novel, *Jean Santeuil*, where we find a "very striking, if buried, reference to Judaism." As White writes:

The autobiographical hero has quarreled with his parents and in his rage deliberately smashed a piece of delicate Venetian glass his mother had given him. When he and his mother are reconciled, he tells her what he has done: "He expected that she would scold him, and so revive in his mind the memory of their quarrel. But there was no cloud upon his tenderness. She gave him a kiss, and whispered in his ear: 'It shall be, as in the Temple, the symbol of an indestructible union.'" This reference to the rite of smashing a glass during the Orthodox Jewish wedding ceremony, in this case *sealing the marriage of mother to son*, is not only spontaneous but chilling. [19]

Kisses that are linked to the maternal through the Narrator's mother and grandmother continue to spread, like the Victorian love for all things mauve, like Odette's mania for all things British and, thereby, all things mauve (from the petals of her favorite flower, the fleshy cattleya, to the dresses that she wore on the Avenue du Bois, where "[she] would appear, blossoming out in a costume which was never twice the same but . . . [was]

typically mauve" [II, 290; I, 625]). The pages of the *Search* are well kissed, often directly in connection with the maternal. The Narrator describes his beloved grandmother with kissing camera-shutter eyes that envelop a touch of the boy-Lartigue. As Proust writes:

> So humble of heart and so gentle that her tenderness for others and her disregard for herself and her own troubles blended in a smile which, unlike those seen on the majority of human faces, bore no traces of irony save for herself, while for all of us *kisses seemed to spring from her eyes*, which could not look upon those she loved without seeming to bestow upon them passionate caresses. (I, 13; I, 12; emphasis is mine)

(In Janine Antoni's *Butterfly Kisses*, she leaves memories of kisses that have sprung from her eyes with 1,254 indexical winks per heavily "mascaraed"

*"Butterfly Kisses* . . . memories of kisses that have sprung from her eyes with 1,254 indexical winks per heavily 'mascaraed' eye."

eye.) Likewise, the Narrator longs to kiss his grandmother's words as they leave her lips only to emerge from the darkness of the telephone. "'Granny!' I cried to her, 'Granny!' and I longed to kiss her, but I had beside me only the voice, a phantom as impalpable as the one that would perhaps come back to visit me when my grandmother was dead. 'Speak to me!'"(III, 177; II, 434).[20] Or, as Proust writes in a letter to a friend: "There is a certain floorboard near Maman's room that always creaks when you tread on it and as soon as Maman would hear it she'd purse her lips with the little noise that means: come kiss me."[21]

To eat the madeleine cake is to eat the mother, just as to kiss her is to eat her up. In Balbec, the young Narrator kisses his grandmother like a nursing baby:

> I threw myself into the arms of my grandmother and pressed my lips to her face as though I were thus gaining access to that immense heart which she opened to me. And when I felt my mouth glued to her cheeks, to her brow, I drew from them something so beneficial, so nourishing, that I remained as motionless, as solemn, as calmy gluttonous as a babe at the breast. (II, 335; II, 28)

So rudimentary is this link between kissing and the maternal in the *Search* that it sometimes appears as if instinctual, as if involuntary (as in Madame Proust's Pavlovian pursing of her lips in response to the sound of her son's feet treading on the creaking floorboards). There, kissing reads like an infant rooting for the breast, just as it does when Swann amidst deep disappointment over Odette's unfaithfulness, hears yet again the "airy and perfumed phrase that he had loved" (I, 299; I, 208); that recurring "little phrase" of Vinteuil's sonata for piano and violin, which always caught his ear, so much so that this time he reacts to it by making involuntary kisses in the air, as he roots for the flavor of memory, one might even argue "mother," of madeleine. In the words of Proust: as "she [the music] passed, light soothing, murmurous as the perfume of a flower, telling him [Swann] what she had to say, every word of which he closely scanned, regretful to see them fly away so fast, he made *involuntary with his lips the motion of kissing*, as it

"'plotting for kisses.'"

ॐ

went by him, the harmonious, fleeting form" (I, 494; I, 342; emphasis is mine).

I am reminded, yet again, of González-Torres; this time to his *Untitled (A Corner of Baci)* (1990) a candy spill of forty pounds of Italian "kisses" waiting in the corner to be eaten, to be kissed, to give kisses. They are kisses, who like the Narrator of *In Search for Lost Time*, are "plotting for kisses." "Each of the silver-and-blue packaged confections contains a little message of love written (in four languages) on a strip of wax paper under the foil wrapper. [Each kiss suggests a] . . . whisper [of] sweet nothings . . . [they] melt in your mouth, leaving only the aftertaste of pleasure."[22]

The Italian kisses, which viewers consume, so as to consume the exhibition with childlike feelings, remind me, now, of Cornell's exhibit of his boxes for "children only," at Cooper Union in 1972. The art was hung about three feet off the floor and children were allowed to drink cherry Coke

(Cornell's madeleine to memories of a starlet named Sheree North) and chew on brownies (simply a favorite of the artist's) — while all the while pressing their noses and sticky fingers right up to the art. Italian kisses, cherry Cokes, brownies, madeleine cakes: they fill mouths and eyes with love, or at least recollections of love.[23]

While there is in the *Search* an overarching system of metaphors that string together the maternal with the condition of photography (capturing the past, reproducible, linked to life and death), it is specifically the grandmother who is, twice, strongly bound to photography. The grandmother is actually photographed in volume 2, *Within a Budding Grove*, arousing an acute displeasure on the part of the Narrator (II, 501). (No doubt this displeasure being less about the Narrator's disgust at his grandmother's uncharacteristic vanity, as it is about photography's relationship to death — and the fact that Proust's mother had herself photographed shortly before she died.) Later in the novel, the Narrator stumbles upon his grandmother in the drawing room, before she had been told of his return, and observes her like "the stranger who does not belong to the house, the photographer who has called to take a photograph of places which one will never see again," as if "instead of . . . eyes" he was taking it all in with "a photographic plate" (III, 183–84; II, 438–39). And the Narrator does not like what he sees with his eyes as photographic plate: "I saw, sitting on the sofa beneath the lamp, red-faced, heavy and vulgar, sick, day-dreaming, letting her slightly crazed eyes wander over a book, an overburdened old woman whom I did not know" (III, 185; II, 440). In both the aforementioned moments, Proust's writerly photography produces images that we do not necessarily normally see, nor do we desire to see: for his eyes as photographic plate, do not always make beautiful pictures of grandmother. Photography makes us see differently, like the process of kissing itself. In Proust's own words: "Apart from the most recent applications of photography . . . I can think of nothing that can to so great a degree as a kiss evoke out of what we believed to be a thing with one definite aspect the hundred other things which it may equally well be, since each is related to a no less legitimate perspective"

"Italian kisses, cherry Cokes, brownies, madeleine cakes: they fill
mouths and eyes with love, or at least recollections of love."

(III, 498–99; II, 660). As Mieke Bal points out, when the Narrator bestows
a kiss on Albertine, its effect is photographic.[24] Indeed, the kiss gives way
to such photographic effects as the close-up, the snapshot, the multiple,
the proof sheet. As the Narrator confesses, in regards to the photographic,
multiple and varied views of seeing Albertine through a kiss:

> At first as my mouth began gradually to approach the cheeks which
> my eyes had recommended it to kiss, my eyes, in changing position,
> saw a different pair of cheeks; the neck, observed at closer range and
> as though through a magnifying glass, showed in its coarser grain a
> robustness which modified the character of the face . . . so now — as if,
> prodigiously accelerating the speed of the changes of perspective and
> changes of colouring which a person presents to us in the course of our
> various encounters, I had sought to contain them all in the space of

few seconds so as to reproduce experimentally the phenomenon which diversifies the individuality of a fellow-creature, and to draw out from one another, like a nest of boxes, all the possibilities that it contains — so now, during this brief journey of my lips towards her cheek, it was ten Albertines that I saw; this one girl being like a many-headed goddess, the head I had seen last, when I tried to approach it, gave way to another. (III, 498–99; II, 660)

And, like his mother, grandmother, and Albertine, a photograph prompts kisses, just as Vinteuil's "little phrase" sends Swann rooting in the air. When the Narrator buys a photograph of Berma at the corner of Rue Royale in an open stall, he writes: "It gave me the idea and consequently the desire to kiss it" (II, 81; I, 478).[25]

For Proust, mothers and grandmothers hold the spirit of the photograph. What was true for Barthes was also true of Proust: Mother is the ultimate, most irreducible, most pure referent of all photographs. When Françoise notes that the Narrator's mother knows everything; she is "worse than the x-rays [*les rayons x*]" — for she "can see what's in your heart" (I, 73; I, 53) — she is reinforcing the maternal's deep relation to the deepest, most penetrating form of photography: the photograph that pierces through your skin, bones, and organs all the way through to the heart. Likewise, when Proust speaks of "involuntary words" ("the only kind that is really important"), he describes them as being "the kind that gives us a sort of x-ray photograph of the unimaginable reality which would be wholly concealed beneath a prepared speech" (II, 222).[26]

Like Mother, Proust *incestuously* deploys his camera-like vision so sharply and so unerringly, producing the emotional detail that it would never occur to us to see, to represent. Yet, Proust's x-ray fantasies also produced the mysterious fog of organs, tumors, fissured bones, cavities, cysts, even other beings of the unknown. One might conclude that the Narrator's mother takes x-rays of the heart, but Proust probes even deeper: he takes x-rays of the spirit.[27] As the Narrator of the *Search* remarks in terms of his own observations, he could never write literature like that of the Goncourts with

its detailed description of the "sort of necklace an old woman might be wearing" (VI, 38; IV, 295). The Narrator claims an "incapacity for looking and listening" (VI, 39; IV, 296), at least in our time-honored sense of story. "So the stories that people told escaped me, for what interested me was not what they were trying to say but the manner in which they said it and the way in which the manner revealed their character or their foibles. . . . So the apparent, copiable charm of things and people escaped me, because I had not the ability to stop short there—I was like a surgeon who beneath the smooth surface of a woman's belly sees the internal disease which is devouring it. If I went to a dinner-party I did not see the guests: when I thought I was looking at them, I was in fact examining them with x-rays" (VI, 39–40; IV, 296–97).[28]

And while there is not a direct link between xs and kisses in French, there is in English. Turning our cheek toward the British culture that fascinated Proust and especially his character Odette, along with the Duc de Guermante's anglophilia and even Bloch's stylish monocle—as if "a shop-assistant has told you that some object imported from England is 'the last word in chic'" (VI, 385; IV, 531)—Mother-kiss and the Photograph become as tightly pledged as Barthes's notion of the referent and the photograph. ("It is as if the Photograph always carries its referent with itself . . . both affected by the same amorous funereal immobility . . . like those pairs of fish [sharks I think according to Michelet] which navigate in convoy, as though united by eternal coitus."[29]) xs first became associated with kisses in the Middle Ages, when, because most individuals were illiterate and could not write their names, documents would be scrawled with an x that would be followed by a kiss on a sheaf of animal skin so thin that it could be served as paper. A little smack next to the *Middle-Aged* x affirmed sincerity. Furthermore, x is a kiss because it looks like two stylized people kissing. (*Bon nuit Maman.*) And again, x is a multiplier (like the infinite reproducibility of the photograph), multiplying delight and love . . . and in the case of the *Search*, inversion.

## Inverted Kissing

Kisses have long been associated with inversion. Kisses make the impossible possible: a princess kisses the lips of an ugly warted toad, so that the latter can bloom back into the stunning prince that he really is, or the handsome woodman's kiss on the frozen Snow White pinks life back into her sleeping-as-if-dead cheeks[30] or the prince's kiss of sleeping Briar Rose ("Sleeping Beauty"): "There she lay, so beautiful that he could not take his eyes off of her, and he bent down to kiss her. No sooner had the prince touched Briar Rose's lips than she woke up, opened her eyes, and smiled sweetly at him."[31] In such fairy stories that turn on a kiss, the Law is inverted: whether it be the Law of Beauty or the Law of Death. Nevertheless, outside of fairy tales, outside of life lived "happily ever after," it is the Kiss of Death, the Kiss of Father Time, the Kiss of the Grim Reaper that rules our lives. To remain boyish is an attempt to duck the kiss of Father Time to stay inside the womb of Mother-Who-Knows-No-Time. To grow up, so say our fairy tales, our novels, our stories (unless you can be Assumed up to heaven like the Virgin Mother) is to grow toward death. As Phillips writes in *The Beast in the Nursery*:

> It is now a commonplace assumption that something essential is lost, or at least attenuated, in the process of growing up. Whether it is called vision or imagination, or vitality or hope, lives are considered to erode over time (the idealization of childhood and adolescence is reactive to this belief). And it is, of course, integral to this story to conceive of death as an enemy — as something we fight, something that makes surprise attacks — and not as of a piece with our lives.[32]

Barthes argues in his essay on Proust, "An Idea of Research," that inversion is "studded all through the great continuum of the search" and is the source of the long novel's pleasure.[33] Not only does it structure the very development of the main characters: "Odette becomes Mme Swann; Mme Verdurin ends as the Princess de Guermantes," etc. — it also makes "sexual inversion" "exemplary (but necessarily primarily)" enabling us

"to read one and the same body as the super-impression of two absolute contraries, Man and Woman."[34] "By a broad sweep which takes up the entire work, a patient but infallible curve, the novel's population, heterosexual at the outset, is ultimately discovered in exactly the converse position—i.e., homosexual (like Saint-Loup, the Prince de Guermantes, etc.): there is a pandemia of inversion, of reversal."[35] Ironically, as White writes: "The Narrator is one of the few unambiguous heterosexuals in the book; almost all of the other characters turn out to be gay."[36]

Perhaps the fairy-tale inversion, sealed with a kiss, is most subtle and dramatic in the figures of M. Swann and Odette (Mme Swann). On the onset of the novel, M. Swann is a man of great taste

"in a reverse inverse, we might see Odette as the Odile of Swann."

and wealth, the epitome of elegance. Initially, we have great respect for his knowledge of literature and the arts, his companionship with the Narrator's family, and, perhaps, overlook or just giggle at his thing for maids. But eventually we learn more—significantly his hopeless love for the indifferent coquette Odette, who will become Mme Swann. Odette, as ballet lovers know, is the name of the good swan in *Swan Lake*, who is actually a young woman transformed into the most elegant of birds by an evil magician. Only at night is Odette able to shed her feathers and appear as a human woman. More importantly, the curse can only be broken with true love and a kiss. Likewise, this fairy-tale-ballerina Odette is doubled by her evil alter-ego Odile (a black-tutued inversion of white-tutued Odette) who tempts the prince (the one who could break the curse) with her sassy dancing.[37] Likewise, but in a reverse inverse, we might see Odette as the Odile of Swann.

And this being Proust, the repetition of inversion is endless, not withstanding the end of the novel in which the Narrator mistakes Gilberte (Odette's and M. Swann's daughter) for Odette herself. While daughter Gilberte had become "a stout lady" who is taken for "Mamma" (VI, 427–28; IV, 558) — the Narrator fails to recognize Odette "because she . . . was like the Odette of old days" (VI, 377; IV, 558). Mme Swann escapes the hands of Father Time; she, more than any of the others, embodies *time regained*. (When Raul Ruiz cast Catherine Deneuve, a living star who too has escaped age, as Odette in his film *Le temps retrouvé* [1999], it was a stroke of genius.)

As Barthes remarks on Proust's inversions: "Pleasure once found, the subject knows no rest until he can repeat it."[38] For Proust, the Freudian compulsion to repeat comes out of the inversion that grows out of the goodnight kiss, which "inaugurates the narrative itself."[39] (It is in this way that the comings and goings of kisses, the kiss as hello and as goodbye, is a reduplication of Ernst's fort/da game that enables him to cope with his mother's absence. Both are fleeting, quick contacts, brushes with the mother.) From the despair of having to go to sleep without Mamma's kiss arises the delight and pleasure of spending the entire night in his mother's company. Furthermore, the night with Mamma produces further *inverted* joy: the stern Father becomes the kind Father: "Go along with him, then . . . stay in his room . . . I don't need anything . . . you can see quite well that the child is unhappy . . . You'll end by making him ill, and a lot of good that will do. There are two beds in his room; tell Françoise to make up the big one for you, and stay with him for the rest of the night . . . Good night" (I, 48; I, 36). As Barthes so finely secures it in a discourse of talented brevity (a writing approach prompted by but entirely foreign to Proust): all that follows in the *Search* is a repetition of the inversion that the mother's kiss ignites.

## Inverted Time: "I Listened as If to a Fairy Tale"

For the last decade of his life (from 1913 to 1922), in constant companionship with his beloved maid Céleste Albaret, Proust wrote most of the *Search*, by turning night into day and day into night, fairy-tale style: "It

"Mme Swann escapes the hands of Father Time; she, more than
any of the others, embodies *time regained*. (When Raul Ruiz cast
Catherine Deneuve, a living star who too has escaped age, as Odette
in his film *Le temps retrouvé* [1999], it was a stroke of genius.)"

was completely upside-down life,"[40] writes Albaret. Albaret's lovely book
*Monsieur Proust* is touching for the queer love between the famous house-
keeper, personal assistant, and companion and the famous author. In her
book, Albaret embraces not only the inversion of night into day, but also
their shared cloak of tender, if dark, inverted familial life, in which the two
were strange offspring of the other, both queer lovers (in Sedgwick's ex-
pansion of the term), both mothers to each other. Albaret was conscious
of being Proust's daughter, wife, and *mother*. And Proust willingly became
Albaret's son, husband, and *mother*. "'I see my mother again in you mon-
sieur,'"[41] writes/says Albaret. Or, "What I felt was so marvelous was that
with him there were moments when I felt that I was his mother, and others
when I felt I was his child."[42] Or, another time Proust joked (?): "The only
person I could have married is you."[43]

The odd coupleness of Albaret and Proust is reminiscent of the strange
bedfellows of Wendy and Peter. ("Wendy, Wendy, when you are sleeping

in your silly bed you might be flying about with me saying funny things to the stars" [*P&W*, 97].) Recall how Peter and Wendy played house in the Neverland as if they might have been mother and father, hence wife and husband. Yet, when Wendy queries Peter: "What are your exact feelings to me?" Peter replies: "Those of a devoted son, Wendy" (*P&W*, 162). And in a similarly twisted notion of the maternal as altered: Barrie became mother to the "five" as well a companion and queerish lover to George. But the comparison also brings to light the arresting difference between Peter and Proust, while nodding at the given folly of such a comparison, given that the eternal boy is fictional and the obsessive author is "real": Peter forgets everything[44] (perhaps that is why he can neither "write nor spell . . . not the smallest word") (*P&W*, 137); Proust remembers everything (perhaps that is because he wrote everything down in his famous carnets). Proust is all story; Peter is no story. Peter: "You see, I don't know any stories. None of the lost boys knows any stories" (*P&W*, 96).

Proust's memory for keeping everything the same was at the root of his obsessional demands, his requirement for the same story over and over. When preparing to venture out, he would use as many towels as a hotel full of guests. Wiping his face with one very clean towel *just once*, Proust believed that he could not afford to wipe his tender face more than once with the same towel: it would chaff his sensitive skin. Dropping the still-clean, barely damp white towels across the apartment floor behind him — his was a game of fort/da without the fort: a da, da, da, da all over the floor, turning his dressing room into a stage set of newly fallen snow (albeit in the form of clean towels). Likewise, propped up in bed, calling out scene changes, staring at the devastated and frozen Albaret, Proust once snipped up a beautiful, fine, truly exquisite, linen handkerchief into tiny snowy bits, because, in his mind, the linen simply was not fine enough.[45]

Albaret's careful attention to every facet of Proust's life enabled its inversion in every detail — from erotic and familial relationships to one's very understanding of passing the time, including Albaret's dutiful washing, pressing, comforting her *patient*-writer, boiling the kettle water, straightening and cleaning up the bits of writing that almost became one with the

"Peter forgets everything (perhaps that is why he can neither 'write nor spell . . . not the smallest word') . . . ; Proust remembers everything (perhaps that is because he wrote everything down in his famous carnets)."

bed's dressing (she could read his already-difficult cursive upside down), listening for the buzzer that summoned her to his bed, day and night, at the onset of an asthma attack or just the simple desire to hear her stories about her childhood one more time, or, listening to another story of his which would be tried out on her and then inscribed into one of his "black books" and later printed into a volume of the *Search*. "I listened as if to a fairy tale" (Albaret).[46]

Proust's writing was enabled by illness (and, of course, his class). Albaret mothered him all night long: keeping his bedside table at the ready for the fumigations that he took every afternoon, the little box of Legras powder, the saucer for the powder, the squares of white writing paper that he used to burn the powder with, and the candle from which he lit the paper; refilling the fresh bottle of water that he never drank from; constantly filling his metal, always-clanking hot-water bottles that he kept underneath his blankets, more and more as the day/night ran on; preparing his first coffee of the day, which had to be ready the moment he rang for it, that took half an hour to prepare, drip by drip to make the thickest coffee possible and could never be reheated because her spoiled employer, like the princess who could detect a tiny pea beneath the stack of mattresses that lie beneath her, could always detect even the slightest burned taste.

Proust has no loving attachment to clocks, he feverishly tried to defeat time through writing photographically. Remembering the clock in his childhood bedroom at Combray, Proust recalls that he was "convinced of the hostility of the violet curtains and of the insolent indifference of a clock that chattered on at the top of its voice as though I were not there . . . until habit had changed the colour of the curtains, silenced the clock" (I, 8; I, 8). In an inversion of Proust, Barthes fell in love with time in order to keep time: "For me the noise of Time is not sad: I love bells, clocks, watches— and I recall that at first photographic implements were related to techniques of cabinetmaking and the machinery of precision: cameras, in short were clocks for seeing, and perhaps in me someone very old still hears in the photographic mechanism the living sound of wood."[47] In "real life," Proust lined his room with cork and shut out natural light and the sounds of life.

Proust lived to keep time out, and he took Albaret with him, down, down, down (Alice-like) into the honey-colored cave of their fairy-tale life: "I ran hither and thither as if it were noon instead of midnight. I'd got so used to turning day into night"[48] (Albaret).

## A Forest of Symbols, A Forest of Thimbles

> A "link"—the "reassurance" and "continuity" of a thread so tenuous, so hard at times to keep hold of (or perhaps to communicate to others is what I mean).
> —Joseph Cornell, quoted by Carter Ratcliff, in *Joseph Cornell*, 48

I come across Joseph Cornell's *Beehive (Thimble Forest)*. It is part jewelry box and part Shaker box. Inside are useful thimbles like you might find in one of those round, nesting Shaker boxes that Cornell loved, yet the interior is lined with mirrors, like those kinds of childish, girlie, jewelry boxes that feature plastic ballerinas who solemnly spin round and round to the wind-up music when the little treasure chest is opened. Each thimble, perched on a needle in anticipation of a remembered pirouette, comes with a small message tied on string. The messages—like price tags at a church bazaar or like fortunes without their cookies or like inventory tags in a natural history museum—are in simple language-book French and speak of gardens and children and music and girls and a château. (The interior of the dark blue lid features directions in English on light blue paper, perhaps the color of a *petit bleu* sent to Proust's Narrator, explaining how to set up the needles and the thimbles and their messages in the "beehive.") Like a beehive, like needles capped by darling protective thimbles: this object is sweet and stinging.

I am pricked by these thimbles, though theirs is a meaning that I cannot quite name. I am reminded of how the Narrator was struck by an image of *three trees* (while on a carriage ride with Mme de Villeparsis to Hudi-mesnil, while still in Balbac). Hailing some unnamable memory, Proust's three trees are nevertheless rich with meaning. Just as the five thimbles are

"I come across Joseph Cornell's *Beehive (Thimble Forest)*."

☙

inside Cornell's box, the Narrator of the *Search* "could see them [the three trees] inside" himself (II, 405; II, 77), but he could not ascertain their significance. Thimbles as symbols, Cornell's thimbles, balanced atop needles, *also* nod at Baudelaire's "Correspondances," and the famed phrase: "*forêts de symboles*." "*Forêts de symboles*" becomes "*forêts de dés.*" Suggesting the miniature, the feminine, the exquisitely rendered, the thimble is a kind of symbol for Proust's own writing.

Thimbles prevent needle pricks, bodily evidence of the process of fine sewing and writing. (Likewise, in our beautifully designed chunky volumes of the *Search*, we no longer see the torn pages, the paperoles, the stains, the rips, the body at work.) Thimbles allow sewing without affecting the body, just as kissing is a kind of eating without (physical) nourishment. I pick up a stitch and I find myself back in the childish world of Barrie's *The Little White Bird*; my fingers tremble with desire; a thimble is a kiss.

> She [Maimie] said, out of pity for him, "I shall give you a kiss if you like," but though he once knew he had long forgotten what kisses are, and he replied, "Thank you," and held out his hand, thinking she had offered to put something into it. This was a great shock to her, but she felt she could not explain without shaming him, so with charming delicacy she gave Peter a thimble which happened to be in her pocket, and pretended that it was a kiss. Poor little boy! he quite believed her, and to this day he wears it on his finger, though there can be scarcely any one who needs a thimble so little. (*LWB*, 198)

Peter wears it on his finger, as if it is a wedding ring, a magical wedding ring as proof of his stunted growth and his marriage to Maimie, who will become Wendy, who is herself a girl-version-inversion of Barrie's own mother, Margaret Ogilvy: a Tom Thumb Wedding. In the early years of the twentieth century, when *The Little White Bird* was born and Barrie was busy getting Peter on stage — neighborhoods and churches would stage little weddings, with children playing all of the roles of the wedding party. These miniature, matrimonial scenes, these Lilliputian weddings, were called Tom Thumb Weddings: they grew from the real 1863 marriage

"Peter wears it on his finger, as if it is a
wedding ring, . . . A Tom Thumb Wedding."

"These miniature, matrimonial scenes, these Lilliputian
weddings, were called Tom Thumb Weddings"

of Charles Sherwood Stratton (General Tom Thumb) to the tiny Lavinia Warren Stratton.[49] (The term "midget" is itself Victorian, originating two years after Tom Thumb's wedding, in 1865. Through analogy to midge, gnat, or small fly, small people were further diminished by the very term "midget."[50] The cruelties of a culturally imposed narcissism of normalized selfhood combined with the fad for fairies in Victorian and Edwardian consciousness were quick to further categorize small people with fairies, often callously turning them into various forms of entertainment. The tiny thimble of the tragic Mademoiselle Caroline Crachami, better known as "The Sicilian Fairy," is still on display, along with her skeleton, at The Royal College of Surgeons, London.[51])

We wait for the thimble/kiss to seal the promise.

In the strange clock-hands of Barthes, Barrie, and Proust, "kissing time" is "stopping time." To "x" out time is to kiss time.

⁂

There is one spot on the road where a thousand times
I have turned to wave my stick to . . . [Mother], while she
nodded and smiled and kissed her hand to me.

—J. M. Barrie, *Margaret Ogilvy*

# BEAUTIFUL,

## BORING,

## AND BLUE:

## THE FULLNESS

## OF PROUST'S

## *SEARCH*

## AND

## AKERMAN'S

## *JEANNE*

## *DIELMAN*

ALLOW ME TO BEGIN MY FINAL CHAPTER with two quotes. First, a line from a Victor Hugo poem[1] as quoted by Proust in his long, beautiful, boring 4,300 page novel. This line occurs in the final volume, near the very end the novel.[2] Second, a quote from the Belgium filmmaker Chantal Akerman, whose work has been profoundly influenced by Proust.

Take away the happiness and leave the boredom to *me*.[3]

Each time I read *À la recherche du temps perdu* right through ... I always felt such an intimate connection with Marcel, I would speak to him in a familiar way, I'd call him "Marcel dear," the way I would a younger brother, he was almost like one of my own family with his obsessions, his secret places, the same themes he kept returning to and developing so often and so well.[4]

I have seen the long, slow moving movie *Jeanne Dielman, 23 Quai du Commerce, 1080 Bruxelles* (released in 1975, clocking in at 198 minutes and directed by the amazing Chantal Akerman) over and over. I have seen this beautiful but undeniably boring film more than any other film. It changed my life; it affected me deeply. I made a habit of showing it in my courses. It affects my students deeply. With *Jeanne Dielman* before us, slowness becomes a gift. In *Vivre l'orange*, Hélène Cixous dedicates the gift of "slowness" to her "amies for whom loving the moment is a necessity." "Slowness," claims Cixous, "is the essence of tenderness."[5] For "saving the moment is such a difficult thing, and we never have the necessary time, the slow, sanguineous time ... that has the courage to let last."[6] Akerman has the courage to "let last." Perhaps the seed of that courage grew from reading Marcel Proust's 4,300 page labyrinth: *In Search of Lost Time*. As Akerman said in a recent BBC interview: "I grew up reading Proust all my life and he is very dear to me."[7] Akerman has had a pro ... long ... ed relationship with Proust. His labor is very dear to her.

*Jeanne Dielman* labors, affectively, like Proust's *Search*. Both film and book share much: a passion for tedium; the comfort and horror of habit;

"'Slowness . . . is the essence of tenderness.'"

an ability to turn boredom into pleasure; a prideful precision of exquisite detail; narrative without its classical narrative structure; an insistence on women's labor as art; an anxious regard for holding time; a talent for using color as a feminine language.

While Akerman has since made a film that directly embraces Proust's novel, *La Captive* (2000), which is very loosely based on the fifth volume of the *Search* ( *La Prisonnière*), one might argue that *La Captive* shares more with Hitchcock's *Vertigo* than with Proust's *Search*. Like *Vertigo*'s Scottie, Simon (the male protagonist of *La Captive*) pursues his love object Ariane (who is situated as both Hitchcock's Madeleine and a morsel of Proust's *madeleine* cake[8]), by following her through the streets and even stalking her in an art gallery. Furthermore, while there are brief scenes and situations in *La Captive* based on *La Prisonnière* (for example, Simon and Ariane live together in

his family's apartment, as does the Narrator and Albertine; Albertine prefers women over men, etc.), the language of Akerman's recent film is closer to that of Marguerite Duras than Proust.[9] *La Captive*, although captivating and successful in its own right, takes a very bare-bones approach to Proust. Differently, *Jeanne Dielman* labors in extreme Proustian fashion. *Jeanne Dielman* is even more than meat on the Proustian bones: it is a full meal.

*Jeanne Dielman* takes place over a drawn-out period of three days. Jeanne is not only a housewife and a widowed mother of an adolescent son, she is also a part-time prostitute. Her professions (mother, housewife, prostitute) are all professions that are not quite professions. As prostitute, she is affectless, robotic, and bored in *the* labor of intimacy taken to exchange. An exception to her affectlessness in bed comes at the end of this film: Jeanne, quite surprisingly, has an orgasm with one of her johns. Her pleasure, as revealed in the distress of her face, gives her great pain. So much pain, that she is driven to murdering her sleeping postcoitus john with a pair of scissors. Yet despite sex and murder, seemingly "nothing happens"[10] in *Jeanne Dielman*—because nothing is left out. For example, as if Akerman were Proust masquerading as a 1970s feminist, we do not witness just the eating of the meal, we witness the meal in its entirety: its purchase, preparation, consumption, the cleaning up of the table, and the washing of *every* dish.

The tedium and the pleasure of Proust's art (both the writing of it and the reading of it) as well as the tedium and the pleasure of Akerman's art (both the filming of it and the watching of it) are mirrored in the tedium and the pleasure of domestic labor as represented in both *Dielman* and the *Search*. Just as Marcel's cook, the famed Françoise, is particular about choosing the best pieces of meat and enriching it with the perfect juices when she is slowly and carefully making her exquisite *bœuf à la gelée*, so do we learn how Jeanne Dielman shops at the butcher, how she dips her veal cutlets in egg, how she kneads, and how she painfully massages her ground beef into a meat loaf. Whereas I have no desire to eat a bite of any of the food made at 23 Quai du Commerce, 1080 Bruxelles (Dielman's cooking is weighed down by the heft of her gendered, lonely, middle-class life), there is much that appeals to me on Françoise's menu in the country home in Combray.

The table—alight with the delights of spring asparagus, yeasty brioche, chocolate crème, roasted chicken, creamed potatoes—gives the lengthy meal a heavenly air suspended by the winds of winged bourgeois life, the pleasures of the Belle Époque.

But what both Akerman and Proust portray in their texts is not so much the details of food but rather a special love for portraying the tiny habits and gestures that make a woman's work a piece of art. As if reenacting a scene from the *Search* (but with a stark modernist approach), we follow Jeanne's search from store to store for the exact button to replace the one missing from her son's jacket. Just as Proust and Akerman search for just the right gesture, moment, and detail to frame in their fictions, Jeanne, too, will settle at nothing less than perfection. The precision of the detail given by each artist to their loved characters of hyper-domesticity (Françoise and Jeanne) becomes a model for their own art. The brilliance of both Akerman and Proust is their ability to keep the viewer and reader fascinated by everything "normally left out" of movies, novels.[11]

Proust and, in turn, Akerman inhabit the watcher eyes and the extreme interiority of the Narrator's great-aunt Léonie: writer, filmmaker, and fictional aunt (based on Proust's real aunt Elizabeth Amiot who lived in Illiers) seem to miss nothing in their studies of the tiny details of life before them. Aunt Léonie's was an existence of confinement where nothing and everything happened, so that life was both held still while flying by. "Confined to two adjoining rooms, in one of which she would spend the afternoon while the other was being aired" (I, 66; I, 48), Aunt Léonie, like Proust, spent her time in bed. (Because of his struggle for breath, Proust was absolutely separated from the nature he worshipped; "If he wanted to see hawthorn trees in bloom, he had to be driven through the countryside in a hermetically sealed car."[12]) While Proust's bed was filled with hot-water bottles, with smoking papers nearby and coffee to be delivered and his notebooks at hand, for Aunt Léonie it was "a table which served at once as dispensary and high altar, on which, beneath a statue of the Virgin and a bottle of Vichy-Célestins, might be found her prayer-books and her medical prescriptions, everything that she needed for the performance, in bed,

of her duties to soul and body, to keep the proper times for pepsin and for vespers" (I, 70; I, 51). Voyeuristically watching the details of outside village life through the window, her life of perfectly ordered boredom enables her to exclaim to the young Narrator: "Three o'clock! It's unbelievable how time flies!" Time lasts forever and is over in a flash. Similarly, the experiencing of watching *Jeanne Dielman*, which documents only three days in a life, can feel like a lifetime. Likewise, it takes many people a whole lifetime (or more) to get through Proust's novel. Or in the words of Céleste Albaret: "The years when he actually wrote his books — feel either like just one year or a whole lifetime."[13]

To watch *Jeanne Dielman* and to read the *Search* is to be caught in up in time told queerly: where days become years and years become days. Perhaps Proust and, in turn, Akerman, learned to tell time not only from Aunt Léonie (as modeled on Aunt Elizabeth Amiot) but also on Françoise (as modeled on Albaret). Focused on the everyday (especially the domestic, the feminine, the maternal), both Akerman and Proust are interested in the noncommodified time of women's work. In a moment from the long hours and sustained second hands of the *Search*, Françoise claims: "My time is not so precious; the one who made it doesn't charge us for it" (I, 75; I, 55). Françoise, it seems, *cannot properly tell time*:

> But Françoise suffered from one of those peculiar, permanent, incurable defects which we call diseases: she was never able either to read or to express the time correctly. When, after consulting her watch at two o'clock, she said "It's one o'clock" or "It's three o'clock," I was never able to understand whether the phenomenon that occurred was situated in her vision or in her mind or in her speech; the one thing certain is that the phenomenon never failed to occur. . . . As for discovering the cause of Françoise's incapacity to tell the time correctly, she herself never threw any light upon the problem. . . . She remained silent. (V, 201–2; III, 662)

And, just as Proust *holds* time still and at a distance with his breathless, labyrinthine sentences, *Jeanne Dielman* achieves its incredible boredom

through its *held* still "shallow-boxed framing,"[14] with no reverse shots, as if life took place in a diorama or a Joseph Cornell box. The always-frontal camera angle defies the classic cinematic pattern.[15] Furthermore, the camera always stays at the same, "respectful" distance.[16] In Akerman's own words: "I didn't get too close, but I didn't get too far away."[17] She avoids "cutting the woman in a hundred pieces . . . cutting the action in a hundred places."[18] We watch her making filtered coffee in a thermos whose shape resonates as an hour glass[19] — dutifully having a snack — repeating the customary question of her son before a meal, "Did you wash your hands?" — polishing her son's shoes — knitting — smoothing down the white towel on the bed before she gives sex to the afternoon john — lifting the lid of the clean, white soup tureen, placing the cash made from her sex work inside the bowl, placing the lid back on top — all done with the same tidiness and precision that marks her every gesture, her every move, her every habit. She is "a human metronome."[20] Like Jeanne's thorough cleaning, there are no short cuts in Akerman's filmmaking. "It is a movie in which neither the heroine nor the director cut any corners, except on dialogue."[21] There is an "integrity of things as they already stand."[22] With "perfect mathematical inhale-exhale clarity"[23] "we are made to feel the length of time . . . the number of spoonfuls it takes to eat soup."[24]

Benjamin has described this Proustian fabric that leaves not a piece of string, yarn, or thread unattended as a structure, a web that is "fiction, autobiography, and commentary in one, to the syntax of endless sentences (the Nile of language, which here overflows and fructifies the regions of truth), everything transcends the norm."[25] (Or as the character Legrandin claims in *Swann's Way*, with "Machiavellian subtlety, 'that land of pure fiction makes bad reading for any boy'" (I, 185; I, 130). Benjamin runs the shuttle through the bright and somber yarns of the warp of the *Search* to emphasize (as I already have in chapter 3, "Splitting") that "the Latin word *textum* means 'web.' No one's text is more tightly woven than Marcel Proust's; to him nothing was tight or durable enough."[26] As Benjamin knows, Proust is at the mercy of "the invisible seamstress" who refuses "to abandon the discarded threads, but collected and rearranged them . . . in the different order which

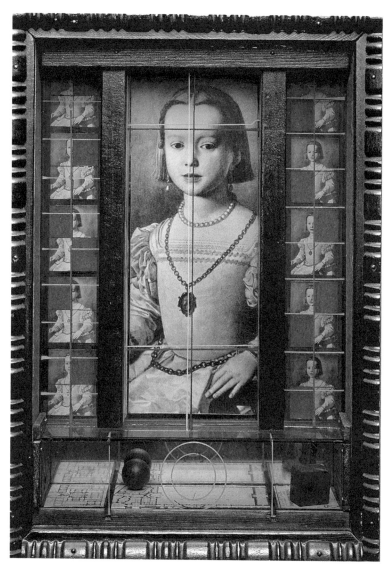

"as if life took place in a diorama or a Joseph Cornell box."

"'I didn't get too close, but I didn't get too far away.'"

she gave to all her handiwork . . . Then, one and all, they took on a meaning . . . [a] new arrangement" (I, 583; I, 403). Just as the *Search* is as much about forgetting as it is remembering, the Narrator both generates and covers up time, like a writer, like Proust, like Barthes. It is through Benjamin's words that I now understand why I have been of late cradling myself in the memory of these following lines spoken by the Narrator in reference to Françoise and the pleasure she derived in consoling herself with "the knowledge that she would one day be buried in her own fine sheets, marked with her name, not darned at all (or so exquisitely darned that it merely enhanced one's idea of the skill and patience of the seamstress), a shroud from the constant image of which in her mind's eye she drew a satisfactory sense, if not actually of wealth and prosperity, at any rate of self esteem" (I, 441; I, 305). (Even Barrie's rougher, perhaps too-quaintly Scottish, text indulges in a singular love of exquisite linen, so that his mother [like Françoise] is also the creative genius of the house, as inspiration for her author-son. As Barrie writes in *Margaret Ogilvy*: when there was "delicious linen for my mother to

finger . . . there was always rapture on her face when the clothesbasket came in: it never failed to make her once more the active genius of the house."[27]) Françoise's perfect sheets, "not darned at all (or so exquisitely darned that it merely enhanced one's idea of the skill and patience of the seamstress)," are the perfect white sheets that are now bound in the book that buried Proust, like a baby swaddled, like a corpse wrapped.

I am reminded (again)[28] of Terry Evans's *Field Museum, Trumpeter Swan, North Dakota, 1891* (2000). Taken from life in 1891 and preserved like a photograph (is photography nothing more than an elevated and bloodless form of taxidermy?), Evans's *Trumpeter Swan* has slept Rip-Van-Winkle-like in a drawer in Chicago's Field Museum for more than a century. Swaddled into an elongated egg by the cheesecloth that binds the large, elegant bird (as if it had not yet broken through its shell), *Trumpeter Swan* calls out a silent song that collapses birth and death at once. *Trumpeter Swan* looks like an infant in swaddling (perhaps like Baldovinetti's *Madonna and Child*) to be carried by a stork; only the swan is the stork who swaddles herself, like death in Françoise's perfectly darned sheets. Like Albaret's decade with Proust, *Trumpeter Swan* feels "either like just one year or a whole lifetime."

The paperies of the *Search* are nearly hidden, now just traces of a collage that once was, that enhance one's idea of the skill and the patience of the writer, of Proust as an exquisite seamstress who works with impalpable threads. Shocking to anyone involved in publishing, once Proust's manuscript was set in type, he would proceed to "use typesetters the way other people use typists, or word processors."[29] Crowding "the margins with more and more new passages, all designed to enrich his design and to establish links [threads] among the various characters and scenes,"[30] even pasting new additions in strips that would fold out. The end effect is beauty at play in the textures of form as content, and the textures of content as form. Just as the characters of the *Search* — the Narrator, Odette, Albertine, Swann, Françoise, Bergotte, the mother, the father, the grandmother and many, many more — exist in a labyrinth of layers of gardens, villages, homes, paths, conversations, deaths, marriages, parties, walks, theater visits and more and more, the manuscripts themselves were made in ma-

"the swan is the stork who swaddles herself, like death
in Françoise's perfectly darned sheets."

"he would proceed to 'use typesetters the way other people
use typists, or word processors.'"

terial layers: exquisite paper pastiches of what the novel's famous cook-maid-nurse Françoise calls the Narrator's "paperies." As Françoise used to say, "'Ah! if only, instead of this girl who makes him waste all his time, Monsieur had got himself a nicely brought up young secretary who could have sorted all Monsieur's paperies for him!'" (VI, 319; IV, 488). But (in *real* life), it was the nicely brought up Albaret who cleaned up and organized his pages of writing in his famous notebooks, gluing on accordion-style additions that could fold out in lengths up to four feet as well as getting pages in order and repairing torn pages, whenever possible. The reparations and additions were done Françoise-style, with her admirable seamstress and make-shift-glazier skills. As Proust writes in *Time Regained*:

> These "paperies," as Françoise called the pages of my writing, it was my habit to stick together with paste, and sometimes in this process they became torn. But Françoise then would be able to come to my help, by consolidating them just as she stitched patches on to the worn parts of her dresses or as, on the kitchen window, while waiting for the glazier as I was waiting for the printer, she used to paste a piece of newspaper where a pane of glass had been broken. And she would say to me, pointing to my note-books as though they were worm-eaten wood or a piece of stuff which the moth had got into: "Look, it's all eaten away, isn't that dreadful! There's nothing left of this bit of page, it's been torn to ribbons," and examining it with a tailor's eye she would go on: "I don't think I shall be able to mend this one, it's finished and done for. A pity, perhaps it has your best ideas. You know what they say at Combray: there isn't a furrier who knows as much about furs as the moth, they always get the best ones." (VI, 510; IV, 611)

(Cornell needed such a helpmate too; that is why he placed an advertisement in the newspaper for a girl with steady hands to cut out his collage materials and to organize the bits and pieces of his endless scraps of life that made up his art: Cornell's own "paperies.")

These "paperies" metaphorically play out Proust's realized desire to weave and connect all the details of life lived into his unfathomable litera-

"exquisite paper pastiches of what the novel's famous cook-maid-nurse Françoise calls the Narrator's 'paperies.'"

ture (which itself was like an umbilical tie, a return to the maternal through his life and work). Remember, again: "It was on the Méséglise way that I first noticed the circular shadow which apple-trees cast upon the sunlit ground, and also those impalpable threads of golden silk which the setting sun weaves slantingly downwards from beneath their leaves, and which I used to see my father slash through with his stick without ever making them deviate" (I, 205; I, 144).

Proust found this poetical respect for women's work in watching Albaret and other servants who religiously tailored his life of bourgeois writing, and he sought it out in the books that he read. As Proust writes in his little essay on George Eliot:

> In *Adam Bede* the thing that strikes me is the careful, detailed, respectful, poetic and sympathetic portrayal of the humblest and most hardworking walk of life. To keep one's kitchen spotlessly clean is a prime duty, almost a religious duty, and a duty that is a pleasure too.[31]

Embracing the habits of the cook and the seamstress, of childhood meals, of Aunt Léonie's existence, Habit becomes a character in the *Search*, as well as in *Jeanne Dielman*. Habit is both the pleasure and the bane of the existence of the housewife and the aspiring writer. As Proust informs us, "The heavy curtain of habit . . . conceals from us almost the whole universe" (V, 732; IV, 124) — or "As a rule it is with our being reduced to a minimum that we live; most of our faculties lie dormant because they can rely upon Habit" (II, 319; II, 17) — yet, it is also the Narrator's habit of turning away from reading his book, toward daydreaming "about something quite different for page after page" (I, 56; I, 41) that enables him to invest his imagination, to become a writerly reader, to become a writer.

Akerman does not sabotage our boredom by distraction; she makes it an intellectual achievement, our intellectual achievement. *Jeanne Dielman*, as in the experience of reading Proust, makes a place for the reader and viewer, a place that the film theorist Teresa de Lauretis simply calls "me."[32] By both engaging and disengaging the viewer we are presented with a kind of pleasure that allows us to think, remember, participate in the making of

"These 'paperies' metaphorically play out Proust's realized desire to weave and connect all the details of life lived into his unfathomable literature (which itself was like an umbilical tie, a return to the maternal through his life and work)."

"Akerman does not sabotage our boredom by distraction"

the meaning of the film, the novel. Barthes describes this pleasure-filled experience of what he has famously termed the writerly text (in which we write and create along with the author, as opposed to the readerly text in which we are subjected to the author's authorial voice) as a utopian "notion of a book (of a text) in which is braided, woven, in the most personal way, the relation of every kind of bliss: those of 'life' and those of the text, in which reading and the risks of real life are subject to the same anamnesis."[33] Or as Cixous puts in her *Three Steps on the Ladder of Writing*: "A real reader is a writer. A real reader is already on the way to writing."[34]

Although Proust and Akerman cannot choose what will *not* be read, what will *not* be seen, what will be overlooked, it is this *absence* marked into the text by the reader and viewer which will send the receiver dreaming (into writing) and will enable the pleasure of the text: in Barthes's own words, "It is the very rhythm of what is read and what is not read that creates the pleasures of great narratives."[35] Barthes reassures us that our bad reading habits are okay: "Proust's good fortune: from one reading to the next, we

never skip the same passages."[36] Likewise, in seeing *Jeanne Dielman* over and over, I never see the same thing from one viewing to the next.

(And here, for this final chapter, I, like Roger Shattuck, "favour the convention of referring to the first person protagonist of Proust's novel as 'Marcel.'"[37] It keeps the edge of Proust's work bordering on that of Akerman's. The *Search* is a memoir "bordering on fiction." *Jeanne Dielman* with its precise recording of three days in the life of a middle-class housewife at 23 Quai du Commerce, 1080 Bruxelles, is a kind of "documentary bordering on fiction."[38])

*Jeanne Dielman* is a peculiar political production, wearing its twofold desire on its French-Belgium cuff and workman's sleeve: a desire to valorize the beauty of women's labor *and* a desire to pinpoint how tedious it is. Jeanne's labor is difficult to swallow—not only because it is *not* the production of goods (for it is always the production of more work, as is in the tired cliché "a woman's work is never done"—but also because it is so relentless. It is an affective labor: its product, whether it be the care for her son, the care of the house, even the sex work for the johns who appear on her afternoon schedule, is intangible. Rather than material goods, Jeanne produces some *thing* "corporeal and affective," what Michael Hardt and Antonio Negri describe as "a feeling of ease, well-being, satisfaction, excitement, or passion."[39] Since we live, now (and even more so than when *Dielman* was produced) in an age "of the informatization of production and the emergence of immaterial labor,"[40] an age where labor has been continually abstracting itself since the rise of industrialization and mechanization—so that we find the weaver's hand loom moving to the power loom and now finally to the computerization of production—immaterial labor has reached new heights. It is not just women's work that is immaterial, but almost all work. As Hardt and Negri *almost* gesture toward: both forms of immaterial labor (the global informational economy *and* what Jeanne Dielman does—what feminists have called "women's work" a labor "in the bodily mode"[41]) come at the cost of the loss of self.[42] This fact is heightened by the film's full title, addressing Jeanne Dielman as commerce itself: specifically *23 Quai du Commerce*.

While Jeanne's labor is affective, because it is bodily and immaterial—it

is also "an economic," because it is a "gift," a problematic gift in the Derridian sense. As Derrida tells us in *Given Time: Counterfeit Money*, economy, like time itself, is circular in nature, but the gift (though related to economy) disrupts the circle. The gift, argues Derrida, is a demand; the gift gives power to the giver and is not, despite all who claim differently, a gesture based on mutual reciprocity. When the mother gives her gift, even if given with love and self-sacrifice, even if seemingly without the ego, it is nevertheless a demand. (Proust, a mother to his servants in his own inverted right, especially to Albaret, seemed to understand this well: "He gave sumptuous presents, but he would never accept them from others";[43] this was key to his character.) Turning around the loving photograph of the boy-Barthes being held by his mother, a picture that Barthes captions in *Roland Barthes* as *The demand for love*—the image becomes the mother's demand for love,[44] perhaps picturing a dangerous "maternal appetite."[45]

In the *mise-en-scène* of Dielman's world, we painfully see her gift as a form of entrapment for her son *and* for herself. The maternal appetite eats away at thin Sylvain and at Jeanne too—who, midway in the film, begins to find herself slipping out of her ritualistic domestic habits, tasks usually completed like clockwork. (She makes a cup of coffee and does not drink it. She kneads the meatloaf for far too long. She forgets to turn a light off. She burns the potatoes.) The maternal appetite also eats away at *Jeanne*'s viewers. Affected, we feel the products of her labor: boredom, pleasure, perhaps even bliss (jouissance), frustration, terror, care.

## Blue

> The most striking thing in the room, apart from the cork, was the color blue—the blue of the curtains.
>
> —Céleste Albaret, *Monsieur Proust*

Throughout the film, Jeanne's mostly silent son is *colored* by the claustrophobic interior of 23 Quai du Commerce, 1080 Bruxelles. Resonating with Roger Caillois's discussions of animal mimicry that appeared in the open-

du sujet (cela même dont il ne peut rien dire).
Il s'ensuit que la photographie de jeunesse est à la
fois très indiscrète (c'est mon corps du dessous
qui s'y donne à lire) et très discrète (ce n'est pas
de « moi » qu'elle parle).

On ne trouvera donc ici, mêlées au
roman familial, que les figurations d'une pré-
histoire du corps — de ce corps qui s'achemine
vers le travail, la jouissance d'écriture. Car tel
est le sens théorique de cette limitation : mani-
fester que le temps du récit (de l'imagerie)
finit avec la jeunesse du sujet : il n'y a de bio-
graphie que de la vie improductive. Dès que je
produis, dès que j'écris, c'est le Texte lui-même
qui me dépossède (heureusement) de ma durée
narrative. Le Texte ne peut rien raconter ; il
emporte mon corps ailleurs, loin de ma per-
sonne imaginaire, vers une sorte de langue sans
mémoire, qui est déjà celle du Peuple, de la
masse insubjective (ou du sujet généralisé),
même si j'en suis encore séparé par ma façon
d'écrire.

L'imaginaire d'images sera donc arrêté à
l'entrée dans la vie productive (qui fut pour
moi la sortie du sanatorium). Un autre imagi-
naire s'avancera alors : celui de l'écriture. Et
pour que cet imaginaire-là puisse se déployer
(car telle est l'intention de ce livre) sans être
jamais retenu, assuré, justifié par la représenta-
tion d'un individu civil, pour qu'il soit libre de ses
signes propres, jamais figuratifs, le texte
suivra sans images, sinon celles de la main qui
trace.

La demande d'amour.

"the image becomes the mother's demand for love"

ing years of the Surrealist journal *Minotaure*, the son takes on the colors of *Jeanne Dielman*. Although the film appears naturalistic, the choices of objects shot and worn participate in a carefully controlled and limited color schema that hails the color-field work of Rothko or the blue walls of Giotto's *Arena Chapel*. Jeanne's housecoat, her sweater, the marble tiles on the bathtub wall, her radiator, her wallpaper, her robe, her bedroom wall, etc. are all in a range of toothpaste blues (which soak up the screen and are punctuated by tastes of mahogany reds and even spots of pure red that build as Jeanne begins to fall apart until the blood of the murder in the final scene). I love this beautiful resonating bottom-of-the-swimming-pool color, this *hygienic* blue-green that can be found in the hospital: I call it Jeanne-Dielman blue. I understand color in Kristeva's sense, as a feminine language (as in the case of Bellini's Madonnas and Giotto's blue walls, where color sings its own song beyond figuration and narrative). Color, when handled with the shocking sensibility of Bellini, Kristeva tells us, operates "beyond and despite corporeal representation."[46] So, when seeing the overgrown boy-Sylvain going to bed in Jeanne-Dielman blue pajamas, there is a kind of violence that occurs. Boredom is disrupted; we are struck by the color. Whether Sylvain has been eaten by Jeanne's maternal appetite or whether he is camouflaging himself from his mother by *giving in*, by taking on the colors of her and her home, the affect is costly. "Mimicry, Caillois argues, is the loss of . . . [self-possession], because the animal that merges with its setting becomes dispossessed, derealized, as though yielding to a temptation exercised on it by the vast outsideness of space itself, a temptation to fusion."[47]

When talking to the shoe repairman, during one of her precious excursions out, Jeanne confesses: "I don't know what I'd do without him." Yet, from all appearances, Sylvain seems to be in a constant state of imagining life without her. After Jeanne ties a wool scarf around the neck of her overgrown child (a man-boy, a Mama's boy, a feminized male adolescent) before he departs for school, we see in his eyes the look of an animal before it is let out of its cage: desire and fear. The domesticated animal (the declawed house cat) desires to be out, yet has little chance of survival. To be "tied to the apron strings (of a mother)," so says the *Oxford English Dictionary*, is

"all in a range of toothpaste blues . . . punctuated by tastes of
mahogany reds and even spots of pure red"

"I call it Jeanne-Dielman blue."

"the shocking sensibility of Bellini"

to be "wholly under her influence."[48] He is latched, locked, and secured by Jeanne, who is herself caged in the role of "smother mother." Jeanne's affective labor, then, is an immaterial gift that hails the status of the Derridian "aneconomic."[49] As a result, Jeanne's gift comes not only at the cost of self (in both a Marxist and a feminist sense), but also at the cost of profoundly alienating her son (in the aneconomic Derridian market of the gift).

Overly attached to the mother, the son hails the stereotype of the gay man in the hands of a lesbian filmmaker, who caresses the mother by giving space to her gestures. When Jeanne matter-of-factly scrubs her entire body that leaps out from the background of turquoise blue tiles, part by part, in the opening bathing scene, only to conclude by scrubbing out the bathtub with the same anarchistic intensity, turning her hand around the corner tiles with the same proletariat-dancer attention that she gave to her own breasts, I fall in love with the orderliness of Jeanne and Akerman too. As Akerman said in an interview on the making of *Jeanne Dielman*: "I give space to things which were never, almost never, shown in that way, like the daily gestures of a woman. They are the lowest in the hierarchy of film images. . . . If you choose to show a woman's gestures so precisely, it's because you love them."[50] Akerman not only loves women's gestures, she loves women. *Jeanne Dielman*, as Brenda Longfellow has beautifully claimed, is "a love letter to the mother."[51] "Because *Jeanne Dielman* is devoted to observing a mother in what Akerman has described as loving detail,"[52] we can understand it as "a love letter to the mother."[53]

The precision and the duration of the film's focus on Jeanne's gestures enable her habits to disable our own. After leaving the film, we return home to a sudden (almost shocking) disruptive awareness of how and when we turn the light switches on when entering and leaving a room — how we make a cup of coffee and whether or not we remember to drink it — how our shoes sound on the floor of our hallway — how we wash our body — how we say goodnight to our loved one. Just as a morsel of Marcel's tea-soaked "woman-cake,"[54] the famed madeleine, "squat" and "plump" (I, 60; I, 44) as Mama, the molded seashell cake that Kristeva names as "incestuous"[55] returns the author/Narrator to all of his childhood memories of Combray — after watch-

"the famed madeleine, 'squat' and 'plump' as Mama, the molded
seashell cake that Kristeva names as 'incestuous'"

ing *Jeanne Dielman*, Jeanne becomes us. Proust writes of swallowing his
madeleine, mother-cake: "This new sensation having had the effect, which
love has, of filling me with a precious essence; or rather this essence was not
in me, it *was* me" (I, 60; I, 44). While Proust is full of a prettiness that stands
apart from Akerman's handsome film, the madeleine cake "so richly sensual
under its severe, religious folds" (I, 63; I, 46) is Dielmanesque.

The beauty of language, whether it be literary or cinematic, is the sus-
tained pleasure consumed by the bodies (both the bodies represented and

our own watching and reading bodies) in *Jeanne Dielman* and the *Search*. Both the film and the book get in our body, like a Proustian madeleine cake, and in that way are like eating. When we consume the "unsettling effect of excess description"[56] in *Jeanne Dielman* and the *Search*, we are confronted with eating time. It passes the time and it bores us with repetition, with too-muchness.

Boredom becomes the gift of pleasures that my long novel and my long film afford, and that is the focus of this chapter. But what makes *Jeanne Dielman* and the *Search* especially memorable? Along with a love and re-spect for the mother, along with incredible attention to detail through a heightened realist use of imaging within space that threatens to become real time, along with a profound sense of loss (whether it be Jeanne's iden-tity of affected labor or Marcel's lost childhood in the form of a never again attainable madeleine cake), the spot of glue that also holds my excessive texts together (the *Search* and *Jeanne Dielman*) is the color blue. Akerman's controlled use of this color makes *Jeanne Dielman* as memorable to the viewer as the color of the enticing Gilberte's eyes become to Marcel. Gil-berte's eyes are the sign of Marcel's crush, which are not really blue at all: they are black. But, because Gilberte had such an affect on young Marcel, they shine as memorably "too blue." Memory and affect had exaggerated their true, objective color. In the words of Proust:

> Her black eyes gleamed, and since I did not at that time know, and indeed have never since learned, how to reduce a strong impression to its objec-tive elements, since I had not, as they say, enough "power of observation" to isolate the notion of their colour, for a long time afterwards, whenever I thought of her, the memory of those bright eyes would at once present itself to me as a vivid azure, since her complexion was fair; so much so that, perhaps if her eyes had not been quite so black — which was what struck one most forcibly on first seeing her — I should not have been, as I was so especially enamoured of their imagined blue. (I, 198; I, 139)

Blue, I would argue, is the ultimate color of "given time": it is the color of pleasure (blue skies forever more) and the color of cost (too blue to go on).

"'too blue.'"

❧

What could be more pleasurable and more full of loss than the color blue? (In the case of Hook, we learn as he is ready to poison Peter: "Dark as were his thoughts his blue eyes were as soft as the periwinkle." Henriette's eyes were blue-green; they hail the curtains that open her son, Barthes's final book.) Blue is the color of *affect.*

When the German researcher David Katz was working in the first decade of the twentieth century (right as Proust was publishing the first volume of the *Search*), he discovered that when his subjects were asked to match a color of an intimate everyday object that was out of sight, the subjects in-

"Blue is the color of *affect*."

evitably "selected a color that was 'too bright to match a bright object,' too dark to match a dark object,' and 'too saturated to match an object which is known to have a distinct hue.' [As Brian Massumi beautifully concludes in response to Katz] . . . the cofunctioning of language, memory, and affect 'exaggerates' color."[57]

Derek Jarman knew all about blue as an affective color when he produced his famous film *Blue* (1993): seventy-two minutes of a beautiful, monochrome blue, inspired by the work of Yves Klein, with a moving voice-over of his farewell to the cinema. The film is Jarman's final work (he was dying of AIDS), in which (like Proust and like Akerman, though in a much different fashion), he will take pleasure in the little everyday things in this obsession with temporality, with death at his doorstep. As when Proust tries to remember and make use of everything in his great novel so as to hold onto time by killing it and overstuffing it like the taxidermist, by freezing it like a series of stop-time photographs taken by Muybridge—as when Jeanne tries to kill time by murdering a john at the end of Akerman's real-time film—Jarman's blue screen (where nothing happens) is an effort to kill time with the "given time" of the color that hails it.

> I step into a blue funk . . .
> Blue flashes in my eyes . . .
> The sky blue butterfly . . .
> Sways on the cornflower . . .
> Lost in the warmth
> Of the blue heat haze
> Singing the blues . . .
> Slow blue love
> Of delphinium days . . .
> Blue stretches, yawns and is awake . . .
> Blue protects white from innocence
> Blue drags black with it . . .
> (Derek Jarman, from the script for his film *Blue*)[58]

"to kill time"

⤳ BLUE FLASHES in my mind's eye.

Just as Gilles Deleuze has taught me through Proust, "What constitutes the unity of . . . [the] *Search* . . . is not simply . . . an exploration of memory . . . Lost Time is not simply 'time past'; it is also time wasted."[59] And that this necessary wasting of time (taking us all of the way to boredom) enables us without us knowing what we are doing to "pursue an obscure apprenticeship until the final revelation of 'lost time'" comes, breaks through.[60] I have plunged into *Jeanne Dielman* as my own blue memory. For, when I was a much, much younger woman watching the tedium of Akerman's *Jeanne Dielman*, for the very first time—a film which features the boring details of a widowed, middle-aged mother of an adolescent boy, "cooking, knitting, killing"[61]—I did not yet know and would have to long postpone

⤳

"'cooking, knitting, killing'"

"blue souvenir"

the discovery, the significance, the signified, of *Jeanne Dielman*. I was left with its memory, a blue souvenir that until now remained in my pocket: unsignified.

Marcel tells of the pleasure of a blue souvenir, bought for him by Gilberte, while the two were playing at the Champs-Elysées:

> I gazed at the agate marbles, luminous and imprisoned in a bowl apart, which seemed precious to me because they were fair and smiling as little

"'luminous and imprisoned'"

girls, and because they cost sixpence each. Gilberte, who was given a great deal more pocket money than I ever had, asked me which I thought was the prettiest. They had the transparency and mellowness of life itself . . . I pointed out one that had the same colour as her eyes. Gilberte took it, turned it round until it shone with a ray of gold, fondled it, paid its ransom, but at once handed me her captive, saying: "Here, it's for you. Keep it as a souvenir." (I, 572; I, 395)

Like Marcel's memory of the sky at Versailles which "consisted entirely of that radiant and slightly pale blue which the wayfarer lying in a field sees at times above his head, but so uniform and so deep that one feels that the pigment of which it is composed has been applied without the least alloy and with such inexhaustible richness that one might delve more and more deeply into its substance without encountering an atom of anything but the same blue" (V, 546–47; III, 906–07), I leave you with two, too-blue souvenirs. The first is the marble that Marcel believes is the same color as Gilberte's eyes: it is an affected object. The second is the affected labor of Jeanne Dielman: objectless, but also blue. But not blue like a sky or even blue in mournful song, but turquoise-blue: like a domestic, like hospital green, like toothpaste blue, like blue Comet for cleaning. Jeanne-Dielman's beautiful blue labor scrubs away at our comfort. As Cixous writes: "The gift of pleasure brings in a return, loss . . . Really there is no 'free gift.'"[62] Marcel knew that, even when Gilberte handed him the blue agate marble and he understood himself as her "captive." Held captive by Gilberte's good and bad parts, by the marble itself, as if it were a much, much larger stone tied to the ankles of his imprisoned body, Marcel writes: "I

"Marcel knew that, even when Gilberte handed him the blue agate marble and he understood himself as her 'captive.'"

kissed the agate marble, which was the better part of my love's heart, the part that was not frivolous but faithful . . . adorned with the mysterious charm of Gilberte's life" (I, 583; I, 403).

Likewise, long after the last reel, long after the final 198th minute of Akerman's too-blue film, she (a quintessence of Jeanne and Chantal) is "not in me," she is "me."

⌁⌁

> This new sensation having had the effect, which love has,
> of filling me with a precious essence; or rather this essence
> was not in me, it *was* me.
>
> —Proust, *In Search of Lost Time*

BOYS:

"TO

*THINK*

A

PART

OF

ONE'S

BODY"

↲ **LIKE THE CONCEPT OF ANORECTIC HEDONISM** that began this book, the desire to have it both ways is akin to having a child. Birth is a beautiful, painful experience (for mother and child alike) that settles nostalgia into the bones of one's body: for the mother, it causes a fresh case of immediate homesickness, like getting measles a second time, and for the child, it causes a homesickness that will come later, like a dormant virus. I can only suppose that the experience of birth for the father produces a mixed bag of health and disease. But as in the work of Winnicott, Proust, Barthes, Barrie, but not so much Lartigue, the father is quite absent from my book; he usually, if only in the most stereotypical way, stands in the way of making boys boyish.

There are a range of ages hypothesized for the first strike of nostalgia. The question of when nostalgia first hits (like other hard questions that blend biology with the social — such as imagining the onset of what we *want to* claim as vision, language, sexuality, ethics) is a hailing of complex philosophical questions, ensuring the brevity of my short (anorectic) conclusion. (I am not that brave.) But one wonders, for example (and wondering is just about as far as I am going to take this), can you have nostalgia without language? And, if not, what constitutes language? Is nostalgia contagious like tuberculosis? If not, then what about those nineteenth-century hysterics housed with the tubercular patients who produced "real" coughs? It is in this way that Proust's asthma, Lartigue's sickly ways as a boy, Barthes's tuberculosis and his death from a broken heart, Winnicott's effeminophobia: all become more or less real illnesses enhanced by the (social?) disease of nostalgia. Most of them seem to have caught it from their moms.

In any case nostalgia hits at a range of ages, but it does seem, at least for the boyish fellows of this book, that it whacks its victims before adolescence (whenever that begins or never ends). Barrie said "two was the beginning of the end." And as if that was not enough, he adds: "Nothing that happens after we are twelve matters very much."[1] Winnicott put the burden on the infant, seeing it as that moment when the breast no longer magically appears and the baby (in a moment as sad as it is joyous) has no

choice but to make a transitional object. Barthes seems to have felt the loss at age three: "It may be significant that it is at the same moment (around the age of three) that the little human 'invents' at once sentence, narrative, and the Oedipus."[2] (I do not think that was such a happy day for Barthes.) Lartigue seems to have almost escaped it, but it was a close call when his eye-trap began to fade at age six. Proust seems to regard it as coming with the inability to easily remember one's childhood, a sensation that begins at age ten and builds until death:

> At other times I went sleep-walking into the days of my childhood, re-suming, easy as a glove, those sensations which by one's tenth year are irreparably mislaid — insignificant sensations that we would be so happy to feel again, as the man who knows he will not live to see another sum-mer will yearn even for the indoor buzz of flies that tells of the hot sun without, or for the whine of mosquitoes that tells of the scented night.[3]

In sum, and you already knew this, birth is a cut that gives way to tre-mendous richness, but also loss. Alas, this is also the story of love (and you already knew that too). Love makes, in the words of my beloved Proust, a kind of "involuntary memory of the limbs" (VI, 11; IV, 277). We might add that birth makes an involuntary love couple (Winnicott's nursing couple); and *real* love, at least the *good* painful kind, is never voluntary. (I am a romantic, a fact that this book wears on its sleeve: pleated French cot-ton, real shell buttons.) When the Narrator speaks of his longing for Mme de Guermantes, Proust links up such cutting with nostalgia and love, as if he were a seventeenth-century doctor, treating the disease with a surgical knife:

> I felt so keen a longing for Mme de Guermantes that I could scarcely breathe; it was as though part of my breast had been cut out by a skilled anatomist and replaced by an equal part of immaterial suffering, by its equivalent in *nostalgia* and *love*. And however neatly the wound may have been stitched together, one lives rather uncomfortably when re-gret for the loss of another person is substituted for one's entrails; it

seems to be occupying more room than they; one feels it perpetually; and besides, what a contradiction in terms to be obliged to *think* a part of one's body. (III, 154; II, 418; emphasis is mine)

The mother, that is me, she too holds onto the burden of holding onto the boy. She encourages the hold, she selfishly demands it, as she tries to make the boy accept the maternal demand. And what if he does? Well, he might go on to travail boyishly, like Barthes, Lartigue, Barrie, Proust, and Winnicott. Although all five perform their boyishness in radically different weaves, their intersecting threads are the touching *parts* of this book.

But I will never be a boy. I can only play at reading and maybe writing boyishly, as I think through those three always tender (missing but so there) parts of my body: Oliver, Ambrose, and Augustine (my children). They have given me a method of reading that I could never have anticipated, an apprenticeship that began long ago, before I even knew that I would be a mother of boys, while playing with my father's old toys in my grand-mother's house. It may or may not be significant that my grandmother on my father's side had been a mother of two boys, that it is she that I was closest to, that it is she who feeds my nostalgia, that it is she who writes every book with me, but I think it is. "Upheaval of my entire being . . . tears streamed from my eyes. The being who had come to my rescue, saving me from bareness of spirit . . . my real grandmother . . . I now recaptured the living reality in a complete and involuntary recollection" (IV, 210–11; III, 152–53). Every time I visited her, she brought out the worn cardboard box with caramel-colored metal horses on white rubber wheels and the green and red race cars that could have come out of Lartigue's *Racecars Ready to Run*. Not many things; no dolls at all. And there were children's books, books that boys would like and I liked too: *Mickey Mouse Pop-Up*, *The War of the Wooden Soldiers*, *Cinder the Cat*, *Little Brothers to the Scouts*, *Smitty the Jockey*, and *Can You Answer It? A Book of Riddles*. I had no choice but to play, perhaps rather boyishly, while basking in all the warmth of my grandmother's house. To play is a form of reading, and as Cixous says a real reader is a writer. I strive to be a boyish reader and writer, but the phantom

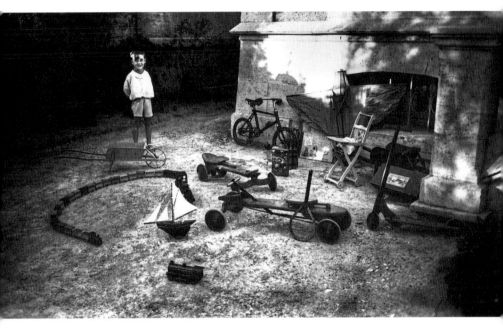

"an apprenticeship that began long ago"

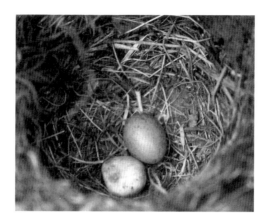

"I hope ('people who love can always hope,' . . .)
that my book is not a rock in place of an egg"

⌐∾

limbs of Winnicott, Barthes, Lartigue, Proust, and Barrie will always leave me missing (as mother, not as boy), just as my real boys are limbs that I am forced to give wings to. But that is what is so beautiful, the *loss*.

I hope ("people who love can always hope," [II, 99; I, 491]) that my book is not a rock in place of an egg (as in Lothar Baumgarten's 1968 *Mondgestein*), but rather, a sky-high vision of birds flown from the nest . . . like boys in the air.

⌐∾

And even when the bird walks one still knows him winged.

—Proust, quoting Antoine-Marin Lemierre in "Sainte-Beuve and
Baudelaire" in *Contre Saint-Beuve*

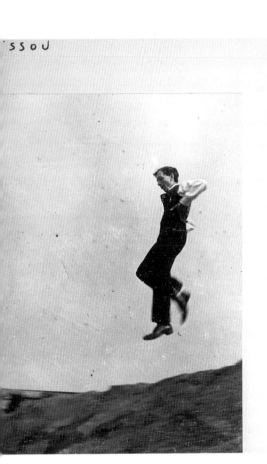

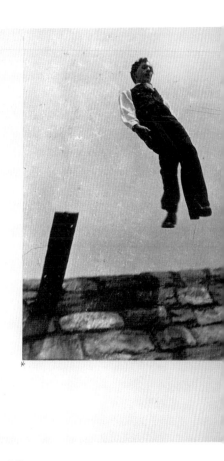

"like in the boys in the air."

# ILLUSTRATIONS

*Notes: Illustrations are listed by page number. Jacques Henri Lartigue's photographs are untitled, although they are accompanied by captions in the albums. All of Lartigue's photographs, album pages, and journals are courtesy of the Donation Jacques Henri Lartigue.*

35 Joseph Cornell in his garden, photograph by Duane Michals, 1970s. Copyright Duane Michals. Courtesy Pace/MacGill Gallery. VAGA.

37 *Butterfly Habitat*, by Joseph Cornell, 1940. Art Institute of Chicago. VAGA.

39 Hummingbirds, from the Hunterian Museum, ca. 1890s. Royal College of Surgeons, London.

40 *Untitled (Pharmacy)*, by Joseph Cornell, ca. 1942. Solomon R. Guggenheim Foundation, New York. VAGA.

41 *Untitled (The Forgotten Game)*, by Joseph Cornell, ca. 1949. Art Institute of Chicago. VAGA.

43 *Object (Soap Bubble Set)*, by Joseph Cornell, 1941. Robert Lehrman Trust, Washington, D.C. VAGA.

46 *Untitled*, photograph by Amos Badertscher, 1975. Courtesy of the artist.

*two* ⋰ **WINNICOTT'S ABCS AND STRING BOY**

60 *Miles of String*, "Installation of the Exhibition First Papers of Surrealism," by Marcel Duchamp, 1942. Philadelphia Museum of Art.

64 *Madonna and Child (The Frizzoni Madonna)*, by Giovanni Bellini, 1470–75. Museo Correr, Venice, Italy. Art Resource, New York.

65 *Madonna and Child*, by Alessio Baldovinetti, ca. 1460. Musée Jacquemart-André, Paris. Art Resource, New York.

67 *Madonna and Child*, by Alessio Baldovinetti, 1460. Louvre, Paris. Art Resource, New York.

71 Bird, squiggle drawing by D. W. Winnicott and 7½-year-old female patient, ca. 1968. Patterson Marsh Ltd. On behalf of the Winnicott Trust.

73 Bears, squiggle drawing by D. W. Winnicott and 9-year-old male patient. Patterson Marsh Ltd. On behalf of the Winnicott Trust.

74 *Yo-Yo*, by Wendy Ewald, 1997. Courtesy of the artist. From *The Alphabet Project*, with Isai Delgado, Omero Cruz, Francisco Melo, Francisco Bautista, Zulio Garcia, Jorge Canuto, Victor Mendez, Edgar Hernandez, Andreina Delgado, Kevin Colindres, Jennifer Lizama, Janette Alarcon, Carlitos Canuto, and Edgar Orozco.

*five* ⌁ NESTING

205 *Wood Sorrel Fairy* by Mary C. Barker, ca. 1930s. Estate of Mary C. Barker.

205 *Four Generations* (King George V; Queen Victoria; King Edward VII; Edward, Duke of Windsor [King Edward VIII]), photograph by Chancellor Dublin, 1899. Royal Portrait Gallery, London.

206 *A Thrums Weaver*, photograph. Photograph from *Old Kirriemuir* by Fiona Mackenzie. Courtesy of Alan Brotchie.

207 Photograph of Alberto Santos-Dumont in cockpit, at the controls of an unknown craft. Photographer unknown, undated. National Air and Space Museum, Smithsonian Institution, Washington, D.C.

208 *La Reine Victoria*, photograph by G. W. Wilson, 1863, as reproduced in *La Chambre claire*. Paris: Éditions du Seuil, 1980. Reprinted by permission of Georges Borchardt, Incorporated.

210 Map of Kensington Gardens, 1905–6. Beinecke Library, Yale University.

210 Map of Kensington Gardens, 1905–6, detail. Beinecke Library, Yale University.

211 *Fairies Visiting Queen Victoria as a Baby*. From the picture book *The Fairies Favourite, or the Story of Queen Victoria Told for Children*, 1897.

212 British coin with Queen Victoria, 1897. Victoria and Albert Museum.

215 Detail of *Untitled (Paul and Virginia)*, by Joseph Cornell, ca. 1946–48. Robert Lehrman Art Trust, Washington, D.C. VAGA.

216 *Neil*, by Edward Weston, 1922. Center for Creative Photography.

218 *The Dog's Cemetery, Hyde Park. London*, undated.

219 Untitled (babies hatching from eggs), found image, ca. 1900.

220 Title page of *The Boy Castaways* by J. M. Barrie, 1901. Beinecke Library, Yale University.

222 *Untitled*, photogram of christening dress from the series "My Ghost" by Adam Fuss, ca. 2000. Courtesy of the artist and Cheim and Read, New York.

223 *For Children: The Gates of Paradise, I Want! I Want!*, by William Blake, 1793. The William Blake Archive.

226 "Warbler," from *Bird Hand Book*, photograph by Victor Schrager, 2000. Courtesy of the artist.

374  Joseph Cornell, photographed in his garden at Utopia Place, by Hans Namuth, 1969. Center for Creative Photography.

377  *Butterfly Kisses*, mascara, paper, by Janine Antoni, 1996–99. Courtesy of the artist and Luhring Augustine Gallery.

379  "Untitled" (A Corner of Baci), installation by Félix González-Torres, 1990. The Félix González-Torres Foundation. Courtesy of Andrea Rosen Gallery, New York.

381  Children photographed at Joseph Cornell's exhibition for "children only" at Cooper Union, 1972. Courtesy of Dore Ashton.

385  Portrait of Charles Haas, photograph by Paul Nadar, 1895. Centre des monuments nationaux, Paris.

387  Film still of Catherine Deneuve, from Raúl Ruiz's film *Le Temps Retrouve*, 1999.

389  A page from Marcel Proust's Carnet des notes, 1908–19. Bibliothèque nationale de France.

392  *Beehive (Thimble Forest)*, by Joseph Cornell, 1939. Private collection.

394  The thimble of Caroline Crachami, "The Sicilian Fairy," ca. 1824, from the Hunterian Museum, Royal College of Surgeons, London.

394  A Tom Thumb Wedding, 1907. Kentucky Library Photographic Collection.

399  Film still from *Jeanne Dielman, 23 Quai du Commerce, 1080 Bruxelles*, by Chantal Akerman, 1975.

404  *Untitled (Medici Princess)* by Joseph Cornell, ca. 1952–54. Robert Lehrman Art Trust, Washington, D.C. VAGA.

405  Film still from *Jeanne Dielman, 23 Quai du Commerce, 1080 Bruxelles*, by Chantal Akerman, 1975.

407  *Trumpeter Swan. North Dakota, 1891* (2001), photograph by Terry Evans. Courtesy of the artist.

408  Marcel Proust's corrected typeset manuscript for *À l'ombre des jeunes filles en fleurs*, 1917–18. Bibliothèque nationale de France.

410 Marcel Proust's manuscript notebooks for *Le Temps retrouve*. Bibliothèque nationale de France.

412 Marcel Proust's manuscript notebooks for *Sodome et Gomorrhe*. Bibliothèque nationale de France.

413 Film still from *Jeanne Dielman, 23 Quai du Commerce, 1080 Bruxelles*, by Chantal Akerman, 1975.

416 Family snapshot of Roland Barthes with his mother, as reproduced in *Roland Barthes par Roland Barthes*. Paris: Éditions du Seuil, 1975. Reprinted by permission of Georges Borchardt, Incorporated.

418 *Number 9*, oil painting by Mark Rothko, 1956. Artists Rights Society, New York.

419 *The presentation of Christ in the Temple*, Scrovegni Chapel, Padua, fresco by Giotto di Bondone, ca. 1305. Art Resource, New York.

420 *Madonna and Child (The Frizzoni Madonna)*, by Giovanni Bellini, 1470–75. Museo Correr, Venice. Art Resource, New York.

422 Portrait of Mme Proust, photograph by Paul Nadar, 1904. Centre des monuments nationaux, Paris.

424 Film still from *Jeanne Dielman, 23 Quai du Commerce, 1080 Bruxelles*, by Chantal Akerman, 1975.

425 *Polaroïd*, photograph by Daniel Boudinet, 1979. Copyright Ministère de la culture, France.

427 Film still from *Jeanne Dielman, 23 Quai du Commerce, 1080 Bruxelles*, by Chantal Akerman, 1975.

427 Film still from *Jeanne Dielman, 23 Quai du Commerce, 1080 Bruxelles*, by Chantal Akerman, 1975.

427 Film still from *Jeanne Dielman, 23 Quai du Commerce, 1080 Bruxelles*, by Chantal Akerman, 1975.

428 Film still from *Jeanne Dielman, 23 Quai du Commerce, 1080 Bruxelles*, by Chantal Akerman, 1975.

429 *Untitled (Rosalba)*, by Joseph Cornell, 1945. VAGA.

430 *An Image for Two Emilies*, a dovecote for Emily Dickinson, by Joseph Cornell, ca. 1954. Robert Lehrman Art Trust, Washington, D.C. VAGA.

431 Detail of *An Image for Two Emilies*, a dovecote for Emily Dickinson, by

Joseph Cornell, ca. 1954. Robert Lehrman Art Trust, Washington, D.C. VAGA.

# NOTES

⌐ **INTRODUCTION**

1. Marina Warner, "Angels and Their Masquerades," *Times Literary Supplement* (London), October 13, 1995, 20.

2. Roland Barthes, *Le Magazine littéraire*, February 1975, from an interview conducted by Jean-Jacques Brochier, reproduced as "Twenty Key Words for Roland Barthes," in *The Grain of the Voice: Interviews 1962–1980*, translated by Linda Coverdale (Berkeley and Los Angeles: University of California Press: 1991), 206. Emphasis is mine. In French: "Vingt mots-clé pour Roland Barthes," in *Le Grain de la voix: Entretiens 1962–1980* (Paris: Éditions du Seuil, 1981), 195.

3. Victor Burgin, "Re-reading *Camera Lucida*," in *The End of Art Theory: Criticism and Postmodernity* (Atlantic Highlands, N.J.: Humanities Press International, 1996), 92.

4. Ibid., 91.

5. Roland Barthes, *Roland Barthes by Roland Barthes*, translated by Richard Howard (New York: Hill and Wang, 1977), from an epigraph at the beginning of the book, unpaginated. Originally published in French as *Roland Barthes par Roland Barthes* (Paris: Éditions du Seuil, 1975). In French: *Roland Barthes par Roland Barthes*, 1.

6. Marcel Proust, from the *Carnet de 1908*, as quoted by Terence Kilmartin in his introduction to *Marcel Proust: On Art and Literature*, 11. In French: *Le Carnet de 1908*, edited by Philip Kolb (Paris: Éditions Gallimard, 1976), 61.

7. Barthes taught a series of courses at the Collège de France, after his election to the Collège on 14 March 1976. In 1977–78, he taught "Comment vivre ensemble" ("How to live together"). In 1978–79, he taught "Le Neutre" ("The neutral"). In 1978 and 1979–80, he taught his last, unfinished seminar: "La Préparation du roman." All of the courses have been published in French. See Barthes, *Comment vivre ensemble: Simulations Romanesque de quelques espaces*

*quotidiens*, ed. by Claude Coste (Paris: Seuil/IMEC, 2002); 1977–78: *Le Neutre: Cours et séminaries au Collège de France, 1977–1978*, ed. by Thomas Clerc and Éric Marty (Paris: Seuil, 2002); and, *La Préparation du roman I et II: Cours et séminaires au Collège de France 1978 et 1979–80*, ed. by Nathalie Léger (Paris: Seuil, 2003). *Le neutre* has been translated into English as *The Neutral: Lecture Courses at the Collège de France* (1977–78), translated by Rosalind E. Krauss and Denis Holier (New York: Columbia University Press, 2005). Much to my delight, one can listen to Barthes's lectures given in his famous soothing voice on CDs distributed by Seuil Multimédia.

8. In French, "Je dis: *pour finir* et non pour *conclure*. En effet, quelle serait la *conclusion* de ce cours? — L'œuvre elle-même." Barthes, *La Préparation du roman I et II*, 377, translation is mine.

9. In Barthes's own words: "Je ne puis sortir aucune Œuvre de mon chapeau." Barthes, *La préparation du roman I et II*, 377.

10. See the facsimile of Barthes's scribbled plans for the *Vita nova* novel, as well as its typed transcription, in Roland Barthes, *Œuvres complètes, Tome V, 1977–1980*, ed. by Éric Marty (Paris: Éditions du Seuil, 2002), 994–1001, 1007–17. For helpful discussions of Barthes's *Vita nova*, see Antoine Compagnon, "Roland Barthes's Novel," translated by Rosalind Krauss, *October* 112 (Spring 2005), 23–34 (originally published as "Le Roman de Roland Barthes," *Critique* 59, no. 678 [November 2003]) and Diana Knight's final chapter of her fine book, "Maternal Space," in *Barthes and Utopia: Space, Travel, and Writing* (Oxford: Clarendon Press, 1997), 244–69.

11. Roland Barthes, "Writers, Intellectuals, Teachers," in *Image, Music, Text*, essays selected and translated by Stephen Heath (New York: Hill and Wang, 1977), 215. Originally published as "Écrivains, intellectuels, professeurs" in *Tel Quel*, autumn 1971. In French: "Écrivains, intellectuels, professeurs," in Roland Barthes, *Œuvres complètes*, Tome III, *1968–1971*, edited by Éric Marty (Paris: Éditions du Seuil, 2002), 907.

12. Marcel Proust, *Within a Budding Grove*, vol. 2 of *In Search of Lost Time*, translated by C. K. Scott Moncrieff and Terence Kilmartin, revised by D. J. Enright (New York: Random House, 1992), 372. Hereafter, text citations to this edition will appear with the roman numeral of the volume number and the page number of the (American) Modern Library, Random House edition. There are six volumes to the Random House edition; volume 5 contains both *The Captive* and *The Fugitive*. The British edition has different pagination. In French: *À l'ombre des jeunes filles en fleurs*, vol. 2 of *À la recherche du temps perdu*, edited by Jean-Yves Tadié (Paris: Éditions Gallimard, 1988), 54. Hereafter, reference to

the French edition will follow the English citations in the text. There are four volumes to the Éditions Gallimard edition.

13. *Roland Barthes by Roland Barthes*, caption to a snapshot of the house in Bayonne, from a series of photographs and texts that serves as a preface to the book, unpaginated. In French: *Roland Barthes par Roland Barthes*, 10.

14. From one of two copies of the private publishing of J. M. Barrie's *The Boy Castaways of Black Lake Island* (1901), iv. The surviving copy is in The Walter Beinecke Junior Collection, housed at Yale University as part of the Beinecke Rare Book and Manuscript Library.

15. Jonathan Culler, *Roland Barthes* (New York: Oxford University Press, 1983), 9–10.

16. *Roland Barthes by Roland Barthes*, caption to snapshot of Barthes as an adolescent, unpaginated. In French: *Roland Barthes par Roland Barthes*, 34.

17. Roland Barthes, *Michelet*, translated by Richard Howard (Berkeley: University of California Press, 1992), 88. Originally published in French as *Michelet par lui-même* (Paris: Éditions du Seuil, 1954). In French: *Michelet par lui-même*, 80.

18. See Stewart Lee Allen's *The Devil's Cup: Coffee, the Driving Force in History* (New York: Soho Press, 1999).

19. Barthes, *The Neutral*, 152. In French, *Le Neutre*, 196.

20. See Proust, *Within a Budding Grove* (II, 21).

21. The origins of the madeleine cake as both seashell and badge of the pilgrims of Saint-Jacques is elaborated upon in chapter 7, "Mouth Wide Open for Proust."

22. Adam Phillips, *On Kissing, Tickling and Being Bored: Psychoanalytic Essays on the Unexamined Life* (Cambridge, Mass.: Harvard University Press, 1993), 94.

23. Proust's mother was Jewish and his father was Catholic. The father's religion prevailed in the home and in Proust's upbringing.

24. As Kristeva writes: "The 'petite madeleine,' which is flavorful, incestuous, delicate, elusive, and diluted in tea although it links the various parts of Combray, offers a taste of Proust even to those who have never read him." See *Time and Sense: Proust and the Experience of Literature*, translated by Ross Guberman (New York: Columbia University Press, 1996), 3. Originally published in French as *Le Temps sensible: Proust et l'expérience littéraire* (Paris: Editions Gallimard, 1994).

25. Kristeva, *Time and Sense*, 5.

26. Ibid., 6.

27. Ibid.

28. Ibid., 14.
29. As quoted in Hayman, *Proust: A Biography* (New York: Carroll and Graf Publishers, 1990), 156. In French: Letter to his mother (August 31, 1901) in *Correspondance de Marcel Proust*, edited by Philip Kolb (Paris: Librarie Plon, 1976), vol. 2, 444.
30. Hayman, *Proust*, 156.
31. As quoted ibid. In French: Letter to his mother (September 8, 1901) in *Correspondance de Marcel Proust*, vol. 2, 450.
32. Mme Daudet was the wife of playwright Alphonse Daudet (*Tartarin de Tarascon*, 1872; *L'Arlésienne*, 1872). Proust was regularly invited to her famous Thursdays.
33. Lucien was Mme Daudet's son, a talented painter and writer. Seven years younger than Proust, Lucien met him for the first time in December 1894 in his parents' salon. Lucien read the whole of *Swann's Way* before its publication and wrote a review of the book, which appeared in *Le Figaro* on November 27, 1913.
34. See Letter to Mme Alphonse Daudet (May 18, 1901) in *Correspondance de Marcel Proust*, vol. 2, 428.
35. Hayman, *Proust*, 156.
36. As Hayman writes of Proust's life after he moved into 102 Boulevard Haussmann in at the end of 1906:

> Because of the sensitivity to dust, neither the bedroom nor any of the other rooms could be cleaned except when he was out, and, because of his sensitivity to smells, this was the only time the parquet could be polished. Instead of having a "smoking-room," he now did his fumigations in bed after starting the day with coffee, and the brass of the bedstead was soon stained with fumes of the Legras powders. He had several cartons of these ordered at a time from Leclerc, the chemist in rue Vignon. To avoid the smell of sulphur he never used matches, but two candles, one of them lighted, were always kept on the small table in the corridor. He poured powder into a saucer and lit a small square of white paper from the candle, lit the powder and made the room thick with fumes which could afterwards be dispelled with smoke from a wood fire. Not wanting to speak after a fumigation, he waved his hand for it to be lit.

See *Proust*, 253.
37. Céleste Albaret, *Monsieur Proust*, as told to Georges Belmont, translated by Barbara Bray (New York: New York Review of Books, 2003), 70.

38. Hayman, *Proust*, 250.

39. The real town of Illiers, which was the model of Proust's fictional Combray, has been renamed Illiers-Combray in Proust's honor, with more than enough shops selling the famed madeleine cakes.

40. A detailed analysis of Barthes's relationship with his mother is taken on in chapter 4, "Pulling Ribbons from Mouths."

41. Marcel Proust, "On Reading Ruskin," translated and edited by Jean Autret et al. (New Haven: Yale University Press, 1987), 100. In French: "Sur la lecture" (Préface du traducteur) in John Ruskin's *Sésame et les lys*, translated by Marcel Proust (Paris: Éditions Complexe, 1987), 40.

42. Proust, "On Reading Ruskin," 100. In French: "Sur la lecture," 41.

43. Proust, "On Reading Ruskin," 101. In French: "Sur la lecture," 42.

44. Proust, "On Reading Ruskin," 101. In French: "Sur la lecture," 42.

45. Proust, "On Reading Ruskin," 103. In French: "Sur la lecture," 45.

46. Proust, "On Reading Ruskin," 118. Emphasis is mine. In French: "Sur la lecture," 73.

47. William C. Carter, "The Vast Structure of Recollection: From Life to Literature," in *The Cambridge Companion to Proust*, edited by Richard Bales (Cambridge: Cambridge University Press, 2001), 25. Emphasis is mine.

48. Kristeva, *Time and Sense*, 8.

49. Kristeva writes that the "incestuous undertones . . . seem to have shocked Sand's contemporaries, particularly after its production at the Odéon theater in 1849 and then at the Comédie-Française in 1881"; see *Time and Sense*, 344, n. 24.

50. Barthes's friend and fellow theorist Algridas Julien Greimas would claim for Henriette and her son: "I have never seen a finer love." As quoted in Louis-Jean Calvet, *Roland Barthes*, translated by Sarah Wykes (Bloomington: Indiana University Press, 1995), 226. Originally published in French as *Roland Barthes, 1915–1980* (Paris: Flammarion, 1990). This quote is taken up again in chapter 4, "Pulling Ribbons from Mouths."

51. Roland Barthes, *Camera Lucida: Reflections on Photography*, translated by Richard Howard (New York: Hill and Wang, 1981), 68. Originally published in French as *La Chambre claire: Note sur la photographie* (Paris: Éditions du Seuil, 1980). In French: *La Chambre claire*, 108. This topic is taken up again in chapter 4, "Pulling Ribbons from Mouths."

52. Barthes, *Camera Lucida*, 65. In French: *La Chambre claire*, 102.

53. Kristeva also makes a play with *champi* (waif) and *champignon* (mushroom). See *Time and Sense*, 11.

54. My concept of the anorexic who politely (yet aggressively) prefers not to eat is a result of reading Adam Phillips's essay on Melville's Bartleby Scribner as model for the anorexic's refusal of food. See "On Eating, and Preferring Not To" in Phillips's *Promises, Promises: Essays on Literature and Psychoanalysis* (New York: Basic Books, 2001), 282–95.

55. Barthes, *Michelet*, 178. In French: *Michelet par lui-même*, 154.

56. Barthes, *Camera Lucida*, 91. In French: *La Chambre claire*, 143.

57. Kristeva, *Time and Sense*, 4.

58. Phillips, *On Kissing, Tickling and Being Bored*, 96.

59. Ibid.

60. Nasio as cited by Adam Phillips in *Promises, Promises*, 294.

61. Phillips, *Promises, Promises*, 134.

62. Kristeva, *Time and Sense*, 304.

63. Susan Stewart, *On Longing: Narratives of the Miniature, the Gigantic, the Souvenir, the Collection* (Durham: Duke University Press, 1993), xi.

64. Ibid.

65. Ibid.

66. Barthes, *Camera Lucida*, 66. In French: *La Chambre claire*, 104.

67. As quoted in Edmund White, *Marcel Proust* (New York: Penguin, 1999), 89.

68. White, *Marcel Proust*, 89.

69. Roland Barthes, "The Image," in *The Rustle of Language*, translated by Richard Howard (New York: Hill and Wang, 1986), 355. Originally published in French as *La Bruissement de la langue* (Paris: Éditions du Seuil, 1984). In French: *La Bruissement de la langue*, 394.

70. Carol Mavor, *Pleasures Taken: Performances of Sexuality and Loss in Victorian Photographs* (Durham: Duke University Press, 1995) and *Becoming: The Photographs of Clementina, Viscountess Hawarden* (Durham: Duke University Press, 1999).

*one* ⌒ **MY BOOK HAS A DISEASE**

1. J. M. Barrie, *Margaret Ogilvy by Her Son* (London: Hodder and Stoughton, 1896), 48–49.

2. Roland Barthes, "Réponses," *Tel Quel*, no. 47 (1971): 81, as quoted by Calvet in *Roland Barthes*, 7.

3. *Roland Barthes by Roland Barthes*, caption to a snapshot of the house in Bayonne, unpaginated. In French: *Roland Barthes par Roland Barthes*, 10.

4. Ibid.

5. Calvet, *Roland Barthes*, 12.

6. Roland Barthes, from an interview conducted by Bernard-Henri Lévy, reproduced as "Of What Use Is an Intellectual?" in *The Grain of the Voice*, 266. Originally published in French as "A quoi sert un intellectuel? Un entretien avec Roland Barthes" in *Le Nouvel Observateur*, January 10, 1977, 64–74. In French: "A quoi sert un intellectual?" 66.

7. *Oxford English Dictionary*, 2d ed., s.v. "boyishly."

8. Lewis Carroll, *Through the Looking-Glass*, in *The Annotated Alice: The Definitive Edition*, with an introduction and notes by Martin Gardner (New York and London: Norton, 2000), 196.

9. *Water Babies: A Fairy Tale for a Land Baby*, written by Charles Kingsley and first published in serial form, 1862–63, was an enormously popular Victorian fairy tale of a magical underwater world. Cameron posed real "babies" who lived on the Isle of Wight with her as the characters of the story, when they were not already playing Jesus and John the Baptist or Paul and Virginia.

10. According to the *OED*, as a noun travail can mean:

> I.1. Bodily or mental labour or toil, especially of a painful or oppressive nature . . . 3. The outcome, product, or result of toil or labour; a (finished) "work"; *esp.* a literary work . . . 4. The labour and pain of child-birth . . . 6. . . . The straining movement of a vessel in rough seas . . . 7. Journeying, a journey.

As a verb, travail can mean all of the aforementioned notions (only as verbs, rather than as nouns) — to work, to labor in childbirth, to roll in rough seas as a ship, to travel. In addition, as a verb, travail can also mean "[I.1d] To shake, stir, 'work' (a thing) about." (*Oxford English Dictionary*, 2d ed., s.v. "travail.")

11. From Emily Dickinson's "We Like a Hairbreadth 'Scape," poem no. 1175 (c. 1870) as collected in *The Complete Poems of Emily Dickinson*, edited by Thomas H. Johnson (Boston: Little, Brown, 1997), 522.

12. Peter Stallybrass, "Worn Worlds: Clothes, Mourning and the Life of Things," *Yale Review* 81, no. 2 (1993): 36.

13. Roland Barthes quoting Jules Michelet's *La Montagne* (1868) in *Michelet*, 49, 50. In French: *Michelet par lui-même*, "44."

14. Barthes, "Inaugural Lecture," as quoted in the epigraph that began this chapter. On January 7, 1977, Barthes gave his inaugural lecture as the Chair of Literary Semiology, Collège de France. See "Inaugural Lecture, Collège de France," translated by Richard Howard, in *A Barthes Reader*, edited by Susan

Sontag (New York: Hill and Wang, 1982), 476. Originally published in French as *Leçon: Leçon inaugurale de la chaire de sémiologie littéraire du Collège de France, prononcée le 7 janvier 1977* (Paris: Éditions du Seuil, 1978). In French: *Leçon*, 41.

15. Stewart, *On Longing*, ix.

16. George K. Behlmer, introduction to *Singular Continuities: Transition, Nostalgia, and Identity in Modern British Culture*, edited by George K. Behlmer and Fred M. Leventhal (Stanford: Stanford University Press, 2000), 7. Behlmer's study does not discuss Barthes, of course, but nostalgia in more general terms and in relationship to his subject of modern British culture.

17. Ibid.

18. Ibid.

19. Adam Gopnik, "Sparkings: Joseph Cornell and the Art of Nostalgia," *New Yorker*, February 17 and 24, 2003, 187.

20. Barbara Land and Myrick Land, *The Quest of Isaac Newton* (New York: Garden City Books, 1960), 24. Cornell's diaries are part of The Cornell Study Center at the American Art Museum. The fact that Cornell quotes Newton in his diaries can be found in *Exploring Joseph Cornell's Visual Poetry*, by James H. Cohan and Arthur M. Greenberg, a catalog in conjunction with the show of the same title at Washington University Gallery of Art (St. Louis, Missouri, April 9– May 9, 1982), 8–9.

21. Cohan and Greenberg, *Exploring Joseph Cornell's Visual Poetry*, 7.

22. Ibid.

23. I am consciously playing with this phrase made a bit famous by Eve Kosofsky Sedgwick (I am a devotee of Sedgwick). Sedgwick uses the phrase "Christmas effects" to describe how at a certain time of year, everything in our culture lines up behind Christmas: big fat glossy magazines filled with Christmas recipes; Christmas stamps at the post office; Christmas sales in retail shops; on the news we learn of the strong desire to bring the hostages home by Christmas, etc. In much the same way our culture lines up behind heterosexuality, it too participates in the Christmas effect. As a result, any position that does not line up, whether you are gay or you are a Jew, or both, or simply not straight, makes for a queer position. Cornell, like all the artists of this book, is made queer by the number of Christmas effects proliferated by modern culture. See Eve Kosofsky Sedgwick, "Queer and Now," in *Tendencies* (Durham: Duke University Press, 1993), 5–6.

24. As quoted by Lynda Roscoe Hartigan in "Joseph Cornell: A Biography," in the collection *Joseph Cornell* by Kynaston McShine (New York: Museum of

Modern Art, 1980), 93. Hartigan is quoting directly from Cornell's papers at the Cornell Study Center.

25. Jodi Hauptman, *Joseph Cornell: Stargazing in the Cinema* (New Haven: Yale University Press, 1999), 133.

26. Emily Dickinson, describing the color of a hummingbird in poem no. 1463 (c. 1879) as collected in *The Complete Poems of Emily Dickinson*, 619.

27. As quoted by Cohan and Greenberg in *Exploring Joseph Cornell's Visual Poetry*, 16. Cohan and Greenberg are quoting directly from Cornell's journals in the Smithsonian Archives of American Art (AAA), cataloged as Cornell Papers, AAA, 1059: 215, September 3, 1949.

28. Hauptman, *Joseph Cornell*, 18

29. McShine, *Joseph Cornell*, 10.

30. As quoted by Carter Ratcliff in "Joseph Cornell: Mechanic to the Ineffable," in McShine, *Joseph Cornell*, 49. Ratcliff is quoting directly from Cornell's papers in the Archives of American Art, catalogued as Cornell Papers, AAA, 1061, 14 October 1956.

31. Ibid.

32. Lynne Huffer, *Maternal Pasts, Feminist Futures: Nostalgia, Ethics and the Question of Difference* (Stanford: Stanford University Press, 1998), 14.

33. *Oxford English Dictionary*, 2d ed., s.v. "nostalgia."

34. Jules Michelet, *The Bird*, translated by W. H. Davenport Adams (London: T. Nelson and Sons, 1869), 248. Originally published as *L'Oiseau* in 1856. In French: *L'Oiseau* (Paris: Librairie de L. Hachette, 1867), 298, 299.

35. *Roland Barthes by Roland Barthes*, 135. In French: *Roland Barthes par Roland Barthes*, 139. Addressed again in chapter 4, "Pulling Ribbons from Mouths."

36. Roland Barthes, *A Lover's Discourse: Fragments*, translated by Richard Howard (New York: Hill and Wang, 1978), 73. Originally published in French as *Fragments d'un discours amoureux* (Paris: Éditions du Seuil, 1977). In French: *Fragments d'un discourse amoureux*, 87.

37. Gaston Bachelard, *The Poetics of Space*, translated by Maria Jolas (Boston: Beacon Press, 1994), 118. Originally published in French as *La Poétique de l'espace* (Paris: Presses universitaires de France, 1957).

38. Bachelard, *The Poetics of Space*, 107.

39. See Bachelard on nests and lost intimacy, *The Poetics of Space*, 100.

40. David Lowenthal, *The Past Is a Foreign Country* (Cambridge: Cambridge University Press, 1985), 10.

41. Behlmer, introduction to *Singular Continuities*, 7.

42. Christopher Shaw and Malcolm Chase, "The Dimensions of Nostalgia," in

*The Imagined Past: History and Nostalgia*, edited by Christopher Shaw and Malcolm Chase (Manchester: Manchester University Press, 1989), 1.

43. Michelet, *The Bird*, 194. In French: *L'Oiseau*, 231.

44. Roland Barthes, "The Light of the Sud-Ouest" in *Incidents*, translated by Richard Howard (Berkeley: University of California Press, 1992), 3. Originally published in French as, "La Lumière du Sud-Ouest," *L'Humanité*, September 10, 1977. In French: "La Lumière du Sud-Ouest," in *Incidents* (Paris: Éditions du Seuil, 1987), 13.

45. Barthes, "The Light of the Sud-Ouest," 4. In French: "La Lumière du Sud-Ouest," in *Incidents*, 14.

46. Barthes, "The Light of the Sud-Ouest," 4. In French: "La Lumière du Sud-Ouest," in *Incidents*, 14.

47. Barthes, "The Light of the Sud-Ouest," 4. In French: "La Lumière du Sud-Ouest," in *Incidents*, 15.

48. Barthes, "The Light of the Sud-Ouest," 7. In French: "La Lumière du Sud-Ouest," in *Incidents*, 18.

49. Barthes, "The Light of the Sud-Ouest," 9. In French: "La Lumière du Sud-Ouest," in *Incidents*, 20.

50. Calvet, *Roland Barthes*, 153.

51. "For Barthes, in these books [*Roland Barthes, A Lover's Discourse* and *Camera Lucida*] (to use the lovely phrase of his expert translator, Richard Howard), was 'intimate but not personal.'" Edmund White, "From Albert Camus to Roland Barthes," *New York Times*, September 12, 1982, sec. 7, p. 1.

52. Ibid. Emphasis is mine.

53. Roland Barthes, *Empire of Signs*, translated by Richard Howard (New York: Hill and Wang, 1982), 3. Originally published in French as *L'Empire des signes* (Geneva: Editions d'Art Albert Skira, 1970). In French: *L'Empire des signes*, 9.

54. Barthes, *Empire of Signs*, 110. In French: *L'Empire des signes*, 150.

55. Barthes, *Empire of Signs*, 33. In French: *L'Empire des signes*, 47.

56. Barthes, *Empire of Signs*, 30. In French: *L'Empire des signes*, 44.

57. Barthes, *Empire of Signs*, 7. In French: *L'Empire des signes*, 15.

58. Barthes, *Empire of Signs*, 46. In French: *L'Empire des signes*, 63.

59. Barthes, *Empire of Signs*, 26. In French: *L'Empire des signes*, 38.

60. Barthes, *Empire of Signs*, 4. In French: *L'Empire des signes*, 11.

61. Trinh T. Minh-ha, "The Plural Void: Barthes and Asia," as collected in Diana Knight, *Critical Essays on Roland Barthes* (New York: G. K. Hall, 2000), 209–18.

62. As Barthes writes in *Empire of Signs* (4):

> Japan has afforded him a situation of writing. This situation is the very one in which a certain disturbance of the person occurs, a subversion of earlier readings, a shock of meaning lacerated, extenuated to the point of irreplaceable void, without the object's ever ceasing to be significant, desirable. Writing is after all, in its way, a *satori*: *satori* (the Zen occurrence) is a more or less powerful (though in no way formal ) seism which causes knowledge, or the subject to vacillate: it creates *an emptiness of language.*

In French: *L'Empire des signes*, 11–12.

63. See Diana Knight's introduction to her *Critical Essays on Roland Barthes*, 12–13.

64. Trinh T. Minh-ha, "The Prural Void," 214.

65. Barthes, "Inaugural Lecture," 478. In French: *Leçon*, 45–46. As is typical of Barthes, his "play" here is being true to the etymology of the Latin *sapere* to have a taste or savour, to be sensible or wise.

66. Calvet, *Roland Barthes*, 153.

67. Barthes, *Empire of Signs*, 9. In French: *L'Empire des signes*, 18.

68. Barthes, *Empire of Signs*, 16. In French: *L'Empire des signes*, 28.

69. Barthes, *Empire of Signs*, 18. In French: *L'Empire des signes*, 29.

70. Calvet, *Roland Barthes*, 31.

71. The attention paid to the rhyming of *taulard* and *tubard* is Calvet's. See *Roland Barthes*, 69.

72. Roland Barthes, from an interview, "Radioscopie," February 17, 1975, Radio France cassette K 1159, as quoted and translated in Calvet, *Roland Barthes*, 68. Emphasis is mine.

73. Barthes, *Empire of Signs*, 33. In French: *L'Empire des signes*, 47.

74. Barthes, *Empire of Signs*, 36. In French: *L'Empire des signes*, 50–51.

75. Calvet, *Roland Barthes*, 153.

76. The seminar was "Roland Barthes: Policeman of Signs, Professor of Desire," given spring semester 2002 at the University of North Carolina, Chapel Hill.

77. Barthes, *Incidents*, 16. In French: *Incidents*, 26.

78. Barthes, *Incidents*, 21. In French: *Incidents*, 33.

79. Barthes, *Camera Lucida*, 7. In French: *La Chambre claire*, 20.

80. *Oxford English Dictionary*, 2d ed., s.v. "hypocrite."

81. *Roland Barthes by Roland Barthes*, 102. In French: *Roland Barthes par Roland Barthes*, 106.

82. Barthes, *Incidents*, 29. In French: *Incidents*, 44–45.

83. Malcolm Chase, "Nostalgia," conference papers, *History Workshop* 20 (1985): 26.

84. Günter Grass, *The Tin Drum*, translated by Ralph Manheim (New York: Vintage Books, 1990), 60. Originally published in German as *Die Blechtrommel* (1959).

85. Shaw and Chase, "The Dimensions of Nostalgia," 5.

86. Barthes, *Camera Lucida*, 119. In French: *La Chambre claire*, 183.

87. Eliza Minot, *The Tiny One* (New York: Alfred A. Knopf, 1999), from the back cover of the book.

88. Ibid., 13.

89. Ibid., 249.

90. I thank my students Elizabeth Dellert and Tyler Emerson for opening up the name of Via Revere to me.

91. Ibid., 14.

92. Ibid., 252–53.

93. Barthes's notion of punctum will be discussed in detail in chapter 4, "Pulling Ribbons from Mouths."

94. J. M. Barrie, *Peter and Wendy*, as found in Oxford World's Classics, *Peter Pan in Kensington Gardens and Peter and Wendy*, edited with an introduction and notes by Peter Hollindale (Oxford: Oxford University Press, 1999), 69. The "novel" was first published under the title of *Peter and Wendy* in 1911. The "play" *Peter Pan* was written in 1904. For a critical history of the differences between the play and the novel, see Jacqueline Rose, *The Case of Peter Pan: Or The Impossibility of Children's Fiction* (Philadelphia: University of Pennsylvania Press, 1993). All of this is taken up again in chapter 5, "Nesting: The Boyish Labor of J. M. Barrie."

95. D. W. Winnicott, *Talking to Parents*, edited by Clare Winnicott, Christopher Bollas, Madeleine Davis, and Ray Shepherd, with an introduction by T. Berry Brazelton (Reading, Mass.: Addison-Wesley, 1993), 72.

96. In *Camera Lucida*, Barthes writes, "I could live without the Mother (as we all do, sooner or later); but what life remained would be absolutely and entirely *unqualifiable* (without quality)," 75. In French: *La Chambre claire*, 118.

97. Eve Kosofsky Sedgwick, "How to Bring Up Your Kids Gay: The War on Effeminate Boys," in *Tendencies*, 157. Sedgwick's concept comes up again in chapter 2, "Winnicott's ABCs and String Boy."

1. Winnicott, "Transitional Objects and Transitional Phenomena," in *Playing and Reality* (New York and London: Routledge, 1996), 15–20. The section entitled "String" was earlier published in *Child Psychology and Psychiatry*, vol. 1 (1960), and in Winnicott, *The Maturational Processes and the Facilitating Environment* (London: Hogarth Press and the Institute of Psycho-Analysis, 1965).

2. Winnicott, "Playing, a Theoretical Statement," in *Playing and Reality*, 38–52.

3. Ibid., 43.

4. Ibid.

5. Ibid.

6. Calvin Tomkins, *Duchamp: A Biography* (New York: Henry Holt and Company, 1996), 332–33.

7. For psychotherapy as play, see Winnicott, "Playing: A Theoretical Statement," 38.

8. Winnicott, "Transitional Objects and Transitional Phenomena," 10.

9. Ibid., 11.

10. Ibid.

11. Ibid., 10.

12. Ibid., 13.

13. Adam Phillips, *Winnicott* (Cambridge, Mass.: Harvard University Press, 1988), 10.

14. Ibid.

15. D. W. Winnicott, "Cure," in *Home Is Where We Start From* (London: Norton, 1986), 112. "Cure" was a talk given to doctors and nurses in St. Luke's Church, Hatfield, on October 18, 1970.

16. Ibid., 120.

17. Winnicott, "Transitional Objects and Transitional Phenomena," 1.

18. In keeping with the subject of my book (boys), I am consciously choosing to use the masculine pronouns. Naturally, Winnicott was writing about both boy babies and girl babies and makes this clear in his own text.

19. Julia Kristeva, "Motherhood According to Bellini," in *Desire in Language: A Semiotic Approach to Literature and Art*, edited by Léon Roudiez, translated by Alice Jardine, Thomas Gora, and Léon Roudiez (New York: Columbia University Press, 1980), 240. Originally published in French as "Maternité selon Giovanni Bellini" in *Polylogue* (Paris: Seuil, 1977).

20. D. W. Winnicott, "Further Thoughts on Babies as Persons," in *The Child, the Family, and the Outside World* (Harmondsworth: Penguin Books, 1964), 88.

21. See chapter 1, "My Book Has a Disease."

22. Winnicott, "Transitional Objects and Transitional Phenomena," 11.

23. Winnicott, "Mirror-role of Mother and Family in Child Development," in *Playing and Reality*, 111.

24. Ibid., 118.

25. Winnicott, "Transitional Objects and Transitional Phenomena," 12.

26. Ibid., 10.

27. Mieczyslaw Wallis, "Inscriptions in Paintings" *Semiotica* 9 (1973): 1–2.

28. Winnicott, "Transitional Objects and Transitional Phenomena," 1.

29. Ibid.

30. Winnicott, "The Place Where We Live," in *Playing and Reality*, 109.

31. Sigmund Freud, "Leonardo da Vinci and a Memory of His Childhood," in *The Standard Edition of the Complete Psychological Works of Sigmund Freud*, translated from the German under the general editorship of James Strachey in collaboration with Anna Freud, assisted by Alix Strachey and Alan Tyson, 24 vols. (London: Hogarth Press and the Institute of Psycho-Analysis, 1953–74), vol. 11, 59–106. Freud focuses on a childhood dream recorded by Leonardo, in which a bird (a kite in the original Italian, a vulture in Freud's mistaken translation; see the editor's note on page 61) came to his cradle, opened his mouth with its tail, "and struck" the baby Leonardo "many times with its tail against my lips"; see ibid., 82. Originally published in German as *Eine Kindheitserinnerung des Leonardo da Vinci* (Leipzig: F. Deuticke, 1910).

32. Freud, "Leonardo da Vinci and a Memory of his Childhood," 127.

33. Ibid. Emphasis is mine.

34. Ibid. It should come as no surprise that this braid of mother-boy-flight is also read as a prescription for Leonardo's homosexuality. (Freud wrote to Fliess that Leonardo was "perhaps the most famous left-handed individual." See editor's note, ibid., 59. Freud's letter to Fliess was written on October 9, 1898.

35. This is Freud's own term; see ibid., 128.

36. Ibid., 127.

37. Ibid., 126.

38. Winnicott, "Transitional Objects and Transitional Phenomena," 13.

39. Ibid., 17.

40. Ibid., 15.

41. Ibid., 16.

42. Ibid.

43. Ibid.

44. Ibid., 17.

45. Ibid., 19.

46. Ibid., 18–19.

47. *Oxford English Dictionary*, 2d ed., s.v. "apron-string."

48. Sedgwick, "How to Bring Up Your Kids Gay," 159. Sedgwick is quoting from Richard Friedman's *Male Homosexuality* (1988).

49. Sedgwick, "How to Bring Up Your Kids Gay," 157.

50. Winnicott, "Transitional Objects and Transitional Phenomena," 20.

51. Ibid.

52. Sigmund Freud, *Beyond the Pleasure Principle*, translated and edited by James Strachey (New York: Norton, 1961), 13–15.

53. Rosalind E. Krauss, "Yo-Yo," in *Formless: A User's Guide*, by Rosaline E. Krauss and Yve-Alain Bois (New York: Zone Books, 1997), 219.

54. Winnicott, "Transitional Objects and Transitional Phenomena," 19.

55. Ibid., n. 1.

*three* ⚘ SPLITTING

1. Mavor, *Pleasures Taken*. Critical to my understanding of the development of material culture of childhood is Karin Calvert's *Children in the House: The Material Culture of Early Childhood* (Boston: Northeastern University Press, 1992).

2. Our culture and even Lartigue himself revel in the idea of his eternal boyishness. But as Kevin D. Moore points out in his fascinating and helpful doctoral dissertation, Lartigue's so-called playful, graphically innovative style was not solidified until around 1910, when the photographer was sixteen years old. *Jacques-Henri Lartigue (1894–1986): Invention of an Artist* (Department of Art and Archaeology, Princeton University, 2002), 19. See also Moore's detailed and fascinating book, *Jacques Henri Lartigue: The Invention of an Artist* (Princeton and Oxford: Princeton University Press, 2004). In it, Moore further discusses Lartigue's innovative work from 1910 onward. Differently than I, Moore chooses to see Lartigue's boyishness not so much as an interesting extension of boyhood as an affectation. Moore writes: "Lartigue at sixteen, still may have been calling his father 'Papi' and his mother 'Mami,' but like Sebastian's continued attachment to his teddy bear in Evelyn Waugh's novel *Brideshead Revisited*, that was mostly just twee affectation" (62).

3. Undoubtedly there were other children who took photographs at the same

time as the boy-Lartigue and even before—but none with the dedication and resulting oeuvre of Lartigue.

4. Martine d'Astier, "The Autobiographical Enterprise: The Invention of Heaven," in *Lartigue: Album of a Century*, edited by Martine d'Astier, Quentin Bajac, and Alain Sayag, translated by David Wharry (New York: Harry N. Abrams, 2003), 29. Originally published in French as *Lartigue: L'Album d'une vie, 1894–1986* (Paris: Centre Pompidou/Le Seuil, 2003).

5. Jacques Henri Lartigue, *Mémoires sans mémoire* (Paris: Éditions Robert Lafont: 1975), 71. This diary entry comes from the penciled pages of Lartigue's diaries (*agendas*) that were transcribed (and altered, according to *memory*) and then published in 1975 as *Mémoires sans mémoire*. This particular diary entry is from 1907 and appears in translation in d'Astier, "The Autobiographical Enterprise," 36. For an absorbing discussion of the transformation of the penciled *agendas* to *Mémoires sans mémoire*, see Moore's dissertation, *Jacques-Henri Lartigue (1894–1986)*, 25–27.

6. This count is according to Moore, who notes that Lartigue's total oeuvre "consists of approximately 280,000 photographs." *Jacques Henri Lartigue: The Invention of an Artist*, 249, n. 113. Different sources give varying numbers to the huge output of photographs, diary entries, and albums. Let it suffice to say that Lartigue's production was overwhelmingly thorough and, it seems, obsessive.

7. This is simply my addition of all the negatives housed by the Donation Jacques Henri Lartigue, as recorded by Maryse Cordess, president of the Association des amis de Jacques Henri Lartigue, in d'Astier et al., eds., *Lartigue: Album of a Century*, 369–70. In addition to prints, the negatives, the large albums, and the handwritten journals, the Donation Jacques Henri Lartigue also houses Lartigue's cameras.

8. See the helpful website of the Donation Jacques Henri Lartigue, http://lartigue.org/.

9. Drawn from notes in conversation with Martine d'Astier, February 2005.

10. Martine d'Astier in an interview on Lartigue with Michel Guerrin, *Guardian Weekly*, September 4–10, 2003, 26, as well as in conversation with her at the Donation Jacques Henri Lartigue.

11. Martine d'Astier in an interview on Lartigue with Michel Guerrin, 26.

12. Shelley Rice, "Remembrance of Images Past," *Art in America* 80 (November 1992): 122.

13. Barthes, *Camera Lucida*, 15. In French: *La Chambre claire*, 33.

14. As Craig Owens writes: "Photography in its earliest manifestations . . . was

frequently referred to as 'Daguerre's mirror'"; see "Photography *en abyme*," *October* 5 (summer 1978): 75, n. 1.

15. Winnicott, "Transitional Objects and Transitional Phenomena," 11.

16. Eugène Atget, John Szarkowski, and Maria Morris Hambourg, *The Work of Atget*, vol. 2, *The Art of Old Paris* (New York: Museum of Modern Art, 1985), 176.

17. In Proust's *Search*, the Narrator (whom is understood to be the young Marcel) was given a magic lantern to lighten his heart, to distract him when he was feeling "abnormally wretched," but he hated this toy of light and shadows, of "impalpable iridescence, supernatural phenomena of many colours." This, "mere change of lighting was enough to destroy the familiar impression I had of my room," writes Proust. "Now I no longer recognised it, and felt uneasy in it, as in a room in some hotel, or chalet, in a place where I had just arrived by train for the first time" (I, 9–10; I, 9).

18. This passage will be taken up again in chapter 7, "Mouth Wide Open for Proust."

19. Ingmar Bergman, *The Magic Lantern*, translated by Joan Tate (London: Hamish Hamilton, 1988), 16. Originally published in Swedish as *Laterna Magica* (Stockholm: Norstedt, 1987).

20. Barthes quoting Kafka in *Camera Lucida*, 53. In French: *La Chambre claire*, 88.

21. Rice, "Remembrance of Images Past," 126. Rice is quoting from and translating lines from Lartigue's *Mémoires sans mémoire*, 32. Lartigue did not begin keeping a regular journal until 1911, which would reach some 50,000 pages before his death in 1986.

22. Barthes's first chapter of *Michelet* is entitled, "Michelet, Eater of History." There, Barthes remarks on how Michelet used history as a "nutriment": he "grazes" over it, passing over it "and at the same time he swallows it." See *Michelet*, 19, 20. In French: *Michelet par lui-même*, 19, 20. Yet this eating and swallowing took a great toll on Michelet's body, giving him the tumultuous disease of always-recurring migraines. See *Michelet*, 17–19.

23. Rice, "Remembrance of Images Past," 128.

24. Roland Barthes, "The Eiffel Tower," in *The Eiffel Tower and Other Mythologies*, translated by Richard Howard (New York: Hill and Wang, 1979), 6. Originally published in French as *La Tour Eiffel* (Paris: Delpire éditeur, 1964). In French: *La Tour Eiffel*, 33.

25. Barthes, "The Eiffel Tower," 8. In French: *La Tour Eiffel*, 38.

26. Barthes, "The Eiffel Tower," 15. In French: *La Tour Eiffel*, 50.

27. Stewart, *On Longing*, 56.

28. Emily Dickinson describing snow, poem no. 311 (c. 1862) as collected in *The Complete Poems of Emily Dickinson*, 146.

29. Ibid.

30. Barthes, "The Eiffel Tower," 15. In French: *La Tour Eiffel*, 50.

31. Meyer Schapiro, "Seurat," in *Modern Art: 19th and 20th Centuries* (New York: G. Braziller, 1978), 107.

32. Ralph Rugoff, essay for *The Eye of the Needle: The Unique World of Microminiatures* (Los Angeles: Museum of Jurassic Technology and the Society for the Diffusion of Useful Information, 1996), 31.

33. Ibid.

34. Bachelard, *The Poetics of Space*, 150.

35. Stewart McBride, "The Last, Sunny Days of Lartigue," *American Photographer* (August 1987): 59.

36. Simon Watney, "School's Out," in *Inside/Out: Lesbian Theories, Gay Theories*, edited by Diana Fuss (London: Routledge, 1991), 397.

37. Phillips, *On Kissing, Tickling and Being Bored*, 77.

38. White, *Marcel Proust*, 144.

39. Proust invokes this notion of "une mémoire involontaire" throughout *Swann's Way* (see especially I, 60–64, and I, 262–64). Proust reads this involuntary memory prompted by the madeleine cake against the more base world of the "voluntary memory, the memory of the intellect" (I, 59). In French: *Du côté de chez Swann* (I, 43).

40. Aaron Pollock, class comment, spring 2001.

41. Jon Bird, "Dolce Domum," in Rachel Whiteread's *House*, edited by James Lingwood (London: Phaidon, 1995), 121.

42. Elvire Perego, "Intimate Moments and Secret Gardens: The Artist as Amateur Photographer, in *A New History of Photography*, edited by Michel Frizot, translated by Piere Albert, Susan Bennett, aand Colin Harding (Cologne: Könemannn, 1998), 337. Originally published in French as *Nouvelle histoire de la photographie* (Paris: A. Biro, 1994).

43. Arthur Danto, "'Sensation' in Brooklyn," *Nation*, November 1, 1999, 28.

44. A phrase used in another context pilfered from Eve Kosofsky Sedgwick, *A Dialogue on Love* (Boston: Beacon Press, 1999), 194.

45. Peter Wollen, "Fire and Ice," *Photographies* 4 (1984). As quoted by Christian Metz, "Photography and Fetish," *October* 34 (fall 1985): 84.

46. Bird, "Dolce Domum," 119.

47. Walter Benjamin, "The Image of Proust," in *Illuminations: Essays and Reflections*, translated by Harry Zohn, edited by Hannah Arendt (New York:

Schocken Books, 1968), 202. Originally published in German as *Illuminationen* (Frankfort on the Main: Suhrkamp Verlag, 1961).

48. Jean-Yves Tadié, *Marcel Proust: A Life*, translated by Euan Cameron (New York: Viking Press, 2000), xvi. Originally published in French as *Marcel Proust: Biographie* (Paris: Gallimard, 1996).

49. Margaret Wise Brown, *Little Fur Family* (New York: Harper and Row, 1946), no pagination.

50. Martha Pichey, "Bunny Dearest," *Vanity Fair*, December 2000, 178.

51. Anthony Vidler, "A Dark Space," in *Rachel Whiteread's House*, 71.

52. White, *Marcel Proust*, 134.

53. Benjamin, "The Image of Proust," 203.

54. Barthes, *Camera Lucida*, 38. In French: *La chambre claire*, 66.

55. There is a version of this game even today, specifically paper flowers that grow in water: I bought them as a child in San Francisco's Chinatown. According to some research done on this topic by Wan Yu Chien in my graduate seminar on Proust, spring 2005, in the Edo period, people carved a core of a Japanese yellow rose, Kerria, or Angelica tree into tiny flowers, birds, etc. They were then colored and dried. Viewers enjoyed watching them open by pouring sake on them.

56. Barthes, *Camera Lucida*, 40. In French: *La Chambre claire*, 68.

57. Charles Baudelaire, "The Painter of Modern Life," in *The Painter of Modern Life and Other Essays*, translated and edited by Jonathan Mayne (New York: De Capo Press, 1964), 8. Originally published in French as "Le peintre de la vie moderne" in three issues of *Le Figaro*, November 26 and 29, 1963, and December 3, 1963.

58. Barthes, *Camera Lucida*, 7. In French: *La Chambre claire*, 20.

59. Barthes, *Camera Lucida*, 39. In French: *La Chambre claire*, 67.

60. Charles Baudelaire, *The Flowers of Evil* in French and English, translated by James McGowan with an introduction by Jonathan Culler (New York: Oxford University Press, 1998), 30–31.

61. Barthes, *Camera Lucida*, 40. In French: *La Chambre claire*, 68.

62. Winnicott, *Home Is Where We Start From*.

63. Bird, "Dolce Domum," 121.

64. Anna Freud was also an early "analyst" of children, though principally guided by her father's own views. Anna Freud published her first book on child analysis in 1927: *Einfuhrung in die Technik der Kinderanalyse*. For an excellent summary of the relationship between Klein and Anna Freud as related to Winnicott and object-relations theory, see Phillips, *Winnicott*, 40–46.

65. Barthes, *The Pleasure of the Text*, 37. In French: *Le plaisir du texte*, 60.

66. Maurice Ravel and Colette, *L'Enfant et les sortilèges* (*The Bewitched Child*), English translation by Katherine Wolff (Paris: Durand, 1925), 1.

67. Colette, *The Bewitched Child*, 1.

68. Ibid., 3.

69. Ibid.

70. Ibid.

71. Ibid., 4.

72. Ibid., 8.

73. Ibid., 6.

74. Ibid., 52.

75. Ibid., 63.

76. Ibid., 85.

77. Ibid., 86.

78. Ibid., 90.

79. Ibid., 91.

80. Ibid.

81. Ibid., 96.

82. Ibid.

83. Ibid., 98.

84. Ibid., 100–101.

85. Carroll, *Through the Looking-Glass*, 263–66.

86. Ibid., 267.

87. Melanie Klein, "Hate, Greed and Aggression," in *Love Hate and Reparation*, by Melanie Klein and Joan Riviere (New York: Norton, 1964), 4.

88. Ibid., 5.

89. Sedgwick, "How to Bring Up Your Kids Gay," 157.

90. Phillips, *Winnicott*, 30.

91. Klein, "Love, Guilt and Reparation," in Klein and Rivere, *Love, Hate and Reparation*, 57.

92. Phillips, *Winnicott*.

93. Adam Phillips, *On Flirtation* (Cambridge, Mass.: Harvard University Press, 1994), 27.

94. The contemporary artist Mary Kelly is famous for creating her own *split* archaeology of the everyday life of the child (in this case her own son Kelly Barrie) in her *Post-Partum Document*, which was an ongoing piece from 1973–78. For *Post-Partum Document*, Kelly saved and documented the mother's memorabilia of her "little one" from birth to the age of five years. In her published

book version of the piece, *Post-Partum Document* (London: Routledge, 1983), Kelly refers to her collection as an "archaeology of everyday life . . . framed . . . [and presented in an] unexpected place," specifically the official space of the museum (xi). But rather than collecting the usual female fetishes of "first shoes, photographs, locks of hair or school reports . . . [Kelly's] work proceeds from this site; instead of first shoes, first words set out in type, stained liners, hand imprints, comforter fragments, drawings, writings or even the plants and insects that were his gifts; all these are intended to be seen as transitional objects" (xvi). Although the piece most certainly was designed to ward off maternal anxiety about an "empty nest," it most certainly is *also* not just the mother's story, it is the child's too, In fact, much of the emphasis throughout the piece is on the split between the two, the necessary splitting.

95. Winnicott uses this phrase in relation to a published case study, *The Piggle: An Account of the Psychoanalytic Treatment of a Little Girl*, edited by Ishak Ramzy (Madison, Conn.: International Universities Press, 1977), 190.

96. Sedgwick, *A Dialogue on Love*, 219.

97. In *Camera Lucida*, Barthes, referencing Sontag, writes that the light of the photograph's referent reaches us "like the delayed rays of a star," 81. In French: *La Chambre claire*, 126. This passage will be taken up again in chapter 4, "Pulling Ribbons from Mouths."

*four* ❧ PULLING RIBBONS FROM MOUTHS

1. Calvet, *Roland Barthes*, 216.
2. Richard Howard, "Remembering Roland Barthes," in *Signs in Culture: Roland Barthes Today*, edited by Steven Ungar and Betty R. McGraw (Iowa City: University of Iowa Press, 1989), 35.
3. Calvet, *Roland Barthes*, 216.
4. Ibid., 226.
5. Barthes, "Inaugural Lecture," 476–77. In French: *Leçon*, 42–43.
6. Benjamin, "The Image of Proust," 213.
7. From a conversation with Richard Howard in February 1997.
8. *Roland Barthes by Roland Barthes*, 121–22. In French: *Roland Barthes par Roland Barthes*, 125.
9. Barthes, *The Pleasure of the Text*, 37. In French: *Le Plaisir du texte*, 60.
10. See Susan Suleiman's prologue to *Subversive Intent: Gender, Politics, and the Avant-Garde* (Cambridge, Mass.: Harvard University Press, 1990), 1–10.
11. Calvet, *Roland Barthes*, 218.

12. Howard, "Remembering Roland Barthes," 34.

13. Ibid.

14. Barthes, *Camera Lucida*, 72. In French: *La Chambre claire*, 112–113.

15. Barthes, *The Pleasure of the Text*, 18. In French: *Le Plaisir du texte*, 32.

16. Barthes, *The Pleasure of the Text*, 4. In French: *Le Plaisir du texte*, 11.

17. Richard Miller translates Barthes's use of the word jouissance as "bliss." Richard Howard's "A Note on the Text," which introduces Miller's translation of *Le Plaisir du texte*, discusses the inherent inadequacy of English when it comes to articulating the French vocabulary of eroticism: "an amorous discourse which smells neither of the laboratory nor of the sewer" (v). Howard continues: "Richard Miller, has been resourceful, of course, and he has come up with the readiest plausibility by translating *jouissance* . . . as 'bliss'; but of course he cannot come up with 'coming,' which precisely translates what the original text can afford" (v–vi).

18. *Roland Barthes by Roland Barthes*, 116.

19. Barthes, *The Pleasure of the Text*, 21. In French: *Le Plaisir du texte*, 36.

20. Phillips, *On Kissing, Tickling and Being Bored*, 68–78.

21. Walter Benjamin, "The Storyteller," in *Illuminations*, 91.

22. Barthes, *The Pleasure of the Text*, 25–26. In French: *Le Plaisir du texte*, 43.

23. Barthes, *The Pleasure of the Text*, 17. In French: *Le Plaisir du texte*, 30.

24. *Roland Barthes by Roland Barthes*, 136. In French: *Roland Barthes par Roland Barthes*, 139.

25. Barthes, *Camera Lucida*, 65. In French: *La Chambre claire*, 102.

26. Culler, *Roland Barthes*, 21.

27. Ibid., 21–22.

28. Barthes, *Camera Lucida*, 72. In French: *La Chambre claire*, 113.

29. Howard, "Remembering Roland Barthes," 36.

30. Roland Barthes, *S/Z*, translated by Richard Miller (New York: Hill and Wang, 1974), 160. Originally published in French as *S/Z* (Paris: Éditions du Seuil, 1970). In French: *S/Z* in *Roland Barthes: Œuvres complètes*, Tome III, edited by Éric Marty (Paris: Éditions du Seuil, 2002), 253.

31. Barthes, *S/Z*, 160. In French: *S/Z* in *Roland Barthes: Oeuvres completes*, 253.

32. In another context, I have previously discussed the Winter Garden Photograph as the other half to Boudinet's *Polaroïd*. See my essay, "Becoming: The Photographs of Clementina Hawarden, 1859–1864," *Genre* 29, nos. 1–2 (1996): 93–134.

33. Barthes, *Camera Lucida*, 96. In French: *La Chambre claire*, 150.

34. Barthes, *Camera Lucida*, 81. In French: *La Chambre claire*, 128.

35. Barthes, *Camera Lucida*, 66. In French: *La Chambre claire*, 104.

36. Diana Knight, "The Woman Without a Shadow," *Writing the Image after Roland Barthes*, edited by Jean-Michel Rabaté (Philadelphia: University of Pennsylvania Press, 1997), 138.

37. In a letter to the author in April 2000, Nancy Spector pointed out that González-Torres read theory while at the Whitney Independent Study Program as well as when studying photography at New York University with Christopher Phillips and others. She believes González-Torres surely would have read *Camera Lucida* in this context.

38. Barthes, *Camera Lucida*, 7. In French: *La Chambre claire*, 20

39. Barthes, *Camera Lucida*, 53. In French: *La Chambre claire*, 88.

40. Barthes, *Camera Lucida*, 66. In French: *La Chambre claire*, 104.

41. Barthes, *The Pleasure of the Text*, 7. In French: *Le Plaisir du texte*, 16.

42. Barthes explains "the grain of the voice," in *The Pleasure of the Text*: "an erotic mixture of timbre and language, and can therefore also be, along with diction, the substance of an art" (66). In French: *Le Plaisir du texte*, 104.

43. *Roland Barthes by Roland Barthes*, caption to snapshot of Barthes with his mother and younger brother, unpaginated. In French: *Roland Barthes par Roland Barthes*, 31.

44. Barthes, *Camera Lucida*, 72. In French: *La Chambre claire*, 112.

45. Françoise Heilbrun, "Nadar and the Art of Portrait Photography," in *Nadar*, edited by Maria Morris Hambourg, Françoise Heilbrun, and Philippe Néagu (New York: Metropolitan Museum of Art, 1995), 53.

46. Barthes, *Camera Lucida*, 70. In French: *La Chambre claire*, 109–110.

47. Roland Barthes, "On Brecht's Mother," in *Critical Essays*, translated by Richard Howard (Evanston, Ill.: Northwestern University Press, 1972), 139. Originally published in French as "Sur la mère de Brecht" in *Essais critiques* (Paris: Éditions du Seuil, 1964). In French: "Sur la mère de Brecht," 143.

48. "Le-Corps-à-corps avec la mère" is usually translated as "The Bodily Encounter with the Mother," as in Luce Irigaray, *The Irigaray Reader*, edited by Margaret Whitford (Oxford: Basil Blackwell, 1991). Carolyn Burke has provided me with the rich translation cited here.

49. See Susan Sontag, *On Photography* (New York: Farrar, Straus, and Giroux, 1977), where she suggests that since the 1970s, "all art," whether painting, sculpture, video, performance, or photography itself, is influenced by ("aspires to") the condition of photography, which includes anxieties about authorship; the ways in which multiple copies challenge notions of "original," "great" works of art; and the indexical connection to the "real" (149). Henry Sayre's

helpful book, *The Object of Performance: The American Avant-Garde since 1970* (Chicago: University of Chicago Press, 1989), turns on Sontag's provocative claim.

50. Barthes, *Camera Lucida*, 73. In French: *La Chambre claire*, 114.

51. Barthes, *Camera Lucida*, 73. In French: *La Chambre claire*, 115.

52. *Roland Barthes by Roland Barthes*, 162. In French: *Roland Barthes par Roland Barthes*, 166.

53. Nancy Princenthal, "Words of Mouth: Lesley Dill's Work on Paper," *On Paper: The Journal of Prints, Drawings and Photography* 2 (1997–98): 28.

54. Barthes, *The Pleasure of the Text*, 66. In French: *Le plaisir du texte*, 104.

55. Ann van Dijk, "The Angelic Salutation," *Art Bulletin* 81 (1999), 421.

56. Barthes, *The Pleasure of the Text*, 66. In French: *Le Plaisir du texte*, 104–105.

57. English translation from New International Version.

58. *The Rohan Book of Hours*, edited by Marcel Thomas, translated by Katharine W. Carson (New York: George Braziller, 1973), entry no. 63 (*Office of the Dead*).

59. Jean Porcher, *The Rohan Book of Hours* (London: Faber and Faber, 1959), 30.

60. Elizabeth Grosz, *Sexual Subversions: Three French Feminists* (Sydney: Allen and Unwin, 1989), 161.

61. Ibid., 161.

62. Barthes, *Camera Lucida*, 26. In French: *La Chambre claire*, 49.

63. Mavor, *Pleasures Taken*, 54.

64. Barthes, *Camera Lucida*, 51. In French: *La Chambre claire*, 84.

65. Meg Sheehan, "Inside the 'Winter Garden Photograph'" (essay for the course "Photographies and Sexualities," University of North Carolina, fall 1999).

66. Barthes, *Camera Lucida*, 80–81. Emphasis is mine. In French: *La Chambre claire*, 126–27.

67. Barthes, *Camera Lucida*, 110. Emphasis is mine. In French: *La Chambre claire*, 169.

68. See Barthes, *Camera Lucida*, 75.

69. Barthes, "Soirées de Paris," in *Incidents*, 61. In French: "Soirées de Paris," 92.

70. Barthes, "Soirées de Paris," 65. In French: "Soirées de Paris," 97.

71. Barthes, *A Lover's Discourse*, 48. In French: *Fragments d'un discours amoureux*, 60.

72. Barthes, *A Lover's Discourse*, 48. In French: *Fragments d'un discours amoureux*, 59.

73. Barthes, referring to Winnicott, in *A Lover's Discourse*, 15–16. In French: *Fragments d'un discours amoureux*, 21–22.

74. Winnicott, "Transitional Objects and Transitional Phenomena," 15.

75. Ibid., 22.

76. Culler, *Roland Barthes*, 113.

77. Barthes, *A Lover's Discourse*, 127. In French: *Fragments d'un discours amoureux*, 151.

78. Barthes, *A Lover's Discourse*, 128. In French: *Fragments d'un discours amoureux*, 152.

79. Barthes, *A Lover's Discourse*, 128. In French: *Fragments d'un discours amoureux*, 152.

80. Michael Hulse, introduction to Johann Wolfgang von Goethe, *The Sorrows of Young Werther* (London: Penguin, 1989) 12.

81. Barthes, *A Lover's Discourse*, 39. In French: *Fragments d'un discours amoureux*, 49.

82. Barthes, "Soirées de Paris," 73. In French: "Soirées de Paris," 116.

83. Barthes, "Soirées de Paris," 73. In French: "Soirées de Paris," 115.

84. *Roland Barthes by Roland Barthes*, caption to a family snapshot of Barthes as a boy, sitting alone on a grassy hill, unpaginated. In French: *Roland Barthes par Roland Barthes*, 28.

85. Phillips, *On Kissing, Tickling and Being Bored*, 76.

86. Winnicott, "Transitional Objects and Transitional Phenomena," 17.

87. Ibid.

88. Phillips, *Winnicott*, 23. The possible connection between a "tie-up" with the mother and a father who specialized in women's corsetry was pointed out to me by Elizabeth Howie.

89. Barthes, *A Lover's Discourse*, 114–115. In French: *Fragments d'un discours amoureux*, 132.

90. Barthes, *A Lover's Discourse*, 126. In French: *Fragments d'un discours amoureux*, 149.

91. Barthes, *A Lover's Discourse*, 137. In French: *Fragments d'un discours amoureux*, 164.

92. Winnicott, introduction to *Playing and Reality*, xi–xii. Emphasis is mine.

93. Nancy Spector, *Félix González-Torres*, exhibition catalog (New York: Guggenheim Museum, 1995), 183.

94. Spector, *Félix Gonzáles-Torres*, 183. Spector, in personal correspondence of April 2000, recalled both González-Torres's interest in *A Lover's Discourse* and the fact that he found the sections on waiting to be poignantly true and cruel. The cruelty of González-Torres's own ultimate catastrophe of waiting for Ross to finally dim, to wind down entirely, to become "absence," mirrors *A Lover's Discourse*, especially the aforementioned passage, in which Barthes writes:

"Absence persists — I must endure it. Hence I will *manipulate* it: transform the distortion of time into oscillation, produce rhythm, make an entrance onto the stage of language (language is born of absence . . .)" (16). González-Torres's profound and original language of candy spills, printed paper stacks, paired clocks, ribbons of lights, and so forth embraces the condition of the photograph (making a presence out of absence), which turns on death and separation.

*five*  NESTING

This chapter is indebted to the work of Elizabeth Jane Towns, whose fine master's thesis, "Alphabet Bird Child: The Alphabet Books and Ornithology of Thomas Bewick and Edward Lear" (University of North Carolina at Chapel Hill, 2001), was of tremendous help in thinking about the relationship of birds to childhood. Beyond her written work, Towns has generously shared many "birdly" thoughts with me in conversation. And last, but not least, I want to thank my son Ambrose Mavor-Parker (who has long grown out of the bird stage), who first taught me to notice the birds. He is my wonderful middle child. And like this middle chapter, which is longer and denser than those which have come before and are to come, he is my mender boy. My mender boy always finds the threads, picks up the stitches, resews, trims, and adds, between the earlier and later chapter of his parents' lives, between "the brothers," between mother and father, between dog and cat, and, of course, between a couple of parakeets. Like Peter's original appearance in Barrie's *The Little White Bird*, Ambrose, too, is also and delightfully "between and betwixt."

A note on Peter: Barrie first brought *Peter Pan* to stage in 1904. The play went through many revisions over the years, but I shall be referring to it as it appears in the Oxford English Drama series, edited by the fine Peter Hollindale. In 1911, Barrie published the novel version of the play and called it *Peter and Wendy*. Although almost everyone today, even many of the publishers who continue to publish the story, refer to the novel as Peter Pan, I have retained the novel's original title of *Peter and Wendy* throughout, in the interest of consistency and historical accuracy. For *Peter and Wendy*, I refer to the Oxford World's Classics series, edited and introduced, also, by Peter Hollindale.

1. J. M. Barrie, *Peter Pan*, as collected in *J. M. Barrie/Peter Pan and Other Plays*, edited with an introduction and notes by Peter Hollindale (Oxford: Oxford University Press, 1995), 92. Hereafter, references to *Peter Pan* will be made

parenthetically in the body of the text, as indicated by *PP* with the page number from this edition following.

2. As Thomas Kellein has noted in his essay on Adam Fuss, the relationship between Fuss's image of the bird and the ladder from his series "In Between" and Fox Talbot's ladder in a courtyard (1844) suggests a connection *between* photography and the heavens. While Kellein does not spell it out—there is also the evocation of "God is in the details" for both photographers. *Adam Fuss: Fotogramme von Leben und Tod. Photograms of Life and Death*, edited by Thomas Kellein (Cologne: Kunsthalle Bielefeld, 2003).

3. Chris Chant, *The Illustrated History of the Air Forces of World War I and World War II* (London: Hamlyn, 1979), 81.

4. Baudelaire, "The Albatross," in *The Flowers of Evil*, in French and English, 14–15. Albatros was the name of the German army's most productive aircraft firm in 1914. See John H. Morrow Jr., *The Great War in the Air: Military Aviation from 1909 to 1921* (Washington, D.C.: Smithsonian Institution Press, 1993), 37.

5. Andrew Birkin, *J. M. Barrie and the Lost Boys* (London: Constable and Company, 1979), 252.

6. Janet Dunbar, *J. M. Barrie: The Man Behind the Image* (Boston: Houghton Mifflin, 1970), 169.

7. Ibid.

8. J. M. Barrie, *Peter and Wendy*, as found in Oxford World's Classics, *Peter Pan in Kensington Gardens and Peter and Wendy*, edited with an introduction and notes by Peter Hollindale (Oxford: Oxford University Press, 1999), 226. Hereafter, references to *Peter and Wendy* will be made parenthetically in the body of the text, as indicated by *P&W* with the page number from this edition.

9. James Kincaid, *Erotic Innocence: The Culture of Child Molesting* (Durham: Duke University Press, 1998), 144. Emphasis is mine.

10. It was largely because of mechanical difficulties that *Peter Pan* started off off-time. See Roger Lancelyn Green, *Fifty Years of Peter Pan* (London: Peter Davies, 1954), 83–84.

11. As cited by Green, ibid., 85.

12. The demonstration was a royal event that took place at Versailles. King Louis XVI was not impressed by the stench of the dense smoke, but the brothers believed at the time that it was the smoke that was causing the balloon to rise. Wool, straw, and old shoes were used to try and make the densest smoke possible. It was only until later that it was realized that it was the heat that was important, not the smoke.

13. Jean Fondin, introduction to *Boyhood Photos of J.-H. Lartigue: The Family Album of a Gilded Age* (Lausanne: Ami Guichard, 1966), 36. The book's text and photo captions were written by Fondin based on interviews with Lartigue. Also published in French as *Les Photographies de J.-H. Lartigue: Un album de famille de la Belle Époque* (Lausanne: Ami Guichard, 1966).

14. Donald S. Lopez, *Aviation: From Our Earliest Attempts at Flight to Tomorrow's Advanced Designs, A Smithsonian Guide* (New York: McMillan 1995), 20.

15. Paul Hoffman, *Wings of Madness: Alberto Santos-Dumont and the Invention of Flight* (New York: Theia, 2003), 140.

16. Ibid., 311.

17. As cited by Hoffman, ibid., 310.

18. Birkin, *J. M. Barrie and the Lost Boys*, 109.

19. Michael Balint, "Flying Dreams and the Dream Screen" in *Thrills and Regressions* (New York: International Universities Press, 1959), 75.

20. Sigmund Freud, *Civilization and Its Discontents* in *The Standard Edition of the Complete Psychological Works of Sigmund Freud*, vol. 21, 64. Originally published in German as *Das Unbehagen in der Kultur* (Vienna: Internationaler Psychoanalytischer, 1930). Emphasis on "eternity" is mine.

21. Freud came up with the term in his correspondence with Romain Rolland. See Ranjana Khanna, *Dark Continents: Psychoanalysis and Colonialism* (Durham: Duke University Press, 2003), 91–95.

22. Green, *Fifty Years of Peter Pan*, vii.

23. Ibid.

24. *Winter's Tale* 1.2.80–81.

25. *Oxford English Dictionary*, 2d ed., s.v. "fairy." The date of this *American Journal of Psychology* article was actually 1896—see n. 29.

26. Colin A. Scott, "Sex and Art," *American Journal of Psychology* 7 (January 1896): 216.

27. As Dan Bacher notes: "Women would go on to play the lead role in Peter Pan for almost 50 years. The first actress to play Peter was 37 year-old, Nina Boucicault, sister to the play's first director, Don Boucicault. Peter Pan was considered a role for a woman until a 1952 German production cast a male in the role. The English didn't break this tradition until the 1980's." "Peter Pan: A Production History," *Irondale News: Ensemble Project*, Special Neverland Issue, vol. 5, no. 1 (fall 2001).

For a complete cast listing of the London productions of *Peter Pan* from 1904 to 1954, see Roger Lancelyn Green's *Fifty Years of Peter Pan*, 219–38.

28. As spoken by Lord Darlington in Oscar Wilde, *Lady Windermere's Fan*, Act III (London: Methuen, 1985), 51.

29. As cited by Green in *Fifty Years of Peter Pan*, 73.

30. Bachelard, *The Poetics of Space*, 100.

31. Michelet, *The Bird*, 248. In French: *L'oiseau*, 298, 299.

32. As Naomi Lewis writes: "In print, the magic boy first appeared by name in Barrie's adult novel *The Little White Bird* (1902) a strange first-person narrative about a wealthy bachelor clubman's attachment to a little boy, David." *Twentieth-Century Children's Writers*, edited by D. L. Kirkpatrick, with a preface by Naomi Lewis (London: Macmillan Press, 1978), 86.

33. My notion of "child-loving" is indebted to James Kincaid's *Child-Loving: The Erotic Child and Victorian Culture* (New York: Routledge, 1992).

34. Throughout this book, when mentioning specifics, I refer to the play as *Peter Pan* and the novel as *Peter and Wendy*, as each was originally titled by their author, in hopes of avoiding confusion.

35. The cottage, in Farnham, belonged to Barrie's wife, Mary Ansell. Barrie was married to Ansell from 1894 to 1909. He divorced her on grounds of adultery, but general wisdom suggests that the marriage was never consummated and was in trouble from the start. Barrie bought Mary their St. Bernard, the famed Porthos, as a wedding present during their honeymoon in Switzerland.

36. You can see a copy of the entire book, with very helpful commentary on Barrie, at Andrew Birkin's wonderful website: http://www.jmbarrie.co.uk.

37. See Mavor, *Pleasures Taken*, 1–42; and Mavor, *Becoming*, 1–4.

38. Birkin, *J. M. Barrie and the Lost Boys*, 196.

39. Peter Llewelyn Davies, *Morgue*, as cited by Birkin in *J. M. Barrie and the Lost Boys*, 196.

40. J. M. Barrie, *The Little White Bird* (New York: Charles Scribner's Sons, 1912), 128. Hereafter, references to *The Little White Bird* will be made parenthetically in the body of the text, as indicated by *LWB* with the page number from this edition.

41. Robert Burton, "The Author's Abstract of Melancholy," in *The Anatomy of Melancholy*, edited and with an introduction by Holbrook Jackson, with a new introduction by William H. Gass (New York: New York Review of Books, 2001), 12.

42. Nina Fletcher Little, "John Brewster, Jr." in *American Folk Painters of Three Centuries*, edited by Jean Lipman and Tom Armstrong (New York: Hudson Hills Press in association of the Whitney Museum of American Art, 1980), 18.

43. When Arthur was sick with cancer of the jaw, his face completely bandaged, "he managed to communicate with Barrie by spidery notes:

> Among the things I think about
> Michael going to school
> Porthgwarra and S's blue dress . . ."

Birkin, *J. M. Barrie and the Lost Boys*, 135. See also ibid., 139 and 142.

44. Elizabeth Jane Towns has brought this idea home to me. See her master's thesis: "Alphabet Bird Child: The Alphabet Books and Ornithology of Thomas Bewick and Edward Lear" (University of North Carolina at Chapel Hill, 2001).

45. Brewster's father, a physician, taught his son to read, write, and speak in signs from an early age. The success of Brewster's education enabled him to become a successful portraitist. See Little, "John Brewster, Jr.," 18–25.

46. Robert Hendrickson, "A little bird told me" in *Encyclopedia of Word and Phrase Origins* (New York, Oxford: Facts on File Publications, 1987), 324. Bible passage cited is from the New International Version.

47. See Teresa de Lauretis, "Desire in Narrative," in *Alice Doesn't: Feminism, Semiotics, Cinema* (Bloomington: Indiana University Press, 1984), 103–57.

48. Roland Barthes, "Introduction to the Structural Analysis of Narratives," in *Image, Music, Text*, 124. Originally published in French as "Introduction à l'analyse structurale des récits," *Communications* 8 (1966): 1–27. In French: "Introduction à l'analyse structurale des récits," 27.

49. Jacques Lacan, "The Mirror Stage as Formative of the Function of the I as Revealed in Psychoanalytic Experience," in *Écrits: a selection*, translated by Alan Sheridan (New York: Norton, 1977), 2. Originally published in French as "Le Stade du miroir comme formateur de la fonction du Je" in *Écrits* (Paris: Éditions du Seuil, 1966). Paper first delivered at the 16th International Congress of Psychoanalysis, held in Zurich on July 17, 1949.

50. Antoine de Saint-Exupéry, *The Little Prince*, translated by Richard Howard (San Diego: Harcourt, 2000), 9. Originally published in French as *Le Petit Prince* (Paris: Éditions Gallimard, 1943).

51. Saint-Exupéry, *The Little Prince*, 25.

52. Gopnik, "Sparkings: Joseph Cornell and the Art of Nostalgia," 184.

53. Stacy Schiff, *Saint-Exupéry: A Biography* (New York: Da Capo Press, 1996), 37.

54. "After a childhood of nicknames, he was transformed by others into 'Saint-Ex,' who became the pilot of legend." Ibid., xi.

55. Saint-Exupéry, *The Little Prince*, 18.

56. Ibid., 18–19.

57. Expatica, http://www.expatica.com, April 7, 2004.

58. Birkin, *J. M. Barrie and the Lost Boys*, 45.

59. Author of *Peter Ibbetson* (1891) and *Trilby* (1894).

60. Birkin, *J. M. Barrie and the Lost Boys*, 182. It has been speculated that she suffered from breast cancer.

61. Birkin, *J. M. Barrie and the Lost Boys*, 194.

62. Jackie Wullschläger, *Inventing Wonderland: The Lives and Fantasies of Lewis Carroll, Edward Lear, J. M. Barrie, Kenneth Grahame and A. A. Milne* (London: Methuen, 1995), 135. Emphasis is mine.

63. Minot, *The Tiny One*, 13.

64. *Winter's Tale* 1.2.80–81.

65. Michael Elder, *The Young James Barrie* (New York: Roy Publishers, 1968), 32.

66. Barrie, *Margaret Ogilvy*, 7.

67. Ibid.

68. Ibid., 11.

69. A. A. Milne, "Halfway Down," in Milne, *When We Were Very Young* (New York: E. P. Dutton and Company, 1924), 81.

70. A housewife is a pocket-case for needles, pins, threads, scissors, and such.

71. Elder, *The Young James Barrie*, 25.

72. Barrie, *Margaret Ogilvy*, 5–6.

73. Ibid., 16.

74. Ibid., 17.

75. Stallybrass, "Worn Worlds," 35–36.

76. Likewise, although not usually with a madeleine-rush, wearing the clothes of a close friend or lover or child, in which their smells come forth, in which the body has worn the cloth smooth or through, is photographic in a Barthesian sense.

77. As cited by Kenneth Kidd in *Making American Boys: Boyology and the Feral Tale* (Minneapolis: University of Minnesota Press, 2004), 1.

78. Wullschläger, *Inventing Wonderland*, 109.

79. Queen Victoria, as cited in *Victorian Women: A Documentary Account of Women's Lives in Nineteenth-Century England, France, and the United States*, edited by Erna Olafson Hellerstein, Leslie Parker Hume, and Karen M. Offen (Stanford: Stanford University Press, 1981), 209.

80. Barrie, *Margaret Ogilvy*, 22.

81. J. M. Barrie, *A Window in Thrums* (Philadelphia: Henry Altemus, 1895), 8.

82. According to Barrie's passport on display in his birthplace turned museum in Kirriemuir.

83. As Janet Dunbar writes in *J. M. Barrie: The Man Behind the Image*: "The nearest one can get to him is to read *Tommy and Grizel*," 108.

84. Barrie, *Tommy and Grizel* (New York: Charles Scribner's Sons, 1913), 284.

85. Ibid., 241.

86. Ibid., 247.

87. Ibid., 243.

88. Ibid., 242.

89. Barrie seems to have outed his queerness, in typical Peterkin fashion, in *Tommy and Grizel*. By the end of the book, Tommy has married Grizel, not out of a lover's passion, but solely to look after. Both Mary Ansell and Grizel learned from their boyish husbands that "boys cannot love."

90. Lynne Vallone, *Becoming Victoria* (New Haven: Yale University Press, 2001), xv.

91. Christoper Hibbert, *Queen Victoria: A Personal History* (New York: Basic Books, 2000), 60–61.

92. For a description of Queen Victoria's size when crowned, see Hibbert, *Queen Victoria*, 60–61. For a description of her size at the end of her life, see Kay Staniland, *In Royal Fashion: The Clothes of Princess Charlotte of Wales and Queen Victoria 1796–1901* (London: Museum of London, 1997), 171. Thanks to Bobbi Owen for pointing me toward these texts.

93. T. Mullet Ellis, *The Fairies Favourite, or the Story of Queen Victoria Told for Children* (London: Ash Partners, 1897).

94. Jane Gallop, "Anne Leclerc Writing a Letter with Vermeer," *October* 33 (1985): 104.

95. Simon Garfield, *Mauve: How One Man Invented a Color that Changed the World* (New York: Norton, 2001), 13.

96. As cited by Garfield in *Mauve*, 61.

97. "The Costumes of The Royal Nuptials," *Illustrated London News*, January 30, 1858, 123.

98. As cited by Garfield in *Mauve*, 65.

99. Garfield, *Mauve*, 86. At the time of the wedding, the court was still in mourning following the recent death of Prince Albert.

100. Garfield, *Mauve*, 86.

101. Birkin, *J. M. Barrie and the Lost Boys*, 59.

102. Hélène Cixous, "Introduction to Lewis Carroll's *Through the Looking Glass* and *The Hunting of the Snark*," *New Literary History* 13 (winter 1982): 235.

103. Benjamin, "The Image of Proust," 213.

104. Jacques Henri Lartigue, as quoted in "19:13 II: Age of Innovation," *Life* 55, no. 22 (November 29, 1963): 726.

105. Barrie, *Margaret Ogilvy*, 41.

106. At his birthplace at Kirriemuir, part of The National Trust of Scotland, the downstairs room, which houses a loom, just as it would have in the early days of Barrie's life, also includes an x-ray film that was taken of Barrie's left hand to investigate the painful trouble. Also of note: not far from the house that he was born in is a cricket pavilion and a camera obscura built for the town of Kirriemuir by Barrie; adjacent to this is the cemetery where both Barrie and his mother are buried.

107. Birkin, *J. M. Barrie and the Lost Boys*, 284.

108. Barthes, *The Pleasure of the Text*, 19–20. In French: *Le Plaisir du texte*, 34.

109. Now fully grown, Eva-Lynn Jagoe was once a graduate student of mine, and the phrase comes from her doctoral written exam, Duke University, 1993. The theme of the "erotics of tininess" is developed in *Pleasures Taken*—see especially 33–35.

110. Stewart, *On Longing*, 111.

111. Charles Baudelaire, "A Philosophy of Toys," in *The Painter of Modern Life and Other Essays*, translated and edited by Jonathan Mayne (New York: De Capo Press, 1964), 198. Originally published in French as "Morale du joujou," *Monde Littéraire*, April 17, 1853.

112. Vincent van Gogh's letter to his brother Theo, as cited by Bachelard in *The Poetics of Space*, 98.

113. Bachelard, *The Poetics of Space*, 98.

114. Ibid., 93.

115. Peter Hollindale, introduction to *Peter Pan in Kensington Gardens and Peter and Wendy*, xix.

116. Bachelard, *The Poetics of Space*, 126.

117. At the beginning of the section on "nests," Bachelard cites two lines from a poem by Yvan Goll (1891–1950): "I found a nest in the skeleton of the ivy/A soft nest of country moss and dream herb," from *Tombeau du père*, as cited in *The Poetics of Space*, 90.

118. See Bachelard on the childish wonder of finding a "living nest," *The Poetics of Space*, 94–95.

119. My understanding of the bed as a boat has been influenced by Barbara Todd's artist's installation, *A Bed Is a Boat*, which I saw in 1998 at the Museum for Textiles in Toronto.

120. Barrie, *Margaret Ogilvy*, 7.

121. Ibid., 9.

122. Stallybrass, "Worn Worlds," 36.

123. Geoffrey Keynes, *Introductory Volume* to the facsimile edition of William Blake's *The Gates of Paradise* (London: Trianon Press for the William Blake Trust, 1968), 2.

124. Ibid., 3.

125. Ibid., 1.

126. Ibid.

127. Blake used this most important surviving source of his early drafts, informal writing, and sketches, now referred to as Blake's *Notebook*, to inscribe some of the *Songs of Experience*, as well as other works. Ibid., 1–2.

128. Lewis Carroll, "Bruno's Revenge," in *Victorian Fairy Tales*, edited by Jack Zipes (New York and London: Methuen, 1987), 75. Originally published in *Aunt Judy's Magazine*, 1867.

129. Arthur Conan Doyle, "Fairies Photographed: An Epoch-Making Event," *Strand Magazine*, Christmas 1920, 466.

130. Ibid., 464.

131. Rolf H. Krauss, *Beyond Light and Shadow: The Role of Photography in Certain Paranormal Phenomena: An Historical Survey* (Munich: Nazraeli Press, 1995), 188.

132. Carroll, "Bruno's Revenge," 75.

133. Stewart, *On Longing*, 113.

134. Two years before the Brownie camera hit the market, *The Ladies' Home Journal* published the following light history of the Brownie (the elf and the fairy kind):

> During the publication of the series of the "Brownies" just closed in *The Ladies' Home Journal*, the question has often come to me "What is the origin of the 'Brownies?'" And perhaps there is no better time to answer this question than now, before the next series of "Brownie" adventures shall begin on this page.
>
> The "Brownie," as the cyclopaedia informs us, springs from an old Scotch tradition, but it leaves us to follow up the tradition ourselves and learn how far back into the past it may be traced. Now a tradition, or legend, is about as difficult game to hunt to cover as your literary fowler can flush, but enough can be found to prove that the "Brownies" were good-natured little spirits or goblins of the fairy order. They were all little

men, and appeared only at night to perform good and helpful deeds or enjoy harmless pranks while weary households slept, never allowing themselves to be seen by mortals. No person, except those gifted with second sight, could see the "Brownies;" but from the privileged few, principally old women, who were thus enabled to now and then catch a glimpse of their goblin guests, correct information regarding their size and color is said to have been gained.

They were called "Brownies" on account of their color, which was said to be brown owing to their constant exposure to all kinds of weather, and also because they had brown hair, something which was not common in the country where the "Brownie" was located, as the people generally had red or black hair. There are different stories about the origin of the name. One is that during the time the Covenanters in Scotland were persecuted because they were said to teach a false and pernicious doctrine, many of them were forced to conceal themselves in caves and secret places, and food was carried to them by friends. One band of Covenanters was led by a little hunchback named Brown, who being small and active could slip out at night with some of the lads and bring in the provisions left by friends in secret places. They dressed themselves in a fantastic manner, and if seen in the dusk of the evening they would be taken for fairies. Those who knew the truth named Brown and his band the "Brownies." This is very plausible, but we have too high an opinion of the "Brownies" to believe that they took their name from a mortal. We are inclined to believe that the well-deserving hunchback took his name from the "Brownies," instead of the "Brownies" deriving their name from him. Besides the story does not reach back far enough.

The "Brownies" were an ancient and well-organized band long before there was a Covenanter to flee to caves and caverns. Indeed, from what can be gathered from the writings of ancient authors, one is led to believe the "Brownie" idea is a very old one. It is fair to presume that the "Brownies" enjoyed their nightly pranks, or skipped over the dewy heather to aid deserving peasants even before the red-haired Dane crossed the border to be Caledonia's unwelcome guest. Every family seems to have been haunted by a spirit they called "Brownie" which did different sorts of work, and they in return gave him offerings of the various products of the place. The "Brownie" idea was woven into the affairs of everyday life. In fact it seemed to be part of their religion, and a large part at that. When they churned their milk, or brewed, they poured some milk or wort through

the hole in a flat, thin stone called "Brownie's stone." In other cases they poured the offering in the corners of the room, believing that good would surely come to their homes if "the Brownies" were remembered. On out of the way islands, where the people could neither read nor write, and were wholly ignorant of what was going on in other parts of the country, so much so that they looked upon a person that could understand black marks on paper as a supernatural being, the "Brownie" was regarded as their helper. The poet Milton had doubtless one of these "Brownies" in his mind when he penned the lines in "L'Allegro" to the "lubber fiend," who drudged and sweat.

"To earn his cream-bowl duly set."

But, strange to say, he was not as complimentary as the untarnished reputation of the "Brownies" might lead one to expect. In some villages, near their chapel, they had a large flat stone called "Brownie's stone," upon which the ancient inhabitants offered a cow's milk every Sunday to secure the good-will of the "Brownies." That the "Brownies were good eaters, and could out-do the cat in their love for cream, is well proven in many places.

It may be gratifying to some to know that even kings have not thought it beneath their dignity to dip the royal pen in the "Brownies" behalf. King James in his "Daemonology" says: "The spirit called 'Brownie' appeared like a man and haunted divers houses without doing any evil, but doing as it were necessarie turnes up and down the house, yet some were so blinded as to believe that their house was all the sonsier, as they called it, that such spirits resorted there." Other writers say that the "Brownie" was a sturdy fairy, who, if he was fed well and treated kindly would do, as the people said, a great deal of work. He is said to have been obliging, and used to come into houses by night, and for a dish of cream perform lustily any piece of work that might remain to be done. The superstitious inhabitants had absolute faith in the "Brownies'" wisdom or judgment. The "Brownie" spirit was said to reach over the table and make a mark where his favorite was to sit at a game if he wished to win, and this "tip" from the "Brownie" was never disregarded by the player.

The seeker after facts concerning the origin of the "Brownies" will find it difficult to gather them in. He may visit the largest libraries in the land and turn the leaves of old volumes that have been neglected for centuries, and fail to find more than that at one time in the long long ago, the "Brownie" was a power in the land that no well-regulated family could

afford to do without. One thing is certain, however, the more we learn about the "Brownies" the better we like them. Theirs is a genealogy that one can trace back through the dusty centuries of the past without finding one blot on their scutcheon, or discovering that they descended from a race of robbers or evil doers. It is indeed refreshing to learn that at a time when the age was so dark that even Christianity could scarcely send a ray of light through it, and when every man's hand seemed to be against his brother, when poachers, moss-troopers and plundering men of might were denuding the land, the "Brownies" through rain and shine were found at their post every night, aiding the distressed, picking up the work that weary hands let fall, and in many ways winning the love and respect of the people.

Palmer Cox, "The Origin of the 'Brownies,'" *Ladies' Home Journal*, November 1892, 8.

135. Nadar, "My Life as a Photographer," translated by Thomas Repensek, *October* 5 (summer 1978): 8.
136. Tom Gunning, "Ghosts, Photography and the Modern Body," in the exhibition catalog *The Disembodied Spirit*, Alison Ferris, Curator, Bowdoin College Museum of Art, Brunswick Maine, September 25 through December 7, 2003, 11.
137. Edward L. Gardner, *Fairies: The Cottingley Photographs and Their Sequel* (London: Theosophical Publishing House, 1966), 32.
138. Charles Baudelaire, "The Painter of Modern Life," in *The Painter of Modern Life and Other Essays*, 8. Originally published in French as "Le Peintre de la vie moderne" in three issues of *Le Figaro*, November 26 and 29, 1963, and December 3, 1963.
139. Baudelaire, "The Painter of Modern Life," 8.
140. Christian Boltanski, as cited in "Studio Visit: Christian Boltanski," *Tate Magazine*, issue 2 (November/December 2002), http://www.tate.org.uk/magazine/issue2/.
141. Birkin, *J. M. Barrie and the Lost Boys*, 41.
142. Pamela Maude, *Worlds Away* (London: Heinemann, 1964), 137–45. As cited by Birkin, ibid., 42.
143. Louis Marin, *Food for Thought*, translated by Mette Hjort (Baltimore: Johns Hopkins University Press, 1989), 136. Originally published in French as *La Parole mangée et autres essais théologico-politiques* (Paris: Librairie des Méridiens, 1986).

144. Stewart, *On Longing*, 112–14.

145. Ibid., 114.

146. Lewis Carroll was Charles Dodgson's pen name, which he used for authoring his children's stories, but not his photography, nor any other aspect of his professional lives.

147. Stewart, *On Longing*, 115.

148. In chapter 3 of *Peter and Wendy*, "Come Away, Come Away!," when Peter does not know what a kiss is, she gives him a thimble so as to not hurt his feelings. Likewise, when Wendy inclines her face toward Peter for a kiss, he drops an acorn in her hand (*P&W*, 92).

149. As Adam Phillips writes, "Worrying, then, is devouring, a peculiarly intense, ravenous form of eating." See *On Kissing, Tickling and Being Bored*, 51.

150. Ibid., 94.

151. Nico Llewelyn Davies, March 15, 1915, as cited by Birkin in *J. M. Barrie and the Lost Boys*, 243.

152. Aubrey Tennyson to Peter Llewelyn Davies, March 1915, as cited by Birkin, ibid., 244.

153. J. M. Barrie to George Llewelyn Davies, March 11, 1915, as cited by Birkin, ibid., 242–43.

154. London's *Evening Standard*, March 12, 1921, as cited by Birkin, ibid., 292–93.

155. As cited by Birkin, ibid., 1.

156. J. M. Coetzee, *Disgrace* (New York: Viking, 1999), 12.

157. Ibid., 170.

158. Below is Stevenson's poem in full:

*My Shadow (1913)*

I have a little shadow that goes in and out with me,
And what can be the use of him is more than I can see.
He is very, very like me from the heels up to the head;
And I see him jump before me, when I jump into my bed.

The funniest thing about him is the way he likes to grow —
Not at all like proper children, which is always very slow;
For he sometimes shoots up taller like an India-rubber ball,
And he sometimes gets so little that there's none of him at all.

He hasn't got a notion of how children ought to play,
And can only make a fool of me in every sort of way.

He stays so close beside me, he's a coward you can see;
I'd think shame to stick to nursie as that shadow sticks to me!

One morning, very early, before the sun was up,
I rose and found the shining dew on every buttercup;
But my lazy little shadow, like an arrant sleepy-head,
Had stayed at home behind me and was fast asleep in bed.

Poem 18 in *A Child's Garden of Verses*, collected in *The Works of Robert Louis Stevenson*, vol. 8 (London: William Heinemann/Charles Scribner's Sons, 1922), 27–28.

159. Barrie, *Margaret Ogilvy*, 169.

160. Brigid Brophy, Michael Levey, and Charles Osborne, "*Peter Pan*" in *Fifty Works of English and American Literature We Could Do Without* (London: Rapp and Carroll, 1967), 109–10.

161. Winnicott, "Transitional Objects and Transitional Phenomena," 20.

162. D. W. Winnioctt, *Holding and Interpretation: Fragment of an Analysis* (New York: Grove Press, 1986), 35. For a very enlightening commentary on what may or may not be labeled as incest between a mother and son, from a personal perspective, see Brooke Hokins's "A Question of Child Abuse," *Raritan* 13 no. 2 (fall 1993): 33–55. Hopkins is remembering his "affair" with his mother when he was six years old. Of interest in Hopkins's story is the fact that, unlike that of the Narrator in the *Search*, it was his mother who sought him out.

163. Eve Kosofsky Sedgwick, *Between Men: English Literature and Male Homosocial Desire* (New York: Columbia University Press, 1985).

164. Barthes, *A Lover's Discourse*, 14. In French: *Fragments d'un discours amoureux*, 20.

*six* ⌁ **CHILDHOOD SWALLOWS**

The full citation to this chapter's second epigraph is Hans Christian Andersen, *80 Fairy Tales*, translated by R. P. Keigwin (Odense: Skandinavisk Bogforlag and Flensteds Forlag, 1976), 45, which was originally published in Danish as "Tommelise," in *Eventyr, fortalte for Børn — Andet Hefte* (Fairytales Told to the Children — Second Booklet) (C. A. Reitzel Publishers, 1835).

1. The color of Proust's cork-lined room is described by his maid Céleste Albaret as honey colored, but there are other accounts of its hue. See Lydia Davis, "Proust's Bedroom," *Nest* (fall 2001): 201.

2. Barthes, *Camera Lucida*, 5. In French: *La Chambre claire*, 15.

3. Barthes, *Camera Lucida*, 5. In French: *La Chambre claire*, 16.

4. Jean Fondin, introduction to the pleasurable and beautiful book *Boyhood Photos of J.-H. Lartigue: The Family Album of a Gilded Age* (Lausanne: Ami Guichard, 1966), 6. The book's text and photo captions were written by Fondin based on interviews with Lartigue. Also published in French as *Les Photographies de J.-H. Lartigue: Un album de famille de la Belle Époque* (Lausanne: Ami Guichard, 1966), the introductory essay of which is slightly different than its English counterpart. "Fairy godmothers" are mentioned in a related context; see *Les Photographies de J.-H. Lartigue*, 6.

5. Lartigue, *Boyhood Photos of J.-H. Lartigue*, 16. In French: *Les Photographies de J.-H. Lartigue*, 16.

6. André Breton, *Nadja*, translated by Richard Howard (New York: Grove Press, 1960), 11. Originally published in French as *Nadja* (Paris: Librairie Gallimard, 1928). For an excellent discussion of how "Breton goes from suggesting that haunting is related to the places and persons that one frequents to reflecting on how this dependence starts to undermine the integrity of the *I* itself," see Margaret Cohen, *Profane Illumination: Walter Benjamin and the Paris of Surrealist Revolution* (Berkeley: University of California Press, 1993), 57–75. The Cohen quote above is from page 63.

7. In association with Lartigue's phantom pictures, the following can be found in his journal from 1905: "I ask Zissou to dress up in a sheet. He comes and puts himself in front of the lens. I open the lens cap, I close it again. Zissou goes away and I open the lens cap again without him in the picture. And I really hope it's going to be a fine ghost photograph." Lartigue, as translated by David Wharry in d'Astier et al., eds., *Lartigue: Album of a Century*, 374. In French: *Lartigue: L'Album d'une vie, 1894–1986*.

8. Lartigue, as quoted by Martine d'Astier and translated by David Wharry in "The Autobiographical Enterprise: The Invention of Heaven," in d'Astier et al., eds., *Lartigue: Album of a Century*, 35. In French: Jacques Henri Lartigue, journal entry from 1900, Pont-de-l'Arche, in *Mémoires sans mémoire* (Paris: Éditions Robert Laffont, 1975), 32.

The Narrator of the *Search*, as a boy walking along the Guermantes way, also desires to savor the world as trapped and held by his eyes *and his nose*, if only to discover what secrets lie beneath the "gleam of sunlight on a stone, the smell of a path":

> Since I felt that this something was to be found in them, I would stand motionless, looking, breathing, endeavouring to penetrate with my mind be-

yond the thing seen or smelt. And if I then had to hasten after my grand-father, to continue my walk, I would try to recapture them by closing my eyes. . . . (I, 252; I, 176) I felt that . . . it would be better to think no more of the matter until I reached home. . . . I had imprinted on my mind and be-neath which I should find it still alive, like the fish which, on days when I had been allowed to go out fishing, I used to carry back in my basket, covered by a layer of grass which kept them cool and fresh. (I, 252–53; I, 177)

9. Lartigue, as quoted by d'Astier and translated by Wharry in "The Autobio-graphical Enterprise," 35. In French: Journal entry from 1900, Pont-de-l'Arche, in *Mémoires sans mémoire*, 32.

10. Lartigue, journal entry from 1901, Pont-de-l'Arche, in *Mémoires sans mémoire*, 34.

11. Fondin, paraphrasing Lartigue, *Boyhood Photos of J.-H. Lartigue*, 35. In French: Journal entry from 1904, Berck, in *Mémoires sans mémoire*, 56.

12. As noted in chapter 1, "My Book Has A Disease," Bachelard describes a shell as "a house that grows in proportion to the growth of the body that inhabits it;" see *The Poetics of Space*, 118.

13. Bachelard, *The Poetics of Space*, 119.

14. Bachelard notes, "an empty shell, like an empty nest, invites day-dreams of refuge"; see ibid., 107.

15. These beautiful words are not the words of Lartigue, but of my student Jennifer Parker (March 2005), writing on the poetics of Cornell's use of seashells.

16. Stewart McBride describes this dollhouse, seen at Lartigue's home near Grasse shortly before his death, in "The Last, Sunny Days of Lartigue," 57.

17. Lartigue, journal entry from 1904, Berck, *Mémoires sans memoire*, 56. Transla-tion is mine.

18. Lartigue, as quoted by d'Astier and translated by Wharry in "The Autobio-graphical Enterprise," 35. In French: Lartigue in an interview with Antoine Peillon, *Le Point* (Paris), March 18, 1985, 74.

19. Lartigue, as quoted by d'Astier and translated by Wharry in "The Autobio-graphical Enterprise," 35. In French: Journal entry from 1900, Pont-de-l'Arche, in *Mémoires sans mémoire*, 23.

20. Lartigue, as quoted by d'Astier and translated by Wharry in "The Autobio-graphical Enterprise," 35. In French: Journal entry from 1900, Pont-de-l'Arche, in *Mémoires sans mémoire*, 23.

21. Lartigue, as translated by Shelley Rice in "Remembrance of Images Past," 124. In French: Journal entry from 1900, Pont-de-l'Arche, in *Mémoires sans mé-moire*, 23.

22. Rice, "Remembrance of Images Past," 124.

23. Clément Chéroux, "Jacques Henri Lartigue: The Memory of the Instant," in d'Astier et al., eds., *Lartigue: Album of a Century*, 25.

24. Martine d'Astier writes that Lartigue's "first camera was the magical object that would at last enable him to satisfy his great desire 'to bottle' the things that made him happy"; see "The Autobiographical Enterprise," 35.

25. As Lartigue notes in his published journals:

> I discover Marcel Proust, a bit like I discovered Chartres Cathedral last year, because of a statue in the corner of an altar—Proust, too, was in a postponed corner. A statue that amazed me before the details that encircle it amaze me, before the amazement at the amazement of discovering the entire monument of which my little statue wasn't just a small detail, but an indispensable detail.
>
> I come to hear a phrase of Proust's. And I am amazed by it as I was first amazed by my little statue. And I come to discover, after this phrase, other phrases. I know that the monument exists. Would I have the time to discover it?

See journal entry from May 1970 in Jacques Henri Lartigue, *L'Oeil de la mémoire: 1932–1985* (Paris: Éditions Carrere-Michel Lafon, 1986), 405. Translation is mine.

26. Lartigue, from his handwritten diaries, as cited and translated by Rice, "Remembrance of Images Past," 128.

27. Lartigue, as quoted and translated by Avis Berman, "Artist's Dialogue: A Conversation with Jacques Henri Lartigue," *Architectural Digest* 40 (July 1983): 154.

28. After his many experiments with flight as a young man, Maurice (Zissou) Lartigue became a businessman like his father. As Jean Fondin notes: "Beyond the demands of business, Zissou's flair for technical innovation and experiment (which had led him to design gliders and jump off the garden wall with only Papa's umbrella as a parachute) eventually resulted in a series of scientific articles written for and published in learned journals"; see Fondin, *Boyhood Photos of J.-H. Lartigue*, 126.

29. Leonardo da Vinci, Codex Atlanticus in the Ambrosiana Library, Milan, Verso A 381, as cited by Ritchie Calder in *Leonardo and the Age of the Eye* (New York: Simon and Schuster, 1970), 224.

30. Lartigue, as found in *Boyhood Photos of J.-H. Lartigue*, 42. In French: *Les Photographies de J.-H. Lartigue*, 42.

31. French caption is written directly on the photograph, housed at Donation Lartigue. Translation is mine.

32. Lartigue took his first flight on November 1, 1916, with his aviator friend Jean Dary. See "Biography and Captions" at the end of d'Astier et al., eds., *Lartigue: Album of a Century*, 378.

33. Nilson, "The Ancient Little Boy," 46.

34. Roland Barthes, *Sade-Fourier-Loyola*, translated by Richard Miller (New York: Hill and Wang, 1976), 116. Originally published in French as *Sade, Fourier, Loyola* (Paris: Éditions du Seuil, 1971). In French: *Sade, Fourier, Loyola*, 121.

35. James Kincaid, "'Watching or Fainting or Sleeping or Dead': Unveiling Dante Gabriel Rossetti's *Beata Beatrix*," paper presented at "Dreaming the Past" conference, University of North Carolina, Chapel Hill, April 24, 1993.

36. Oscar Wilde, as quoted by Isobel Murray in her introduction to *Oscar Wilde: Complete Shorter Fiction* (Oxford: Oxford University Press, 1998), 5.

37. George MacDonald, "The Light Princess," in *The Complete Fairy Tales*, edited with an introduction by U. C. Knoepflmacher (New York: Penguin), 1999. Originally published in *Adela Cathcart* (London: Hurst and Blackett, 1864).

38. MacDonald, "The Light Princess," 20.

39. Ibid.

40. Ibid., 23.

41. Ibid., 26.

42. Lartigue's very photogenic son Dani was born on August 23, 1920, and was not struck by fate. Dani is featured in some of Lartigue's most charming, if more conventional, photographs taken during his adult period.

43. Lartigue, as translated by Vicki Goldberg in her introduction" to *Jacques Henri Lartigue: Photographer* (Boston: Little, Brown, 1998), x. In French: Journal entry from December 1915 in *Mémoires sans mémoire*, 224.

44. Lartigue, as translated by Goldberg in her introduction to *Jacques Henri Lartigue*, x. In French: Journal entry from November 1917, Paris, in *Mémoires sans mémoire*, 273.

45. d'Astier, *Guardian Weekly* interview, 26.

46. Ibid.

47. As translated by David Wharry in d'Astier et al., eds., *Lartigue: Album of a Century*, 378. The album page, "1914 Aout—Rouzat: Guerre" is reproduced ibid., 105.

48. Rice, "Remembrance of Images Past," 128.

49. Berman, "Artist's Dialogue," 154.

50. Lartigue, as quoted and translated by Berman, ibid., 156.

51. Lartigue, journal entry from 1900, Paris, in *Mémoires sans memoire*, 24. Translation is mine.

52. Lartigue, from his black book now housed at the Mission du patrimoine, Paris. As cited and translated by Rice in "Remembrance of Images Past," 129.

53. Berman, "Artist's Dialogue," 154.

54. Svetlana Boym, *The Future of Nostalgia* (New York: Basic Books, 2001), 21.

55. Lartigue, as translated by David Wharry in d'Astier et al., eds., *Lartigue: Album of a Century*, 392. In French: from a typed note entitled, "Pour fin de mon Journal—(Ecrit en 1977)," reproduced ibid., 366.

56. Lartigue, as translated by David Wharry in d'Astier et al., eds., *Lartigue: Album of a Century*, 392. In French: from a handwritten note reproduced ibid., 367.

57. Brassaï, *Proust in the Power of Photography*, translated by Richard Howard (Chicago: University of Chicago Press, 1997), 97. Originally published in French as *Marcel Proust sous l'emprise de la photographie* (Paris: Gallimard, 1997).

58. Céleste Albaret, *Monsieur Proust*, as told to Georges Belmont and translated by Barbara Bray (New York: New York Review of Books, 2003), 251–52. Emphases are mine.

59. This is according to Lartigue's third wife Florette. See Florette Lartigue, *Jacques Henri Lartigue: La traversée du siècle* (Paris: Bordas, 1990), 38. Avedon, a great supporter and lover of Lartigue's photographs, conceived of and wrote the introduction to *Diary of a Century: Photographs of Jacques Henri Lartigue* (New York: Viking Press, 1970).

60. I thank Marianne Le Galliard at the Donation Lartigue for tracking for me this scribbled note by Lartigue. The translation is mine.

61. Marianne Le Galliard also helped to discover this Proust reference.

62. Chéroux, "Jacques Henri Lartigue: The Memory of the Instant," 25. I trust that this comment by Lartigue written in response to one of Proust's letters is there in the piles and piles of all things Lartigue at the Donation Lartigue. However, Marianne Le Galliard was unable to find it.

63. As quoted by Shelley Rice, *Parisian Views* (Cambridge, Mass.: MIT Press, 1997), 179.

64. Baudelaire, "The Swan," in *The Flowers of Evil*, in French and English, 174–75. Originally published in French as "Le Cygne" in *Les Fleurs du mal* (1857).

65. My understanding of these little machines comes directly from Sylvie Aubenas's catalog entry no. 97 in *Nadar*, edited by Maria Morris Hambourg, Fran-

çoise Heilburn, and Philippe Néagu (New York: Metropolitan Museum of Art and Harry N. Abrams, Inc., 1995), 248.

66. Nadar, as quoted by André Rouillé, "*When I Was a Photographer*: The Anatomy of a Myth," in Hambourg et al., *Nadar*, 109. Emphasis is mine.

67. Benjamin, "The Image of Proust," 211–12. Emphasis is mine.

68. Ibid., 211.

69. Ibid.

70. As quoted by Jean-Yves Tadié and translated by Euan Cameron in *Marcel Proust: A Life* (New York: Viking, 2000), 606. Originally published in French as *Marcel Proust: Biographie* (Paris: Éditions Gallimard, 1996). In French: *Cahier 57 (1913–1916)* [Notes for *Le Temps retrouvé*, Manuscript 16 697 in the Bibliothèque nationale, Paris], note in the margin of Recto 17; see Marcel Proust, *Matinée chez la princesse de Guermantes: Cahiers du temps retrouvé*, edited by Henri Bonnet and Bernard Brun (Paris: Galliard, 1982), 326.

71. Tadié, *Marcel Proust*, 251.

72. Ibid.

73. This fragment of Mallarmé's "Le Cygne" is quoted in a letter that the Narrator writes to Albertine in *The Fugitive* (V, 614; IV, 39).

74. Albaret, *Monsieur Proust*, 93.

75. Ibid., 94.

76. Tadié, *Marcel Proust*, 605.

77. Brassaï, *Proust in the Power of Photography*, 140.

78. Unfortunately the English translation of *Pleasures and Regrets* has omitted this wonderful and illuminating dedication as well as the beautiful illustrations by the flower painter Madeleine Lemaire (1885–1928). This translation is from Chris Taylor's excellent website, a "labour of love not of scholarship," dedicated to works by Proust that have not been translated into English. http://www.yorktaylors.free-online.co.uk/index.htm. In French: "A mon ami Willie Heath: mort à Paris le 3 octobre 1893," in *Les Plaisirs et les jours* (Paris: Librairie Gallimard, 1924), 13–14. Originally published in 1896.

79. Brassaï, *Proust in the Power of Photography*, 140.

80. These are words from chapter 4, "Pulling Ribbons from Mouths."

81. Barthes, *Camera Lucida*, 7. In French: *La Chambre claire*, 20

82. Barthes, *Camera Lucida*, 53. In French: *La Chambre claire*, 88.

83. Barthes, *Camera Lucida*, 53. In French: *La Chambre claire*, 88.

84. Lartigue, as quoted by d'Astier and translated by Wharry in "The Autobiographical Enterprise," in d'Astier et al., eds., *Lartigue: Album of a Century*, 33. In French: Journal entry from 1908, Rouzat, in *Mémoires sans mémoire*, 73.

85. Marcel Proust, *Selected Letters*, 1904–1909, vol. 2, edited by Philip Kolb, translated with an introduction by Terence Kilmartin (New York: Oxford University Press, 1989), 237. In French: Letter to Madame Catusse (December 12, 1906) in *Correspondance de Marcel Proust*, edited by Philip Kolb (Paris: Librarie Plon, 1976), vol. 6, 328.

86. White, *Marcel Proust*, 43–44.

87. Ibid., 24.

88. Tadié, *Marcel Proust*, 474.

89. Proust, as quoted in Tadié in *Marcel Proust*, 474. In French: Letter to Madame Catusse (December 4, 1906) in *Correspondance de Marcel Proust*, vol. 6, 302.

90. In May 1919, Proust was forced to leave Boulevard Haussmann, eventually settling into a fifth floor apartment on rue Hamelin, where he died on November 18, 1922.

91. Tadié, *Marcel Proust*, 474.

92. Ibid., 475.

93. Ibid., 474.

94. Diana Fuss, *The Sense of the Interior: Four Writers and the Rooms that Shaped Them* (London: Routledge, 2004), 155.

95. Ibid., 184.

96. Ibid., 185.

97. Ibid., 168.

98. Ibid.

99. Fuss, *The Sense of the Interior*, 184. Indeed, to step inside the Madeleine, dark and windowless save for the two circular skylights high above in the ceiling, feels strangely womb-like. Light bleeds through from the Madeleine's moon-like orbs into the dark, dusty-feeling interior that hails (at least in my imagination) the experience of being within Proust's own cork-lined room on Boulevard Haussmann, with its limited glow.

100. Ibid., 152.

101. Michelet, *The Bird*, 194. In French: *L'Oiseau*, 231.

102. Brassaï, *Proust in the Power of Photography*, 140.

103. Proust, as cited by André Maurois and translated by Gerard Hopkins in *Proust: Portrait of a Genius* (New York: Harper and Brothers, 1950), 38. Originally published in French as *À la recherche de Marcel Proust* (Paris: Hachette, 1949). These questionnaires were very popular; we have already seen a glimpse of one filled out by George Llewelyn Davies in the last chapter. Recall:

Your greatest misery: Early School
Your pet flower and colour: Wood Sorrel Mauve.
Your favourite novelist: Robert Louis Stevenson
(George Llewelyn Davies's 1911 entry in Barrie's querist album)

104. Swallow's Nest Soup with Rock Sugar

Also known as Bird's Nest Soup, this sweet dessert soup is made from the nests of the swiftlet, a type of swallow.

Serves 4

Ingredients:

2 ounces bird's nests (approximately 6 whole nests)

7 tablespoons crushed rock sugar, or to taste

4 cups water

Directions:

Prepare the bird's nest: soak it in cold water for several hours or overnight. Rinse well. Go over the nests and pick out any loose feathers. Bring a pot of water to boil and simmer the bird's nests for about 5 minutes. Again, rinse well and squeeze dry. (You should have about 1½ cups at this point. If not, adjust the amount of water and rock sugar accordingly.)

Place the bird's nests in the pot and add the water. Bring to a boil and simmer until the bird's nests are quite soft. Add the rock sugar, stirring to dissolve. Serve the soup hot.

Note: You'll want to save this for a special occasion. Authentic bird's nests are quite expensive, not surprising given that the nests come from the hardened saliva of the swiftlet swallow. It could be a good choice for a romantic evening, as bird's nest is rumored to be an aphrodisiac.

This recipe is adapted from "Chinese Regional Cooking" by Florence Lin in *Florence Lin's Chinese Regional Cookbook: A Guide to the Origins, Ingredients, and Cooking Methods of Over 200 Regional Specialties and National Favorites* (New York: Hawthorn Books, 1975), 299.

105. The swiftlet weaves its nest from strands of saliva. The male regurgitates a long, thin, gelatinous strand from salivary glands under its tongue which is then wound into a half-cup nest which bonds like quick-drying cement to the inside of a cave wall, where the nests are found. The nests are relatively tasteless.

106. Michelet, *The Bird*, 195. In French: *L'Oiseau*, 231–32.

107. Benjamin, "The Image of Proust," 203.

108. Oscar Wilde, "The Happy Prince," as found in Oxford World's Classics *Oscar Wilde: Complete Shorter Fiction*, edited with an introduction and notes by Isobel Murray (Oxford: Oxford University Press, 1998), 95. Originally published as *The Happy Prince and Other Tales* (London: Walter Crane, 1888). Hereafter, references to "The Happy Prince" will be made parenthetically in the body of the text, as indicated by *HP* with the page number from this edition following.

109. Jacques Rivière, as quoted by Benjamin in "The Image of Proust," 213.

110. Albaret, *Monsieur Proust*, 148.

111. d'Astier, "The Autobiographical Enterprise," in d'Astier et al., eds., *Lartigue: Album of a Century*, 31–32.

112. As quoted by Michel Guerrin in "Tracing the Career of a Child Prodigy Who Became an Icon of Photography," *Guardian Weekly*, September 4–10, 2003, 26. In French: *Le Monde*, June 6, 2003.

113. Elizabeth Goodenough, "Oscar Wilde, Victorian Fairy Tales, and the Meanings of Atonement," in *The Lion and the Unicorn* 23, no. 3 (1999): 340.

114. Isobel Murray, introduction to *Oscar Wilde*, 11.

115. Wilde, "The Happy Prince," 102.

116. Murray, introduction to *Oscar Wilde*, 11.

117. Wullschläger, *Inventing Wonderland*, 114.

118. "According to a touching thirteenth century legend, the Christ child plays in the mud, forming little birds, which come to life — and are swallows. This story reflected a belief that when swallows disappeared during the winter, they were hibernating in the mud at the bottom of ponds, to be resurrected in the spring." Diana Wells, *100 Birds and How They Got Their Names* (Chapel Hill, N.C.: Algonquin Books, 2001), 239.

*seven* **MOUTH WIDE OPEN FOR PROUST**

I dedicate this chapter and its ideas to Ambrose Mavor-Parker, my adolescent boy with the name and the spirit of a basilica.

1. I had not yet seen the Who at San Francisco's Winterland. I had not seen them break guitars, yet, but I had heard Roger Daltrey (the Who's lead singer) sing "Baba O'Riley" with its line, "It's only teenage wasteland" on the radio. I liked it. But my family and I were not there to see British rock. We were in London to see what all the other families had come to see.

2. See Gilles Deleuze, *Proust and Signs*, translated by Richard Howard (Minne-

apolis: University of Minnesota Press, 2000). See especially, chapter 3, "Apprenticeship," 26–38. Originally published in French as *Proust et les signes* (Paris: Presses universitaires de France, 1964).

3. Victor Hugo, *Les Contemplations, II*, "Pauca meae," "A Villequier," in *Œuvres de Victor Hugo* (Paris: Librairie Alphonse Lemerre, 1951), 35. As quoted by Proust in *Le Temps retrouvé* (IV, 615).

4. Tadié, *Marcel Proust*, xvi.

5. Proust as quoted by Tadié, xix. Tadié is quoting from an article about Reynaldo Hahn that appears in *Contre Sainte-Beuve. Précédé de pastiches et mélanges et suivi de essais et articles*, edited by Pierre Clarac and Yves Sandre (Paris: Gallimard, 1971), 556.

6. Roger Shattuck, "Lost and Found: The Structure of Proust's Novel," in Richard Bales, ed., *The Cambridge Companion to Proust* (Cambridge: Cmbridge University Press, 2001), 79.

7. Tadié, *Marcel Proust*, 9.

8. Ibid., 11.

9. Not that anyone but a few California baby boomers like myself would care. There is no Matterhorn at Disney World. Disney World's Cinderella Castle, at a height of almost 180 feet, is almost twice the height of the Sleeping Beauty Castle at Disneyland, in Anneheim, California. The latter is not as dramatically French Gothic and was inspired by the Neuschwanstein Castle in Bavaria, built between 1869 and 1886, mixing a range of styles, including the mock turrets so characteristic of Disneyland's own fantasy castle.

10. Proust had begun this novel in autumn 1895, a novel which he later abandoned in autumn 1899. It was never finished. It was finally published in 1952 as *Jean Santeuil* (Paris: Gallimard, 1952).

11. Tadié, *Marcel Proust*, 8.

12. Proust, as translated by Euan Cameron in Tadié, *Marcel Proust*, 8. In French: *Jean Santeuil*, edited by Pierre Clarac and Yves Sandes with a preface by Jean-Yves Tadié (Paris: Gallimard, 2001), 161–62.

13. Tadié, *Marcel Proust*, 348.

14. "The title is a frivolous variation on the sober title of . . . [an] ancient Greek classic, Hesiod's *Works and Days*." White, *Marcel Proust*, 57.

15. Diane Leonard, "Ruskin and the Cathedral of Lost Souls," in Bales, ed., *The Cambridge Companion to Proust*, 52.

16. Proust, as quoted by Leonard in "Ruskin and the Cathedral of Lost Souls," 53. In French: Letter to Comte Jean de Gaigneron (August 1, 1919) in *Correspondance de Marcel Proust*, vol. 18, 359.

17. White, *Marcel Proust*, 5.

18. Jean Cocteau, "La Voix de Marcel Proust," in *Poésie Critique*, 2 vols. (Paris: Gallimard, 1959), vol. 1, 127, as translated by White in *Marcel Proust*, 5.

19. As André Aciman writes in his foreword to Céleste Albaret's *Monsieur Proust*: "The greater-incalculable—loss is the disappearance of Proust's *cahiers noirs* (black books), which Céleste describes as containing 'the first drafts of the book, long fragments and even whole chapters written in the course of earlier years, even of his youth'"; see *Monsieur Proust*, x. Tadié writes: "We do not know exactly when, but one day towards the end of 1908 Proust bought the school exercise books—probably in bulk, since he would need ten of them for *Contre Sainte-Beuve*—ninety-five of which survive in the Bibliothèque Nationale; a further thirty-two Céleste Albaret said she destroyed on her master's instructions . . . the project was linked to a return to childhood: the greatest author of our time had suddenly become a schoolboy, writing in his exercise books, just as his father and mother had once urged him to do"; see Tadié, *Marcel Proust*, 520–21.

20. Shattuck, "Lost and Found," 79.

21. Ibid., 80. Shattuck's altered translation of Proust is from *Swann's Way* (I, 83; I, 60).

22. Marcel Proust, "The Days" in *Contre Sainte-Beuve*, collected in *Marcel Proust: On Art and Literature, 1896–1919*, 44. In French: "Journées" in *Contre Sainte-Beuve*, 69.

23. The visitor to Saint-Jacques will find that only Saint-Jacques has a scallop shell above his head. The Virgin, to one's right as you face the altar, is not graced with this beautiful motif.

24. Carter, "The Vast Structure of Recollection," in Bales, ed., *The Cambridge Companion to Proust*, 27.

25. Leonard citing Proust from *Contre Sainte-Beuve* in "Ruskin and the cathedral of lost souls," 44. See Proust, "Pèlerinages Ruskiniens en France" in *Contre Sainte-Beuve. Précédé de pastiches et mélanges et suivi de essais et articles*, 441.

26. As Edmund White has noted: "Proust's complicated way of talking was dubbed by his friends with the French made-up verb *proustifier*, 'to Proustify'"; see *Marcel Proust*, 52.

27. See Vera and Hellmut Hell, *The Great Pilgrimage of the Middle Ages: The Road to St. James of Compostela*, translated by Alisa Jaffa (New York: C. N. Potter, 1966). Originally published in German as *Die grosse Wallfahrt des Mittelalters: Kunst an den romanischen Pilgerstrassen durch Frankreich und Spanien nach Santiago de Compostela* (Tübingen: E. Wasmuth, 1964).

28. Robert de La Sizeranne, as quoted by Tadié and translated by Euan Cameron in *Marcel Proust*, 351. See La Sizeranne, *Ruskin et la religion de la beauté* (Paris: Librarie Hachette, 1897), 96.

29. Tadié notes that Proust meditated on La Sizeranne's *Ruskin et la religion de la beauté*. See *Marcel Proust*, 352.

30. While Ruskin's taste for nostalgia is not the subject of this book, and perhaps no author can, in fact, escape a hunger for it, the British art critic did embrace it. Consider not only his love of Gothic architecture, but the whole Arts and Crafts movement triggered by Ruskin and William Morris, in which the two promoted the revival of trade building crafts, as they rejected all machine-produced products. Like so many utopianists, they imagined a better world based on the past, as is made most evident in Morris's novel, *News from Nowhere* (1890), a future world based on medievalism.

31. "Adrien Proust [Marcel's father] . . . made famous—and effective—the idea of a *cordon sanitaire*, a 'sanitary zone' circling Europe in order to keep out cholera. In order to put his principles to work Dr. Proust traveled to Russia, Turkey, and Persia in 1869 and figured out the routes by which cholera in previous academics had entered Russia and thereby Europe. For this successful investigation and the resulting efficacious sanitation and quarantine campaign Dr. Proust was awarded the Legion of Honor"; see White, *Marcel Proust*, 14–15.

32. John Ruskin, *Sesame and Lilies*, part 3, "Mystery of Life and Its Arts" as collected in *The Works of John Ruskin*, edited by E. T. Cook and Alexander Wedderburn, 38 vols. (London: George Allen, 1905), vol. 18, 167.

33. The French should be around vol. 4, pages 616–17, but it appears that there is an entire paragraph in English omitted from the French edition. As Joseph Litvak suggested to me in a personal correspondence, "Could the editors simply have been dozing?"

34. Phillips, "Clutter: A Case History," in *Promises, Promises: Essays on Literature and Psychoanalysis* (New York: Basic Books, 2001), 61.

35. Adam Phillips, "On Being Bored," in *On Kissing, Tickling and Being Bored*, 69.

36. Ibid., 69.

37. Deleuze, *Proust and Signs*, 3.

38. Ibid., 22.

39. Ibid., 19.

40. What Phillips does with clutter is not unlike Winnicott's notion of a "child's eye-view of archaeology," which I develop into the concept of the "unmaking

of childhood." See chapter 3, "Splitting: The Unmaking of Childhood and Home."

41. Adam Phillips, "Clutter," 64.

42. Proust, "On Reading Ruskin," 103–5. Emphasis is mine. In French: Proust, "Sur la lecture," 45–48.

43. Deleuze, *Proust and Signs*, 24.

44. Ibid., 17.

45. I owe this phrase to Julia Kristeva; see *New Maladies of the Soul*, translated by Ross Guberman (New York: Columbia University Press, 1995), 199. For more on adolescence and art, see Mavor, *Becoming*.

46. James Vincent Cunningham, "Coffee" in *The Poems of J. V. Cunningham*, edited by Timothy Steele (Athens, Ohio: Swallow Press, 1997), 26–27.

47. Shattuck, "Lost and Found," 75.

48. For further discussion of "writerly," as defined by Barthes, see this book's final chapter, "Beautiful, Boring, and Blue."

49. Proust, "The Days," in *Contre Sainte-Beuve*, 39. In French: "Journées," in *Contre Sainte-Beuve*, 2.

50. Proust probably met Manet at Mèry Laurent's salon; see Paul Nadar's book, *The World of Proust as Seen by Paul Nadar*, edited by Anne-Marie Barnard, translated by Susan Wise (Cambridge, Mass.: MIT Press, 2002), 110.

51. Mark Driscoll has helped me understand the definition of this term in relation to Morimura's work.

52. Antoine Bibesco, son of Princesse Aleandre Bibesco reminiscing on Proust, as cited by Tadié and translated by Euan Cameron in *Marcel Proust*, 378. In French: Antoine Bibesco's preface to his edition of Proust's letters, *Lettres de Marcel Proust à Bibesco* (Lausanne: Clairfontaine, 1949), 30.

53. In the *Search*, Vinteuil is a musician and author of a "little phrase," which whenever heard or recalled, becomes the "national anthem" of Swann's love for Odette. See vol. 1, 308–9, 335–36, 374–75.

54. Proust, "In Slumbers," in *Contre Sainte-Beuve*, 31. In French: "Sommeils," in *Contre Sainte-Beuve*, 55.

55. See Joseph Litvak, *Strange Gourmets: Sophistication, Theory, and the Novel* (Durham: Duke University Press, 1997), especially the chapter "Taste, Waste, Proust," 77–111.

56. Deleuze, *Proust et les signes*, 34. The passage translates as, "The worldly signs imply chiefly a time wasted"; see Deleuze, *Proust and Signs*, 24.

57. Joseph Litvak, "Strange Gourmet: Taste, Waste, Proust," in *Novel Gazing: Queer Reading in Fiction*, edited by Eve Kosofsky Sedgwick (Durham: Duke

University Press, 1997), 77. See also Litvak's excellent full-length study of taste and waste, *Strange Gourmets*. On the topic of shifting from adolescence to adulthood, Litvak cites Thierry Laget's "Notice" in *À la recherche* (2: 1492); see "Taste, Waste, Proust," 85, 62, n. 15.

58. Kristeva, *Time and Sense*, 3.

59. Shattuck, "Lost and Found," 76. Shattuck describes the whole story of *In Search of Lost Time* as basically a repetition of "a boy-man becomes lost, meanders, and finds his way again" (ibid.).

60. Roland Barthes, "The Death of the Author" in *Image, Music, Text*, 144. Originally published in French as "La Mort de l'auteur" in *Manteia*, 4th trimester, 1968. In French: "La Mort de l'auteur," in Barthes, *Œuvres complètes*, Tome III, 42.

61. Julia Kristeva, "The Adolescent Novel," in *New Maladies of the Soul*, 135. Emphasis is mine.

62. Litvak, "Taste, Waste, Proust," 108.

63. Ibid.

*eight* ⌣ SOUFFLÉ/SOUFFLE

1. As Jean-Yves Tadié writes: "From the age of nine, Marcel suffered from an illness that was both well known and mysterious, and which would accelerate, if not cause, his premature death: asthma. One day in 1881, probably in the springtime, after a long walk in the Bois de Boulogne . . . 'Marcel,' Robert [Proust's brother] related, 'was struck by a frightening spasm of suffocation which, with my terrified father watching, almost proved to be fatal.'" *Marcel Proust*, 50.

2. We get one of the few clues to the Narrator's actual age in *Within a Budding Grove* (II, 65) when the character Norpois mentions Gilberte as "a young person of fourteen or fifteen," who is apparently about the same age as the Narrator.

3. Hélène Cixous describing the work, not of Proust, but of Lewis Carroll; nevertheless the birdly and breathy metaphors feel very Proustian. See her "Introduction to Lewis Carroll's *Through the Looking-Glass* and *The Hunting of the Snark*," *New Literary History* 13 (winter 1982): 234. In French: "Introduction" to Lewis Carroll, *De l'autre côté du miroir et ce qu'alice y trouva/La chasse au snark*, Chronologie et bibliographie par Jean Gattégno (Paris: Aubier-Flammarion, 1971), 16.

4. Deleuze, *Proust and Signs*, 13.

5. For example, in 1975, Hélène Cixous published an entire book of this name. See Cixous, *Souffles* (Paris: des Femmes, 1975). Jean-Luc Godard's famous, stylish film, known to Anglo-American audiences as *Breathless*, is, of course, *À bout de souffle* (1960).

6. Roger Shattuck, *Marcel Proust* (New York: Viking Press, 1974), 23.

7. Ibid. The comparison between Baudelaire and Leonardo is Shattuck's.

8. Charles Baudelaire, "Correspondences," translated by McGowan in *The Flowers of Evil* in French and English, 18–19. Originally published in French as "Correspondances" in *Les Fleurs du mal* (1857).

9. Walter Benjamin, "On Some Motifs in Baudelaire" in *Illuminations*, 191. Originally published as "Über einige Motive bei Baudelaire" in *Zeitschrift für Sozialforschung*, edited by Max Horkheimer, vol. 8, 2 (1939).

10. *Oxford English Dictionary*, 2d ed., s.v. "correspond."

11. This phrase will be taken up in chapter 9, "Kissing Time."

12. Baudelaire, "Correspondences," 19.

13. For the cultural gendering of smell (and touch) as feminine, see Carol Mavor, "*Odor di femina*: Though You May Not See Her, You Can Certainly Smell Her," *Cultural Studies* 12, no. 1 (1998): 51–81.

14. Ibid.

15. *Oxford English Dictionary*, 2d ed., s.v. "transpose."

16. Ibid.

17. Adam Phillips, "On Translating a Person," in *Promises, Promises: Essays on Literature and Psychoanalysis* (New York: Basic Books, 2001), 131.

18. Ibid.

19. Rolf Tiedemann, "Dialectics at a Standstill: Approaches to the *Passagen-Werk*," in Walter Benjamin, *The Arcades Project*, translated by Howard Eiland and Kevin McLaughlin, prepared on the basis of the German volume edited by Rolf Tiedemann (Cambridge, Mass.: Bellknap Press of Harvard University Press, 1999), 935.

20. Tiedemann explaining Benjamin's approach to history in "Dialectics at a Standstill," 935.

21. Benjamin, "The Image of Proust," 202.

22. Benjamin, *The Aracades Project*, 461.

23. Barthes, *Camera Lucida*, 26. In French: *La Chambre claire*, 49.

24. Walter Benjamin, "One-Way Street," in *Selected Writings, Vol. 1: 1913–1926*, edited by Marcus Bullock and Michael W. Jennings, translated by Rodney Livingstone et al. (Cambridge, Mass.: Harvard University Press, 1999), 210.

Originally published in German as "Einbahnstraße" (Berlin: Ernst Rowohlt Verlag, 1928).

25. The metaphor of Benjamin's writing as resembling the early stages of house building is Tiedemann's. See "Dialectics at a Standstill," 931.

26. Baudelaire, "Benediction," translated by McGowan in *The Flowers of Evil* in French and English, 12–13. Originally published in French as "Bénédiction" in *Les Fleurs du mal* (1857).

27. Barthes, *Michelet*, 17. In French: *Michelet par lui-même*, 17.

28. Barthes, *Michelet*, 17. In French: *Michelet par lui-même*, 17.

29. Barthes, *Michelet*, 17. In French: *Michelet par lui-même*, 17.

30. Barthes, *Michelet*, 22. Emphasis is mine. In French: *Michelet par lui-même*, 20–21.

31. Elizabeth Howie, unpublished essay on Barthes and Michelet for my seminar "Roland Barthes: Policeman of Signs, Professor of Desire," spring semester, 2002.

32. Victor Hugo as cited by Barthes in *Michelet*, 213. In French: *Michelet par lui-même*, 185.

33. Lesley Dill, as quoted by Nancy Princenthal, "Words of Mouth: Lesley Dill's Work on Paper," *On Paper: The Journal of Prints, Drawings and Photography* 2 (1997–98): 28.

*nine* ⌇ **KISSING TIME**

The quotation in this chapter's third epigraph is from a story written during Proust's last year at the Lycée de Condorcet, as published in *The Lilac Review*, and was cited by White in *Marcel Proust*, 38. In French: one of three contributions by Proust collected in *La Revue Lilas* (November 1888), as cited by Jean-Yves Tadié in *Marcel Proust: Biographie* (Paris: Éditions Gallimard, 1996), 114.

1. Between 1897 and 1902, the pneumatic letter-card sent by tube through Paris was known affectionately as the *petit bleu* or simply a *bleu*, because the "little letter" was on blue paper. When the Narrator first meets the lady in pink, who is, of course, Odette, she discusses with the Narrator's uncle, how she might get the "delicious" boy, the "perfect 'gentleman,'" the "little Victor Hugo" over for a snack: "Couldn't he come to me some day for 'a cup of tea,' as our friends across the Channel say? He need only send me a 'blue' in the morning?" (I, 107; I, 77). Later the Narrator will send his own *petit bleu* to Odette's

daughter Gilberte. "I had sent her an express letter, writing on its envelope the name, Gilberte Swann . . . one of the *petits bleus* that she had received in the course of the day" (I, 572–73; I, 395–96).

2. This is, as we learned in chapter 5, "Nesting," is Peter Llewelyn Davies's name for Barrie's *Peter Pan*. See Birkin, *J. M. Barrie and the Lost Boys*, 196.

3. Phillips, *On Kissing, Tickling and Being Bored*, 94.

4. Winnicott, "Transitional Objects and Transitional Phenomena," 11.

5. Barthes, *Camera Lucida*, 72. In French: *La Chambre claire*, 112.

6. Phillips, *On Kissing, Tickling and Being Bored*, 94. Emphasis is mine.

7. Sandor Ferenczi, "Oral Eroticism in Education" (1930), a fragment from his papers, as collected in *Final Contributions to the Problems and Methods of Psycho-Analysis*, edited by Michael Balint, translated from the German by Eric Mosbacher (New York: Brunner/Mazel, 1980), 219.

8. Phillips, *On Kissing, Tickling and Being Bored*, 94.

9. Proust, *Contre Sainte-Beuve*, collected in *Marcel Proust: On Art and Literature, 1896–1919*, 44. In French: *Contre Sainte-Beuve*, 69.

10. Phillips, *On Kissing, Tickling and Being Bored*, 97.

11. Kristeva, *Time and Sense*, 4.

12. Phillips, *On Kissing, Tickling and Being Bored*, 97.

13. Ibid.

14. Erwin Panofsky, "Father Time," in *Studies in Iconology: Humanistic Themes in the Art of the Renaissance* (New York: Harper and Row, 1962), 69–94.

15. Julia Kristeva, "Women's Time," in *The Kristeva Reader*, edited by Toril Moi (New York: Columbia University Press, 1986), 190. First published as "Le temps de femmes," in *34/44: Cahiers de recherche de sciences des textes et documents* 5 (winter 1979): 5–19.

16. John Berger, "Mother," as collected in *John Berger: Selected Essays* (London: Vintage, 2003), 493.

17. Proust was baptized on August 5, 1871, and was later confirmed as a Catholic, but he never practiced Catholicism. And even though Jews trace their religion to their mothers, he never was a practicing Jew either. And although he is famous for supporting Dreyfus, there are disturbing and offensive passages describing caricatures of Jews peppered throughout the *Search*, as in the following from *The Guermantes Way*: "In a French drawing-room . . . a Jew making his entry as though he were emerging from the desert, his body crouching like a hyena's, his neck thrust forward, offering profound 'salaams,' completely satisfies a certain taste for the oriental" (III, 253; II, 487–88). Nevertheless,

Proust's passage is somewhat ambiguous, suggesting that it is the Euro-Christian who insists on seeing the Jew as other, as Orientalized, in order to make sense of the "anti-Dreyfus cyclone" (III, 253; II, 487).

18. In a similar way, when upon leaving his aescetic Aunt Léonie's room, the Narrator would always be expected to kiss his aunt's hand, a scene which would invoke a Christ-like image: "She would hold out for me to kiss her sad, pale, lacklustre foreheard, on which, at this early hour she would not yet have arranged the false hair and through which the bones shone like the points of a crown of thorns or the beads of a rosary (I, 71; I, 51–52).

19. White, *Marcel Proust*, 9.

20. As discussed in chapter 4, "Pulling Ribbons from Mouths," Barthes also knows how the telephone cannot compensate for the kisses of a Maman or a maternally cast lover. Barthes writes in *A Lover's Discourse*: "I try to deny separation by the telephone — as the child fearing to lose its mother keeps pulling on a string; but the telephone wire is not a good transitional object, it is not an inert string; it is charged with a meaning, which is not that of junction but that of distance"; see *A Lover's Discourse*, 115. In French: *Fragments d'un discours amoureux*, 132.

21. As cited by White in *Marcel Proust*, 94.

22. Nancy Spector, *Félix Gonzáles-Torres*, exhibition catalog (New York: Guggenheim Museum, 1995), 147.

23. Ibid.

24. Mieke Bal, *The Mottled Screen: Reading Proust Visually*, translated by Anna-Louise Milne (Stanford: Stanford University Press, 1997), 202. Originally published in French as *Images littéraires, ou, comment lire visuellement Proust* (Montreal: XYZ éditeur; Toulouse: Presses universitaires du Mirail, 1997).

25. The character of Berma is based on Sarah Bernhardt.

26. In French, the passage is, "Ces paroles, de la sorte qui est la seule importante, involontaires, nous donnant la *radiographie* au moins sommaire de la réalité insoupçonnable que cacherait un discours étudié"; see Proust, *À l'ombre des jeunes filles en fleurs* (I, 577; emphasis is mine). So here in the original French, the x is not there, but the notion of the x-ray as the most piercing, most probing, form of photography is retained.

27. Taking x-rays of the spirit was an observation that M. S. made in reviewing Akira Kurosawa's 1952 film *Ikiru* (To Live): "He deploys his camera so sharply and unerringly that it seems to take x-rays of the spirit"; see M. S., "Film Notes: Ikiru," *New Yorker*, January 6, 2003.

28. In French, the final line is "je les radiographiais." Like the previous Proust quote, it doesn't have an x but retains the notion of the piercing, probing x-ray.

29. Barthes, *Camera Lucida*, 6. In French: *La Chambre claire*, 17.

30. This is, of course, Disneyfied. See Disney's 1937 animated classic. There is no kiss in the original Snow White version by Grimm. However, the Disney version is the one that most of us know. Even the famed feminist literary critics, Susan Gubar and Sandra Gilbert, "use the Disney version as their interpretive point of departure." Maria Tatar, editor, *The Classic Fairy Tales* (New York: Norton, 1999), 78.

31. Brothers Grimm, "Sleeping Beauty" as edited by and with an introduction by Maria Tatar, *The Annotated Classic Fairy Tales* (New York: Norton, 2002), 103–4.

32. Adam Phillips, *The Beast in the Nursery* (New York: Pantheon Books, 1998), 107.

33. Barthes, "An Idea of Research," in *The Rustle of Language*, translated by Richard Howard (New York: Hill and Wang, 1986), 273. Originally published in French as "Une idée de recherche" in *Le Bruissement de la langue* (Paris: Éditions du Seuil, 1984). In French: "Une idée de recherche," 309.

34. Barthes, "An Idea of Research," 274. In French: "Une idée de recherche," 310.

35. Barthes, "An Idea of Research," 274. In French: "Une idée de recherche," 310.

36. White, *Marcel Proust*, 150.

37. I am indebted to Anna Miller, a graduate student in my seminar "Reading Boyishly," for making this astute observation.

38. Barthes, "An Idea of Research," 273. In French: "Une idée de recherche," 309.

39. Barthes, "An Idea of Research," 273. In French: "Une idée de recherche," 309.

40. Albaret, *Monsieur Proust*, 49. This theme of living an upside-down life with Proust is repeated often throughout *Monsieur Proust*.

41. Ibid., 110.

42. Ibid., 90.

43. Ibid., 173.

44. There are countless examples of this. Such as "Peter had seen many tragedies, but he had forgotten them all" (*P&W*, 143). Or, "No one ever gets over the first unfairness; no one except Peter. He often met it, but he always forgot it. I suppose that was the real difference between him and the rest" (*P&W*, 150).

45. Albaret, *Monsieur Proust*, 59.

46. Ibid., 149.

47. Barthes, *Camera Lucida*, 15. In French: *La Chambre claire*, 32–33.

48. Albaret, *Monsieur Proust*, 96.

49. Stewart, *On Longing*, 111.

50. Carole G. Silver, *Strange and Secret Peoples: Fairies and Victorian Consciousness* (Oxford: Oxford University Press, 1999), 118.

51. Ibid. I had long been fascinated by Caroline Crachami's thimble since viewing it at the Royal College of Surgeons. (Incidentally, the Royal College of Surgeons also houses this book's hummingbirds encased in glass; see chapter 1, "My Book Has a Disease.") But it was not until I read Silver's fine book that I learned that Caroline Crachami was known as The Sicilian Fairy.

### ten ∽ BEAUTIFUL, BORING, AND BLUE

An early version of this chapter was delivered as a paper at the conference, "The Visibility of Women's Practice," co-organized by Deborah Cherry and Gill Perry, Tate Britain (May 2003).

1. Victor Hugo, "15 février 1843," on the marriage of his daughter Léopoldine, in *Les Contemplations* II, "Pauca meae," in *Œuvres de Victor Hugo* (Paris: Librairie Alphonse Lemerre, 1951), 4.

2. Precisely: in English, 4,282 pages into the 4,347-page *In Search of Lost Time*; in French, 3,012 pages into the 3,054-page *À la recherche du temps perdu*.

3. Hugo's original line is, "Emporte le bonheur et laisse-nous l'ennui!" Proust has changed the "us" to "me." Hugo, as cited by Proust (VI, 467; IV, 583).

4. Chantal Akerman, "Interview with Director Chantal Akerman" (text), *The Captive* (2000), DVD, Artificial Eye, July 18, 2000.

5. Hélène Cixous, *Vivre l'orange* in *L'Heure de Clarice Lispector* (in French and English), translated by Ann Liddle and Sarah Cornell (Paris: Éditions des Femmes, 1989), 18. Originally published in French as *Vivre l'orange* (Paris: Éditions des Femmes, 1979).

6. Cixous, *Vivre l'orange*, 18.

7. Chantal Akerman, interview by David Wood, British Broadcasting Corporation, April 26, 2001, http://www.bbc.co.uk/films/2001/04/26/chantal_ackerman_the_captive_interview.shtml.

8. For more on the spirals and intersections of *Vertigo*'s Madeleine and Proust's *petite madeleine*, see Chris Marker's interactive CD-ROM: *Immemory* (Cambridge, Mass.: Exact Change, 2002).

9. J. Hoberman, "Persistence of Memory," *Village Voice*, March 12, 2001.

10. See Ivone Margulies's *Nothing Happens: Chantal Akerman's Hyperrealist Everyday* (Durham: Duke University Press, 1986).

11. Gary Indiana, "Getting Ready for the Golden Eighties: A Conversation with Chantal Akerman," *ArtForum* 21 (summer 1983): 56.

12. White, *Marcel Proust*, 27.

13. Albaret, *Monsieur Proust*, 11.

14. Patricia Patterson and Manny Farber, "Kitchen Without Kitsch," *Film Comment* (November–December 1977): 48.

15. Margulies, *Nothing Happens*, 68.

16. Chantal Akerman, "Chantal Akerman on *Jeanne Dielman*: Excerpts from an Interview with *Camera Obscura*, November 1976," *Camera Obscura* 2 (fall 1977): 119.

17. Ibid.

18. Ibid.

19. Thierry de Duve, "Les Trois Horloges," in *Chantal Akerman, Cahier 1*, edited by Jacqueline Aubenas (Brussels: Atelier des Arts, 1982), 89.

20. Patterson and Farber, "Kitchen Without Kitsch," 49.

21. Ibid., 48.

22. Ibid.

23. Ibid., 49.

24. Ibid.

25. Benjamin, "The Image of Proust," 201.

26. Ibid., 202.

27. Barrie, *Margaret Ogilvy*, 123.

28. We had the first glimpse of Evans's *Trumpeter Swan* when it cradled the words of Baudelaire's "The Swan" in chapter 6, "Childhood Swallows."

29. White, *Marcel Proust*, 110.

30. Ibid.

31. Marcel Proust, "George Eliot," in *Marcel Proust: On Art and Literature, 1896–1919*, translated by Sylvia Townsend Warner, with an introduction by Terence Kilmartin (New York: Carroll and Graf Publishers, Inc., 1984), 5. In French: "Sur George Eliot" in *Contre Sainte-Beuve. Précédé de pastiches et mélanges et suivi de essais et articles*, 656.

32. Teresa de Lauretis, "Rethinking Women's Cinema: Aesthetics and Feminist Theory," in *Technologies of Gender: Essays on Theory, Film, and Fiction* (Bloomington: Indiana University Press, 1987), 142. For de Lauretis, films like *Jeanne Dielman* make "a place for what I will call me, knowing that I don't know it, and give 'me' a space to try to know, to see, to understand" (142).

33. Barthes, *The Pleasure of the Text*, 59. In French: *Le Plaisir du texte*, 93–94.

34. Hélène Cixous, *Three Steps on the Ladder of Writing*, edited by Sarah Cornell and Susan Sellers (New York: Columbia University Press, 1993), 21.

35. Barthes, *The Pleasure of the Text*, 11. In French: *Le Plaisir du texte*, 21–22.

36. Barthes, *The Pleasure of the Text*, 11. In French: *Le Plaisir du texte*, 22.

37. Roger Shattuck, *Proust's Way: A Field Guide to Proust* (New York: Norton, 2000), 33.

38. Chantal Akerman, "On *D'Est*," in *Bordering on Fiction: Chatal Akerman's D'Est* (Minneapolis: Walker Art Center, 1995), 17. Akerman uses this phrase when speaking of her film, *D'Est (From the East)* (1993).

39. Michael Hardt and Antonio Negri, *Empire* (Cambridge, Mass.: Harvard University Press, 2000), 293.

40. Ibid., 292.

41. Ibid., 293, noting the work of Dorothy Smith, *The Everyday World as Problematic: A Feminist Sociology* (Boston: Northeastern University Press, 1987), especially pages 78–88.

42. The emphasis is on "almost" because Hardt and Negri acknowledge feminism, without really taking it on in a detailed historical way.

43. Tadié, *Marcel Proust*, 407.

44. *Roland Barthes by Roland Barthes*, caption to snapshot of Barthes as a boy being held by his mother, from a series of photographs and texts that serves as a preface to the book, unpaginated. In French: *Roland Barthes par Roland Barthes*, 6.

45. Barthes, *The Pleasure of the Text*, 26. In French: *Le Plaisir du texte*, 43.

46. Julia Kristeva, "Motherhood According to Bellini," in *Desire in Language: A Semiotic Approach to Literature and Art*, edited by Leon S. Roudiez, translated by Thomas Gora, Alice Jardine, and Leon S. Roudiez (New York: Columbia University Press, 1980), 243. Originally published in French as "Maternité selon Giovanni Bellini," idem., *Polylogue* (Paris: Éditions du Seuil, 1977).

47. Rosalind Krauss, "Corpus Delicti," in *L'Amour Fou: Photography and Surrealism* (New York: Abbeville Press, 1985), 74.

48. *Oxford English Dictionary*, 2d ed., s.v. "apron-string."

49. Jacques Derrida, *Given Time. I, Counterfeit Money*, translated by Peggy Kamuf (Chicago: University of Chicago Press, 1992), 7. Originally published in French as *Donner le temps. 1. La fausse monnaie* (Paris: Éditions Galilée, 1991). As Derrida writes:

> One cannot treat the gift, this goes without saying, without treating the relation to economy, even to the money economy. But is not the gift, if there

is any, also that which interrupts economy? That which, in suspending economic calculation, no longer gives rise to exchange? That which opens the circle so as to defy reciprocity or symmetry, the common measure, and so as to turn aside the return in view of the no-return? If there is gift, the *given* of the gift (*that which* one gives, *that which* is given, the gift as given thing or as act of donation) must not come back to the giving (let us not already say to the subject, to the donor). It must not circulate, it must not be exchanged, it must not in any case be exhausted, as a gift, by the process of exchange, by the movement of circulation of the circle in the form of return to the point of departure. If the figure of the circle is essential to economics, the gift must remain *aneconomic*. Not that it remains foreign to the circle, but it must keep a relation of foreignness to the circle, a relation without relation of familiar foreignness. It is perhaps in this sense that the gift is the impossible.

50. Akerman, "Chantal Akerman on *Jeanne Dielman*," 118–19.
51. Brenda Longfellow, "Love Letters to the Mother: The Work of Chantal Akerman," *Canadian Journal of Political and Social Theory* 13, no. 1–2 (1989): 86.
52. Janet Bergstrom, "Invented Memories," in *Identity and Memory: The Films of Chantal Akerman*, edited by Gwendolyn Audrey Foster (Trowbridge, U.K.: Flicks Books, 1999), 102.
53. Bergstrom quoting Brenda Longfellow, ibid.
54. Kristeva, *Time and Sense*, 14.
55. Ibid., 3.
56. Margulies, *Nothing Happens*, 72.
57. Brian Masumi, "Too Blue," in *Parables for the Virtual: Movement, Affect, Sensation (Post-Contemporary Interventions)* (Durham: Duke University Press, 2002), 210.
58. Derek Jarman, *Blue: Text of a Film by Derek Jarman* (Woodstock, N.Y.: Overlook Press, 1994), 3–15.
59. Deleuze, *Proust and Signs*, 3.
60. Ibid., 22.
61. Margulies, *Nothing Happens*, 69.
62. Hélène Cixous, "Sorties: Out and Out: Attacks/Ways Out/Forays," in *The Newly Born Woman*, translated by Betsy Wing (Minneapolis: University of Minnesota Press, 1986), 87. Originally published in French as "Sorties," idem., *La Jeune née* (Paris: Union d'Éditions Générales, 1975).

1. Barrie, *Margaret Ogilvy*, 41.
2. Roland Barthes, "Introduction to the Structural Analysis of Narratives," in *Image, Music, Text*, 124. Originally published in French as "Introduction à l'analyse structurale des récits," *Communications* 8 (1966): 1–27. In French: "Introduction à l'analyse structurale des récits," 27.
3. Proust, "In Slumbers" in *Contre Sainte-Beuve*, collected in *Marcel Proust: On Art and Literature, 1896–1919*, 28. In French: "Sommeils" in *Contre Sainte-Beuve*, 52–53.
4. Proust quoting Antoine-Marin Lemierre in "Sainte-Beuve and Baudelaire" in *Contre Saint-Beuve*, 128.

# INDEX

CAROL MAVOR is professor of art history and visual
studies at the University of Manchester. She is the author
of *Becoming: The Photographs of Clementina Viscountess
Hawarden* (1999) and *Pleasures Taken: Performances of
Sexuality and Loss in Victorian Photographs* (1995).

⋰⋱

Library of Congress Cataloging-in-Publication Data
Mavor, Carol
Reading boyishly : Roland Barthes, J. M. Barrie,
Jacques Henri Lartigue, Marcel Proust, and
D. W. Winnicott / Carol Mavor.
p. cm.
Includes bibliographical references and index.
ISBN 978-0-8223-3886-4 (cloth : alk. paper)
ISBN 978-0-8223-3962-5 (pbk. : alk. paper)
1. Mothers and sons. 2. Boys—Psychology.
3. Boys in literature. I. Title.
HQ755.85.M35 2007
306.874'3—dc22
2007005225